Transition and Turmoil

Pictures edited by Eamonn McCabe

Text by Terence McNamee with Anna Rader and Adrian Johnson

DECADE

Jonathon Porritt
Climate Change and Human Inertia

As I write in early 2010, plans are being laid for 'Rio+20', the United Nations Earth Summit scheduled for 2012, which aims to celebrate the twentieth anniversary of the Earth Summit held in Rio de Janeiro in 1992. However, one would need to be a pretty deluded party-goer to imagine that there will be much to celebrate from an environmental perspective. Two reprehensibly wasted decades is about the sum of it.

And when it comes to relative reprehensibility, the second of those two decades has been so much more disappointing than the first. For political and business élites, the 1990s were spent catching up with the uncomfortable environmental realities that scientists had just brought to their attention. It was a decade of strategies, action plans and high-flown rhetoric at global gatherings – all of which somehow managed to retain a residual sense of optimism. So much to do; so much political will to muster.

The current decade has been infinitely worse. For lack of any serious action, those strategic policies, action plans and global gatherings have become deeply cynical exercises in manipulating both the media and the electorate. We know so much more now about the state of the world, but evidence has been ignored on every front. Almost everything we learn (on fresh water, soil, forest, biodiversity, oceans, atmospheric pollution, climate change, toxics, and so on) demonstrates a continuing deterioration in the integrity of those ecosystems on which we depend. Yet the gap between what we are doing and what we need to be doing increases year on year.

If we analyse the statistics that book end the last 10 years, this situation is hardly surprising. In 2000, the population of the world was 6 billion. At the beginning of 2010, it's 6.8 billion. That is an average of 80 million additional people every year over the decade, with the majority born in developing and emerging countries, many of which are still wholly ill-equipped to deal with such growth.

In 2000, global GDP was $40 trillion. In 2009, it was $70 trillion. There is nothing wrong with that in itself, and many of those trillions helped hundreds of millions of people to climb out of poverty, especially in countries like China and India. But much of that huge increase in wealth came at the expense of the natural environment – through unsustainable use of resources, chronic air and water pollution, loss of top soil, accelerating climate change, and so on.

Every year, Ecological Debt Day marks the day on which we've used up that year's allocation of natural resources, 'going into the red' from that point onwards. In 2000, Ecological Debt Day fell on 1 November. In 2009, it was 25 September. We are using 30 per cent more resources than the Earth can replenish each year, leading to deforestation, degraded soils, polluted air and water, and dramatic declines in the numbers of fish and other species. As a result, we're running up an ecological debt of around $4 trillion every year – even the financial crash in 2008 pales in comparison to this looming ecological credit crunch.

In 2000, concentrations of CO_2 in the atmosphere stood at 370 parts per million (ppm). In 2009, it was 387 ppm. Concentrations are now increasing by about 2.3 ppm a year and in April 2009 the highest-ever single reading for CO_2 levels in the atmosphere was recorded at 397 ppm.

In 2000, total spending on arms was $875 billion. In 2009, it was $1.3 trillion. Those with good memories may recall widely shared expectations back in the 1990s that the collapse of the Soviet Union (most powerfully symbolized by the tearing down of the Berlin Wall in 1989) would produce a powerful peace dividend. One of the great signals of hope at the start of this decade was the agreement by the richest nations to reverse some of the worst trends in the world's poorer countries through the adoption of the Millennium Development Goals.

But what little evidence there was of any emerging peace perished with the collapse of the Twin Towers in New York in 2001. The shadow of 9/11 has haunted the whole of the decade since then, birthing two wars, in Iraq and Afghanistan, and diverting political leaders the world over into a futile and ultimately self-defeating War on Terror.

One of those leaders was the UK Prime Minister, Tony Blair. As Chair of the UK's Sustainable Development Commission between July 2000 and July 2009, I saw for myself the devastating impact these events had on the quality of his leadership. Whatever else one may think about Blair, there is no disputing the energy and skill he brought to bear on the climate change agenda from his very first day in office. He sustained this commitment at the international level all the way through to the end of his premiership, but his efforts to translate any of that

into specific measures in the UK, in his own backyard, were all but non-existent.

Environmentally, this has of course been the decade of climate change. Two blockbuster reports from the Intergovernmental Panel on Climate Change (IPCC), in 2001 and 2007, established a powerful scientific consensus embraced by all but a small and very vocal minority of scientists. In 2005, Hurricane Katrina jolted bemused Americans into belated recognition that the rich world would not be immune from the consequences of accelerating climate change. US presidential candidate Al Gore's film *An Inconvenient Truth* was shown all around the world, persuading millions that further delay would be disastrous. And in 2007 Gore and the IPCC shared the Nobel Peace Prize in recognition of the transformative effect their work has had on the global community.

But the decade of climate change ended in chaos and controversy. That hard-earned consensus was jeopardised by a number of scientific contro-versies, including mistakes make by the IPCC and less-than-transparent process from some leading climate scientists at the University of East Anglia. This has greatly strengthened the hand of those who argue that even if climate change is happening, it's down to natural variations in the climate rather than to man-made emissions of CO_2 and other greenhouse gases.

This had a knock-on effect on the United Nations Climate Change Conference held in Copenhagen in December 2009. This ended in miserable failure, with China and the US playing hardball in a way that brought the whole UN process into disrepute – despite the fact that the vast majority of reputable scientists still believe that the science is rock-solid and that if emissions continue to rise at the same rate as today, we'll be unable to stop average temperature increases climbing above the 2 °C level. This is the absolute upper limit if we are to avoid runaway climate change. Let alone irreversible climate change.

With the failure of the Copenhagen conference still resonating round the world, perhaps one of the most important lessons of the decade is the realization that even if climate change were not a direct result of man's actions, our natural world is still under terrible pressure. We seem completely incapable, even now, of recognizing that there really are physical limits to the size and reach of the human economy, and that if we go on transgressing those limits, our entire way of life will be at risk. As George Monbiot (one of the most trenchant commentators on environmental issues throughout the decade) put it in his column in the *Guardian* newspaper on 14 December 2009:

'Humanity is no longer split between conser-vatives and liberals, reactionaries and progressives … Today the battle lines are drawn between expanders and restrainers; those who believe that there should be no impediments and those who believe that we must live within limits. The vicious battles we have seen so far between greens and climate change deniers … are just the beginning. This war will become much uglier as people kick against the limits that decency demands.'

Today's cornucopian world-view – limitless plenty for all, in a global economy driven by consumerism and the relentless pursuit of novelty – reached its zenith in the financial crash of 2008. The earlier dot-com boom and bust and the Enron scandal were all forgotten as greed, pathetically inadequate regulation and irrational exuberance took the global economy to the edge of the abyss. Early in 2010, it looks as if the worst has been avoided. Yet the burden of debt built up through the entire decade remains at an historically high level. Unemployment is still rising and environmental programmes the world over are already being cut back.

Looking back over this decade's backdrop (9/11, the financial crash, accelerating climate change still unaddressed, and so on), it's hard to be particularly optimistic. But we can and must focus on the upsides of the past 10 years: the huge increase in the evidence base now available to decision-makers, with environmental scientists painstakingly gathering in the data on which our future depends; the very welcome commitment on the part of leading companies all around the world to play their part in creating a more sustainable economy; technological breakthroughs starting to come in thick and fast; the growing engagement of the world's leading religions and faith communities, helping people to lead more responsible, sustainable lives; the rolling out of increasingly sophisticated educational programmes in schools, colleges and universities. All these advances raise a hope that the next generation will be far better equipped to address our challenges than the generation that has presided over this past decade.

The solutions are all there, ready to be implemented on a global stage. All that's lacking is the political will to make it happen.

Christopher Coker
9/11: The Glass Shatters

The German philosopher Martin Heidegger said that the world only becomes real to us when it breaks. We notice things and become conscious and aware of them – we draw them into the focus of our attention – only when they break, or behave differently than expected, thereby challenging our assumptions about what the world is like and what can be expected from it. To illustrate this he used a glass of water. We tend to take both the glass and water for granted until the glass breaks. It is only at this point that we are likely to ask what is the essence of a glass and what is the essence of water. We become fully aware of the ephemeral nature of life.

Our world changed on 11 September 2001, when our perception of the West as an impregnable fortress was shattered. We could say, as would Heidegger, that the spur to action is fear and disappointment. Americans became at once excessively fearful and at the same time disappointed that the post-Cold War world was not going to be quite as secure a place as they had hoped. Whether the United States really was more insecure after the attacks on New York and Washington, DC, was beside the point. What 9/11 brought home to Americans was the alarming thought that a major power had become vulnerable for the first time in centuries to attacks by a group of individuals acting without the authority or trappings of a state.

The annals of war, the historian John Keegan wrote a few years earlier, could be divided into a three-act struggle between the 'haves' and 'have-nots'. For three thousand years, war involved a series of raids by the horse-peoples of the central Asian steppe on the 'haves' – the great civilizations of the world. The names of the 'have-nots' are etched on our collective memory – they are the great nomadic peoples, the Huns, the Goths, the Mongols. The form of warfare they practiced was primitive and destructive, and it ran its course until the fifteenth century, when Europeans learned to put gunpowder in the service of their own culture.

In the second act the 'haves' fought each other. In the course of this 500-year struggle the societies of the Western world and Russia conquered most of the world, but in a parallel move they turned on themselves until they reached a terrible endgame with the United States' atomic attacks on Hiroshima and Nagasaki in August 1945. At that point one 'have', the United States, found itself powerful enough to impose peace on all its enemies, particularly Germany and Japan. With the end of the Cold War in 1990, the last enemy – the USSR – followed suit.

The third act opened in the 1990s when 5 million people died in bloody civil conflicts across the world as the 'have-nots' turned on one another in the world's most remote and resourceless regions: in Afghanistan, the poorest area of southwest Asia; in Bosnia, the poorest region in Europe; in the Caucasus, the poorest portion of the old USSR; and in Angola, Rwanda and Somalia, the poorest parts of the poorest continent in the world. As US journalist Robert Kaplan famously observed in his 1994 essay 'The Coming Anarchy', much of the world had degenerated into conflicts between 'skinhead Cossacks and Juju warriors' (as in private armies and ethnic groups) who seemed to be influenced by ancient tribal hatreds, battling over scraps of overused earth.

Before the terrorist attacks of 9/11 we were able to draw comfort, like Adam Smith in *The Wealth of Nations* (1776), from the fact that the 'haves' had finally found the answer to the depredations inflicted on them by the 'have-nots'. Before the adoption of gunpowder by the Europeans, Smith reminded his readers, civilization had been on the defensive. Afterwards, everything had changed:

'In ancient times the opulent and civilized found it difficult to defend themselves against the poor and barbarous. In modern times the poor and barbarous find it difficult to defend themselves against the opulent and civilized.'

With 9/11 this comforting illusion was shattered, for Americans and their allies found they had to add a fourth act to the drama, one in which history had returned full circle. They now lived in a world in which the 'have-nots', this time in the form of terrorists, were once again in a position to target the 'haves'.

At least that is one version of history, and it was one that resonated with the Bush administration after 9/11. Indeed, if we take the analogy a little further we can appreciate that the great strength of the horse-peoples of the central Asian steppe had been strategic mobility. They could project power hundreds of miles beyond their own home base and then retreat, safe from reprisal. Today, terrorist movements such as Al Qaeda have the same global reach and, like the nomads of old, it is largely impossible to deter or constrain them. They have no centre of gravity: no trade routes to destroy, no capital city to occupy. At best, the world can only attempt to cut off their communication links and embargo their financial resources.

The Bush administration set the scene for the entire decade when only days after the World Trade

Center attack it announced that it was engaged in a 'War on Terror'. The metaphor came naturally to the policymakers. After all, the West had long talked of a 'war on AIDS', a 'war on crime' and, even earlier still, of a 'war on poverty'. Military metaphors resonate more than most. Some of us still live in the shadow of World War I. We still talk about 'going over the top', 'fighting' for our principles, or 'winning' respect (as opposed to earning it).

But, to its credit, the administration was quick to insist that the new 'nomads' were not non-Western societies, or civilizations, or even peoples. The war of the 'have-nots' against the 'haves' had nothing to do with 'the clash of civilizations' (a theme made popular by the late Harvard political scientist, Samuel Huntington). The West did not face 'the rest', but it did seem to confront movements that were deeply opposed to its way of life. It was also challenged by rogue states that had scant respect for Western values or the principles of international law. Three states – Iran, Iraq and North Korea – were seen to constitute what President Bush famously called an 'axis of evil' in his State of the Union address in January 2002.

Within days of 9/11, the United States resolved to force the Taliban government in Afghanistan to give up Al Qaeda's leader, Osama bin Laden, the man intelligence agencies believed was behind the attack. When it refused to do so, the Bush administration committed itself to regime change, which was not long in coming. It also decided to remove the West's old enemy Saddam Hussein from power in Iraq. It took three months to effect the first and only three weeks to effect the second – a remarkable display of 'Shock and Awe', a way of war pioneered by the Americans. But both military campaigns, though impressive, were inconclusive.

The United States and its coalition allies soon found post-Saddam Iraq a nest of unresolved tribal differences, sectarian animosities and political divisions. Instead of an antiseptic war in the desert, the US military soon found itself mired in operations in the concrete valleys that form the cityscapes of Baghdad, Fallujah, Najaf and Tikrit.

In Afghanistan too, the Taliban was not eliminated. Instead they spent several years regrouping, learning lessons from foreign fighters with experience in Iraq, who brought with them into the Afghan theatre new technologies, such as roadside bombs and new ways of fighting, such as suicide bombers. When NATO intervened in 2006, it found that the country was made up of a vast and intricate web of ethnic, tribal and clan feuds. It has been engaged in a long and debilitating counter-insurgency struggle ever since.

Historians looking back on the decade may see it in terms of a Greek tragedy. The idea that military power alone could reshape the world and make the United States and its allies more secure was a product of what is known as the 'unipolar' moment – when the United States found itself the only superpower in the world, following the collapse of the Soviet Union. In its own eyes the United States became the 'indispensable nation'. It seemed obvious then that nothing could withstand the force of America's political example, any more than it could the force of American arms. By the end of the decade, Hubris had brought about inevitable Nemesis: excessive confidence had given way to an appreciation of the limits of American power.

The ideologue of unipolarity was Francis Fukuyama. Like his fellow neo-Conservatives, Fukuyama believed that American military and

economic might should be deployed to spread democracy around the world, though he deserted the cause after the Iraq War. His 'end of history' thesis, articulated in a 1989 essay as communism collapsed in Eastern Europe, has been much misunderstood, but it set the scene for the belief that liberal internationalism had triumphed; that the West had seen off all its ideological competitors. No one then foresaw that the next challenge to the Western model would come from outside the Western world, and no one even mentioned Asia, largely because Japan had gone into recession at the very end of the Cold War. Elsewhere in the world, intellectuals with very different hopes for the future had a global vision too, and theirs was a dream not of the end of history but of its rebirth. They dreamed that the twenty-first century would be forged by non-Western ideas and ideologies.

Indeed, future historians may conclude that the twenty-first century began not on 11 September 2001 but in 1979; and that the nomads were at best parasites, not true agents of history. For 1979 witnessed two historic turning points: Chinese leader Deng Xiaoping's modernization of his country's economy, which launched China on the road to becoming the next superpower; and the Iranian Revolution, which inspired fundamentalists across the world, most of whom were not terrorists but political idealists who dreamed of political reform. Within this context, the response to 9/11 may be seen as the last manifestation of the 'Western moment' in history, that short era which lasted for about 150 years in which the West largely shaped the international landscape. At the end of the first decade of the twenty-first century the world seemed set to enter a 'post-American world'.

Simon Kuper
The Globalization of Sport

Imagine in the year 2000 an American or African or Russian trying to find out the result of Manchester United's match of the night before. Few of his friends would have heard of Manchester United. His local newspaper wouldn't have published the score. He probably couldn't have found it on the internet – back then, hardly anyone in Russia or Africa possessed a computer and fewer than one in three Americans used the web. In 2000, Manchester United were followed largely by Britons, Irish, Scandinavians and British expats.

That all changed in the next decade. In the 1990s sport had become unprecedentedly commercial; in the 2000s it went global. Today the major English football clubs have fans everywhere: from the Jamaican sprinter Usain Bolt, who supports Manchester United, to Russians who follow Chelsea out of pride that it's owned by a compatriot, to owners of 'matatu' taxis in East Africa who plaster the logos of their favourite English clubs on their windscreens.

Actually, the claim that sport went global in the 2000s needs refining. More precisely: a small number of Western male teams and individual Western male athletes attracted global followings. This was the decade of what the sports scholar Gerard Akindes, speaking of African TV viewers, calls 'electronic colonialism'.

Whereas the first spread of colonialism was enforced by the Maxim gun, the latest was carried by cable TV. In the 2000s more poor people than ever acquired TV sets, and more rich people signed up to cable packages. For the most part they absorbed the games that were easiest to comprehend on television: basketball, but above all soccer. Zinedine Zidane's head-butt of Marco Materazzi during the 2006 World Cup final was seen by more viewers than had ever before watched a single TV programme.

Before 2000, fans had been expected to support their local teams. During the age of cable TV that idea largely died. Most soccer fans in 'new' soccer countries like the United States, Canada, Japan, China or Australia thought globally. They preferred the real thing – Chelsea or Barcelona – to the bunch of semi-pros playing down the street. Even in traditional soccer countries like Nigeria or Argentina, local stadiums emptied as people watched European games at home, or on big screens in sports bars known as 'chicken parlours' or 'show houses'.

The cliché is that globalization equals Americanization. That hasn't been true in the field of sports during the 2000s. To the contrary, many North Americans have themselves been globalized by soccer. A friend of mine, an English Burnley fan living in Miami, recalls landing in the United States and being interrogated by a suspicious customs official. Then the official, leafing through his passport, spotted his birthplace: 'Burnley! You had a good result last night.' 'The odd thing is,' my friend reflected later, 'it was only a League Cup game.'

It's not just the fans who went global; so did the athletes, the owners and even the venues catering for modern sport. Take cycling, for instance. For almost all the twentieth century, the Tour de France was a cosy affair between West Europeans. But then globalization spread enthusiasm for the race, and new nationalities took it up. From 1999 to 2005 the American Lance Armstrong won seven Tours in a row.

Conversely, in this decade US sports were invaded by foreign athletes. The Japanese baseball player Ichiro Suzuki was a rare curiosity when he joined the Seattle Mariners in 2001, accompanied by hordes of Japanese journalists who reported his every meal. Suzuki became the American League's Rookie of the Year and most valuable player. Today, North America's basketball, baseball and ice hockey teams live off imported stars.

Even owners of UK football clubs now come from all over the globe. Back in 2000 the only foreign owner of an English Premier League club was the Egyptian Mohamed Al-Fayed, a long-time Londoner who owned his local side, Fulham Football Club. In 2003, to general amazement, the Russian oligarch Roman Abramovich took over Chelsea, apparently because he needed a hobby. Today most big English clubs belong to foreigners.

The biggest games also now take place in cities around the world. In 2000, soccer's World Cup had still never been held outside Europe and the Americas, but cable TV had already spread the game's popularity to new regions, and the West Europeans were losing dominance over their former plaything. In 2002 the tournament visited Japan and Korea, and as I write, it's in South Africa. The Olympics are also ceasing to be a white man's show: in 2008, China hosted them for the first time.

Almost every sport on earth has spotted that in the age of cable, its best chances for growth lie outside its traditional markets. Baseball has tried to chase global fans with its World Baseball Classic. India gathered together the world's best cricketers in one entity, the Indian Cricket League (which played its second season in South Africa).

Yet while most sports sought a large global audience, only a few actually found one. The upshot of all this globalization: never before have so many people around the planet watched so few athletes. No fan sitting in China wants to watch Polish basketball or Polish soccer. Instead, the spoils of the age of cable have gone to a small élite of players and clubs – chiefly the English Premier League and basketball's NBA – most of whom play in English-speaking countries. For instance, even the bottom team in the Premier League now earns more money via TV than all the Belgian football clubs combined.

All these trends have changed the ethos of the top-class athlete. With ever more money flooding in from TV channels and fans around the world, the comparatively small élite of high-ranking sports people have swallowed the professional ethic: you must be a workaholic perfectionist, winning matters more than anything else in life, and if you play a team sport you must submit completely to the collective like a model Stalinist worker under communism.

Generally in the 2000s, top sports people were forced to lose a little of their human touch. The growing rewards encouraged competitors such as the American sprinter-turned-basketball player Marion Jones to take performance-enhancing drugs. And the rewards persuaded athletes such as Tiger Woods to try to turn themselves into brands. Often, the brand didn't quite match the personality that lay beneath the public persona. The deaths of past greats – like the English footballer Stanley Matthews (who died in 2000) – became occasions for nostalgia for an age when brilliant athletes were ordinary people much like the rest of us. But then, it was easier for Matthews to behave like the rest of us: he was paid like the rest of us.

While the money rained on popularized Western sports, small local ones still bumped along in their own corners of the world. Afghans still play the horseback sport of *buzkashi*, and some Southeast Asians and a few others play the volleyball-like game of *sepak takraw*. But their fans probably support Chelsea Football Club too.

In the 2000s women and disabled people began competing in sport in unprecedented numbers. However, few fans bothered to watch them. Able-bodied male athletes are followed because they are perceived in many countries as versions of the ideal man. Small boys want to be David Beckham or Cristiano Ronaldo. By contrast, great female athletes aren't widely regarded as ideal women. Small girls tend to model themselves on singers or actresses instead. It was notable that the tennis player Anna Kournikova, ranked eighth in the world in 2000, soon drifted out of the game and turned herself into a model: there was more money there. When a successful sportswoman gets noticed outside an Olympic final it's usually either because she is beautiful or because something bizarre has happened – as when the South African runner Caster Semenya, who competed as a woman, was accused of being a man.

In 2009, Semenya became 'news' on the thousands of cable channels and sports websites that had not existed in 2000. Increasingly, the world follows the same handful of sports stories. A surprising number of those revolve around English football clubs. In the days of the British Empire, Britain was the 'workshop of the world'. In the age of electronic colonialism, it supplies the sports teams of the world.

Frank James
Science in the Public Eye

The opening decade of the twenty-first century saw science, technology and medicine dominating, as perhaps never before, the political agenda and media headlines. From genetically modified (GM) crops, the MMR vaccine, new forms of influenza, transgenic animals, new surgical procedures, drugs policy and stem cells, to weapons of mass destruction, global climate change and nanotechnology, science was an integral part of the political and media narratives of the decade. In many ways this continued trends established during the second half of the twentieth century, but with perhaps more public awareness of how scientific issues directly impacted on everyday life and how they might do so in the future.

Such awareness led to public concern about the wisdom of how some scientific knowledge was obtained and used in technology and medicine. In turn, this caused the scientific community much anxiety (which continues) about the basis on which the public developed its knowledge and views about the role and value of science in society. The decade opened and closed with two illuminating instances of the problems involved. At the start, issues relating to whether eating products from cattle suffering from bovine spongiform encephalopathy (BSE) could cause new variant Creutzfeldt–Jakob disease (CJD) in humans were widely discussed; while at the end of the decade the dismissal of the scientist who chaired the British government's drugs advisory committee caused a major controversy about the precise role of scientific advice to government. Both episodes included the unedifying spectacle of politicians and scientists publicly blaming each other over the management of these public health issues. Less clear-cut was the matter of GM foods which the scientific community, on the whole, believed were safe, but where campaign groups,

such as Greenpeace, persuaded the general public that it was not worth the risk (both personally and to the environment) to consume foods produced in this way. This was an example of the application of the 'precautionary principle', which states that no new process should be implemented widely (or sometimes at all) without assessing every conceivable risk. This principle has come to dominate the thinking around many (though by no means all) of the issues involved in the novel use of science.

In the early part of the decade, so strong was the public's negative perception of science surrounding the issues of BSE and GM foods that, as a result, in Britain, the Committee on the Public Understanding of Science (COPUS), which during the 1990s had received substantial government funding, was deemed to have failed in promoting science and was wound up. Indeed the very phrase 'Public Understanding of Science', very fashionable during the 1980s and 90s, fell into disfavour because of its association with the 'deficit' model of science communication. Embodied in this view was the presumption that if the public were provided with sufficient information about science, they would learn not to fear it. During the first decade of the twenty-first century this rather patronizing approach was, generally, abandoned in favour of more sophisticated strategies that emphasized the integral role of science and technology in culture and society. Furthermore, emphasis was placed on the contingent nature of science and the provisional nature of many of its findings. In other words, there was open public discussion about how the scientists arrived at their conclusions in terms of constructing theories, experimental procedure, data and statistical analysis, the value of reputation, peer review, sources of funding, etc. This new inclusive

approach to science communication seems to have had some effect during the decade in improving the quality of media coverage of science and political discussions on policy issues. Both the tone and the institutional arrangements (for instance, the Science Media Centre at the Royal Institution in London, which opened in 2002), which stressed engagement and dialogue (both two-way processes), seem to have markedly improved public appreciation of issues that have a strong scientific component.

Exceptions by a few members of the scientific community to this new approach caused some problems, most notably the writings of Richard Dawkins, Professor of the Public Understanding of Science at Oxford University from 1995 to 2008. Dawkins associated science, especially in his book *The God Delusion* (2006), with the most extreme forms of rationalism, materialism and atheism, demonstrating little understanding of the historical contexts in which science has been and is practised. While it is necessary (in order to maintain the Enlightenment values) to combat, especially in the United States (but also elsewhere), 'creationism' and its successor 'intelligent design', what was widely seen as hectoring and arrogant rhetorical strategy deployed by Dawkins was seen as self-defeating. This is illustrated by the rebuttals produced by a range of writers, from the Catholic historian John Cornwell (with his elegant *Darwin's Angel*, 2007, written in the form of a letter from an angel to Dawkins) to the atheist writer Fern Elsdon-Baker (with her splendidly titled *The Selfish Genius*, 2009).

What this whole debate illustrates is that science, especially that with limited practical application, commands widespread interest, generating intense general curiosity about our understanding of the natural world and how it

relates to culture and society. For instance, great public interest was displayed in the unsuccessful *Beagle 2* mission to Mars and the Large Hadron Collider (which sort of started working towards the end of the decade) and its search for the Higgs Boson, the so-called 'God particle', and subsequent repercussions. It is in this ideological arena of the relationship between science and religion that much public fascination centred, including the Kitzmiller v. Dover Area School District court case in the United States where the tenets of the philosophy of science were seriously misused by the proponents of intelligent design. Although Dawkins and creationism are at the opposing ends of the science and religion discussion (though interestingly their rhetorical strategies are structurally remarkably similar), there is an enormous extent between these positions where much valuable work was conducted during the decade, especially by historians of science such as John Brooke, Geoffrey Cantor and Peter Harrison. Indeed, it is also one of the few fields in science where the history of science played a significant role in insisting on nuanced accounts of the relationship between science and religion rather than the polarized attitudes that were widespread as recently as the 1980s.

Nevertheless, it is the practical applications and implications that have the most direct impact on how the public views science. During the last decade, advances in information technology, in particular, have altered profoundly the everyday life of almost every individual around the globe. The use of computers and mobile devices and their capabilities – the internet, text messaging, personal navigation devices – expanded enormously, especially with the widespread implementation of web-based technologies in the creation of interactive information sharing

and web-based communities such as Google, Facebook, Twitter, YouTube, Flickr, and so on. It is even claimed, though on what evidential basis is unclear, that no human being is now more than 2 metres (6 feet, 5 inches) away from a microchip. Of all those technologies developed during World War II, the computer, invented at the British government's Bletchley Park codebreaking centre, now exerts an influence beyond the wildest dreams of twentieth-century scientists and science-fiction writers. This power became ever more apparent during the last decade. From carving stone, to modelling the very large and the very small (galaxies and crystals), to booking flights, to navigating aircraft, to fighting wars, to undertaking historical research, to sending messages cheaply and instantly to the other side of the world, the full potential of the computer was realized and it was made accessible to almost everyone. Other consequences also became clear: high-street travel agents disappeared, newspapers struggled in the face of the internet, postal systems contracted, books started being published on demand (though predictions of the demise of the book proved premature), and so on.

The ease and rapidity with which computers, together with their enormous range of uses, were accepted by society as a whole contrasts sharply with the reception of some of the technologies developed in the biological and medical sciences. There were, of course, some critics of computers, especially over issues of privacy (the state and businesses, for instance, knowing more than they should about individuals) and the legal ethics of unmanned war machines. While these concerns have been (or are being) addressed by governments in different ways, it is clear that the public saw that the benefits of computers and mobile phones easily outweighed any risks with which they might

be associated – in this case, the precautionary principle was simply ignored. However, with regard to some biological technologies (GM crops, transgenic animals, stem cells, fertilization, embryology, and so forth), there was (and continues to be) much more public opposition to their introduction. This has tended to result in the application of the precautionary principle and the establishment of authorities and ethical committees (with considerable lay input) to regulate these sciences and their use. On the other hand, developments such as the Human Genome Project – to sequence all the genes in the human body – and the (computer-aided) design of novel pharmaceuticals were generally welcomed, though with some reservations usually centring around discussions about their commercial applications – is it right, for instance, to patent a gene or test new drugs in developing countries?

An interesting subject where the application of the precautionary principle clashed with other social needs was global climate change. Images showing the deliberate destruction of the environment (for instance, the clearance of rainforests) or the contraction of glaciers were disturbing. On the other hand, the amount of individual, industrial and governmental effort (as opposed to talk) put into reducing levels of greenhouse gas emissions seemed to have very little effect and certainly nowhere near the magnitudes that most climate scientists considered necessary to avert global catastrophe. Individuals saw the advantages of maintaining (or, in parts of the world, expanding) their energy-rich lifestyles but, at the same time, there was widespread alarm about global warming. The resolution of this conflict might perhaps be the defining scientific issue for the general public in the coming decade.

Christopher Burge
How the Art Market Survived

So much seemed new and different, this time: the opening up of China, the rapid acceleration of technology, globalization, Russian and Indian billionaires, the Louvre in Abu Dhabi. The economic slowdown in 2000 barely dented the art market and the worldwide demand for a declining supply of major works of art appeared to be insatiable. Added to which, the fashionable appeal of new art – manipulated by the media, by artists' agents and by the auction houses, and even by formerly serious art writers – had resulted in astounding prices for young artists not even in mid-career.

During the course of the decade, and by summer 2008, important paintings by Mark Rothko and Andy Warhol had fetched more than $70 million at auction; a triptych by Francis Bacon, a Gustav Klimt portrait and a Claude Monet *Water Lilies* had each sold for more than $80 million; and the record auction price stood at $104 million for Picasso's 1905 *Boy with a Pipe*. In the private market in 2006, Klimt's magnificent 1907 portrait of Adele Bloch-Bauer had sold for a much publicized $135 million.

Hard on the heels of this record price, Picasso's celebrated 1932 portrait of Marie-Thérèse Walter, *The Dream* – which had sold at the famous Ganz sale in New York in 1997 for $48 million – was sold privately, with much fanfare, for $139 million: with even greater fanfare the work was damaged and the sale fell through. And in November 2006, Jackson Pollock's *No. 5, 1948*, one of the last of his drip paintings in private hands, sold privately for a price reportedly close to $140 million, the highest consummated price yet recorded for a work of art.

Auction prices for works by living artists were rising proportionately even faster. By the time this bloated section of the market had reached its peak in autumn 2008, Jeff Koons' sculpture, *Balloon Flower (Magenta)*, had sold for $25.7 million and Damien Hirst's *The Golden Calf* had fetched over £10 million in an auction of the artist's work that he himself had organized and that totalled £110 million. For the younger pundits and for many in the art business frantically protecting their interests, a new art world order was proclaimed, one that this time could never fail. The older hands knew better.

To put this all in perspective, it should be remembered that in the late 1950s, when the Impressionist painting market was initiated at auction, the longest living Impressionist painter, Monet, had been dead for 32 years. In the auction market of 1970, Picasso's early masterpiece, *Yo Picasso* (1901), fetched what seemed a fortune at $300,000 and his late work was barely saleable; and the first work by a living painter to sell at auction for $1 million, in 1980, was De Kooning's 1955 painting *Two Women*, when the artist was 75 years old. Old Master paintings dominated the market until the early 1980s, eighteenth-century decorative arts were a mainstay of the business, huge volume was the staple, and works of art in many fields were affordable to a wide audience. Connoisseurship was alive and well, it seemed.

On closer inspection, the shifting trends were clear. As the major auction houses began, in the late 1960s, to open branches throughout Europe, the United States, South America and Asia, there was a greater demand for works of art. The exponential growth of art museums, particularly in the United States, siphoned off works from the market, as well as educating a broader swath of potential collectors. The media began to take an interest, art history was much more widely taught, and by the 1970s the dreaded word 'investment' was being linked with art collecting. The supply of important works of art began to dwindle rapidly. Major Old Master paintings were now in institutional hands or had been unsurprisingly designated as patrimony. Many collectors turned to more plentiful hunting grounds: Impressionism, Post-Impressionism and the Twentieth Century. In the field of decorative arts supplies of seventeenth and eighteenth-century material were waning. Interest in nineteenth and early twentieth-century design made swift strides and new fields of collecting, such as photography, took their first steps.

This tendency accelerated as a growing international art-buying public, encouraged by media hype and the marketing efforts of the auction houses and dealers, often pushed prices to unsustainable heights too quickly. Boom-and-bust became the norm: in 1974, 1981, 1991 and 2000, setbacks of differing intensity checked the market, following periods of injudicious overindulgence, 1974 and 1991 being particularly severe. By 1990 there were now shortages of major Impressionist and Post-Impressionist works and the few masterpieces still available fetched extraordinary prices when they came to market, highlighted by Van Gogh's *Portrait of Dr. Gachet* (1890), and Renoir's *Bal au Moulin de la Galette* (1876), which sold for $82 million and $78 million respectively in May 1990, just before the market crashed. Throughout the 1990s, limited supplies drove collectors to focus on much more recent material, including twentieth-century decorative arts, photography and collectibles. The offering at auction of works by younger artists, once

anathema to the market, was becoming common-place. Shortages of major twentieth-century paintings now began to occupy buyers.

By the advent of the new millennium, the worldwide building boom of museums devoted to post-war and contemporary art was also affecting supply in this area. Art of the 1960s and 70s became the new focus, while supplies lasted. From 2001 to 2008, prices for important Andy Warhol paintings increased by approximately 700 per cent and for Francis Bacon by closer to 1000 per cent. Even in this 'new world' the vastly inflated art market bubble was bound to burst. All that was needed was a major financial disruption; and the 2008 crash in the banking and real estate markets, fuelled by the insanity of sub-prime mortgages and unbridled greed, the collapse of Lehman Brothers and plummeting oil prices, provided the impetus. The world was brought to the brink of another depression and the art market was seriously damaged – as severely, in fact, as it had been in 1991.

Extraordinarily, however, as so often happens in the art market in the depths of a financial crisis, when confidence is at its lowest, important works of art are sold out of necessity and point the way to impending recovery. In February 2009, at the worst possible moment from a world economic point of view, the remarkable collection of fine and decorative arts formed by Yves Saint Laurent was offered at auction in Paris, following his death in 2008. This superb assemblage of major twentieth-century paintings and sculpture, twentieth-century design, Old Master paintings and drawings, extraordinary early German silver, fine French furniture and antiquities, fetched

$484 million, more than double the previous record for a single-owner collection at auction. This was undoubtedly the sale of the decade, with honours going to Paris over New York and London. And for all the record prices paid that week for works by Henri Matisse and Constantin Brancusi, Piet Mondrian and Marcel Duchamp, the $28 million paid for an armchair by Eileen Gray was perhaps the most remarkable.

Amazing as these results were, they did little, at first, to settle the market, and for most of 2009 sellers stayed away, as they always do in difficult times. Volume was down sharply, jobs were lost, and the outlook was bleak, just as it had been in 1974 and 1991. But at the beginning of 2010 the market was clearly improving, led by the huge price of $104.3 million, a new auction record for any work of art, paid for Giacometti's 1960 sculpture *Walking Man I*. Volume is increasing and collectors in all fields are buying art, both fine and decorative, in part as a 'safe haven'.

This recovery will take time, particularly for fields such as post-war and contemporary art, which have cooled considerably. But it is predicted that in a year or two the market will be strong again in all areas, and shortage of supply combined with fashion and hype, greed and market manipulation will begin to form a new bubble, set to burst, no doubt, in 2016 or 2017. As I write we have already seen a new auction record set by Picasso's *Nude, Green Leaves and Bust* (1932), which was sold in New York for $106.5 million in May 2010, and we will probably see a price of over $200 million before the next downturn.

However, the availability of works of art will continue its inevitable and precipitate decline,

as newly forming museums in the Middle East and Asia make their serious mark on supplies. Even works from the 1980s and 90s are now becoming rarities, and the decreasing pool of potential sales will eventually reach the point at which the two major auction houses will probably no longer be able to continue in their present form. In 20 or 30 years even a truly extraordinary price will not be sufficient to compensate for the drastic shortage of important works of art and the loss of volume in the major selling fields.

After nearly three hundred years in business, and pre-eminence in the auction market for the last hundred, Christie's and Sotheby's will most likely become 'boutique' auction houses, owned as playthings by billionaire Asian, Russian or Arab owners. Their auctions, if such they are, will probably consist of a few 'trophies' from various fields – an Old Master painting here, an Impressionist painting there, perhaps another Eileen Gray chair – or even a single Old Master drawing of the importance of Raphael's *Head of a Muse*, which sold in London in December 2009 for an astounding $48 million.

Chinese and other Asian works of art will be sold by Chinese auctioneers, who in 2010 already control that field, despite Christie's and Sotheby's best efforts. New art will be looked after by art dealers. Antique dealers will look after what little is left in their fields. And estate property, the second-hand goods and chattels that for centuries have been the stuff of auctions, some of it fine, much of it not, will be handled by regional auctioneers around the world. The business will return to its roots. But that is for another decade.

2000
Promise

Expectations on New Year's Eve 1999 were a mix of assured optimism and fearful trepidation. The world, it seemed, was free from the threat of nuclear destruction that had once hung over it like a pall. Yet the so-called 'Y2K' computer bug had been hyped to such an extent that warnings ranged from minor inconvenience at cash machines to the complete collapse of Western civilization. These fears proved unfounded – but old questions and new uncertainties were never far away in the year 2000. The ghost of Europe's past materialized with the inclusion of the far right, led by Jörg Haider, in a new Austrian parliamentary coalition. Haider's commemoration of Austrian veterans of World War II raised concern across the continent, and reminded Europeans of their unsavoury past. And in the Holy Land the peace process, which had once seemed so promising just seven years before, shuddered to a halt at Camp David and Taba. Israel and the Palestinian territories again descended into bloodshed: the Al Aqsa Intifada erupted after an inflammatory visit to Temple Mount by the

controversial Ariel Sharon. A foretaste of wars to come was given when Al Qaeda struck the American warship, the USS *Cole*, in Aden harbour – a potent military vessel knocked out by a few fanatics and some explosives. The United States, the world's richest democracy, was briefly wracked by political chaos as its presidential election hinged on a handful of votes. 'Hanging chad' entered the common vocabulary as the results of Florida's pick fell to a small hole (or not) in a slip of paper. The Republican from Texas and son of a previous president, George W. Bush, was ultimately declared winner following the intervention of the US Supreme Court. He promised to unite a nation divided by its politics. However, there were also causes for optimism. Science and technology marched forward. In a great achieve-ment that promised much for medical advances, researchers mapped the building block of life itself: the human genome. Humankind's furtive steps into space continued with the arrival of the first full-time crew aboard the orbiting International

Space Station, after years of meticulous planning. While old conflicts raged elsewhere, it seemed a few were coming closer to resolution. For the first time since 1953 the leaders of North and South Korea met at a summit meeting. And in the West African state of Sierra Leone, the brutal civil war turned a corner. The kidnapping of several hundred peacekeepers prompted a decisive British intervention, setting the nation down a long road to lasting peace. There was also time for reinvention: the Sydney Olympics reinvigorated a grand sporting contest that had suffered scandals and lost some of its prestige. Sprinter Cathy Freeman waved the flag of Aboriginal Australia in the opening ceremony and went on to win the 400-metre sprint event. British rower Steve Redgrave became one of the great Olympians of all time with five gold medals at consecutive Games. Spectators and athletes alike praised the organization and enthusiasm of the host nation. The limits of human endeavour were to be pushed yet further in the years to come.

The Space Shuttle *Discovery* made its last solo flight during the final weeks of the twentieth century. Astronauts on board witnessed the rare stillness of the Earth from space, captured here with the sun glinting off the seas surrounding the island of Haiti.

Far below, preparations continued apace as the world geared up for a truly momentous occasion. At the stroke of midnight on 31 December 1999, at the international date line in the middle of the Pacific Ocean, the century came to an end, sweeping

quickly westward to Kiribati, New Zealand and Australia where the first rays of 2000 and the new millennium fell. Across the globe billions of people welcomed in the new millennium with some of the most spectacular celebrations the world had ever seen.

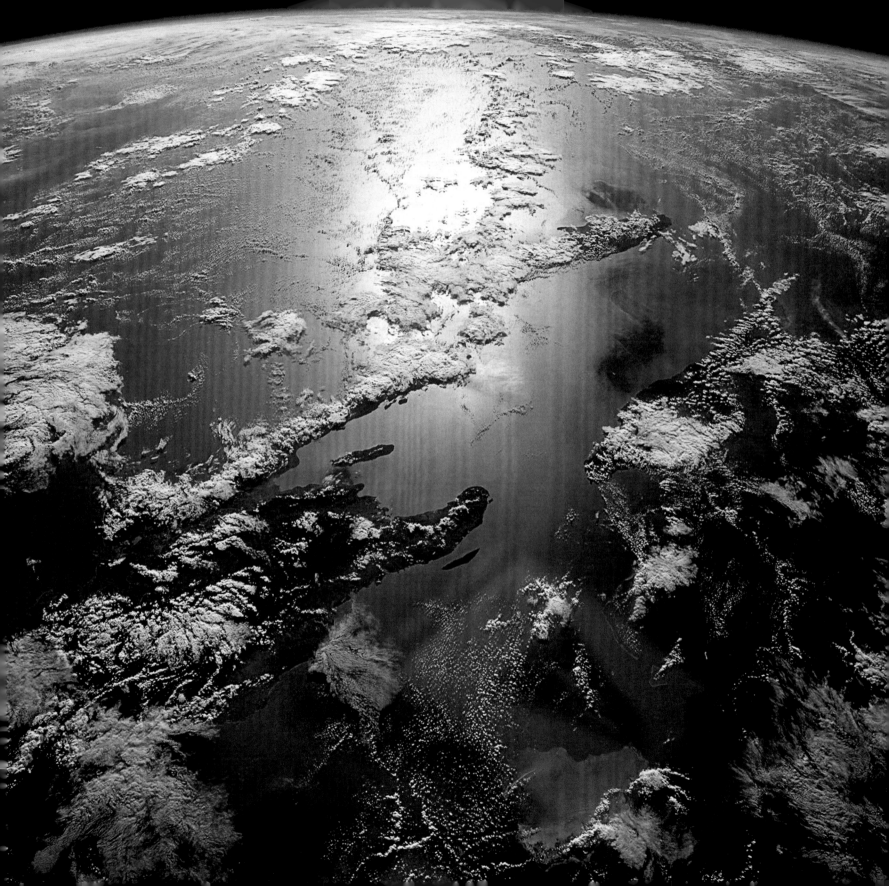

As the new millennium began, widespread fears that the dreaded 'millennium bug' (also known as the Year 2000 or 'Y2K' problem) would cause computer meltdown and unleash chaos around the world proved unfounded. The concern arose in the mid-1990s, when experts suggested that computers, and the countless systems dependent on them, would be unable to operate normally after the year 1999, because of the unfamiliar 2000 date format. Vital date information, once stored in a two-digit rather than a four-digit field in order to save memory space, meant that the year 2000 could have appeared as '00', interpreted as '1900', or not be recognized at all. Companies and organizations worldwide invested billions in checking and upgrading their computer systems to avert the crisis. In the end few malfunctions were reported, causing some to question whether the significance of the problem had been overstated.

20

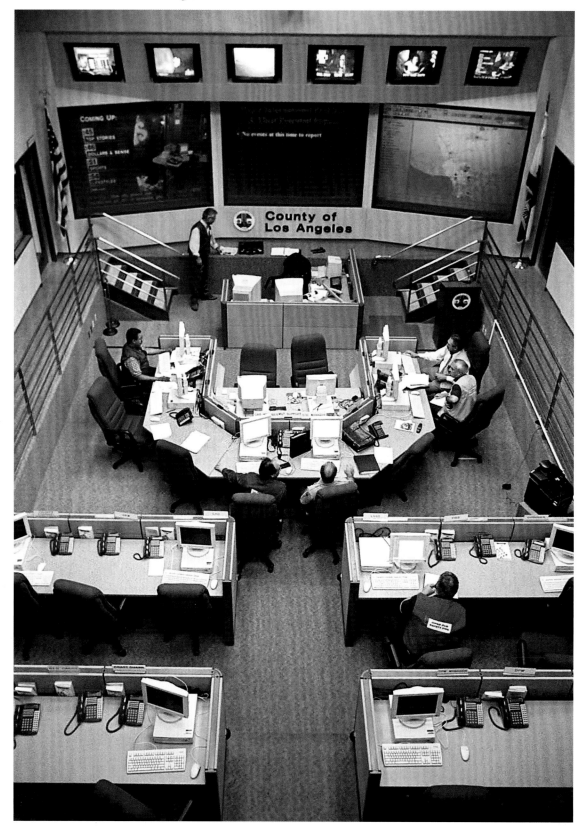

Staff at the Los Angeles County Emergency Operations Center spend New Year's Day on alert for the 'Y2K' bug.

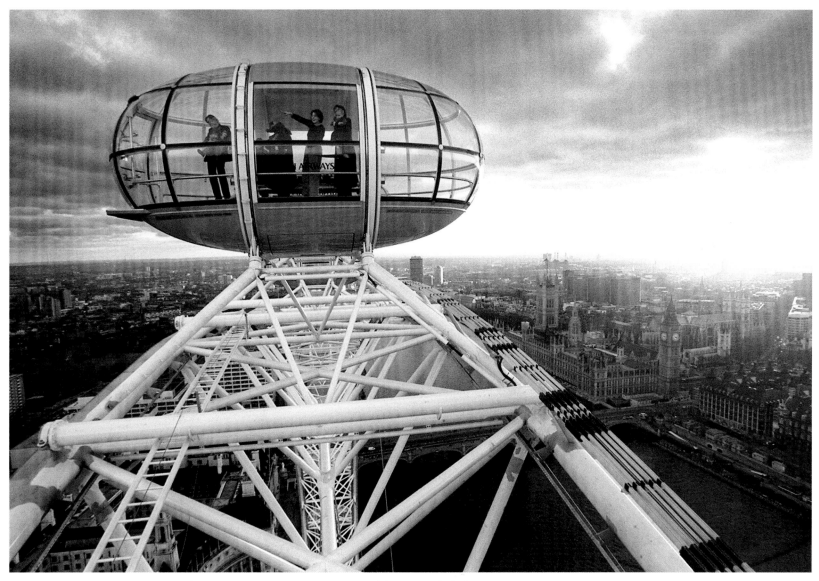

Lucky advance passengers on the newly built London Eye marvel at the view of the metropolis below.

21

The London Eye has been hailed as a civic icon to rival Paris's Eiffel Tower. Designed by Marks Barfield Architects, it was rejected in a competition for a millennium landmark, but in a tale of remarkable perseverance, was nurtured by the firm until they secured planning permission and funding. To overcome serious construction obstacles, the 135 metre (443 foot) cantilevered wheel was assembled horizontally over the River Thames and erected in a single day. Initially a temporary structure, the Eye officially opened in March and quickly became a show-piece of the capital's skyline, promising its passengers the chance to briefly escape pedestrian life and soar above the city. Millions of people visit every year and some are even married in one of its 32 glass capsules, as the wheel's rotation gently imitates the passage of life.

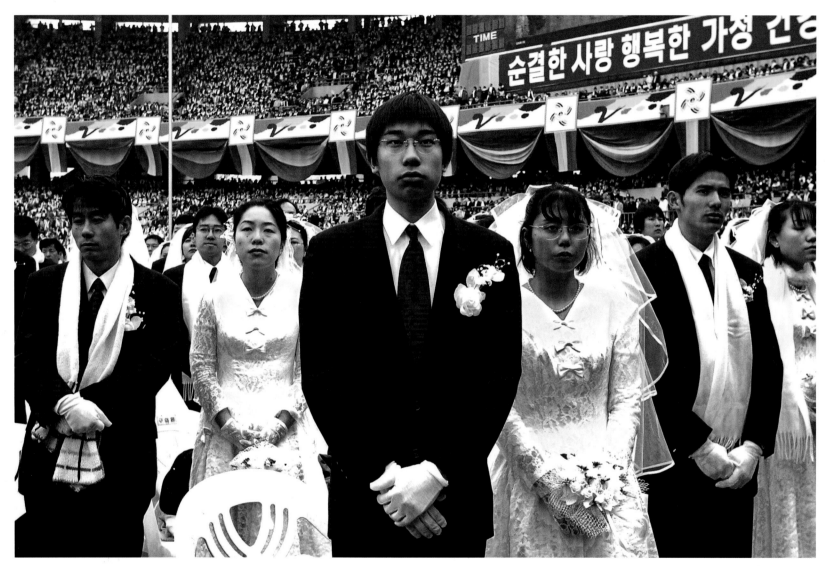

A busy day for church leader Reverend Sun Myung Moon at a mass marriage of 'Moonies' in Seoul, South Korea.

22

Organized by the Federation for World Peace, the World Culture and Sports Festival in Seoul, South Korea, in February 2000 included a large procession and a rare inter-Korean fine arts exhibition. The event also included a mass wedding ceremony, conducted by the federation's parent organization, the Unification Church. Held in the Chamsil Olympic Stadium on 13 February, the church's leader, Reverend Sun Myung Moon, matched and blessed 20,000 couples, all identically dressed in white gowns and black suits. An additional 40,000 people renewed their vows, some over the television or internet, others in person but without their partners who had been unable to make the occasion. The Unification Church believes that marriage is the key to world peace; the 'Moonies' have been participating in collective blessings since 1961.

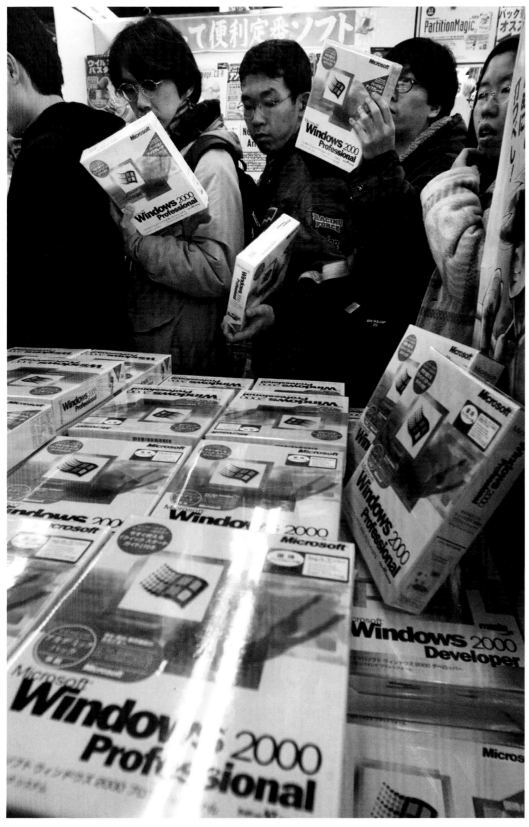

Eager Japanese consumers grab Microsoft's new operating system at a store in Tokyo.

Over the course of 25 years, the computer software firm Microsoft had built itself up from nothing into one of the world's largest companies. In February, it launched Windows 2000, marketing it as the most secure and stable operating system to date.
But cracks were beginning to appear in Microsoft's dominance of the software world. Hackers quickly exposed embarrassing security flaws in the new Windows 2000 and new, free operating systems began to undermine its position in lucrative business markets. Microsoft found itself falling behind in the development of internet technologies as younger, more flexible companies seized opportunities. Added to this were punishing US and EU regulator lawsuits, begun in the 1990s and carrying on through the 2000s, which alleged that the firm had engaged in anti-competitive business practices.

23

24

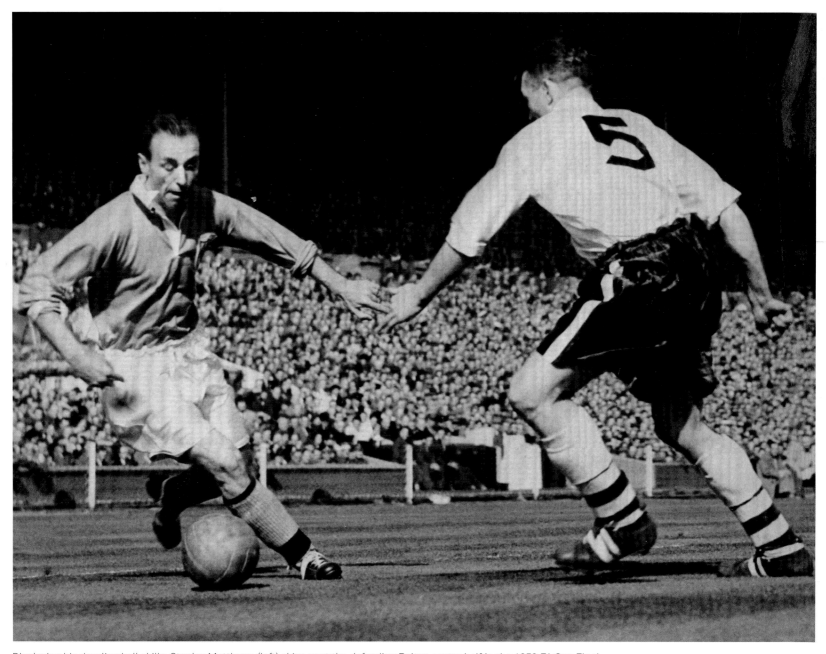

Displaying his dazzling ball skills, Stanley Matthews (left) skips past the defending Bolton centre half in the 1953 FA Cup Final.

Considered one of the finest English footballers of all time, Sir Stanley Matthews died on 23 February at the age of 85. His playing career spanned an incredible 33 years, during which he quickly earned worldwide acclaim. A forward on the outside right, he was nicknamed 'Wizard of Dribble' in honour of his tactical and technical skills. He was also legendary for his sportsmanship, having never received a booking for foul play. His finest hour was perhaps the 1953 FA Cup Final. Watched at Wembley Stadium in London by 100,000 fans and HRH the Queen, Bolton Wanderers were leading Blackpool 3-1, with half an hour to go. Matthews, playing for Blackpool, took control and set up the three goals that won his team the cup.

In the aftermath of the Amadou Diallo case, women clad in black protest against police brutality in New York City.

The failure to convict four New York City policemen who had shot a young Muslim, Amadou Diallo, 41 times one year earlier, led to widespread outrage. The unarmed Guinean immigrant, who had been reaching for his wallet and not a gun, was considered a victim of the pernicious culture of racial profiling that had led to the registration, detention and interrogation of thousands from black, Latino and immigrant communities. Demonstrations against police brutality erupted throughout the city following the 25 February acquittal. Women wore black veils to symbolize their grief and despair at the curtailing of hard-fought-for civil liberties; and more than 1,700 protesters were arrested, including former NYPD officers, local and federal politicians, and clergy such as the Reverend Jesse Jackson.

26

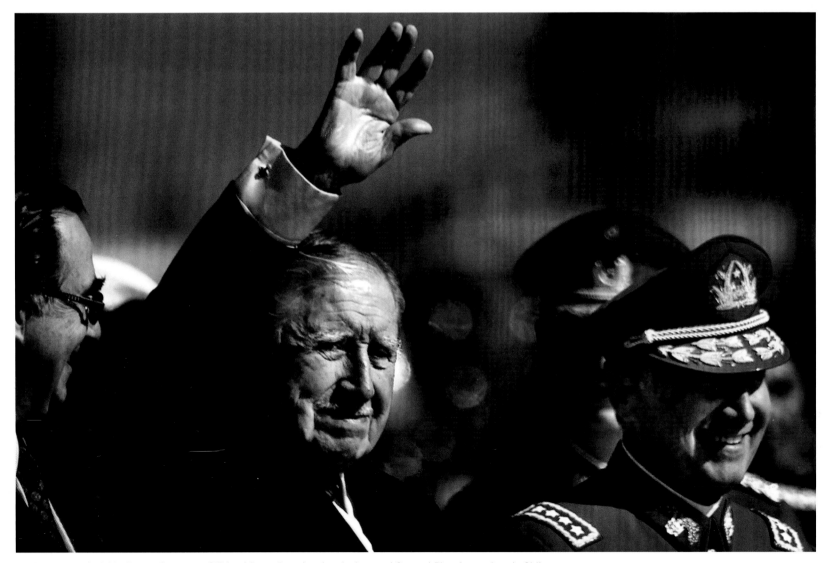

Having escaped trial in Europe because of ill-health, a miraculously reinvigorated General Pinochet arrives in Chile.

The former Chilean dictator General Augusto Pinochet was arrested in London in October 1998 at the request of a Spanish judge, accused of murder, kidnap and torture committed during his 17-year reign. His arrest prompted worldwide debate about whether former heads of state were entitled to immunity from prosecution and divided opinion within Chile. Human rights activists applauded the decision but many Chileans, who believed Pinochet saved the country from communism, were outraged.

After 16 months of house arrest, the legal wrangling over Pinochet's fate ended on 1 March when Britain's Home Secretary, Jack Straw, announced that he was free to leave the country on grounds of ill-health.

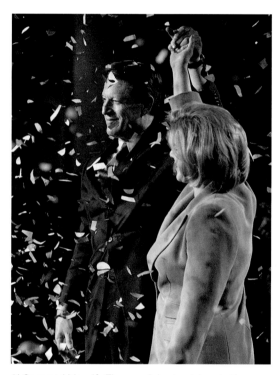

Al Gore and his wife Tipper celebrate victory in the Tennessee Democratic primary.

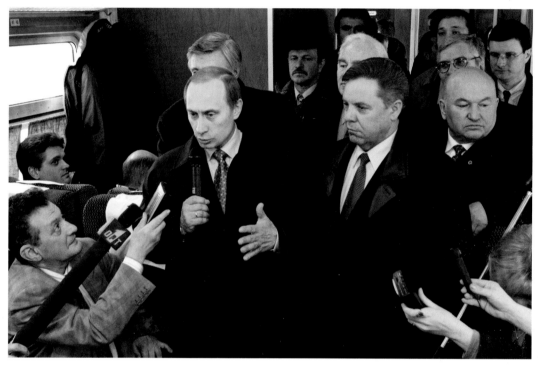

Acting president since New Year's Eve 1999, Vladimir Putin speaks to the press on the campaign trail in the Russian presidential election.

27

Having first made a bid for the US presidency in 1988, Al Gore announced his candidacy while serving as Vice President in 1999. Gore distanced himself from President Bill Clinton's indiscretions but did not have a coherent message to counter George W. Bush's 'compassionate conservatism'. He easily secured the Democrat nomination, sweeping the elections on 'Super Tuesday', when traditionally a large number of state caucuses simultaneously hold elections –16 states this time round. However, he was unable to win the personality contest against the Texas governor, who the media depicted as a lovable rogue, while mauling Gore's track record and demeanour. Most damaging was the wildfire of spin and reporting discrepancies in the popular press – including the infamous misquote that Gore had 'invented' the internet.

As the fifth Russian prime minister in less than 18 months, few believed that Vladimir Putin – the dour former KGB officer and political unknown – would succeed Boris Yeltsin, the architect of democracy. Although Putin's campaign was devoid of policy commitments, his tough handling of the Second Chechen War had won over a population eager for order and stability after the cronyism and economic exploitation of recent years. Having inched just above the 50 per cent threshold to avoid a runoff, Putin's 20-point lead over the Communist Party candidate gave him a strong electoral mandate to oversee Russia's resurgence as a world power. Putin was elected on 27 March and on 7 May he was formally inaugurated as the Russian Federation's next president.

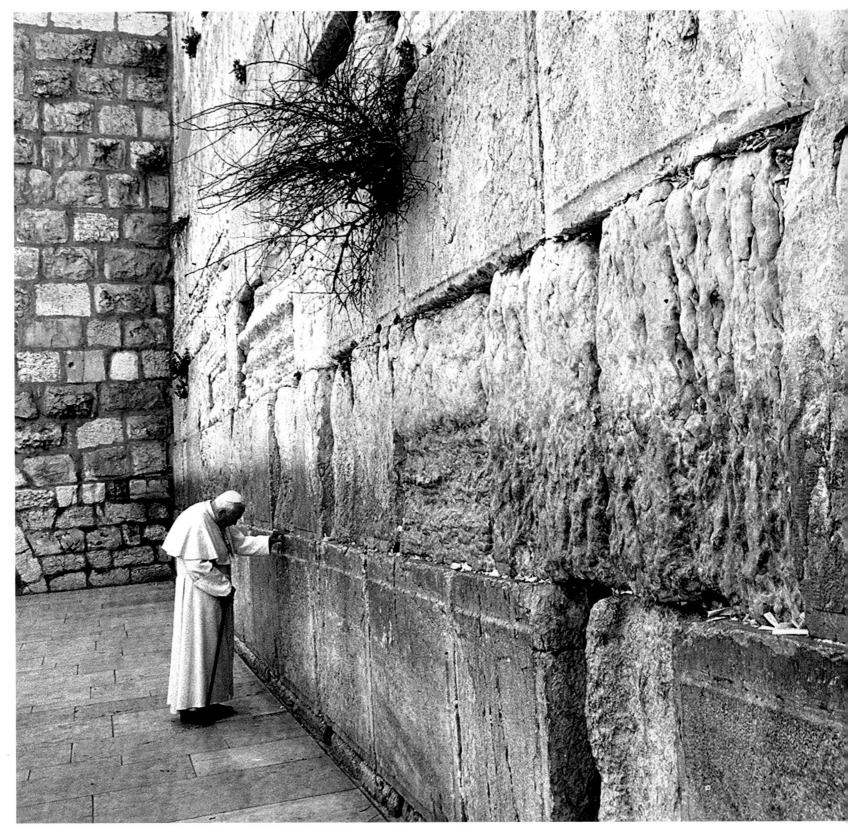

Pope John Paul II pays his respects at the remains of the Second Temple in Jerusalem.

As only the second pope to visit Jerusalem, John Paul II's week-long journey through Jordan, Israel and Palestine to retrace the steps of Jesus was meaningful in more ways than one. Placing a prayer in the crevices of the Western Wall – the remains of the Second Temple, Judaism's most holy place – he deplored the tragedy of the Holocaust. The pontiff visited contested religious sites and met with both Jews and Palestinians, repeating his call for inter-faith harmony and peace in the region. Nevertheless, the Pope's pilgrimage was marred by political tensions as the feud over the status of Jerusalem erupted once more.

29

30

Tommy Bayley, a Zimbabwean farmer, is driven off his land by a triumphant mob near Harare.

Ever since Cecil Rhodes's appropriation of land in the late nineteenth century, the land issue had been at the heart of conflict in Zimbabwe. Almost half the country's arable land was owned by 4,500 white commercial farmers, many of whom had turned their hectares over to horticulture or tourism, leaving many black farmers with the poorest soils. The 1979 Lancaster House Constitution had included a 'willing buyer, willing seller' clause, ensuring that the government could buy up farmland for redistribution only if it paid the right price. When constitutional amendments failed to pass the referendum of February 2000, President Mugabe gave tacit permission for the seizure of white farms; Zimbabwe's war veterans invaded farms, attacking – and in some instances killing – their residents.

The capture of Elián González, the young Cuban boy at the heart of an international custody battle, enraged residents of Miami's Little Havana. Elián had been found on Thanksgiving Day 1999 floating in an inner tube off the US coast; his mother was among those who had been lost at sea attempting to make the 150 kilometre (90 mile) journey from Cuba to Florida. Defying requests to return the six-year-old to his father, Elián's relatives in the United States had left local authorities with little choice but to take him by force. The seven-month battle became heavily politicized as both the Cuban leader Fidel Castro and American politicians weighed in on the matter.

The arm of the law intervenes to end the international custody battle of Elián González as US agents take him by force.

31

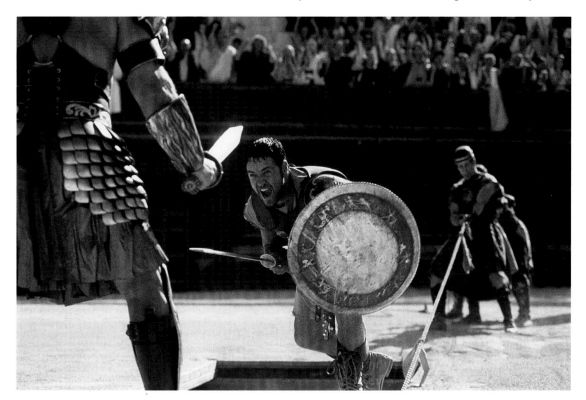

'Are you not entertained?' roared Roman general Maximus in *Gladiator*, played by Australian actor Russell Crowe. Audiences certainly were – the film grossed over $400 million at the box office following its release in the United States on 5 May. Crowe won an Oscar for Best Actor and the film, a return to form for British director Ridley Scott, was named Best Picture. The film led to a brief resurgence of the forgotten Hollywood genre of the historical epic. Critics praised its lavish and vivid portrayal of ancient Rome, if not the accuracy of the story. So capable was the special effects team that it completed a scene featuring actor Oliver Reed even though he had died of a heart attack before the sequence was filmed.

Russell Crowe in one of his defining roles as an avenging Roman general in *Gladiator*.

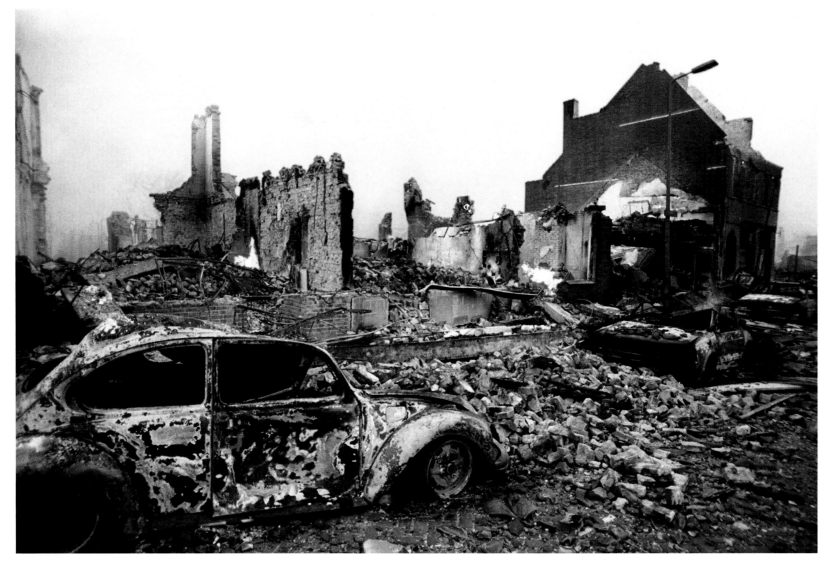

An apocalyptic scene amidst the rubble of the Enschede fireworks factory disaster in the Netherlands.

32

On a sunny Saturday in May, chaos ripped through Enschede; an enormous fireball erupted in the working-class neighbourhood of Roombeek. It was not a bomb, although the damage suggested as much: the explosion was caused by a local fireworks factory, where 100 tonnes of fireworks ignited to create a blast that was felt 30 kilometres (19 miles) away. Twenty-two people died, including four firefighters who had been attempting to contain the early flames, and the Dutch town resembled a war zone with whole streets destroyed. Local residents angrily asked how this could have happened but neither the police nor the government had a ready answer.

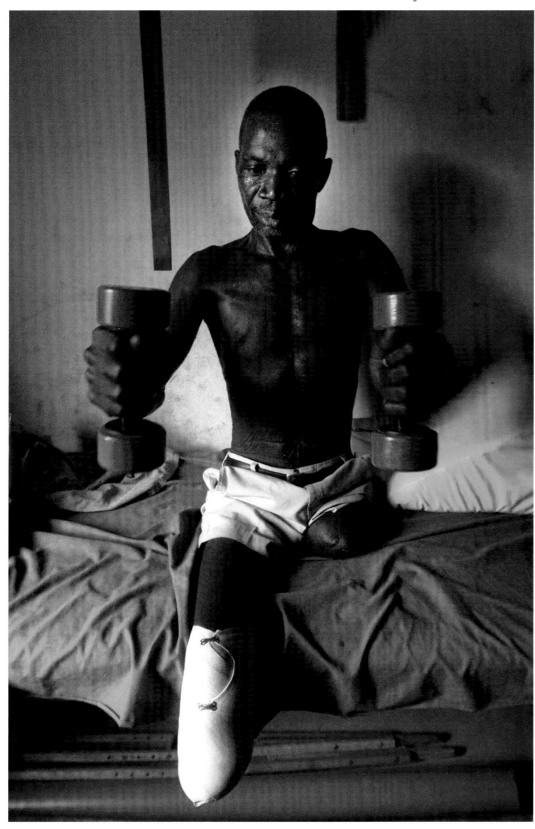

The victim of a rebel atrocity, a Sierra Leonean man slowly begins his recovery in Freetown.

The decade-long civil war in Sierra Leone, which erupted in 1991 following years of government corruption and mismanagement, left a miserable legacy of mental and physical scars on its inhabitants. The rebels of the Revolutionary United Front, led by Foday Sankoh, were particularly cruel: they hacked off the hands of innocent civilians to intimidate others from voting, creating a gruesome reminder of the war persisting into peacetime. The violence was in part fuelled by the illicit trade in gems, known as 'blood diamonds', across west Africa: army and rebels often colluded to share profit and power. Villagers armed themselves against both soldiers and rebels. Tens of thousands died, and more than 2 million people (over one-third of the population) were displaced because of the conflict.

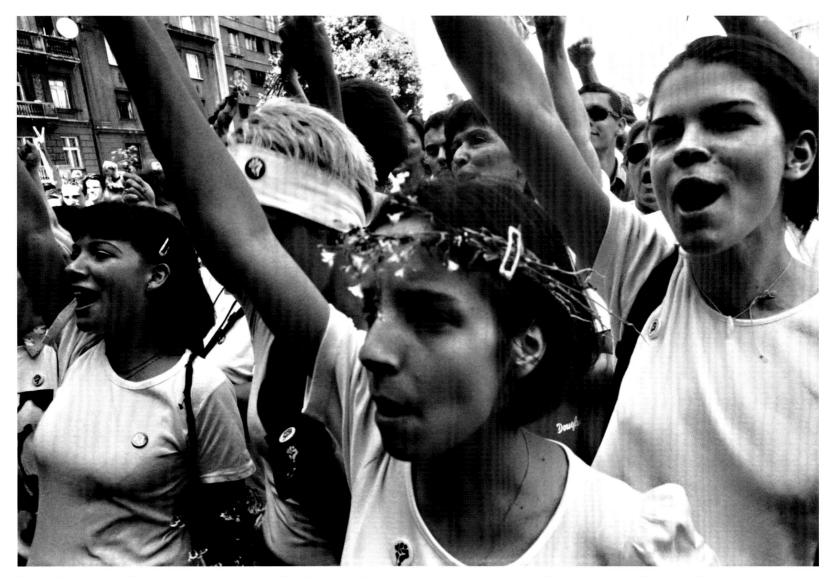

Wearing Otpor! badges (featuring the hallmark clenched fist), thousands of young Serbs take to the streets to call for the overthrow of Slobodan Milosevic.

Slobodan Milosevic launched himself into power as leader of Serbia in 1989 by stoking the flames of nationalism in the dying Yugoslavia. By 2000, however, the Serbian people were increasingly fed up with his oppressive regime and its association with the criminal underworld. An organization of young Serbs called Otpor! (Resistance!) began to turn grumbling and discontent into protest. Milosevic responded by shutting down independent newspapers and TV stations, and arresting Otpor! members. But in October his luck ran out. When Milosevic tried to annul the presidential election he had lost to opposition leader Vojislav Kostunica, angry mobs – led by demonstrators driving a bulldozer – stormed parliament. Milosevic resigned, opening a new era in Serbia's history.

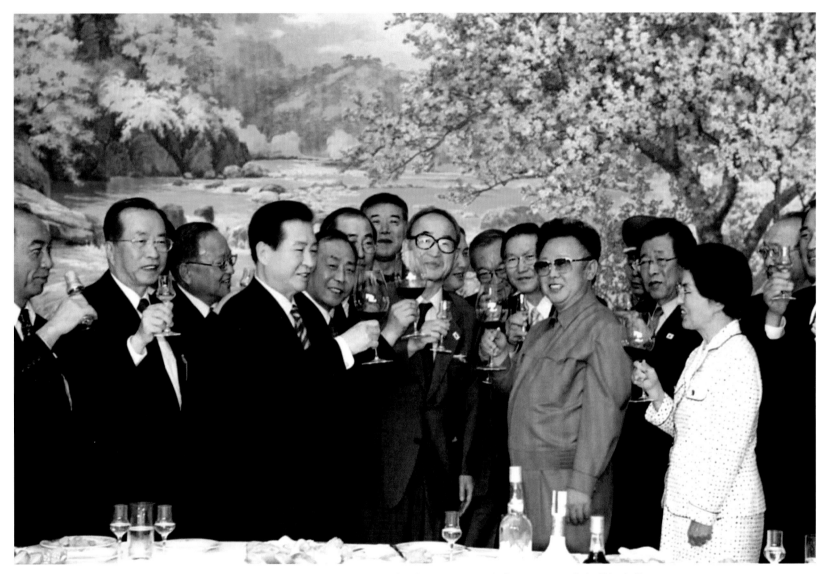

Blossoming wallpaper and a friendly toast belie the artifice of the historic North/South Korea summit in Pyongyang, capital of North Korea.

35

The Inter-Korean summit in 2000 (13–15 June) between North and South Korea was the first time a leader of either country had met his counterpart. The two states, separated by one of the last military frontiers on Earth, had never formally ceased the hostilities of the 1950–3 war. Nevertheless, South Korean President Kim Dae-jung (centre left, wearing striped tie) followed the 'Sunshine Policy', which called for reconciliation with the North and won him the 2000 Nobel Peace Prize. However, it was later revealed that the South Korean government had paid Pyongyang $500 million to hold the summit. Over the next decade, the North's leader, Kim Jong-il (centre right, in khaki suit) used a growing nuclear weapons programme in a game of brinkmanship with both South Korea and the US.

36

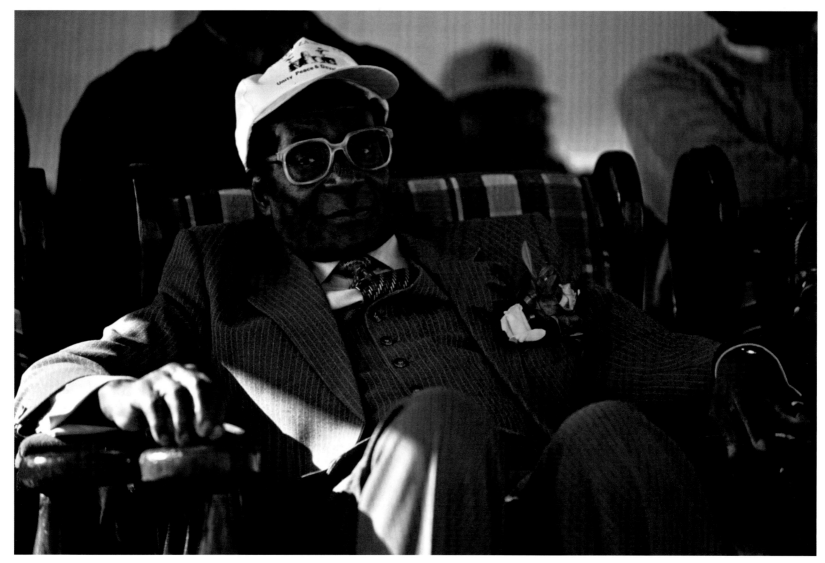

Zimbabwean liberation hero, President Robert Mugabe, attends a campaign rally in Harare before ordering a massive clampdown on the opposition.

The father of the liberation struggle in Zimbabwe, Robert Mugabe had come to power promising reconciliation and peace. Years later, however, his politics soured and a racist nationalistic agenda dominated, focusing on the contentious issue of white land-ownership. Land grabs preceded the crippling of Zimbabwe's commercial agricultural industry – once the 'breadbasket of Africa' – leading to widespread disillusionment and discontent. Having unsuccessfully tried to force through autocratic measures in February, Mugabe received another shock when, despite reports of electoral fraud and voter intimidation, the June elections returned 57 seats for the opposition party, the Movement for Democratic Change. As the country slid into an inflationary spiral, Mugabe's rule became increasingly despotic.

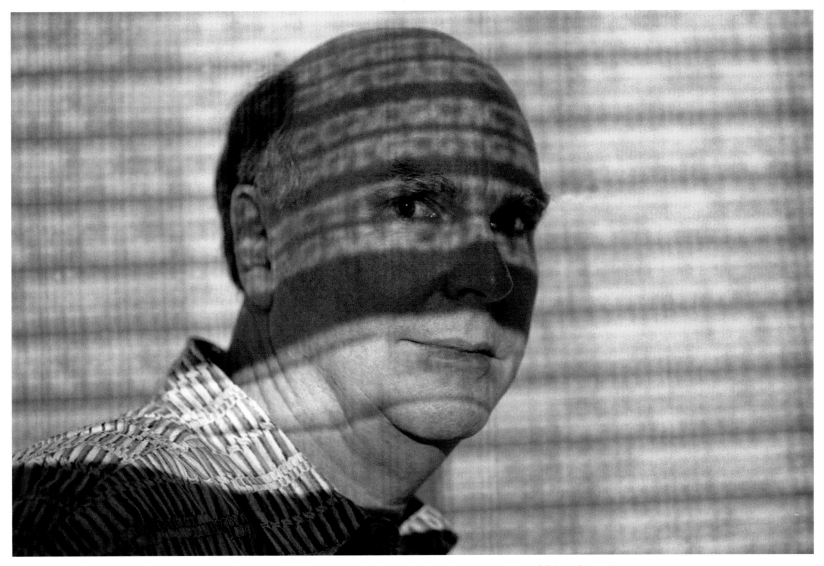

A projection of human genetic code – a chain of letters A, T, G, C – catches the face of J. Craig Venter, president of Celera Genomics.

In a fitting start to the new millennium, scientists revealed the first draft of humankind's biochemical blueprint on 26 June. The mapping of the human genome was heralded as a breakthrough akin to the invention of the wheel. The pioneering project took 13 years (it began in 1990 and was completed in 2003), and sought to determine the sequence of the 3 billion pairs of chemical bases that make up human DNA, and identify the estimated 20,000–25,000 genes. An international consortium of scientists battled with a private venture, Celera Genomics, to be the first to reveal the secrets of the genetic code. The quest led to fractious debate about the appropriate limits of commercial research and the legal, ethical and social implications of gene-based medicine.

The 7.8 kilometre (5 mile) Øresund Bridge is part of the direct road and rail link between the Swedish city of Malmö and the Danish capital, Copenhagen. Underneath the four-lane road are also two railway tracks. Construction finished in August 1999, and in July 2000 the bridge was opened to public traffic. Queen Margrethe II of Denmark and King Carl XVI Gustaf of Sweden were guests of honour at the inauguration.

It was the first time the two countries had a direct land connection since the last ice age, 7,000 years ago. The bridge allowed Danes to settle in the cheaper city of Malmö but still commute to Copenhagen. Local politicians hoped the bridge would spur a new era of economic growth.

38

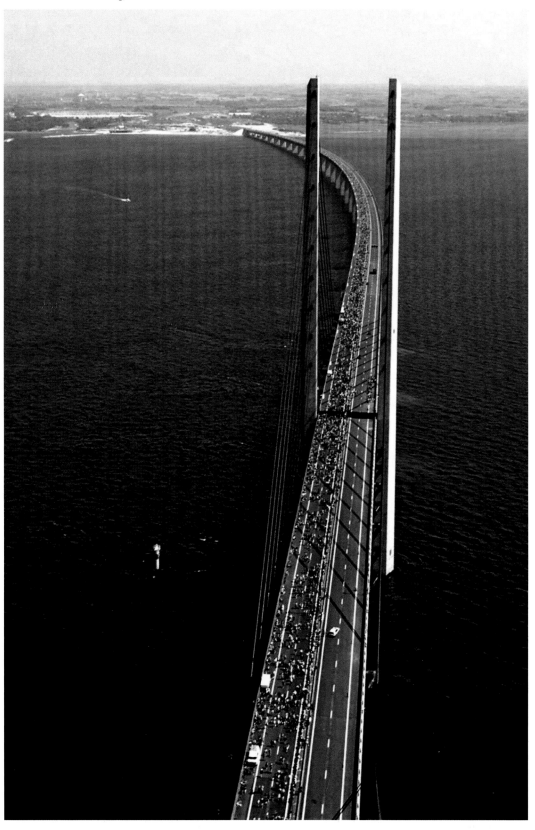

50,000 people traverse the Øresund Bridge, a new highway between Sweden and Denmark, on its inauguration.

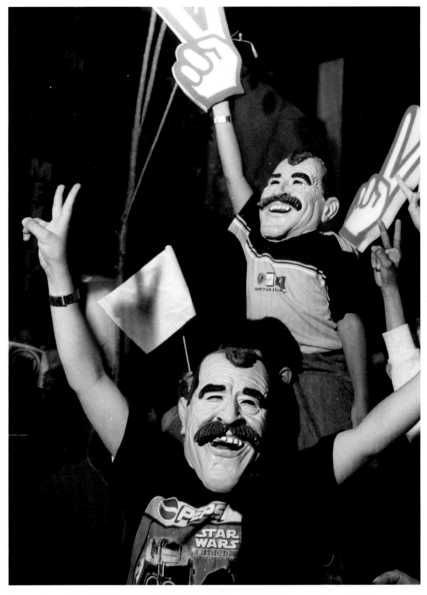

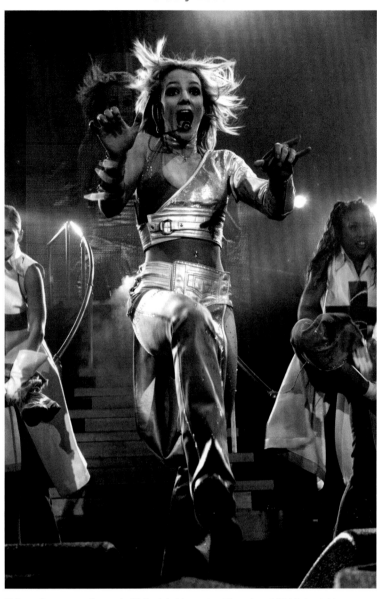

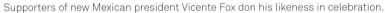

Supporters of new Mexican president Vicente Fox don his likeness in celebration.

Britney Spears performs in Philadelphia on her 'Oops! . . . I Did It Again' tour.

The victory of Vicente Fox in the Mexican presidential election of 2000 ended the 71-year reign of the Institutional Revolutionary Party (PRI). The charismatic native of Guanajuato state had campaigned on a simple slogan: *cambio* (change). Mexicans decided that the PRI had had its day, ushering in the new president with 42.7 per cent of the vote. Although his predecessor had been a competent technocrat, the challenges Fox's incoming administration faced were immense. Economic growth was uneven, with people speaking of 'two Mexicos'. Petty corruption still plagued the system, while the police force – although no longer in the pocket of the regime – still required many reforms to better tackle crime.

Bursting onto the pop scene with the irrepressible '. . . Baby One More Time', Britney Spears quickly became a teen sensation. Her follow-up album 'Oops! . . . I Did It Again' repeated the successful formula of dance-pop and sentimental ballads, and went diamond with 10 million copies sold in the United States. Britney's contradictory persona – both wholesome and sexy – sparked endless debates about her status as a role model. While she praised the virtues of abstinence, her personal life became prime media fodder, ensuring she was constantly in the spotlight. Nevertheless, she continued to deliver as a recording artist, with 'Oops! . . . I Did It Again', released on 16 May 2000, setting a new record for single-week sales by a female artist.

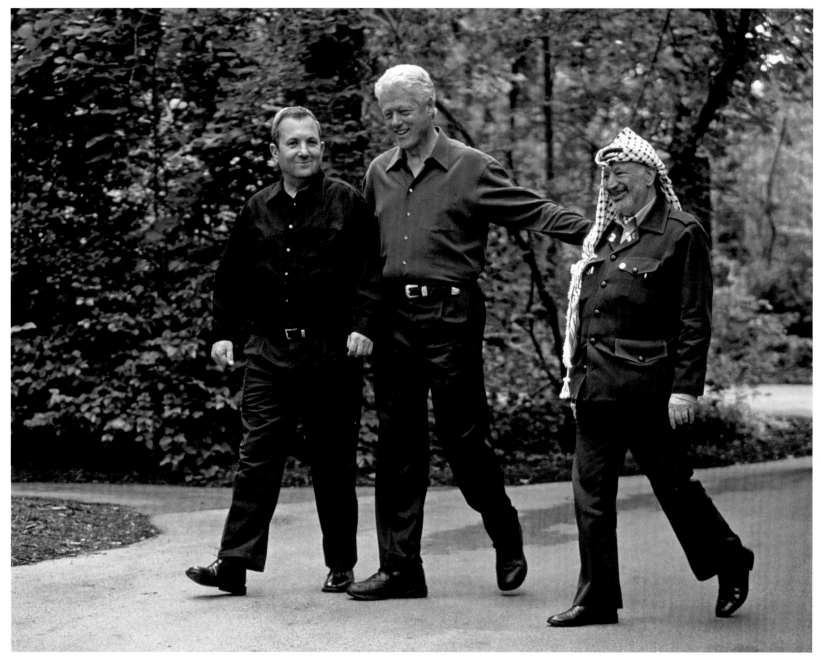

US President Bill Clinton (centre) attempts to bridge the gulf between Israeli Prime Minister Ehud Barak (left) and Palestinian President Yasser Arafat (right) at Camp David, Maryland.

For 15 tortuous days in July 2000, the Middle Eastern Peace Summit at Camp David – US President Bill Clinton's last attempt to hammer out a settlement for Israel and Palestine – spluttered along. The parties were unable to reach agreement on a range of crucial territory issues, and the right of return of Palestinian refugees proved a serious sticking-point. The summit's failure was widely attributed to the intransigence of Palestinian leader Yasser Arafat in the face of what were considered to be significant concessions by Israel, and the absence of a Palestinian counterproposal to ground the negotiations. However, such a caricature of the proceedings disguised the nuanced and complex dynamics at work: in particular, Israeli Prime Minister Ehud Barak's all-or-nothing strategy, which alienated Arafat and undermined Clinton's political capital. While the scope of the negotiations was unprecedented, ultimately the two positions proved to be unbridgeable and the climate of acrimony and blame soon returned.

40

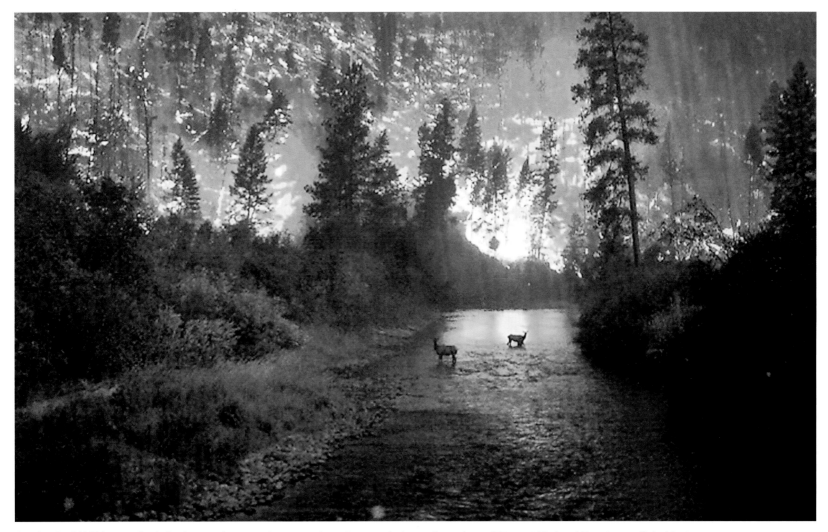

Despite the 800 °C heat, a fire behaviour analyst was close enough to photograph the conflagration at Bitterroot National Forest, near Sula, Montana.

The wildfires of 2000 in the western United States were the worst seen in half a century. A hot spring and summer saw record temperatures across many states. Combined with a persistent drought, a dry tinder bed was created throughout forests in a dozen states. Lightning strikes started the fires, as dry timber and grassland were ignited. The forest fires ravaged 3.2 million hectares of land – an area twice the 10-year average for territory burnt – causing over $2 billion dollars of damage. It took natural intervention in the form of cold weather and snow to quell many of the fires.

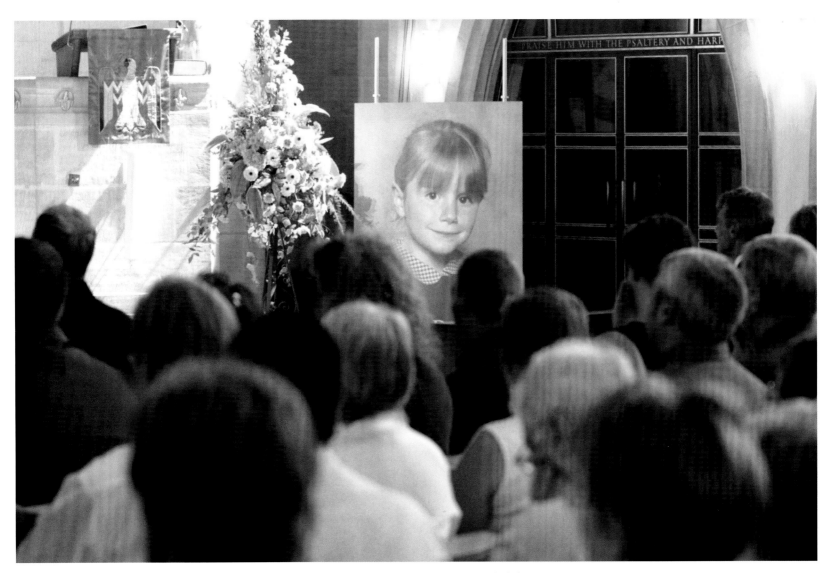

Sarah Payne, the young British girl murdered by a convicted paedophile, is mourned at Guildford Cathedral, Surrey.

A public memorial service was held on 12 August for Sarah Payne, the eight-year-old British schoolgirl whose naked body was found in a field 24 kilometres (15 miles) from where she had been abducted while playing with her brother and sister. Hundreds of mourners gathered at Guildford Cathedral for a memorial service; 12 white doves were released to commemorate Sarah's life. The police investigation was notable for its extensive use of forensic science. A hair found in the vehicle of the prime suspect was matched to Sarah by DNA testing, with a billion-to-one chance it could have belonged to anyone else.

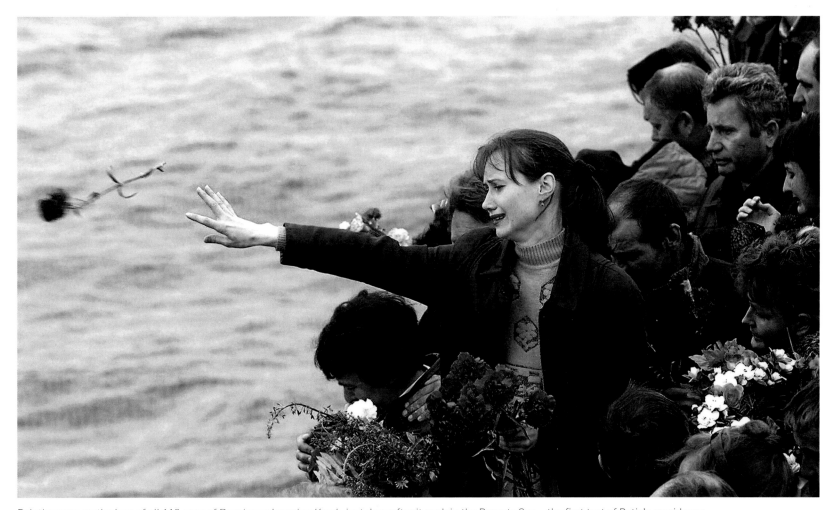

Relatives mourn the loss of all 118 crew of Russian submarine *Kursk*, just days after it sank in the Barents Sea – the first test of Putin's presidency.

43

The Kursk was a nuclear-powered submarine in the Russian Northern Fleet. On 12 August it was on naval exercises in the Barents Sea when a rusty torpedo on board leaked fuel and exploded, setting off seven other warheads. The vessel went down with 118 hands.

The sinking caused controversy in Russia: the new president, Vladimir Putin, had to face angry family members demanding the truth about the incident. The government and military at first blamed a collision with an American submarine that had secretly been observing the exercise. Two years later, however, they publicly accepted that poor technical maintenance and dangerous torpedo design had caused the disaster.

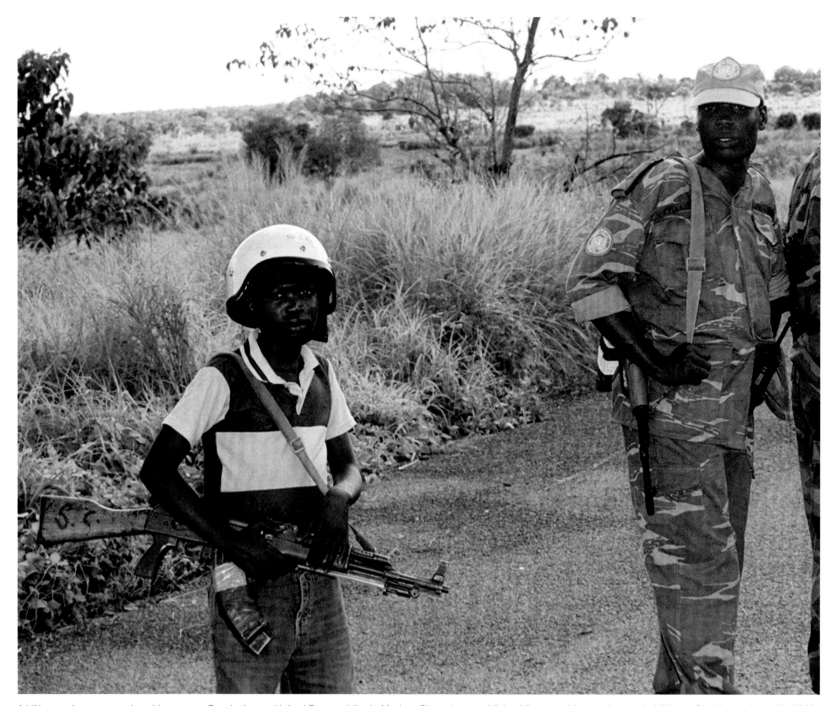

A UN peacekeeper stands aside a young Revolutionary United Front soldier in Markot, Sierra Leone: child soldiers would struggle to rehabilitate after the war's end in 2002.

The Sierra Leonean civil war saw much use of child soldiers, often drawn from the fringes of society. For thousands of these children, the war was initially nothing more than a rumour spreading from village to village. Quickly, however, it became very real as they were conscripted into one armed faction or another. Marijuana, amphetamines and adulterated cocaine ('brown-brown') were supplied by officers and enthusiastically consumed, fuelling the violence. Even government forces, severely short of personnel, recruited children. Though desperate, such a lifestyle had a perverse draw. A gun meant power; child soldiers could command the respect of adults and elders. Rehabilitation – giving up the gun – was thus very difficult.

A street troupe perform marionette theatre, a Czech tradition dating to the eighteenth century, as part of the European City of Culture festival in Prague.

45

Prague, once the most important city in Central Europe, had languished under a communist yoke, with its historical links to the West severed. In 1968 it suffered particularly badly: Soviet tanks rumbled down its streets, bloodily suppressing the Prague Spring, a short period of reform and freedom in Czechoslovakia. However, after the fall of the Iron Curtain in 1989, and the subsequent splitting into the Czech Republic and Slovakia, the city enjoyed a renaissance. Prague was made a European City of Culture at the turn of the millennium, reaffirming its historical stature as a centre of free expression and vibrant culture.

To win one Olympic gold medal is an achievement beyond the dreams of most, but to win five golds in consecutive Olympic Games is the stuff of legends. Rower Steve Redgrave did just that on day 9 of the 2000 Sydney Games – 23 September – and became the greatest Olympian in British history. It was a close-run race. In the coxless fours final, the Italian crew mounted a fierce challenge, surging to a blistering pace of 44 strokes per minute, finishing less than half a second behind the British. Redgrave's medal was all the more remarkable given his diabetes, which was managed with six insulin injections a day.

46

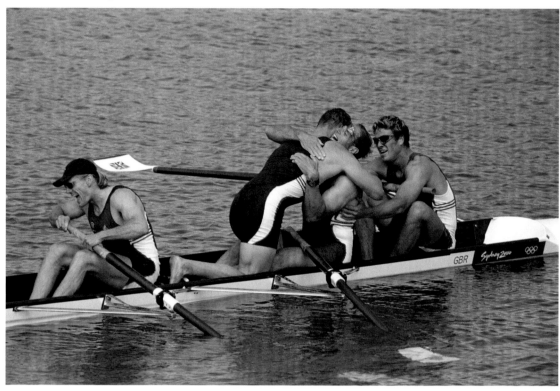

Every ounce of strength expended, British rowers savour their victory in the coxless fours. For Steve Redgrave (centre right), it is his fifth gold medal in as many Olympics.

After lighting the Olympic flame at the Sydney opening ceremony, Cathy Freeman went on to win gold in the 400 metres on 25 September. She became the second Aboriginal Australian Olympic champion and took a victory lap waving both flags, despite the fact that the Aboriginal nation was not recognized by the International Olympic Committee. Freeman was named Sportswoman of the Year in the 2001 Laureus World Sports Awards, and also received the Olympic Order. Freeman went on to take gold in the 400-metre-relay at the 2002 Commonwealth Games before announcing her retirement.

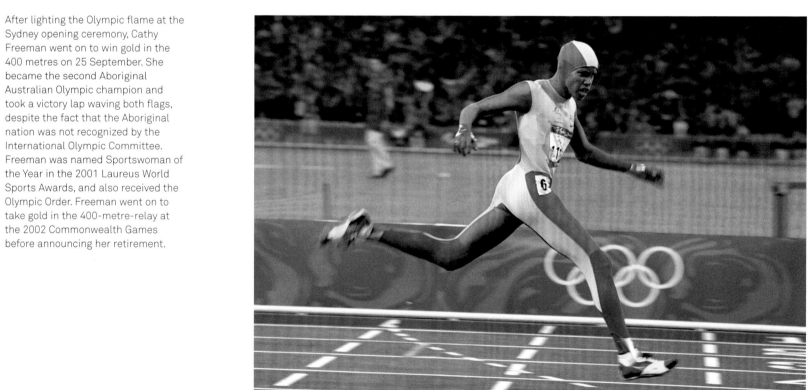

Sprinter Cathy Freeman won gold at Sydney, only the second Aboriginal Australian Olympic champion in history.

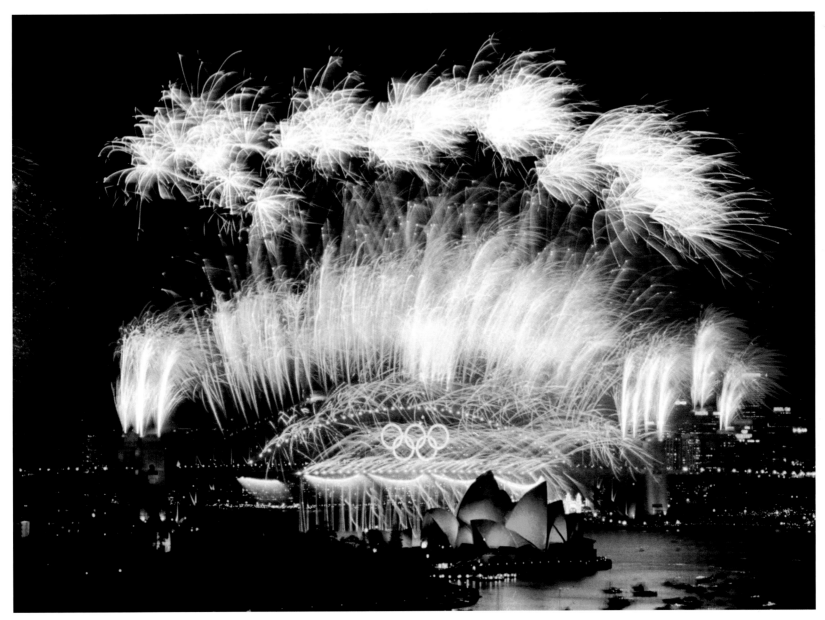

A pyrotechnic spectacular over Sydney Harbour closes the Olympic Games, hailed by fans and organizers alike as one of the best ever.

While relatively few world records were beaten at the 2000 Sydney Olympic Games, the superb organization and unrivalled atmosphere were a credit to the genuine Australian enthusiasm for the event. The highest ever attendance was recorded on day 11 of the games, when 114,714 fans packed into Stadium Australia. Nearly all the seven million tickets available were sold to fans, rather than hoarded for sponsors. The Games also marked a turning point in the battle against doping: stringent new rules on testing were implemented to deter athletes from using performance-enhancing substances. But perhaps most importantly, the Sydney Olympics returned the event to the common sports fan.

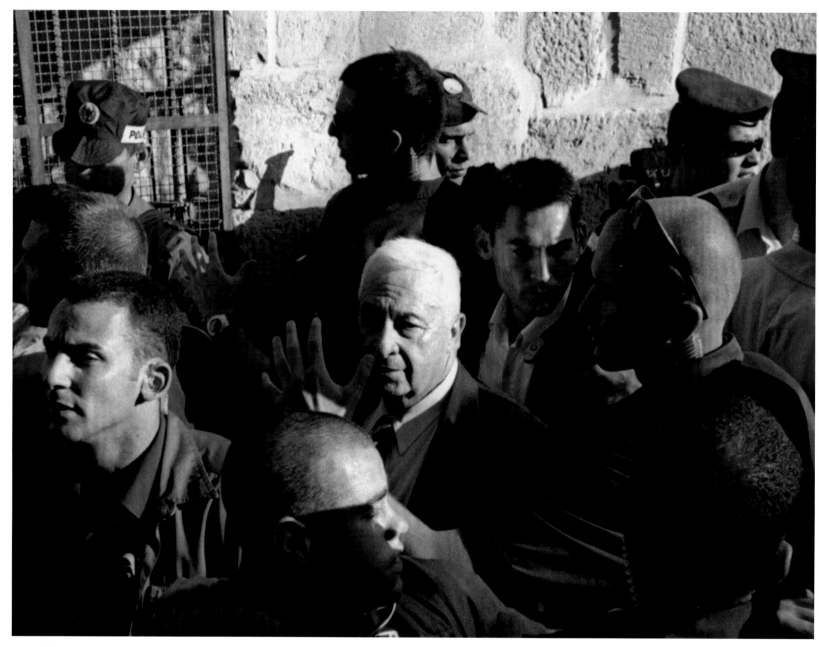

In a bold political gesture, controversial right-wing politician Ariel Sharon visits Temple Mount, Jerusalem. Violence that day sparks a Palestinian uprising.

The ancient city, holy to three major faiths, once again proved an explosive tinderbox. Any peace deal for Jerusalem was fraught with political peril for Israelis and Palestinians alike. Israeli politician Ariel Sharon's visit to Temple Mount, the sacred site comprising the Al Aqsa mosque and the Dome of the Rock, was a deliberate and provocative signal to nervous Israelis that his opposition Likud party would not give up an inch of the ground conquered in 1967. The Palestinians reacted with fury. Following Friday prayers the next day, violence erupted throughout Jerusalem and the West Bank. Israeli police responded with deadly force, reportedly killing five and injuring 200. The Oslo peace process was sunk.

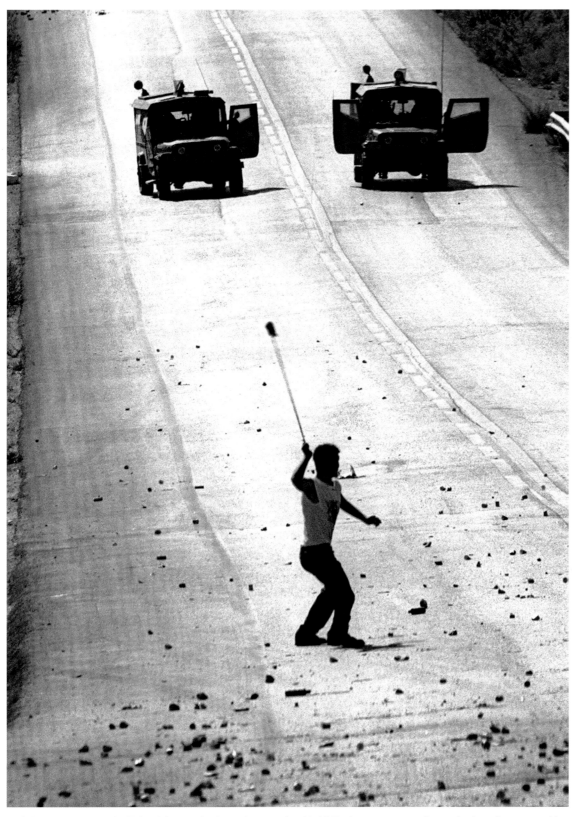

Fighting rages across the Palestinian territories: a lone youth with biblical armament confronts the Israeli army outside Hebron. The peace process is effectively dead.

The Palestinian's Second Intifada ('uprising') was in many ways more worrying for Israelis than the first, which had ended in 1993. The conflict had spread beyond the occupied territories – Israeli Arabs rioted in Jaffa, destroying Jewish shop fronts. And it soon became clear that Yasser Arafat, the Palestinian leader, was unable to rein in either the many factions behind the violence or angry Arab youths. While the Israel Defense Forces had a massive advantage in training and equipment over the Palestinians, the latter began to strike back through a suicide bombing campaign that terrorized the Israeli population in their cities and towns.

49

50

Far-right politician Jörg Haider pays his respects to Austrian WWII veterans at an annual gathering in Ulrichsberg. The commemoration is intensely controversial.

The far-right populist politician Jörg Haider led the Austrian Freedom Party into a coalition government at the turn of the millennium. He was a greatly controversial figure. In October 2000, at the annual gathering of Austrian World War II veterans – including former members of the SS – he told the crowd that the wartime memory of these men should not only be associated with the crimes of the Nazi regime. Haider's outspoken nature panicked many European governments and criticism turned to ostracism. Fellow European Union member states imposed sanctions on Austria, though many questioned what business it was of other European countries to interfere with a democratically elected government that had not violated any laws.

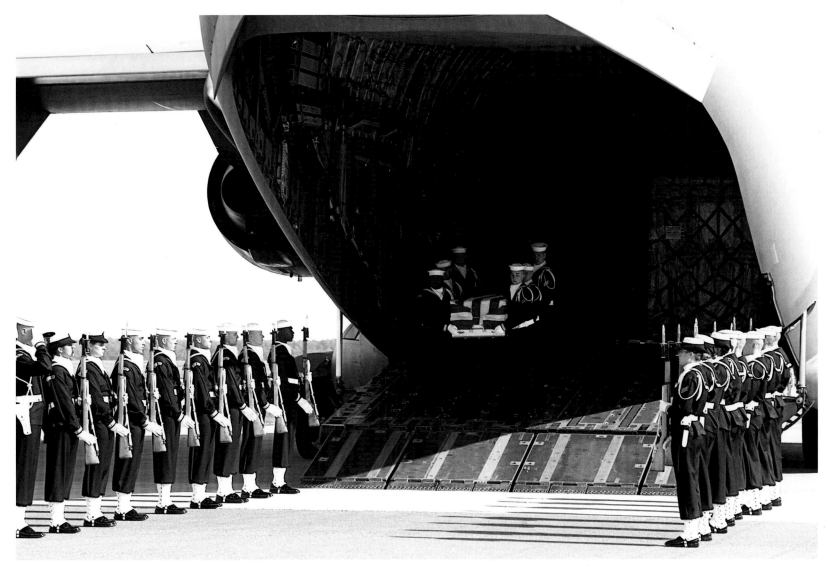

One of the 17 victims of the USS *Cole* suicide attack is carefully unloaded from a transport plane at Dover Air Force Base, Delaware.

As the bodies of 17 US sailors killed in the suicide attack on the USS *Cole* in the Yemeni port of Aden were flown home, a nation mourned. In the immediate aftermath of the bombing (a motorboat and some explosives knocked out the multi-billion dollar warship), no organization was firmly implicated. But in the training camps of Al Qaeda – a diffuse terrorist network known at the time to Western intelligence agencies – recruits celebrated and new blood flocked to join the organization. It was later confirmed that Al Qaeda operatives were responsible for the attack, which demonstrated that a small group of dedicated fanatics could create political effects wildly disproportionate to their physical means.

52

Anchored to a robotic arm, NASA astronaut Michael Lopez-Alegria orbits above the Earth while working on the International Space Station.

After years of planning, the International Space Station received its first full-time crew on 2 November 2000. The most ambitious aerospace engineering project to date, the space station was the result of a US-led collaboration of 16 nations – itself a feat of diplomacy and vision. Forty-six space missions and multiple spacewalks were required to launch and assemble the station's components including flight STS-92, which launched from the Kennedy Space Center, Florida on 11 October to complete the final touches. Able to observe more than two-thirds of the Earth, the research-led project included a state-of-the-art laboratory system that aimed to grow the perfect crystal and explore the nature of space and life in low gravity. Despite hopes that the station would be a pioneering step towards space exploration, the project failed to capture the imagination of many earthlings.

British commandos storm Mamyko beach in Sierra Leone. This demonstration of strength helps consolidate the country's fragile peace.

53

Sierra Leonean rebels of Foday Sankoh's Revolutionary United Front kidnapped 300 United Nations peacekeepers in May 2000. They had been taken hostage in yet another depressing reversal of the country's prospects for peace. Britain, Sierra Leone's former colonial power, now felt compelled to intervene. British military forces, enthusiastically welcomed by locals, came on shore and moved quickly. The rebels soon gave up, to a great degree intimidated by the carefully calculated demonstrations of British strength. Supporting the larger UN mission, British troops helped disarm rebels and end the civil war.

54

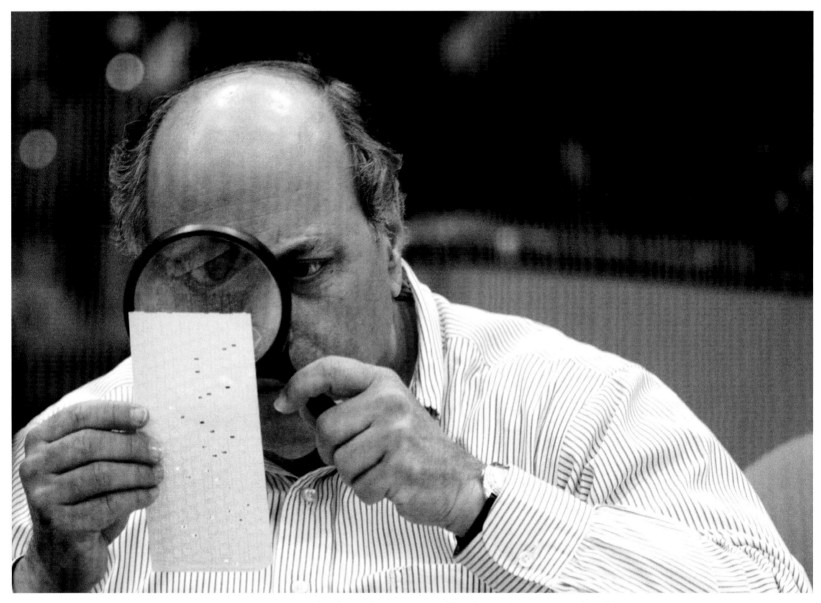

Judge Robert Rosenberg casts an eye over punch-ballots during the Florida election recount. The US presidency hangs in the balance.

Hanging, dimpled and pregnant chads – never had something so seemingly inconsequential portended so much for the fate of a nation. The close results of the Florida state vote in the 2000 US presidential election – a mere 350 votes by some accounts – and confusion in tabulating votes on the night led to the infamous re-count, delaying confirmation of the outcome for over a month. The failure of the so-called 'butterfly ballot' – which required voters to punch out a hole in the polling card next to the name of their preferred candidate – was blamed for counting anomalies, leading to a call for electoral reform and the use of electronic voting machines in future elections.

Safe from groping hands, women passengers ride in a female-only commuter train carriage in Tokyo.

In March 2001 Japan reintroduced the 'flower train' to combat lewd conduct on its crowded commuter trains. First used in 1912 to preserve the modesty of schoolgirls, the modern women-only carriages were piloted by Keio Electric Railway during the Christmas 2000 rush hour. Over the next year, a number of other suburban train services joined the initiative to protect female passengers from the *chikan* (gropers), a growing problem in a country usually known for its decorum. Marked by pink stickers, the special carriages allowed women to travel safely. Both sexes welcomed the scheme, which was rolled out in the Tokyo area in 2005.

55

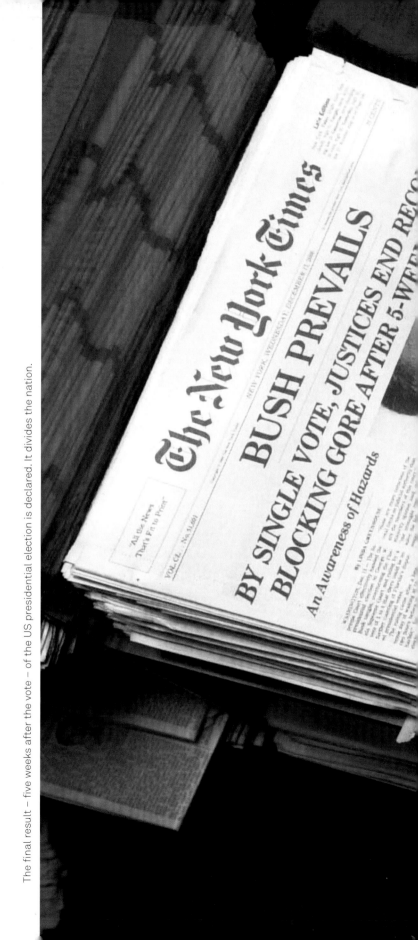

The final result – five weeks after the vote – of the US presidential election is declared. It divides the nation.

It had been one of the most closely fought races in history, but in the end it came down to numbers. Although Al Gore won the national popular vote by over half a million votes, the slim margin in Florida eventually fell in George W. Bush's favour, giving him a five-point lead in the Electoral College. The night of the US presidential election had been gripping, as exit polls and television networks declared first a Gore victory, then a Bush presidency, and then dramatically retracted that prediction altogether, just as Gore was preparing his concession speech. A historic Supreme Court ruling in early December gave Bush his first presidential term.

SPORTS **FINAL**

DAILY ◉ NEWS

NEW YORK'S Hometown Newspaper

www.nydailynews.com

Wednesday, December 13, 2000

HISTORIC RULING

BUSH WINS

U.S. SUPREME COURT REJECTS FLA. RECOUNT

COMPLETE ELECTION COVERAGE BEGINS ON PAGES 2-3

G.O.P. IS CAUTIOUS

Gore's Choices to Digest
Ruling and Decide to
End Their Battle

A Shaky Plaft...

58

One of the most controversial films of the decade, the violent *Battle Royale* would become a cult classic outside of Japan.

The most controversial film to appear in Japanese cinemas in 2000 was Kinji Fukasaku's *Battle Royale*. Labelled 'crude and tasteless' by conservative parliamentarians in Japan, the film centres on a large group of high school students who are kidnapped by their sadistic teacher and sent to an isolated island. Over three days they are forced to kill each other in a macabre competition. The filmmaker's dystopian vision of a crumbling, fascistic society angered some senior politicians. But its clever rendering of the still-nascent reality television genre and the growing trend towards extreme violence in Asian cinema was hailed by critics and fans, among them acclaimed American director Quentin Tarantino, who counted it among his favourite films of all time.

The suggestive advert of a voluptuous Sophie Dahl provoked a flurry of complaints and was pulled from British billboards.

59

Sophie Dahl, the granddaughter of famed children's author Roald Dahl, achieved unexpected notoriety in 2000 when she appeared in an advertisement for Opium, a perfume by Yves Saint Laurent. The advert attracted no controversy when it was published in fashion magazines, but when the same picture of the 22-year-old model was displayed on billboards, Britain's Advertising Standards Authority received 730 complaints. The watchdog responded by ordering all the 'sexually suggestive' posters to be withdrawn because they were deemed offensive and 'degrading' to women.

2001
Terror

The traditional honeymoon period that new US presidents enjoy during their first few months in office was over before it began for George W. Bush. On the day of his inauguration in January thousands of activists marched on Washington to voice their anger at the Supreme Court's decision to halt the manual re-count of votes in Florida, which had given Bush the keys to the White House. The new president found a perhaps unlikely friend in British Prime Minister Tony Blair, a stalwart ally of his democratic predecessor Bill Clinton. The folksy, shoot-from-the-hip Texan and the eloquent Brit forged an immediate bond when the two leaders met at Camp David in February. The population of the world's biggest democracy, India, reached beyond a billion in March – triple the figure at independence in 1947. While tens of millions remained stuck in crushing poverty, India's educated élite was driving a new economic powerhouse built on services,

manufacturing and high technology. Yet, India's ever-present sacred past was also on glorious display at the first Maha Kumbh Mela of the millennium. An estimated 70 million people gathered at Allahabad to celebrate the festival and take the ritual bath in the holy Ganges River. In Afghanistan the Taliban showed not reverence for the past but contempt. In March they blew up two giant Buddhas, which had sat undisturbed in a beautiful valley northwest of Kabul for 1,400 years. The Taliban's heinous destruction of the statues was condemned by people of all faiths and cemented their reputation as the world's most evil regime. In the UK, destruction of another kind provided some of the most grisly imagery of the year. An outbreak of foot-and-mouth disease prompted the government to order the slaughter of 6 million animals, a move that cost the country billions and devastated its farming industry. American multimillionaire Dennis Tito became the

first space tourist when he orbited the Earth in a Russian Soyuz spacecraft, though at a cost of $20 million for a single trip this form of travel didn't appear ready to enter the mainstream just yet. Unlike the iPod, a portable digital music player launched by Apple. Few would predict the iPod's global popularity; less still, the way it would revolutionize the music business. The international political success story of 2001 was Macedonia. Clever diplomacy proved instrumental in preventing the small southern European country from collapsing into ethnic war like its Balkan neighbours. This achievement was to go largely unheralded because of what happened on 11 September. So unprecedented and viscerally shocking were the terrorist attacks on New York and Washington, DC that they seemed to render unimportant all events that went before them in 2001, at least in American minds. The world held its breath, waiting to see what would happen next.

62

In the aftermath of a powerful earthquake in El Salvador, rescue workers make frantic efforts to rescue buried survivors.

On a Saturday afternoon in January, a massive earthquake measuring 7.6 on the Richter scale hit the Central American nation of El Salvador. Hundreds were killed by landslides in Santa Tecla, said by many to have been aggravated by the extensive land development there. The earthquake triggered more than 2,500 after-shocks, causing panic and further distress to tens of thousands of homeless Salvadoreans. Exactly a month later, another earthquake compounded the disaster, as a regional earthquake sequence was set off in the Cocos-Caribbean subduction zone. With local authorities still unable to handle the fallout from the first hit, President Flores was forced to ask Colombia to donate 3,000 coffins to help bury the dead.

The son of former US President George H.W. Bush, George W. Bush was officially inaugurated as the 43rd President of the United States on 20 January 2001. In his speech he called on Americans to be 'citizens, not spectators', continuing his campaign themes of responsibility and compassion. It seemed that many of his new charges had taken the message to heart, as thousands of activists marched in the capital to protest against voter disenfranchisement in light of the electoral irregularities that had marked Bush's journey to the Oval Office. The protests demonstrated the depth of division facing the new president, who promised to work 'to build a single nation of justice and opportunity'.

At his inauguration, George W. Bush, promising to be 'a uniter, not a divider', glances at outgoing President Bill Clinton.

63

Millions of Hindu faithful flock to the sacred river Ganges in Allahabad for the holiest festival of the religion.

The Maha Kumbh Mela is the most sacred of Hindu pilgrimages. It occurs every 144 years at Allahabad (Prayag), at an auspicious point of celestial alignment when the forces of creation are believed to collect in a vessel (kumbha), prompting a celebration (mela) by thousands of pilgrims, including the Naga sadhus who cover themselves in a layer of ash. The most spectacular event of the month-long celebration is the ritual bath, when devotees cleanse themselves in the waters of the Ganges, symbolizing the elixir of immortality. An estimated 70 million people attended the first Maha Kumbh Mela of the millennium, making it the largest congregation in the world.

66

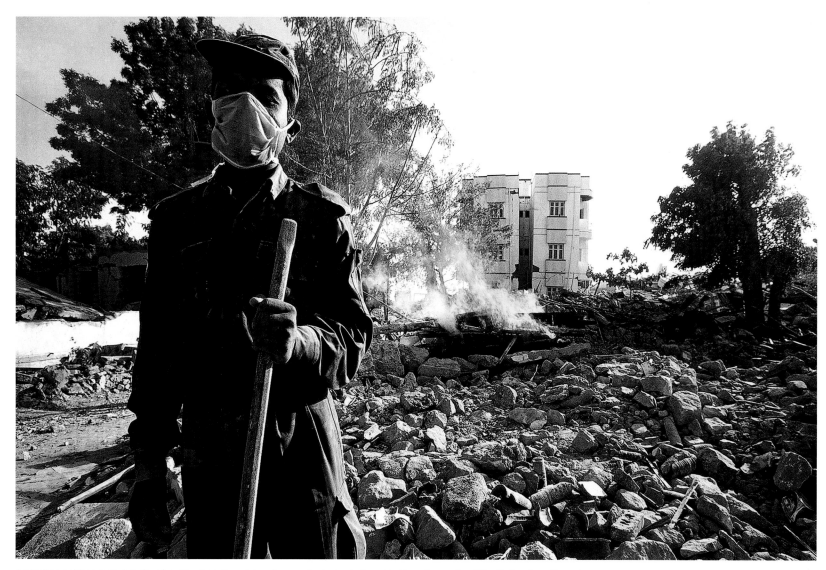

An Indian soldier rests briefly after the macabre duty of cremating a body found in the aftermath of the Gujarat earthquake.

A tremendous earthquake hit the Indian state of Gujarat as celebrations began for the 51st Republic Day. The worst natural disaster to strike the country since independence, the powerful earthquake reduced the cities of Bhuj and Bhachau to rubble, and caused serious infrastructural damage across the region. More than 20,000 were killed and 167,000 injured. The night sky, which should have been lit up with fireworks, was illuminated by huge funeral pyres. Yet there were some miracles among the tragedy, as people – young and old – survived for days under the debris, before being pulled to safety by local and international relief personnel.

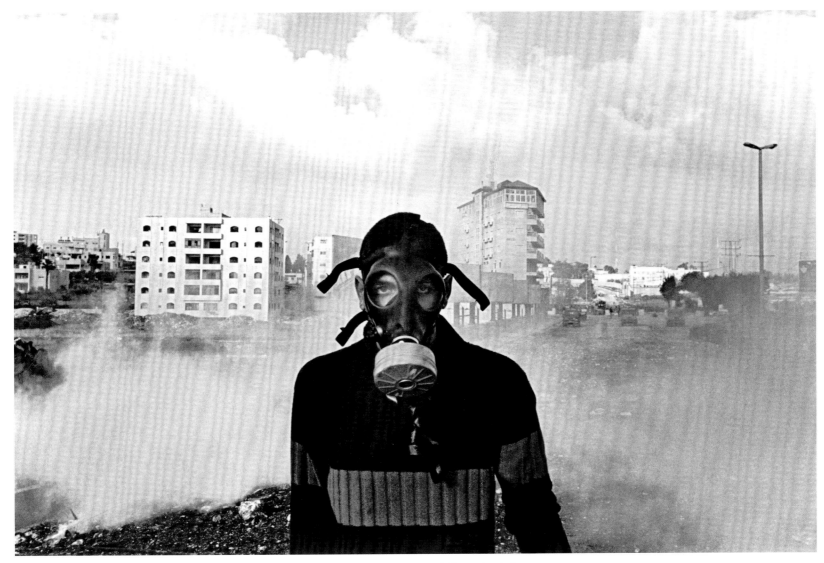

As Israeli forces renew attacks on the West Bank city of Ramallah, a Palestinian protestor defies a cloud of tear gas.

The victory of Ariel Sharon in a special election on 6 February 2001 after the collapse of Ehud Barak's government saw an intensification of fighting in the Palestinian territories. In particular, the town of Ramallah in the West Bank was singled out because of its role as the de facto Palestinian capital. Israeli tanks lay within firing distance of the headquarters of Yasser Arafat, who was unable to halt attacks by various Palestinian factions, including Hamas and Islamic Jihad. Israel responded to terrorist attacks by isolating Ramallah, occupying swaths of the town and fighting militants in the streets. Once again, the West Bank had become a battleground.

68

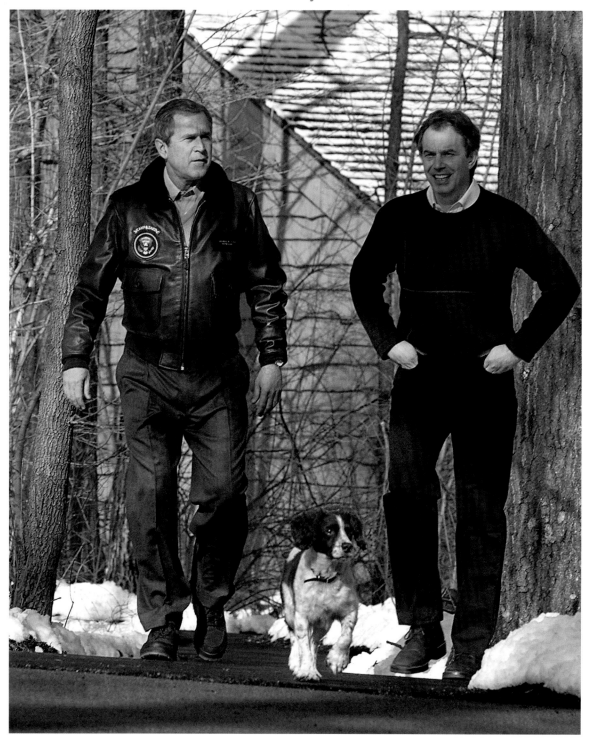

Taking a walk through the grounds at Camp David, George W. Bush and Tony Blair cement their 'special relationship'.

Winston Churchill once described a 'special relationship' between Britain and the US. Meeting in February 2001 at the presidential retreat at Camp David, Maryland, Prime Minister Tony Blair and President George W. Bush forged an instant rapport that became one of the defining political friendships of the 2000s. Even before the terrorist attacks of 9/11, their priorities were aligned: Blair had denounced Iraqi dictator Saddam Hussein as the 'world's most dangerous leader' shortly before the visit to Camp David. Asked at the press conference what the two leaders had in common, Bush replied in his characteristic style that both men used Colgate toothpaste.

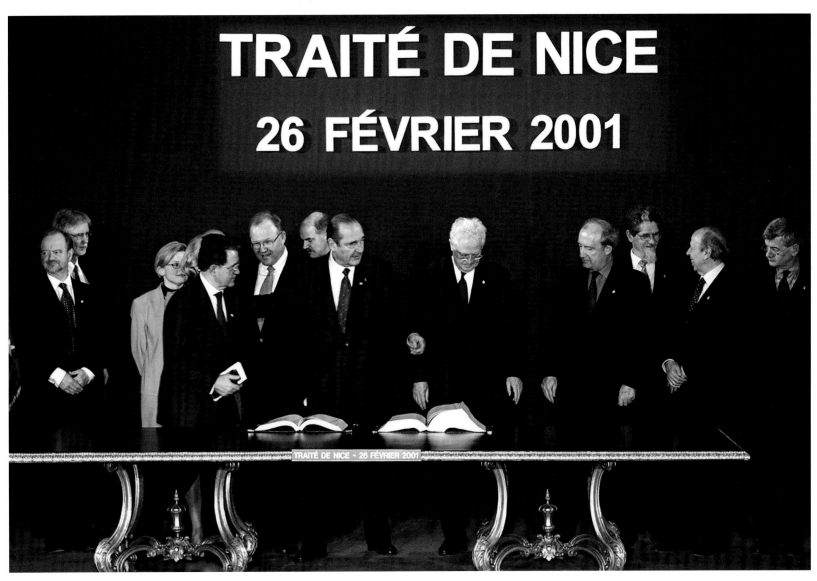

EU leaders and foreign ministers pose for a photograph as the Treaty of Nice is signed, but no one seems to have a pen.

The Treaty of Nice was agreed in December 2000 and signed by European leaders on 26 February 2001. The Treaty represented a further step on the path to deeper European integration and provided for new institutional reforms to accommodate the eastward expansion of the European Union. Negotiations over EU enlargement to include countries of Central and Eastern Europe, as well as Cyprus and Malta, were beset by the long-standing arguments about the utility of supranational as opposed to intergovernmental structures. Although these divisions were eventually overcome, the ratification of the Treaty of Nice was thrown into doubt when Irish voters rejected it in a national referendum a few months later. It finally came into force on 1 February 2003 after a subsequent referendum in Ireland reversed the country's decision.

As India's population crosses the 1 billion mark, it becomes only the second country after China to do so.

70

A year after the world's population hit 6 billion, India's 2001 census declared that as of 1 March its population crossed the 1 billion threshold, giving it 16 per cent of the global populace on 2.4 per cent of the land area. The population increase rendered conservation efforts ineffective, while a Malthusian decline in food-grain production was felt disproportionately by the poorest segments of Indian society. The National Population Policy, instituted the same year, attempted to reduce the total fertility rate to just below replacement level by 2010. However, such initiatives seemed to have come too late for a country whose population had more than tripled since independence, and looks likely to overtake China by 2030.

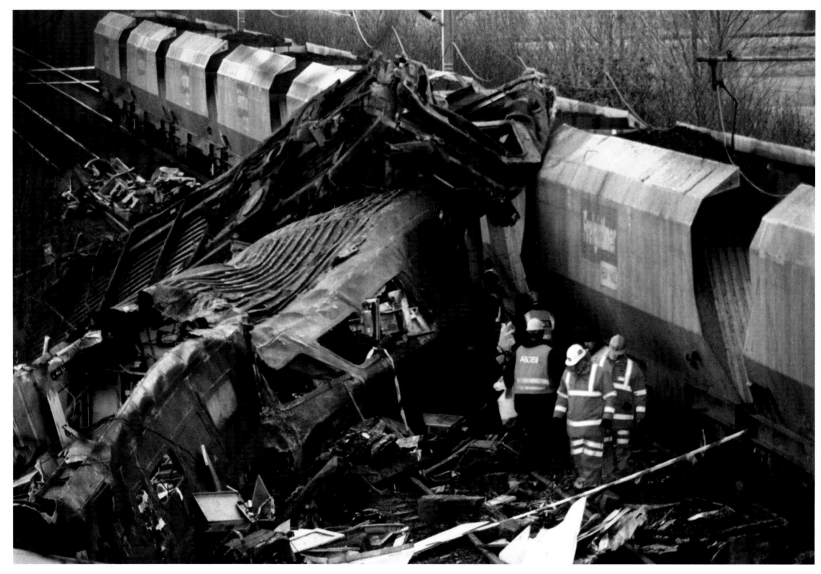

The true impact of the high-speed train crash at Great Heck, North Yorkshire, is revealed the morning after, as rail workers pick through the wreckage.

At 6.12 a.m. on 28 February a Newcastle–London passenger train crashed into a Land Rover that had plunged off the adjacent motorway onto the tracks, near Selby in North Yorkshire. The express train was deflected into the path of a freight train, causing a devastating collision. Both trains were derailed: 10 people were killed and many more injured. The motorist, Gary Hart, escaped unscathed, but was charged with 10 counts of unlawful killing. The judge denounced the actions of the sleep-deprived Hart, finding that they were morally indistinguishable from drink driving. The UK Health and Safety Commission later reported that such an accident was unlikely to be repeated for another 300 years.

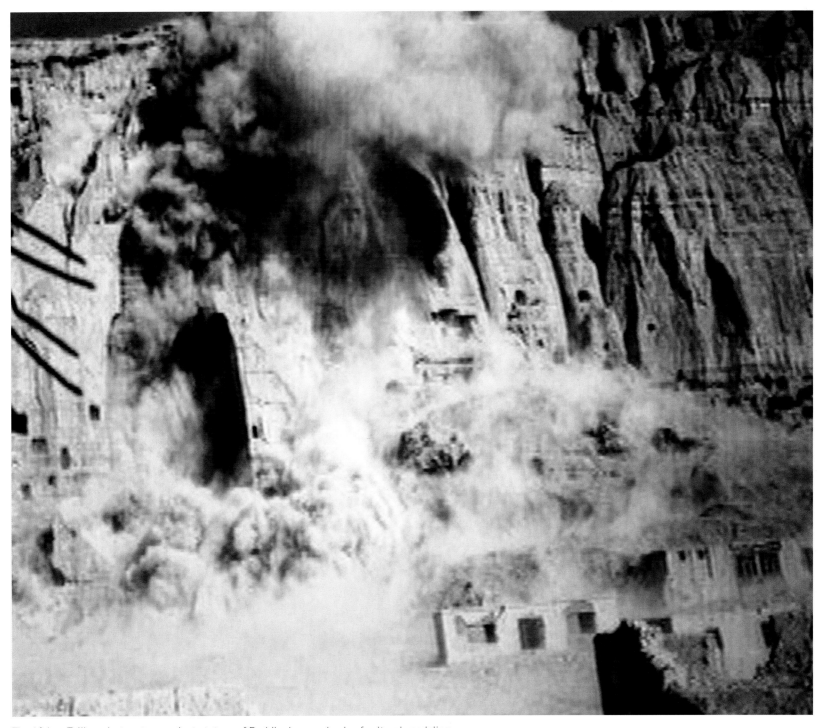

The Afghan Taliban destroy two ancient statues of Buddha in an episode of cultural vandalism.

In a beautiful valley on the fabled Silk Route northwest of Kabul, Afghanistan, two enormous Buddhas had watched over pilgrims, merchants and travellers for centuries. Made of sandstone, wood and mud, the statues stood in hollowed-out sections of the mountainside, their rocky homes painted with images of enlightened beings and the Sun God. Considered idolatrous by the puritanical Taliban, the pre-Islamic, archaeologically valuable statues were blown apart by explosives and anti-aircraft missiles in March, destroying the heritage of Bamiyan, a base for anti-Taliban rebels, and constituting a visible act of defiance against the West. The remaining caves, which had once been home to Buddhist monks, became sanctuaries once more as Afghans fled the wildfire of violence.

A pit of charred animal carcasses is testament to the grim thoroughness of Britain's foot-and-mouth cull.

In 2001 an outbreak of foot-and-mouth – a highly contagious disease that infects cloven-hoofed animals – led to widespread contamination and mass slaughter of livestock. Although there were little more than 2,000 cases of infection, the culling of 6 million animals as part of the preventative 'stamping out' policy was economically and psychologically devastating for UK farmers. One, however, faced a different fate: Bobby Waugh of Northumberland was charged with neglect and failing to alert the authorities when his pigs began to exhibit symptoms of the disease. They had been fed untreated waste and though it was impossible to know for certain, many suspected Waugh's farm to be the source of the epidemic that had cost the UK billions of pounds.

76

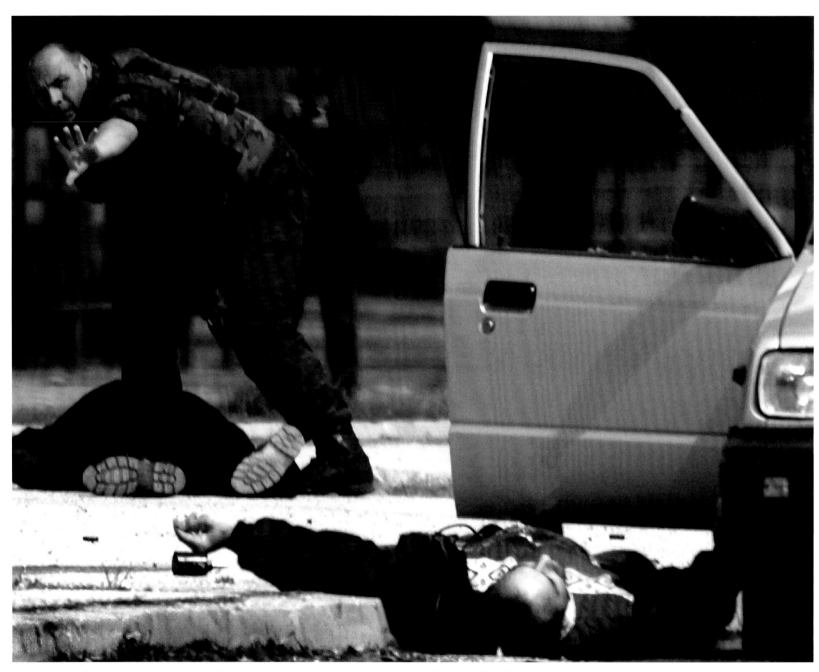

Macedonian police shoot dead two ethnic Albanians in error at a checkpoint in Tetevo; rebels had shelled the area earlier that day.

For a moment it looked as if Macedonia would offer a bloody reprise of the ethnic fighting during the break-up of Yugoslavia. Ethnic Albanians in the country's north, a quarter of the population, wanted more political rights. Their armed organization, the National Liberation Army, began challenging the Macedonian state in early 2001. Skirmishing was limited, but there was potential for wider violence. In Tetevo, Macedonia's second city, sporadic gun battles turned into exchanges of artillery fire as Albanian guerrillas took control of the city's hinterland. Fortunately, swift international intervention and tireless mediation by US and European diplomats helped broker a peace deal in August 2001.

On May Day, Russia celebrates the start of spring. These two 'Soviet heroes' chose this day to visit Moscow's Lubyanka, headquarters of the KGB – their new president's former employer. Having photographed the horrors of the Chechen War that helped bring Putin to power, Stanley Greene documented the moment Russia turned its back on its Soviet past and brief dalliance with liberal democracy, and looked ahead to its resuscitation as a great power. This shift was to be accompanied by reduced political freedom and rule of law, a strengthened state, and a massive accumulation of oil and gas wealth over the decade.

Russian veterans of the Great Patriotic War display their medals in front of the old KGB offices.

77

Following the post-Cold War decline in space activity, a US businessman and former aerospace engineer undertook a mission reminiscent of early science fiction by becoming the world's first space tourist. Launched from Kazakhstan in a Russian Soyuz spacecraft, Dennis Tito orbited the Earth before making a port call at Alpha International Space Station, at a cost of $20 million. Five more spaceflight participants during the decade helped raise the profile of space tourism, but it nevertheless remained prohibitively expensive. Instead, other suborbital initiatives looked set to give citizen astronauts a taste of weightlessness and wonder beyond the Kármán Line.

The world's first space tourist comes back to Earth near the Kazakh city of Arkalyk.

Birthplace of the modern cancan dance, first seen here in the 1890s, the Moulin Rouge (French for Red Windmill) has become one of Paris's better-known – and more lurid – tourist destinations. Close to Montmartre in the city's red-light district of Pigalle, the cabaret has retained much of the romance of turn-of-the-century Paris in its décor and atmosphere. Its popularity soared in 2001 with the release of Australian director Baz Luhrmann's film *Moulin Rouge!*. Starring fellow Australian Nicole Kidman as the lead cabaret actress and prostitute Satine, the film won two Oscars and was the first musical nominated for Best Picture in 22 years.

Baz Luhrmann's lush visual epic, *Moulin Rouge!*, premieres at the Cannes Film Festival.

78

David Lynch's mesmerizing film about an aspiring actress newly-arrived in Los Angeles was hailed by critics as a masterpiece of film noir and earned him the Best Director Award at the 2001 Cannes Film Festival. Originally conceived as a pilot for a prospective American television series, *Mulholland Drive* was rejected by studio executives, prompting Lynch to devise an ending so that the project could be released as a feature film. This gave the film an eerie disconnectedness, which only amplified the murkiness and surrealism that are characteristic of Lynch's work. *The New York Times* described the plot as an 'intoxicating liberation from sense'.

Actresses Laura Elena Harring and Melissa George kiss in a scene from the complex and compelling *Mulholland Drive*.

An exhibit eyes some visitors as the Hitchcock exhibition opens in Paris.

79

In Paris, one of the summer's main cultural events was a bold and innovative celebration of film director Alfred Hitchcock. The exhibition at the Pompidou Centre – *Hitchcock and Art: Fatal Coincidences* – sought to answer questions concerning Hitchcock's influences and preoccupations. Curators assembled around 200 works of art – paintings, engravings, photographs – and juxtaposed them with stills and clips from the director's films. The aim was to provoke ideas and theories about what inspired Hitchcock and made him not only the master of suspense but also, according to French director Jean-Luc Godard, 'the greatest creator of forms in the twentieth century – and it is forms that finally tell us what lies at the bottom of things'.

Once considered the natural party of government, the Tories were still wracked by internal division during the 2001 British general election. Nor had they shaken off the unpopular image from their previous terms in government, especially in Britain's once-prosperous industrial regions. Senior Conservatives criticized the ineffective election campaign. Leader William Hague had played to the fears of the electorate and focused on asylum seekers and the EU, while the real issue for the voters was aspirational: they wanted better public services. Hague – a talented politician in charge of the party at the wrong time – resigned after the defeat. He became the first Conservative leader to step down without having become prime minister.

Conservative leader William Hague, who failed to disassociate his party from the Thatcher era, votes with his wife Ffion in Catterick, North Yorkshire.

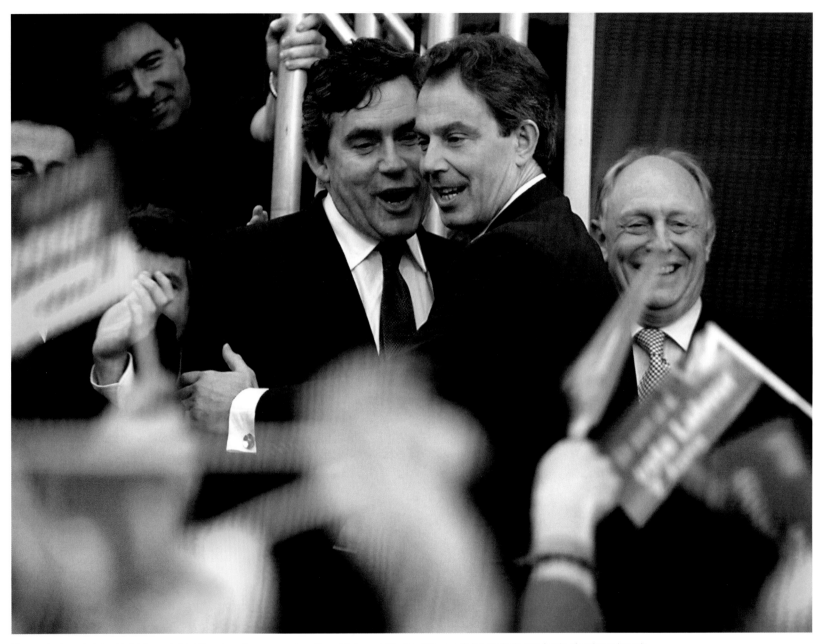

Former Labour leader Neil Kinnock (right) enjoys the moment as Tony Blair and Gordon Brown celebrate their emphatic election triumph.

The Labour Party maintained its solid hold on power in Britain with a convincing election victory over its historical rivals, the Conservative Party. Although they lost a few seats, Labour nevertheless enjoyed a significant win.

Prime Minister Tony Blair and Chancellor Gordon Brown had been swept into government in 1997, but this triumph was all the more special because it was the first time in history that two successive Labour governments had been elected. The election was remarkable for another reason – the lowest voter turnout for 80 years. Some began to worry that voters were increasingly uninterested or uninvolved in politics.

Marches of the Protestant Orange Order in Northern Ireland have long provoked the nationalist community. The Whiterock parade on 30 June saw minor scuffles with police by nationalists who objected to the route. There were also more extreme examples of violence, including rioting and one episode where police had to shield Catholic schoolgirls from stones and abuse, simply for daring to take the quickest route through the 'wrong' estate. But the peace process nevertheless moved forward. A series of reforms culminated in the renaming of the Royal Ulster Constabulary in November 2001. It was a great symbolic turning point. Traditionally dominated by Protestants, the new Police Service of Northern Ireland adopted a strict intake quota to redress this imbalance.

A nationalist at the Whiterock Orange Order march in Belfast fails to seriously disrupt the Northern Irish peace process.

Surgeons install the world's first fully implantable artificial heart.

83

In 2001, surgeons at Jewish Hospital in Kentucky successfully implanted the AbioCor replacement heart into 59-year-old teacher Robert Tools, who survived for 151 days without a living heart. Designed for end-stage heart failure, the AbioCor was notable for being a fully implantable device without any wires piercing the skin, thus reducing the risk of infection. The first permanent artificial heart was successfully implanted in 1982. Subsequent development of new technologies made the prospect of a fully implantable, electrically powered device more likely, just as the incidence of chronic heart disease in the West soared, and the number of organ donors failed to keep up.

84

Italian Carabinieri cordon off the area around a shot protestor at the G8 summit in Genoa.

The infamous riots at Seattle's G8 meeting in 1999 were thought to have set the standard for anti-globalization protest. Though most of the 100,000 protesters in Genoa two years later were peaceful, a small group was determined to wreak havoc, and their violent clashes with police drowned out the calls for the cancellation of Third World debt. During one particularly fierce stand-off, an Italian police vehicle became trapped by protesters; the Carabinieri fought back, and a 23-year-old Roman, Carlo Giuliani, was shot point-blank in the face. In a decision many regarded as controversial, no one was charged with the protester's death. Later, however, stories of police brutality emerged, calling into question the tactics used to protect the summit.

BANDARANAIKE INTERNATIONAL AIRPORT

85

Shot dead by Sri Lankan soldiers, this Tamil Tiger rebel was not to make use of his cyanide capsule.

In an audacious early morning attack, 14 members of the Tamil Tigers infiltrated the Sri Lanka Air Force base at Katunayake. After a gun battle in which they destroyed several aircraft, they moved on to the nearby Bandaranaike Airport. They destroyed or damaged a large portion of the Sri Lankan Airlines fleet, including several Airbus planes. All the guerrillas died in the assault, each with the Tigers' trademark vial of cyanide around their neck. Seven government military personnel were killed. The attack was timed to coincide with the 18th anniversary of the start of the Sri Lankan civil war.

86

Ahmad Shah Massoud was nicknamed 'Lion of Panjshir' for his prominent role resisting the Soviet occupation of Afghanistan in the 1980s. His birthplace, the Panjshir valley, was also the centre of his power. In the 1990s Massoud gained international renown as the charismatic and moderate leader of the United Islamic Front for the Salvation of Afghanistan (the Northern Alliance), a grouping of Afghan factions who fought against Taliban rule. He was a near-mythical figure in the war-ravaged country and a key ally of the United States. In a speech to the European Parliament in April 2001 Massoud described the links between the Taliban and Al Qaeda, warning that a major terrorist attack was imminent. On 9 September 2001 two men posing as Arab journalists sat down to interview him in Khwaja Bahauddin, Afghanistan. The bombers detonated their explosives, killing Massoud.

Ahmad Shah Massoud, leader of the Afghan resistance to the Taliban, is photographed here in Dasht-e-Qala, less than a year before he is assassinated.

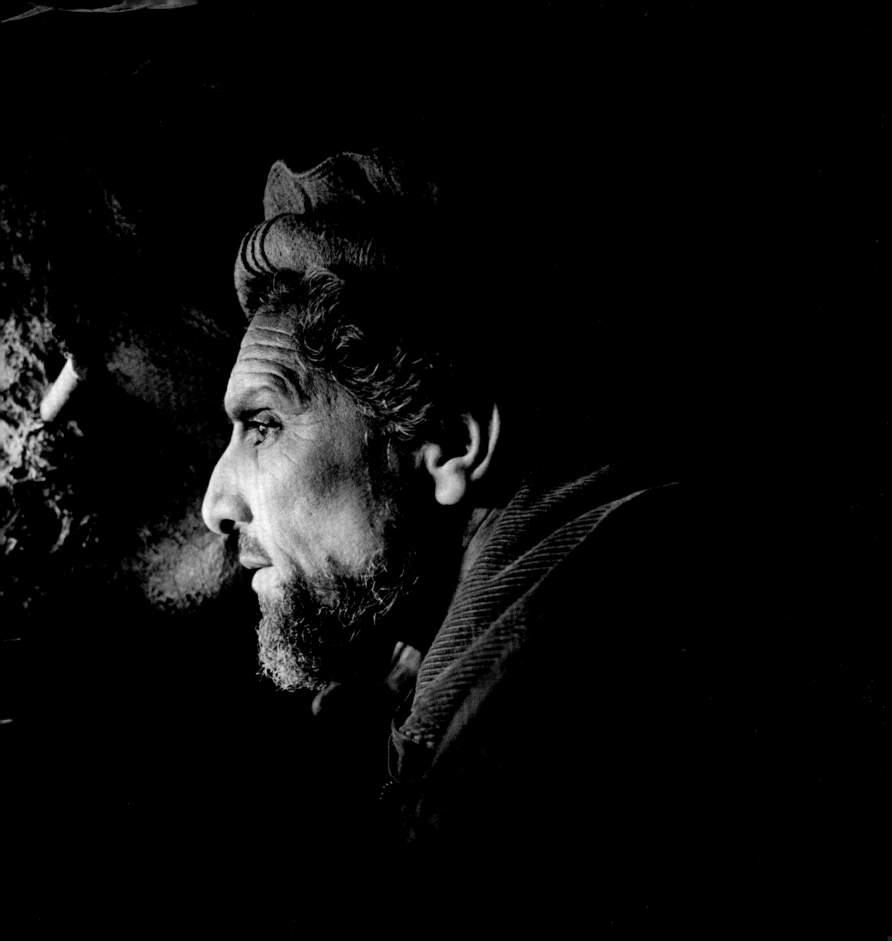

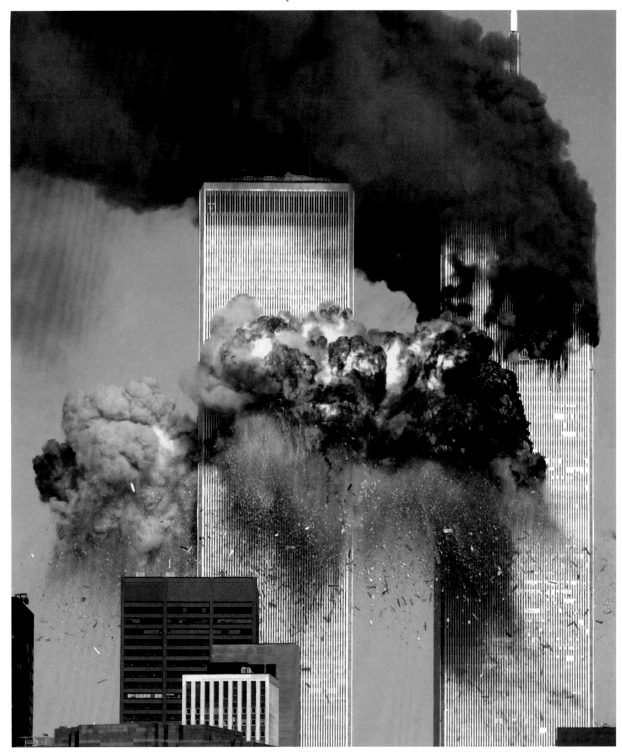

Captured live on television, the second plane disintegrates into a fireball as it strikes the South Tower of the World Trade Center.

On the morning of 11 September 2001, 19 terrorists hijacked four commercial passenger airliners over the eastern United States. They intentionally crashed two of the planes into the Twin Towers of the World Trade Center in New York City, killing everyone on board. Within two hours both buildings had collapsed. The hijackers crashed a third plane into the Pentagon in Washington, DC and the fourth came down in rural Pennsylvania, after some flight crew and passengers attempted to retake control of the craft. There were no survivors from any of the flights. In total nearly 3,000 people were killed.

Visiting an elementary school in Florida, President Bush is discreetly told of the 9/11 attacks, while reading *The Pet Goat*.

With the immediate threat of further attacks apparently diminished, US President George W. Bush returned to Washington, DC in the early evening of 11 September and gathered his most senior national security advisers in a bunker beneath the White House grounds. Intelligence was by now conclusive in suggesting that Osama bin Laden and his Al Qaeda network, based in Afghanistan, had carried out the worst attack on United States soil in the country's history. The Bush administration's response would be to 'punish whoever harbours terrorists, not just the perpetrators'.

90

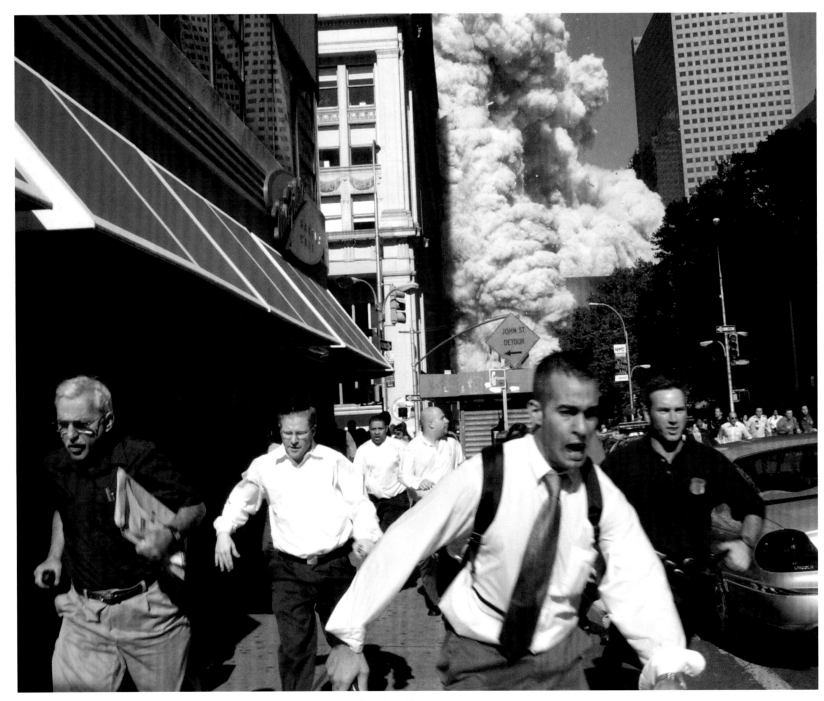

Terrified New Yorkers flee the colossal dust cloud following the collapse of the Twin Towers.

The significance of the terrorist attacks on New York and Washington, DC was such that the events were known around the world almost instantly as '9/11'. The overwhelming majority of casualties were employees who worked in the North and South Towers of the World Trade Center. Although most were American, victims included nationals of over 90 different countries. Within seconds of their collapse everything – computers, furniture, glass and building material – inside the towers was pulverized, sending a mountain of toxic dust swirling through the city's streets. More than a dozen other buildings adjacent to the towers were severely damaged or destroyed.

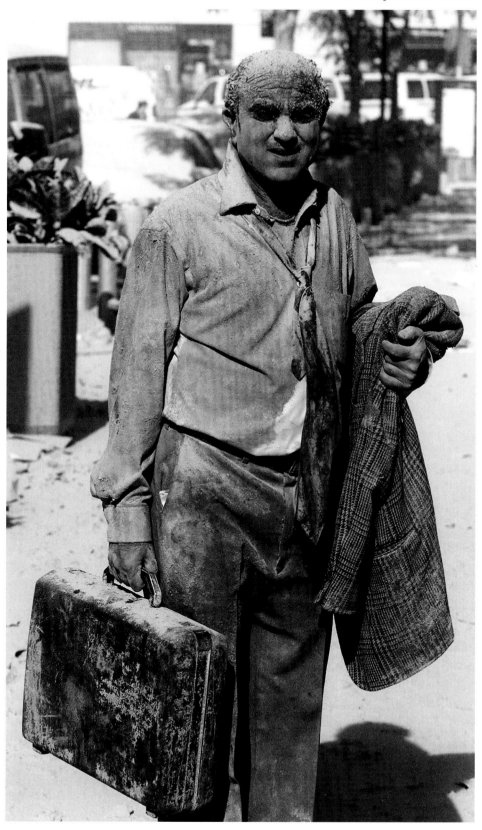

Filthy, but safe: this fortunate Manhattan worker has escaped the carnage of 9/11.

In the hours following the collapse of the Twin Towers, media reports suggested that tens of thousands may have perished. Later investigations revealed that at the time the first plane hit the North Tower, up to 19,000 were estimated to have been inside the World Trade Center complex. Remarkably, more than 99 per cent of the Towers' occupants who were below the levels of the planes' impacts were able to evacuate successfully. Countless lives were saved due to the calm and compassion demonstrated by co-workers as they walked to safety via the only means of escape, the stairwells. One paraplegic accountant owed his survival to colleagues who carried him down 69 flights of stairs to safety. However, survivors in and around the Towers were exposed to choking dust after the collapse of the buildings, with thousands developing asthma. Several deaths were later linked to toxins; the authorities decided to include those victims' names on the World Trade Center memorial.

91

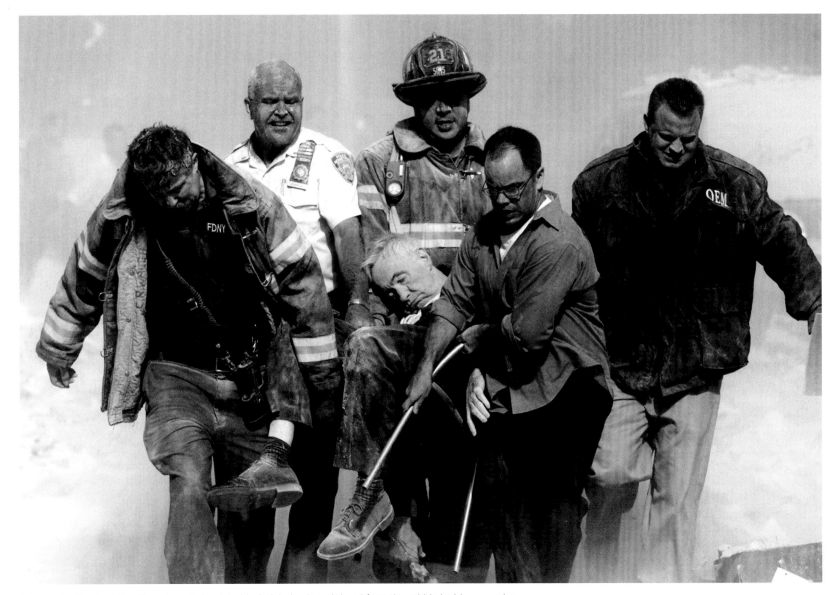

The crushed body of Fire Department chaplain Mychal Judge is reclaimed from the rubble by his comrades.

More than 400 emergency rescue workers who responded to the attacks on the Twin Towers lost their lives. The New York City Fire Department suffered the heaviest fatalities, with 341 firefighters and two paramedics lost. The prevalence of post-traumatic stress symptoms among rescue workers was to increase year on year. Nearly all had witnessed appalling scenes, including the final moments of some of the estimated 200 people who jumped to their deaths from the burning Towers. The Fire Department's chaplain, Mychal Judge, had rushed to the World Trade Center immediately after the planes struck and was met by the city's mayor, Rudolph Giuliani, who asked him to pray for the victims. Judge went inside the lobby of the North Tower to administer last rites to the wounded and dead. After removing his helmet to give last rites to a firefighter who had been struck by the falling body of a woman, Judge was killed by flying debris from the South Tower's collapse.

Letters containing anthrax spores were sent to NBC's Tom Brokaw and Senate Majority Leader Tom Daschle during the post-9/11 hysteria.

A US postal worker wears latex gloves and a surgical mask to protect against possible infection.

Exactly one week after the 11 September terrorist attacks, letters containing spores of anthrax, a potent biological toxin, were sent to news media offices in the United States. Two further letters were sent to Democrat senators on Capitol Hill, this time containing highly refined material, believed by many to be a weaponized form of the bacterium. Considered the most serious bioterrorism attack on American soil to date, a billion dollar programme was quickly announced to improve security measures and protect national infrastructure. The attack helped galvanize the government's counterterrorism efforts, with the controversial Patriot Act signed into law on 26 October, which expanded the definition of terrorism to justify enhanced surveillance and detention powers.

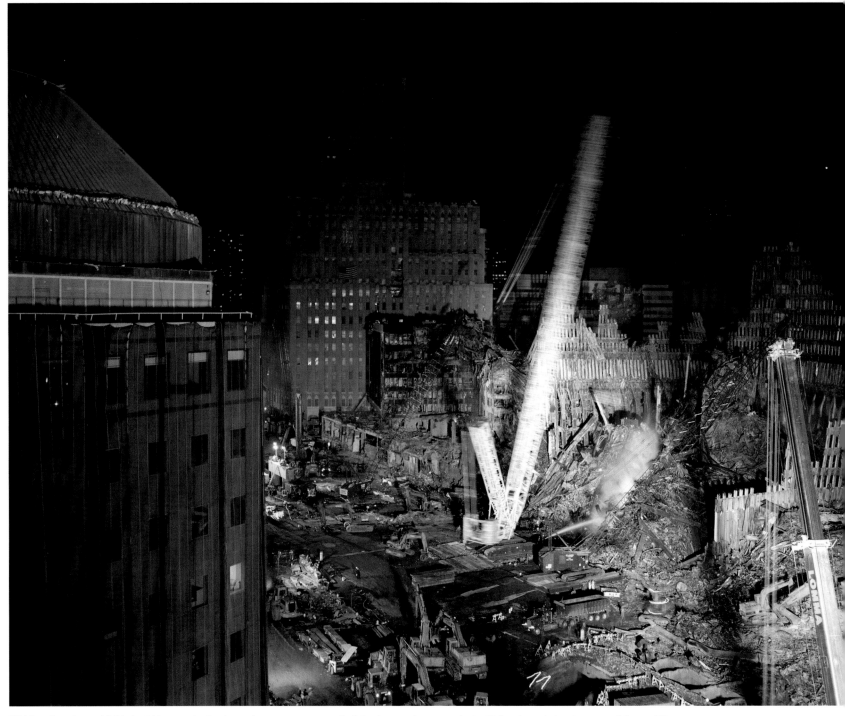

94

Within a few days of 9/11, Joel Meyerowitz begins a documentary record of the destruction wrought by Al Qaeda and the clean up of Ground Zero.

The transformation of Ground Zero was exclusively documented by photographer Joel Meyerowitz who, thanks to his foresight and sheer persistence, gained access to the World Trade Center site from September 2001 to June 2002. His 8,000 photographs offer a unique archival record of the 9/11 tragedy and its aftermath. Icons of New York's skyline since the 1970s, the Twin Towers had been part of the World Trade Center in downtown Manhattan. The terrorist attacks rendered the city's busy commercial district unrecognizable as the remains of the skyscrapers lay amid the debris. Five years after 9/11, although plans to replace the buildings themselves were mired in controversy, construction started on a monument to the lost, which will be inscribed with the victim's names.

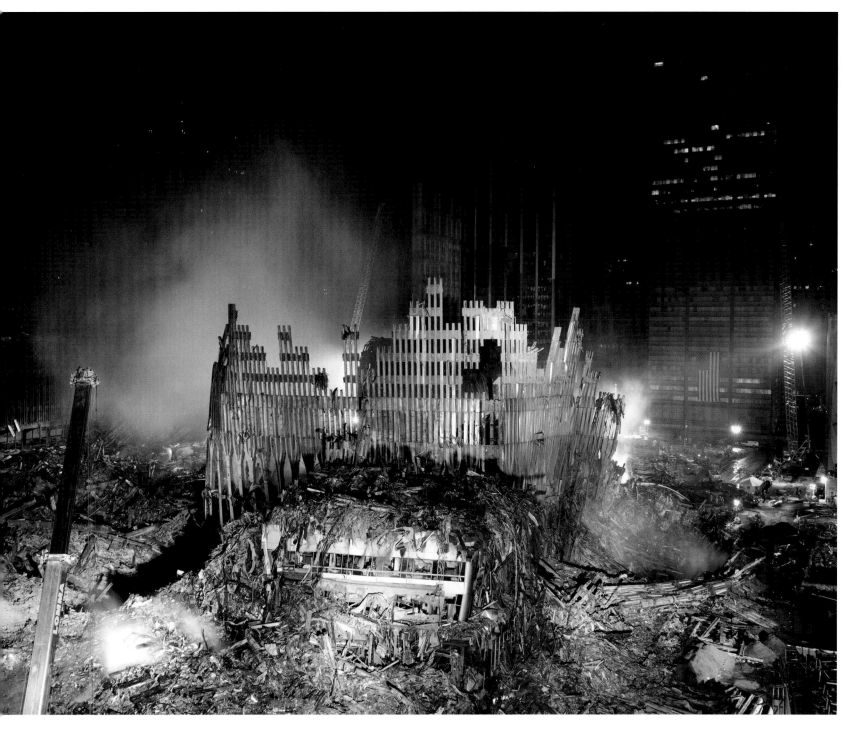

96

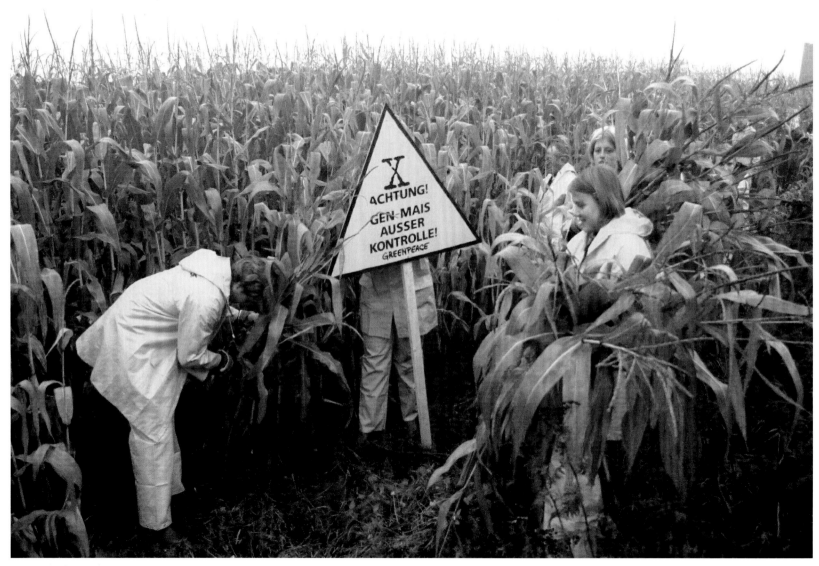

German Greenpeace activists harvest unauthorized genetically modified corn in Helvesiek, Lower Saxony. The same day, Friends of the Earth warns of cross-contamination from illegally planted GM crops.

High-profile actions by the environmental protection group Greenpeace helped fuel the international controversy over genetically modified (GM) crops and foods, which were first put on the market in the 1990s. Proponents of GM products, defined as such because of changes made to their DNA by genetic engineering, argued that genetic modification would result in healthier, more sustainably produced food, which could aid poor countries suffering acute food shortages. Anti-GM groups claimed that profit-driven multinational biotech companies were promoting GM technology with scant regard for ecological and public health considerations. Their message initially had greater resonance with European governments, who proved more resistant to the introduction of GM crops.

A revealing dress is adjusted backstage during the inaugural fashion show at the Teatro Armani in Milan.

To mark the opening of the new Teatro Armani in Milan, celebrated photographer Roger Hutchings documented its inaugural show, a stylish combination of fashion designer Giorgio Armani's sartorial elegance and architect Tadao Ando's sleek planes and exposed concrete. Designed as the new Armani headquarters, the renovated Nestlé warehouse was simple and versatile, with large airy spaces for catwalks, exhibitions and mass dining. Formerly at the *Observer*, Hutchings was noted for his incisive journalistic coverage of the fall of communism in East Germany and Czechoslovakia, before finding a new voice in fashion reportage. His four-year collaboration with Armani included the book *Armani Backstage* in 2002, the same year Hutchings was appointed chair of the prestigious World Press Photo jury.

97

British comic double-act Ant and Dec compère the opening night of 'Pop Idol', a televised singing contest that transformed the entertainment industry.

At the confluence of reality TV and social networking, the talent show was a highly successful television format that became a multimillion-pound industry in its own right. Beginning with 'Pop Idol' in the UK, these programmes offered ordinary people the chance to become a star – a singing contract and celebrity lifestyle were the promised prizes, though often humiliation was the price of getting there. Bright young hopefuls auditioned in front of music moguls, including the notoriously difficult-to-please Simon Cowell, and a live studio audience; the public then voted via telephone and text message. More dreams were shattered than realized, but 'Pop Idol' spawned an international franchise with spin-offs in America and Europe, and as far afield as Kazakhstan and Vietnam.

98

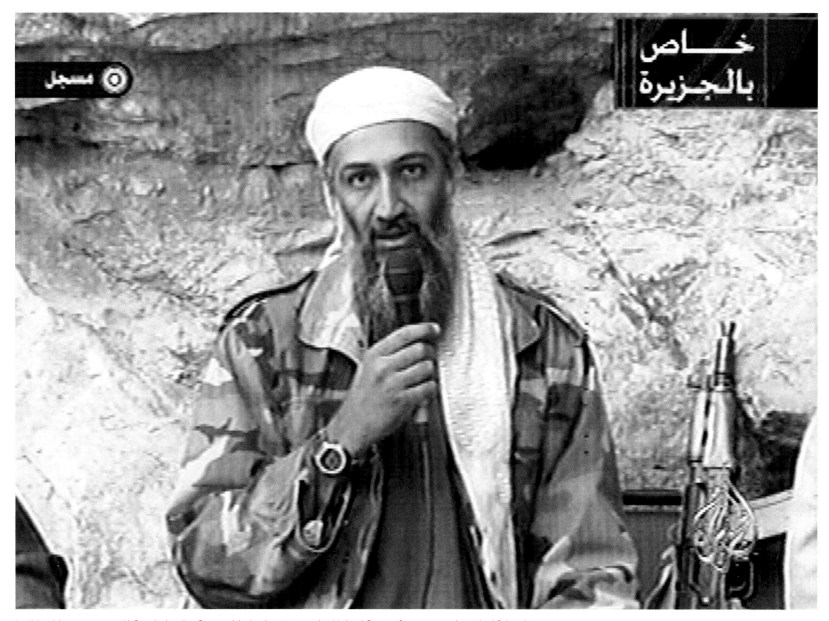

In this video message, Al Qaeda leader Osama bin Laden taunts the United States from somewhere in Afghanistan.

Within hours of the start of the US-led military operation against Afghanistan on 7 October, the Arabic TV news network Al Jazeera broadcast a statement by Osama bin Laden, who was believed to have ordered the 9/11 terrorist attacks. Turning against his former ally, the United States, which had backed his campaign to evict the Soviets from Afghanistan in the 1980s, he formed Al Qaeda in 1988 to consolidate his international network of Muslim fighters. Its aim was to foment Islamic revolutions throughout the Muslim world and expel 'infidel armies' (mainly American and Israeli) from the Middle East. He became the world's most wanted terrorist in the 1990s after orchestrating a series of attacks against US interests, from Sudan and later from his base in Afghanistan, where he allied himself with the ruling Taliban. In his 7 October statement, likely recorded a day or two earlier, he thanked God for the attacks on the US and warned of more to come.

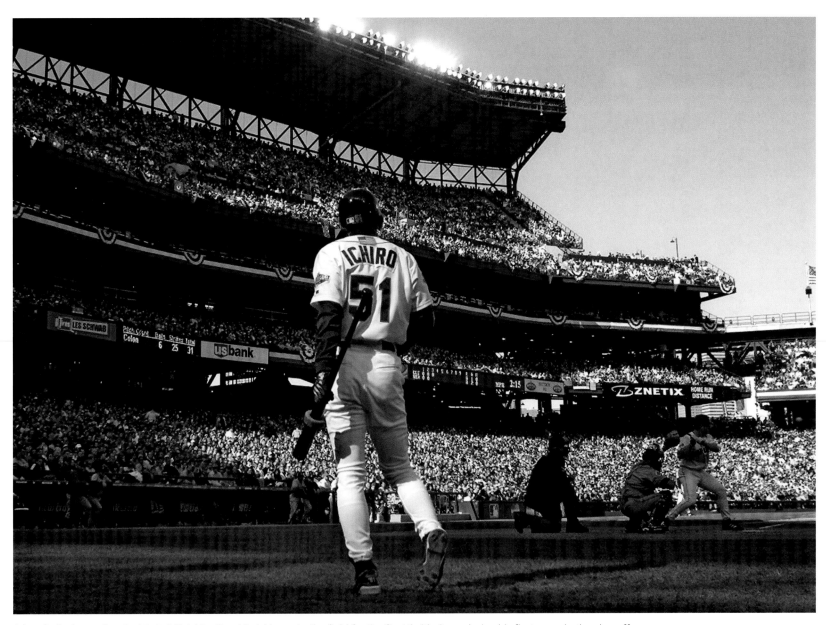

A baseball player of undoubted skill, Ichiro Suzuki strides onto the field for the Seattle Mariners during his first game in the play-offs.

99

In 2001 Japanese baseball star Ichiro Suzuki exploded onto the US professional sports scene. In his first season with the Seattle Mariners he led the American League with a .350 batting average, scored more hits (242) than anyone since 1930 and won Rookie of the Year and Most Valuable Player honours. The diminutive 27-year-old, known simply as 'Ichiro', made his name in the sport after nine sensational years with the Orix Blue Wave in Japan's Pacific League. The Mariners' outfielder instantly drew support from legions of US baseball fans with his speed, batting prowess and laser-like throwing accuracy.

100

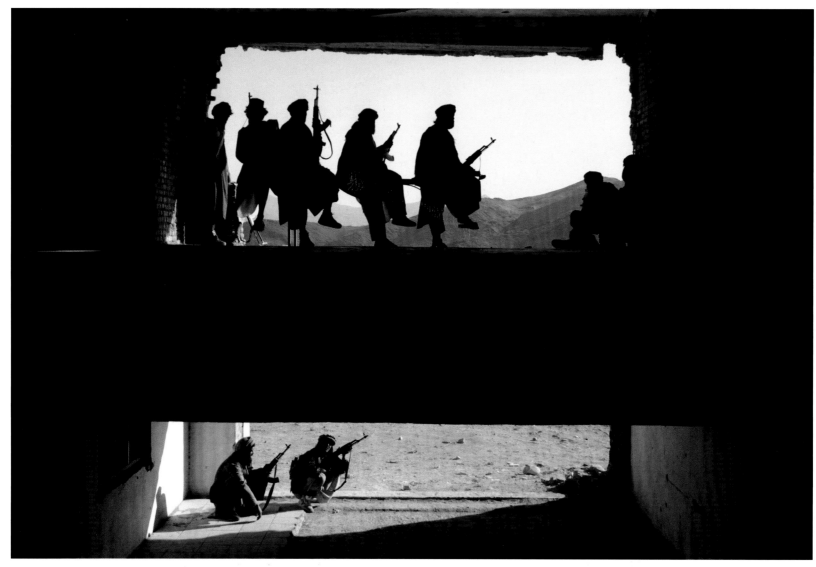

The profiles of Afghan mujahideen are silhouetted near the front line in Kapisa province, northern Afghanistan.

The air strikes on the Afghan cities of Kandahar, Jalalabad and Kabul on 7 October 2001 marked the start of Operation Enduring Freedom, the US-led military response to the 9/11 attacks. The declared aims of the operation were to find Osama bin Laden and other senior Al Qaeda leaders, destroy the terrorist organization and topple the Taliban regime which provided Al Qaeda with a safe haven. Within weeks, Taliban positions across the country collapsed under relentless aerial bombardment and combined assaults by mainly US special forces and mujahideen fighters of the anti-Taliban Northern Alliance. On the night of 12 November, Taliban forces fled Kabul, enabling the Northern Alliance to retake Afghanistan's shattered capital, which they had lost to the Taliban in 1996.

Racing legend Michael Schumacher pictured during his title-winning 2001 season with Ferrari.

In Formula 1 racing, the decade belonged to Michael Schumacher, with five consecutive titles from 2000 onwards. His skilful technique and relentless style drove him to victory in the 2001 championship, with an all-time record margin of 58 points over the next best driver. Crowned champion at the Japanese Grand Prix on 14 October, he had mathematically won the title at the Hungarian Grand Prix in August. Schumacher's dominance over the period was total. When he retired in 2006 the German was statistically the greatest Formula 1 driver ever, holding seven championships and 91 Grand Prix wins. His brilliance was best displayed in his final race in Brazil. Despite falling into last place because of a puncture on lap nine, he daringly battled his way up the crowded track to finish fourth.

Ubiquitous white iPod earphone cables become a trendy barometer of Apple's newfound success.

102

On 23 October 2001 the American electronics and software giant Apple announced the release of its first portable music player, the iPod. Earlier hard-disk digital music players had complicated user interfaces and typically were large and clunky. The first iPod was smaller, with a 5-GB hard drive capable of storing 1,000 songs and easy-to-use navigation. Initially, critics rounded on Apple and its larger-than-life CEO Steve Jobs for the iPod's lack of Windows compatibility, unorthodox scroll wheel and hefty price tag – $400. Consumers disagreed. Sales of the iPod skyrocketed and before long it revolutionized the music business.

Outside Enron's Houston headquarters, the day after the company filed for bankruptcy, disconsolate employees consider their futures.

The collapse of the Texan energy company Enron was the biggest bankruptcy in US history. Led by Kenneth Lay, its executives created a system of falsification over the years that fraudulently disguised the loss of billions of dollars. A prestigious auditing firm, Arthur Andersen, was also implicated in this elaborate system of deceit, and dissolved in the wake of the crisis. Even some politicians and journalists came under the sway of the rotten firm and the cash it spent lobbying and buying favours. In December 2001 the inevitable collapse came. Twenty thousand employees lost their jobs. More damage was done to shareholders, who saw $74 billion vanish from their holdings.

In Waco, Texas, aid workers Heather Mercer (left) and Dayna Curry (right) praise Jesus following their release from the Taliban.

In August 2001, 24 aid workers were arrested in Afghanistan and charged with preaching Christianity, an imprisonable offence under the Taliban regime. Family and friends of those taken had little information to go on, though news leaked out of the harsh penalties being considered by the senior clerics in judgement. The 9/11 terrorist attacks halted legal proceedings and the Westerners were moved from Kabul to Kandahar as fears of retaliation from the United States grew. Northern Alliance fighters freed all the detainees in November. However, the situation for other foreign aid workers became increasingly precarious as the country descended again into conflict and chaos.

104

Shown here at London's Tate Britain, Martin Creed's work sets off artistic controversy – and not for the first time.

105

The 2001 Turner Prize (a contemporary art award) was won by Martin Creed, a British artist whose work with recycled materials and found objects suggests a refreshing anti-materialism. The controversial £20,000 art prize was presented by 'material girl' Madonna at a ceremony in London. Some had considered Creed's *Work No. 227: The Lights Going On and Off* – an empty room that was illuminated and darkened at five-second intervals – a comment on mortality; others dismissed it as absurd, and the installation was vandalized in protest. Creed's earlier work includes a crumpled piece of paper and Blu-Tack adhesive affixed to a wall – provocative art that is nevertheless wittily subversive, making Creed one of the most talked-about artists of his generation.

106

Possessing little but each other, these Afghan refugees, whose home was destroyed by the Taliban, find rudimentary shelter in Bamiyan's caves.

Decades of civil war created a devastating humanitarian emergency in Afghanistan. At the start of 2001, 2 million Afghan refugees were camped in Pakistan, with another 1.4 million in Iran. Those who had stayed suffered a massive crop failure that year, bringing them perilously close to starvation. Food aid that did arrive faced seizure by bandits and the Taliban. The UN estimated that 5 million people were dependent on these foreign supplies. The fierce Afghan winter heaped more misery on the population. Temperatures around Herat plunged to 25 degrees below zero and 500 people in refugee camps froze to death – the squalid camps were short of blankets and tents. Countless others sought shelter in the caves of the Hindu Kush, but their fate would be unknown.

Argentine mounted police flee angry rioters under the shadow of El Obelisco in Buenos Aires.

Argentina's economic history has been one of promising growth punctuated by severe recessions. The crisis of 2001 was one such example. Years of poor economic performance had led to an increasing government spending deficit. President Fernando de la Rúa attempted to fix the problem by slashing the budget. This was wildly unpopular. In December, while Argentina panicked international investors by effectively admitting it could not pay its foreign debts, domestic anger erupted into riots as confidence in the economy collapsed. Unemployment reached 18.3 per cent and unions called a general strike. Riots saw violent clashes between protestors and the police. Several people were killed and, on 20 December, de la Rúa's government resigned.

108

Hamid Karzai prays to Allah at his swearing-in ceremony in Kabul, Afghanistan.

Hamid Karzai, a 44-year-old Pashtun tribal leader, was sworn in on 22 December 2001 to head Afghanistan's interim government after the fall of the Taliban regime. A member of the powerful Popalzai clan (from which many Afghan kings originated), Karzai had spent much of his life fighting what he described as 'foreign influences' in Afghanistan. He initially supported the Taliban in the early 1990s but turned against its increasingly brutal leadership, believing it was controlled by neighbouring Pakistan's intelligence service. Forced to flee Afghanistan in 1996, Karzai worked with US officials to help overthrow the Taliban in the weeks following 11 September and eventually slipped back into the country to muster support for a new government. In early December the urbane and articulate Karzai was named interim leader at an international conference for exiled Afghan leaders in Bonn, Germany.

When passengers aboard Flight 63 from Paris to Miami smelled smoke, cabin crew were alerted to Richard Reid's suspicious behaviour. A British citizen, he was attempting to light a fuse connected to explosives concealed in his shoe, but was overpowered by other travellers using seat belts and headphone cords. His intention had been to blow up the plane in a 9/11 follow-up attack inspired by Al Qaeda. Reid had converted to Islam while at the notorious Young Offenders Institution at Feltham, just outside London, and allegedly travelled to Pakistan where he became a self-declared enemy of the United States. The so-called 'shoe bomber', who pleaded guilty to terrorism charges, was sentenced to life imprisonment. His legacy was more stringent security measures at airports, where passengers were forced to remove their shoes at checkpoints.

109

Having been overpowered by other passengers aboard his flight, 'shoe bomber' Richard Reid is held in custody.

2002
Belief

The fires that had burned in New York beneath the World Trade Center site since 9/11 were finally extinguished at the dawn of 2002. But the flames of terror continued to smoulder in many parts of the world. Bomb-laden Chechen militants stormed a packed theatre in Moscow and threatened to kill everyone inside. The death of more than a hundred hostages in the rescue operation that followed did not dent the reputation of the man who ordered it – President Vladimir Putin – a clear sign that Russians supported tough action to defeat terrorists. No more unlikely scene of terror could be imagined than the paradisiacal island of Bali, yet it too was rocked by atrocities committed by an Islamist group with links to Al Qaeda. On another island, Cuba, alleged Al Qaeda members captured by US forces in Afghanistan began to arrive at a detention facility in Guantánamo Bay. In January, President Bush declared the existence of an 'axis of evil' and set the United States on a course for war in Iraq. Britain remained steadfast behind Washington in demanding that Saddam Hussein give up his reputed weapons of mass destruction. France, Germany and Russia advocated diplomacy. The United Nations wanted more time. The principal villain of the Balkan wars of the previous decade, Slobodan Milosevic, went on trial in The Hague, Netherlands. The former president of Yugoslavia chose to represent himself, which protracted the process for years. Just as he sought to drag Europe back to its violent past, much of the rest of the continent was moving towards greater unity. The euro was introduced as legal tender in 12 European Union member states, known as the Eurozone, giving birth to a new continental currency for over 300 million people. The economic news was less encouraging in the United States, still reeling from the financial losses incurred due to 9/11. Millions of shareholders saw their investments swallowed up by accounting frauds at Enron and WorldCom, former giants of the stock market. Meanwhile, Asia played host to football's World Cup for the first time. Co-hosts Japan and South Korea shocked many of the traditional contenders en route to the knockout stages. But the sport's greatest side, Brazil, secured their fifth trophy in typically flamboyant style. In the world of art and culture, one of Hollywood's last racial barriers fell when Halle Berry became the first African-American woman to win the Best Actress Oscar, for her electrifying performance as a death-row widow. US television saw the premiere of 'The Wire', a gritty low-budget drama based on the experiences of a former homicide detective in Baltimore. The programme garnered little commercial success and no awards, but within a few years it was to be hailed by critics as the greatest television series of all time. Before 2002 the Larsen ice shelf in Antarctica was known to polar scientists but few others. That changed when a large chunk of it collapsed at the beginning of the year after it had seemingly remained stable for 10,000 years. Most blamed human-induced global warming.

112

Change arrives – Europeans wake up to a new single currency, the euro.

On New Year's Day 2002, 300 million people in 12 countries adopted a new single European currency. It was the culmination of a long process that started with the 1992 Maastricht Treaty and involved the managed convergence of a dozen very different economies. The currency itself entered into use in 1999, but it was another few years before the coins (37 billion) and notes (6 billion) were introduced. A few mourned the passing of the old currencies and, with it, the loss of something of their national identity. Others grumbled that, in the conversion, shops and businesses had taken the opportunity to round up all their prices.

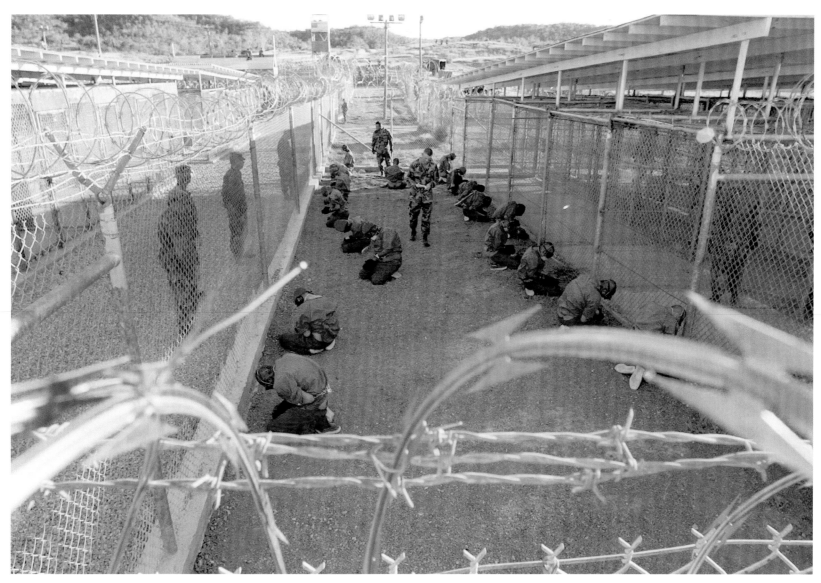

New inmates at Camp X-Ray are subjected to the first of many humiliations.

113

The US naval base at Guantánamo Bay, on the southeast coast of Cuba, gained worldwide infamy in the aftermath of the invasion of Afghanistan. In 2002 the Bush administration made Guantánamo the central detention facility for captured Al Qaeda suspects. It comprised three main areas: Camps Delta, Iguana and X-Ray. Deemed 'unlawful enemy combatants' in Bush's War on Terror, the detainees were denied the prisoner-of-war rights guaranteed by the Geneva Convention. Subjected to demeaning treatment and harsh interrogation methods, a number of prisoners committed suicide and hunger strikes became commonplace. The techniques used on detainees were widely condemned, internationally and also within the United States.

114

Yves Saint Laurent lunches in his opulent Rue de Babylone apartment, the day before his final haute couture show.

His final show in Paris on 22 January, received with grand applause, left no one guessing who was the master couturier: Yves Saint Laurent had once again wowed the fashion set after 40 years in the business. His retrospective collection showcased his most famous designs: the safari jacket, the trapeze dress, the trouser suit and, of course, 'le smoking'. He was the self-appointed creator of the contemporary woman's wardrobe, championing the changing tides of female empowerment throughout the 1950s and swinging 60s. Saint Laurent died in 2008, at the age of 71, leaving an imaginative and inspiring legacy.

115

Days before what would be a defining speech of his presidency, George W. Bush reads through his State of the Union address.

On his election in 2000, few imagined George W. Bush would be a president much interested in foreign policy. Many outside the United States feared he would usher in a new era of US isolationism – until the shock of the 9/11 terrorist attacks. A taste of what was to come was given in the January 2002 State of the Union address. While the country was still reeling from the September 11 atrocities, Bush accused Iraq, Iran and North Korea of sponsoring international terrorism, oppressing their own people and developing nuclear and chemical weapons. He boldly declared to the nation that this 'axis of evil' threatened the 'peace of the world'.

116

Photographs of kidnapped American Daniel Pearl circulated worldwide days before his beheading.

South Asia bureau chief for the *Wall Street Journal*, Daniel Pearl was working in Karachi when he was abducted on 23 January 2002. His captors were a group calling themselves 'The National Movement for the Restoration of Pakistani Sovereignty'. They issued various demands to the US government via e-mail, attaching photos of Pearl in captivity. Within days he was murdered, but it was not until the middle of May that his body was found buried, cut into pieces, on the outskirts of the city where he had been kidnapped. A grisly video of his execution, including his beheading, emerged on the internet. The Pakistani authorities traced the video to the perpetrators, who were caught and sentenced to death.

118

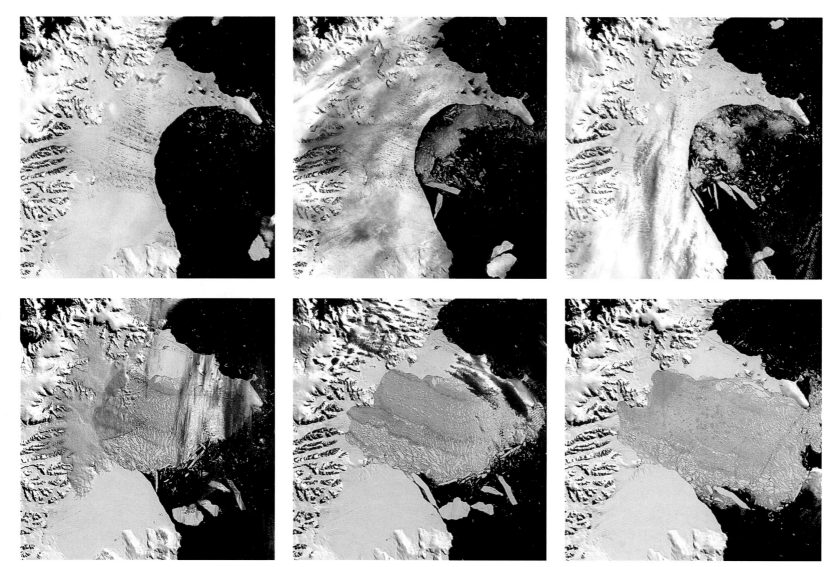

The staggeringly rapid disintegration of a 500 billion tonne ice sheet in Antarctica.

The Larsen B ice shelf on the Antarctic Peninsula disintegrated within a matter of weeks. The 12,000-year-old plate of ice had floated atop the ocean, plugging glacier flow into the waters. During the start of 2002, ponds of meltwater on its surface leaked into crevices and fissures, prising open the 3,250 square kilometre (1,250 square mile) sheet; meanwhile, warm water currents ate away at its base, implicating the hand of global warming. The phenomenal collapse of the ice sheet led scientists to turn their attention to other ice shelves in the region, in particular the Ross ice shelf, a monolith the size of France, whose collapse would have serious ramifications for seawater levels.

A thick sulphurous haze suffocates Beijing, China's capital city: the price of economic development.

China, a signatory of the Kyoto Protocol, is the world's second-largest producer of greenhouse gas emissions. Despite committed efforts to improve China's air quality – including spending over half a billion yuan on clean-up initiatives – 16 of the world's 20 most polluted cities are located in the rising economic nation. In Beijing, the smog is a daily hazard, caused by the low-grade petrol emitted from millions of cars and the coal particulates belched out by power plants, mines and small factories around the city. Peking University blamed air pollution for roughly 25,000 premature deaths in Beijing in 2002; other researchers list bronchitis, pulmonary fibrosis, tuberculosis and lung cancer as the costs of China's unfettered industrial growth.

Although deposed Serbian leader Slobodan Milosevic was handed over to the International Criminal Tribunal in The Hague in 2001, and indicted for crimes against humanity in Croatia, Bosnia and Kosovo, his trial did not begin until February 2002. Victims of the Yugoslav Wars, many of whom held him responsible for the ethnically motivated bloodshed, prayed for justice. Across the region, people followed the process closely. But Milosevic proved a master of his game. Refusing legal representation (he rejected the jurisdiction of the court), he turned the dock into a podium from which he railed against the proceedings and frustrated the judges with endless delaying tactics. The showpiece trial of international justice had become an expensive farce.

As the midnight train sped south from Cairo, many on board were looking forward to celebrating Eid al-Adha with their families. The carriages were packed to the rafters, with people sitting on the floor and squeezed into luggage racks. Early in the morning, a small fire from a portable gas stove spread out of control as open windows fanned the flames. Passengers were unable to break free in the cramped conditions, and charred human remains were found curled under seats. Some, desperate to escape, had leapt off the moving train, plunging down the banks. In all, over 370 people lost their lives.

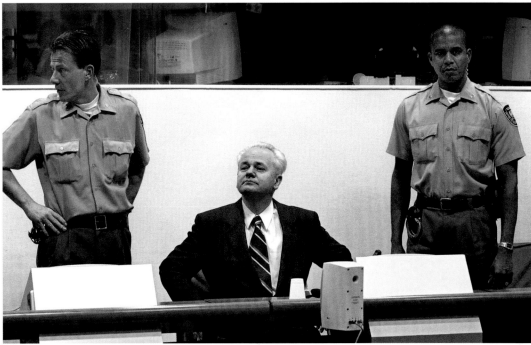

Defiant to the last: former president Slobodan Milosevic in the dock at The Hague, the Netherlands.

Unable to escape, hundreds of Egyptians died when an overcrowded train caught fire.

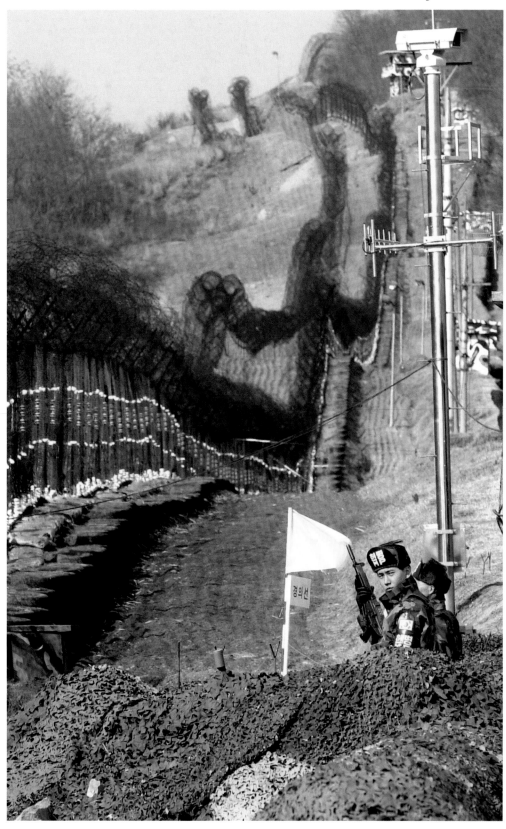

Along the world's most heavily fortified border, troops in the Korean Demilitarized Zone have been primed for conflict since the 1950s. As US President George W. Bush peered into North Korea for the first time on a visit to the DMZ, the country he had labelled part of an 'axis of evil' run by a 'pygmy' returned an icy stare. His rhetorical flippancy had serious repercussions: North Korean media agencies decried Bush as a 'moral leper'; while in South Korea there were concerns that its neighbour could be about to retreat down the path of isolationism. Protests were held in central Seoul denouncing the hard line taken by the United States towards North Korea, amid fears that Bush's East Asian junket would bring war to the Korean Peninsula.

121

South Korean troops remain vigilant on duty at the border with their reclusive neighbour.

At the Kodak Theatre in Hollywood, Los Angeles, Halle Berry sobs as she accepts her Oscar for Best Actress.

The 74th Academy Awards made history, as three of its coveted golden statuettes went to African-American actors: Sidney Poitier, Denzel Washington and Halle Berry, the latter the first black woman to win the Best Actress award. Berry was overcome, making an emotional tribute to other black actresses and 'the nameless, faceless women of colour' for whom her award had opened the door to recognition. The former Miss Teen All-American had previously won critical acclaim for her television portrayal of Dorothy Dandridge, the first African-American to be nominated for a Best Actress Academy Award. Berry received her Oscar for the role of Leticia Musgrove in *Monster's Ball*, Marc Forster's tale of racism, betrayal and sex in the American South.

Brian Warner, aka Marilyn Manson, is no stranger to controversy. The Ohio-born musician, notorious for his provocative lyrics and interrogation of Christian and conservative mores, cut an unconventional figure throughout the decade in his gothic clothing and distinctive pale contact lens. He enjoyed considerable artistic success, winning a cult following with his albums *Antichrist Superstar* and *Mechanical Animals*. In April 2002 he was sued by the mother of a friend, Jennifer Syme, who had died at the wheel of her car the previous year, after having consumed 'various quantities of an illegal controlled substance' at Manson's home. Manson denied culpability.

123

Goth rocker Marilyn Manson attends a film premiere during another controversial year.

Queen Elizabeth The Queen Mother lies in state as her grandsons stand vigil on the eve of her funeral.

124

As the tenor bell of Westminster Abbey tolled 101 times, Queen Elizabeth The Queen Mother was laid to rest by the British nation on 9 April, after lying in state for three days. Her passing was mourned by many, young and old: those who remembered her stalwart courage in the face of the Blitz, and others who bore witness to her tireless patronage of good causes. She was immensely popular, revered for her uprightness and dedication to public life in the face of war, bereavement, scandal and change; and also her love of gin and horse-racing. The ceremonial funeral, attended by lords and ladies, royalty and heads of state, was a fitting reminder of a woman who commanded respect across the country.

Caracas descends into chaos as coup and counter-coup threaten Venezuela's political balance.

125

Venezuela, a country riven by class division and widespread poverty, faced political turmoil in 2002. The government of Hugo Chávez was not universally popular, with many members of the middle and upper classes disagreeing with his policies. Against the backdrop of striking oil workers and street protests, a military coup was launched on 11 April after 13 demonstrators were killed in the riots. The plotters installed Pedro Carmona, a prominent businessman, and detained Chávez. However, Carmona was unseated two days later after units loyal to Chávez took the presidential palace. Although the restored president pledged to unite the public and rework his failing policies, Venezuela remained a divided country.

126

Afghanistan's past and future meet as the interim leader Hamid Karzai (centre) welcomes the country's former king (left).

On 18 April the former king of Afghanistan set foot on home soil for the first time in almost three decades. Mohammed Zahir Shah had been exiled by his cousin in 1973, formally abdicating his throne that year. He returned in 2002 to take part in a historic grand assembly of tribal elders and leaders – the Loya Jirga – that was to consider Afghanistan's future. Many elders supported the former king as their new ruler, but US-backed interim leader Hamid Karzai emerged as president. Zahir's reign had not been forgotten, however. His rule had been marked by peace, even democratic reforms, and so the Loya Jirga granted him the ceremonial title 'Father of the Nation'. Zahir died in Kabul on 23 July 2007.

Life begins to return to normal in Angola, though the scars of war remain.

Angola's 27-year civil war cost the lives of more than half a million people, shattered the country's infrastructure and scarred its territory with countless unexploded land mines. The Luena Memorandum of Understanding, signed on 4 April 2002, formally brought the last proxy conflict of the Cold War to a close, six weeks after the guerrilla leader Jonas Savimbi was killed by Angolan government forces. Although thousands of people took to the streets of the nation's capital to celebrate the end of hostilities, Angola faced a famine. At least 1.5 million people in the resource-rich country were suffering from severe starvation, a result of years of ruthless exploitation and forced removals from farmlands by both government and rebels.

Early results confirm Jacques Chirac's resounding victory over Jean-Marie Le Pen in the French presidential runoff.

After a brief scare in April, incumbent President Jacques Chirac crushed far-right candidate Jean-Marie Le Pen in the second-round presidential election, with a massive 82 per cent of the vote. Even communist leaders called for their supporters to back Chirac to prevent the National Front from winning. But more fundamental changes were afoot. The Fifth Republic's tradition of 'cohabitation' – voters choosing a president from one party, while filling the legislature with another – disappeared. Chirac's triumph over Le Pen was followed up in June with a landslide in the legislative elections for his electoral umbrella organization, the Union for a Presidential Majority, who won the biggest majority in the National Assembly for 34 years.

Relief and jubilation greet the results of Sierra Leone's first democratic election after a decade-long civil war.

Sierra Leone emerged from a decade of civil war in 2002 with the help of Britain, the former colonial power, and a UN peacekeeping force. Some 18,000 UN troops would be on the ground in Sierra Leone until December 2005 at a cost of $2.3 billion. Much would be achieved over this time, including the restoration of peace and security to the country and the rehabilitation of former combatants, including thousands of child soldiers. Yet Sierra Leone's economic recovery from years of devastating conflict would be painfully slow, despite a massive influx of foreign aid and other development assistance, principally from Britain. Six years after the guns fell silent, the United Nations Human Development Index would rate Sierra Leone as the poorest country in the world.

The president of the world's newest nation, Xanana Gusmão, stands proudly amid his cabinet in Dili, the capital of East Timor.

Twenty-five years of occupation finally ended as the Indonesian government recognized the results of the 1999 plebiscite on East Timor's future. Over 75 per cent of registered voters had rejected proposals for limited autonomy within Indonesia, thus beginning the process of transition towards independence. On 20 May 2002, East Timor became the first new sovereign state of the twenty-first century, following the creation of its own constitution, parliament and presidency. The transformation of the small island's fortunes, following Portuguese colonization and Indonesian arrogation, was a huge success for the United Nations, whose diplomatic and peacekeeping functions had been critical to securing peace for the East Timorese.

Raw and gritty, 'The Wire' won a legion of fans with its exposé of crime, corruption and destitution in urban America.

131

'The Wire' débuted on American television screens on 2 June with little fanfare and no famous names on the cast list. Created by David Simon, a former reporter in the city of Baltimore, the first season focused on attempts by the city's police force to infiltrate a drug gang. It failed to garner commercial or critical success, but as the seasons progressed 'The Wire' attracted an intensely loyal audience, rapt by a precision, unpredictability and moral ambiguity no other TV series could match. By the end of its fifth and final season in 2008, it was widely hailed as a masterpiece and perhaps the greatest series in US television history.

132

Sri Lanka's greatest cricketer displays his trademark loose-limbed delivery while warming up for the Third Test at Old Trafford, Manchester.

Brazil's victorious footballers hold the World Cup trophy aloft for a record-breaking fifth time.

Sri Lankan spin bowler Muttiah Muralitharan has a highly unorthodox, experimental style and consistently torments batsmen with his disguised, unpredictable deliveries. He was named the best bowler in history by the authoritative *Wisden Cricketers' Almanack* in 2002. On 15 January 2002 in Harare, he became the fastest and youngest player ever to take 400 wickets in international Test matches. His hard work, enthusiasm and skill were coupled with a genetic defect – his arm could flex in an unusual way. This unique action attracted controversy, as to the eye of an umpire it could look like he was throwing the ball, illegal in the laws of cricket. Comprehensive medical examination, however, cleared his name.

An impressive Brazilian football team beat Germany 2-0 in the 2002 World Cup final, watched by 69,000 spectators in Yokohama. This was their fifth triumph in the competition, and retribution for their dismal showing against France in the 1998 final. Star forward Ronaldo was rampant for Brazil, scoring two goals and winning the Golden Boot award for being the tournament's top scorer. Ironically, it was the highly rated German keeper, Oliver Kahn, whose blunder let Brazil score first. The 2002 World Cup was the first held in Asia, and enthusiastically hosted by Japan and South Korea, although marred by a series of refereeing errors.

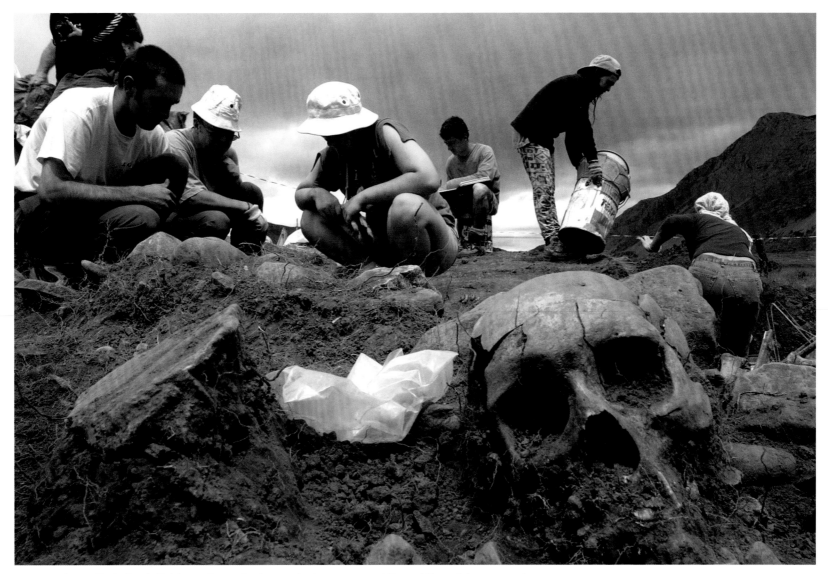

An excavation at Piedrafita de Babia, northwest Spain, reveals the remnants of General Franco's lost generation.

133

For over 60 years, speaking of the brutal execution of a generation of young men had been Spain's last taboo. Under General Franco's dictatorship, thousands of Republicans were shot, many having surrendered before being taken out for 'a walk', then unceremoniously dumped in ditches or left by the roadside. The unmarked graves had been secretly commemorated by widows and offspring, until relatives and civic groups – empowered by the passage of time – began to reveal the past. In July 2002 the Association for the Recovery of Historical Memory uncovered a mass burial at Piedrafita de Babia in northwest Spain. They hoped that its discovery would reveal further sites as more people, no longer terrorized into silence, came forward.

Derided as the Dictators' Club, the Organization of African Unity (OAU) had long been hampered by chronic functional weaknesses: although committed to human rights, it was unable to intervene where serious violations occurred – contrary to its principle of solidarity, many of its members had opposing interests or loyalties. At the start of the new millennium, African leaders signed the African Union constitution in Lomé, Togo, officially launching the OAU's successor in Durban, South Africa, in July 2002. The African Union was conceived by Libyan leader Colonel Muammar Gaddafi, who sought to emulate the European Union. Comprising 53 African nations, the new body was committed to pan-African democracy and security, becoming the only supranational organization to explicitly recognize the right to intervene on humanitarian grounds.

134

The faces of a new united Africa: the launch of the African Union is celebrated in Durban.

Aishwarya Rai, former Miss World, plays pure-of-heart Paro in Bollywood blockbuster *Devdas*.

Devdas, a reintepretation of Sarat Chandra Chattopadhyay's novella, is an Indian tale of impossible love. The most expensive Bollywood production to date, Sanjay Leela Bhansali's opulent film was highly stylized and included sensational song-and-dance numbers. Shahrukh Khan plays Devdas, a rich young man who returns from England to his childhood sweetheart, Paro (Aishwarya Rai), who has kept a candle burning in his memory. Their hopes to marry are dashed by the intransigent caste system. Devastated, Devdas finds solace in alcohol and the arms of a local prostitute. The simply drawn characters and modest plot belie an exploration of complex social mores, and the award-winning film won over an international audience.

136

Paper lanterns on the Motoyasu River, Hiroshima, commemorate the victims of the world's first atomic bomb.

The radioactive fallout of 'Little Boy', the U-235 atomic bomb dropped on Hiroshima on 6 August 1945, was permanently seared onto Japan's historical memory. About a third of the city's population died in the blast, while tens of thousands of *hibakusha* (explosion-affected people) suffered sickening after-effects. Every year, a remembrance ceremony at the Peace Memorial Park commemorates the devastation and loss that accompanied the end of war in the Pacific. As the only nation to have experienced the sharp end of nuclear warfare, Japan committed itself to non-proliferation, adopting the Three Non-Nuclear Principles in the 1960s. Hiroshima's mayor, Tadatoshi Akiba, used the 57th anniversary to once again call for a worldwide ban on weapons of mass destruction.

Come the September 2002 German federal election, it looked as if the Social Democrat Party and Green Party coalition government would be thrown out by voters frustrated by continuing high rates of unemployment and a stagnating economy. The opposition coalition of Christian Democrats and Free Democrats were seven points ahead in the polls. Yet, in what was the closest election in post-war German history, Chancellor Gerhard Schröder's incumbent coalition edged out the challengers by just nine seats. Schröder's outspoken opposition to the brewing Iraq War was said to have played a role in boosting his support; others pointed to his swift, effective response to the catastrophic flooding that hit during August.

138

Three years after India and Pakistan went to war – for the third time – over the disputed region of Kashmir, relations between the two neighbours remained tense. Elections in Indian-administered Kashmir in September were marred by attacks on polling stations and assassination attempts on leading Indian politicians. Pakistan, which administers the other half of the majority-Muslim region, reaffirmed its refusal to accept the international Line of Control as the border and sought greater control over the territory. While proxy forces of both countries continued to fight a bitter war amid its spectacular hills and lakes, various Kashmiri factions waged their own violent struggle for independence.

On the final leg of his re-election campaign, Gerhard Schröder is accompanied by Nobel Prize-winning author Günter Grass.

Mourners crowd around the body of Naz Bunu, killed in an attack on an Indian politician – another casualty of the elections in Kashmir.

South Korea played host to the 14th Asian Games from 29 September to 14 October. A total of 7,556 athletes from 44 countries competed. They included North Korea, which sent an unprecedented delegation to the host city of Pusan, and Afghanistan, which had been absent from the Games since the Taliban had come to power. The Games also marked the first time that all 44 member-nations of the Olympic Council of Asia participated. China came first in the final medal tally, followed by the host team. The successful Games helped erase some of the anguish experienced in 1988 when the Olympic Games in Seoul were tarnished by a drugs scandal.

Malaysia's Mohammad Azman and South Korea's Yoo Dong-young tussle in the *sepak takraw* semi-final.

Once hailed as an oasis of stability in a region wracked by conflict, Côte d'Ivoire descended into internal strife on 19 September 2002 after a mutiny led by troops from the country's predominantly Muslim North escalated into a full-scale rebellion. It was the sixth coup or attempted coup in the space of less than three years. Thousands died as rebels launched attacks in several cities, including the capital, Abidjan, and the country was split into two. The rebels' aim was ostensibly to end discrimination against northern Muslims in Ivorian politics. French troops were brought in to help resolve the crisis and a peace deal was signed in 2003 but the country remained tense and divided.

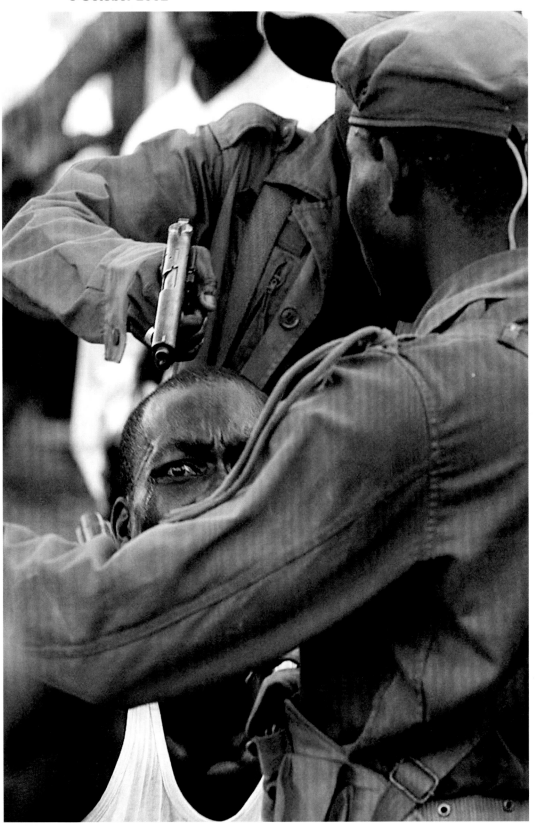

Patriotic Movement of Côte d'Ivoire rebels toy with the life of a loyalist outside the central city of Bouaké.

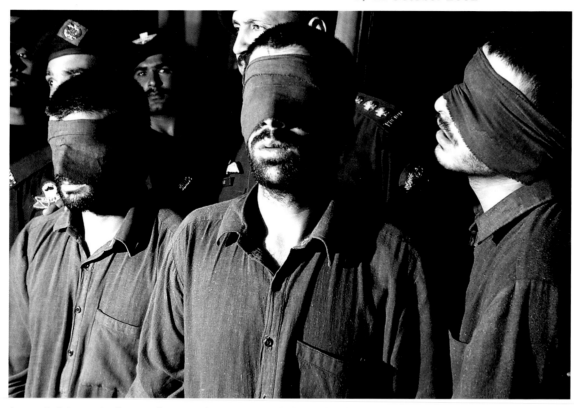

The October 2002 general election in Pakistan was General Pervez Musharraf's attempt to legitimize his 1999 coup. The vote took place against a backdrop of heightened tensions between India and Pakistan: Musharraf's government had ordered ballistic missile tests just weeks earlier; India had large numbers of extra troops stationed on the border in response to guerrilla attacks from the disputed province of Kashmir; and three suspected Indian agents were arrested in late September, accused of plotting terrorism to disrupt the elections. But despite some election-day gun battles, the voting passed mostly without incident. Opponents claimed the election was rigged – although, in any case, parliament could do little to challenge Musharraf.

Accused of electoral sabotage, three men become pawns in the stand-off between India and Pakistan.

141

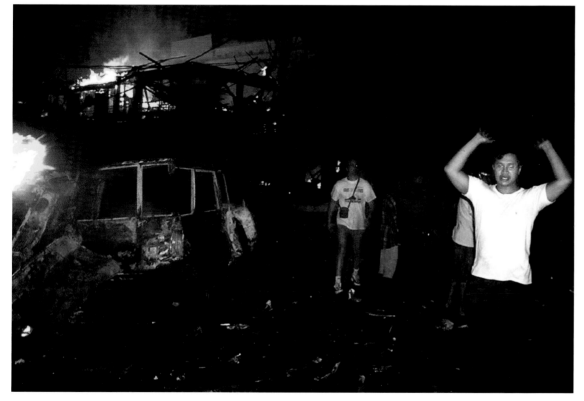

The blissful tranquillity of the Indonesian 'Island of the Gods' was shattered on 12 October when a massive car bomb exploded in Bali's main tourist area. A suicide bomber detonated explosives that ripped through one of the local bars, killing nine people. Moments later, another blast at the Sari nightclub killed civilians from 21 countries. The final death toll reached 202, while two hundred more sustained injuries from the bombs and subsequent blaze. Not long afterwards, another explosion near the capital's US consulate made this a notorious day in the War on Terror and the worst terrorist attack to date in Indonesia, home to the world's largest Muslim population.

Paradise lost: tourists and locals alike are caught up in Bali's terrorist bombings.

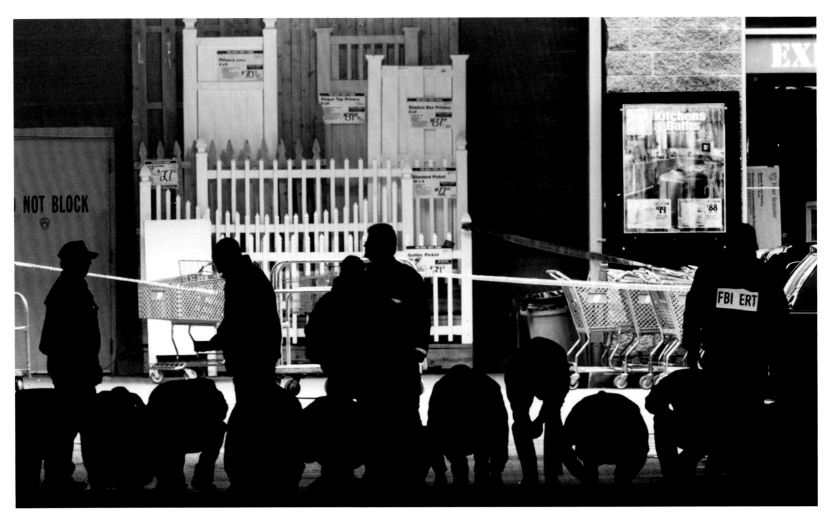

Police search for clues the day after Linda Franklin, the ninth victim of a 23-day shooting spree, is killed in Fairfax County, Virginia.

The 'DC sniper' John Allen Muhammad and his accomplice, Lee Boyd Malvo, ran amok in the US capital during three weeks in October. Their motives were unclear, but the effects were not. The shooting of ordinary civilians going about their daily business in car parks, petrol stations and outside shopping malls caused widespread panic in Washington, DC. Ten people were killed, five of them on 3 October, in Maryland and Virginia as well as Washington, DC. The media went into a frenzy of coverage, lasting hours after each killing. Muhammad and Malvo were arrested on 24 October. Acting as his own lawyer, Muhammad was ultimately sentenced to death. Malvo received life imprisonment without chance of parole.

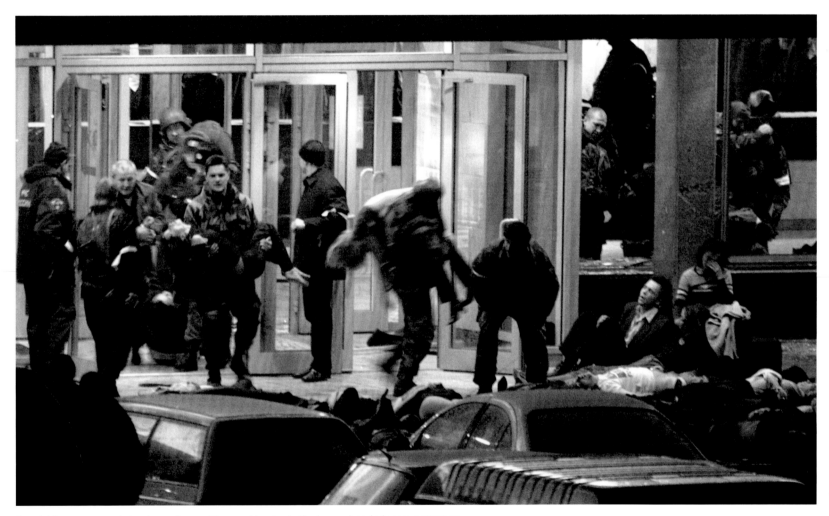

Special forces evacuate hostages from a Moscow theatre in the heavy-handed rescue attempt.

143

In a dramatic climax, Russian soldiers stormed the Moscow theatre where Chechen rebels had been holding the 700-strong audience hostage. The two-and-a-half-day siege came to an end when special forces, believing that the Chechens had begun executing hostages in advance of the dawn deadline, pumped an opiate-based gas through the ventilation system before taking the building. The terrorists had demanded an end to the three-year Chechen War, a conflict President Putin had already declared over. The crisis did not have a happy ending – in scenes reminiscent of the 1995 Budennovsk hospital siege, many of the hostages died during the rescue, and almost all the perpetrators were killed.

144

Hu Jintao (far left) stands with other members of the Chinese Communist Party as the new Politburo élite is unveiled in Beijing.

Hu Jintao succeeded Jiang Zemin as General Secretary of the Communist Party of China in 2002. That year all other top officials of the all-powerful Central Committee had stepped aside to make way for the 'fourth generation' of party leaders. Reserved and moderate, the former engineer sought to address the growing economic disparity between rural and urban areas. Internationally, Hu advocated an enhanced global role for China through 'peaceful development', a policy that would see China forge much deeper economic and trade relationships with countries in Africa and Latin America especially. The following year he also succeeded Jiang Zemin as the country's president.

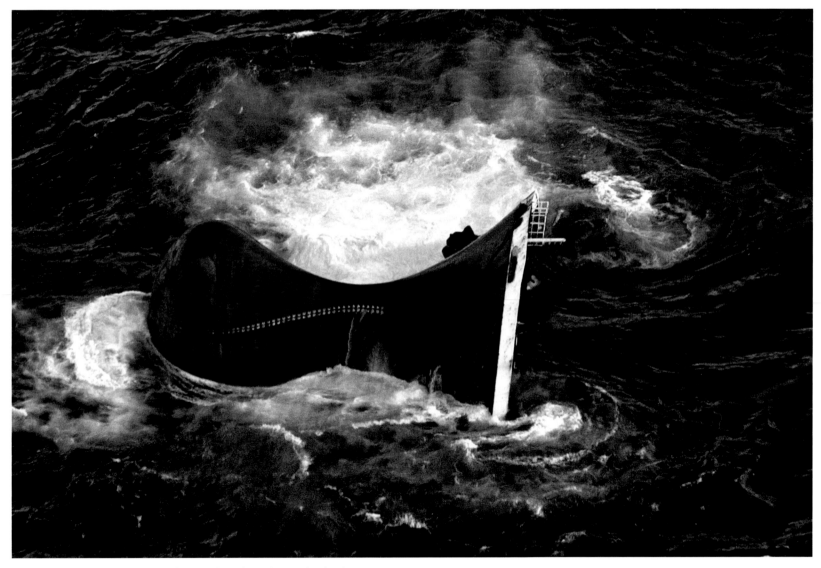

The last glimpse of the *Prestige* before the oil tanker is lost to the depths.

On 19 November 2002 the *Prestige*, a single-hulled oil tanker, caused one of the largest environmental disasters to date. The ship was caught in a storm off the Spanish coast when one of its tanks burst. Turned away by the Spanish, French and Portuguese port authorities, the tanker was towed out to sea by Spanish tugs, where it split in two, shedding crude oil onto the seabed. Rescue missions over the next two years salvaged 20 per cent of the tanker's cargo, though nearly 100 million litres (22 million gallons) of oil had already been released into the fragile marine eco-system. The spill polluted miles of coastline and seriously damaged the region's fishing industry, leaving many unanswered questions about the state of international shipping regulations.

UN weapons inspector Hans Blix begins the hunt for Iraq's reputed weapons of mass destruction.

The Iraqi government permitted UN weapons inspectors to return to Baghdad following unanimous agreement by the UN Security Council to Resolution 1441, which threatened 'serious consequences' were Iraq to be found in breach of its disarmament obligations. Beginning on 19 November, an inspection mission led by Hans Blix, head of the UN Monitoring, Verification and Inspection Commission, and Mohamed ElBaradei of the International Atomic Energy Agency, explored various sites in Iraq, finding no weapons of mass destruction. In his report, Blix stated that, in light of Iraq's frequent inaccurate and incomplete declarations, there could be no confidence that Iraq had disarmed in the wake of the Gulf War. Though many former stockpiles were unaccounted for, Blix and his team ultimately discovered no evidence of chemical or biological weapons in Iraq.

Acclaimed author Philip Roth assumes a contemplative pose at his Connecticut home.

In 2002 the prestigious National Book Foundation's Medal for Distinguished Contribution to American Letters went to the novelist Philip Roth. Just shy of his seventieth birthday, Roth received the award for a rich canon of work that explored Jewish and American identity in post-war America. By turns desolate and hilarious, Roth's novels are often set in his hometown of Newark, New Jersey, and frequently feature his alter ego, Nathan Zuckerman. His recurrent use of Zuckerman as narrator or protagonist challenged both readers and critics to disentangle fiction from autobiography.

On 13 June 2002 a US Army armoured vehicle struck and killed two 14-year-old Korean girls in Yangju, Gyeonggi-do, South Korea. The incident occurred on a public road as the vehicle was returning to base after a training exercise. In November a US military court controversially found the soldiers not guilty. The decision enflamed anti-American sentiment in South Korea, where 37,000 US troops were stationed. Despite an apology from President Bush on 27 November, large demonstrations were held outside US Army bases and in Seoul 50,000 people attended a protest rally, demanding that American troops leave. South Korean campaigners claimed that the deaths were among thousands of crimes committed by US soldiers on Korean soil that had gone unpunished since the 1960s.

Police and protesters clash in Seoul at an anti-US demonstration, after US soldiers are cleared of killing two Korean girls.

On an ordinary Wednesday in December 2002, a celestial coincidence saw the brief but perfect alignment of the full moon with the sun's bright disc. The total solar eclipse's shadow cut a dark swathe from Angola, across the Indian Ocean, finishing at Ceduna in South Australia. Meanwhile the rest of Earth remained illuminated by the star's fiery halo, bringing to mind supernatural explanations for the extraordinary event. There would not be another solar eclipse in this Australian neighbourhood for another few hundred years.

A solar eclipse achieves momentary totality over the outback town of Lyndhurst, South Australia.

149

The worst drought in over a century was to have devastating consequences for New South Wales in late 2002. The Australian bushfire season, usually from December to February, began months earlier than usual, causing havoc across the parched region. In December at least 60 fires erupted around Sydney: firefighters and residents tried desperately to save their homes but, nurtured by high temperatures and strong winds, the fires could not be contained. Thick, acrid smoke filled the air as suburbs were evacuated, and many parts of the city were without power. Authorities suspected human intervention, banning the movement of flammable materials and closing national parks to prevent further arson.

A garden hose proves no match for the raging bushfire in Glenorie, near Sydney.

2003
Clash

The run-up to, waging of and aftermath of the US-led invasion of Iraq were mired in divisive controversy. US President George W. Bush, British Prime Minister Tony Blair and others in the 'coalition of the willing' argued that the regime of Saddam Hussein was a threat to international peace and security, and the policy of containment instituted after the 1991 Gulf War was no longer viable. Other world leaders – and many people worldwide – argued that the claims were overblown and there was still time for diplomatic resolution. The West was divided: polarized between pro- and anti-war, even between 'old' and 'new' Europe, in the words of US Secretary of Defense Donald Rumsfeld. Millions of people protested in a coordinated worldwide demonstration against the war, the likes of which had never been seen before, and 'WMD' entered common parlance as short-hand for the 'weapons of mass destruction' Saddam was supposedly hiding. The invasion took place on 20 March. The war itself was swift – Iraqi forces were little match for the might of the coalition. With a 'mission accomplished' banner displayed behind him, President Bush triumphantly declared an end to major combat operations – a scene that would return to haunt him. Occupation quickly turned to chaos, and chaos into insurgency. 'Shock and awe' had worked – but the United States and UK were to learn that building a nation out of the ruins of dictatorship and sectarian division would be the most challenging of tasks. Conflict and catastrophe was not just limited to Iraq. A new civil war broke out in Darfur, western Sudan, just as the 20-year-old war between the north and south of the country seemed to be ending. In Iran the ancient city of Bam – a World Heritage Site – was flattened by an earthquake. And in Australia the worst drought in a century continued and bushfires raged across New South Wales. Even the march of technological progress seemed to stumble. The *Columbia* disaster killed its crew of seven and grounded the space-shuttle programme. The unmanned *Beagle 2* explorer, sent to Mars to probe its surface, fared no better. It was successfully launched into Mars's orbit, but failed to make contact. Concorde, the iconic supersonic airliner, was retired from service, its operation no longer economic and with no similar aircraft to replace it. Political events of 2003 were a mix of the curious, the tragic and the new. Arnold Schwarzenegger, former bodybuilder and star of such films as *The Terminator* and *Kindergarten Cop*, became governor of California (whose economy rivalled that of France). Sweden's Foreign Minister Anna Lindh was murdered in a Stockholm department store, the first Swedish politician to be assassinated since Olaf Palme in 1986. And in Britain, the death of chemical and biological weapons expert Dr David Kelly brought about intense intrigue as the justification for the Iraq War came under increased scrutiny.

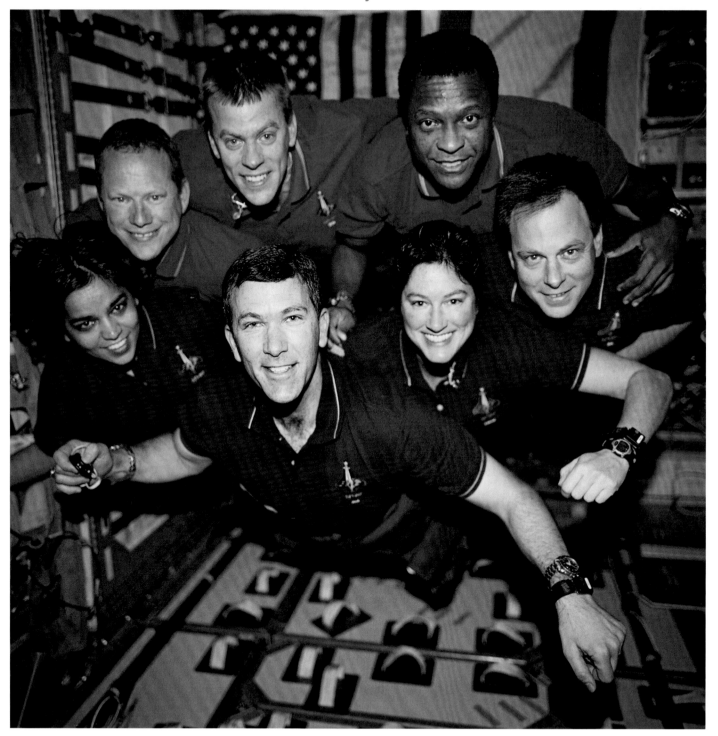

The *Columbia*'s doomed crew smile for the camera in a photograph discovered among the shuttle's wreckage.

'The *Columbia* is lost; there are no survivors.' As US President Bush addressed the nation on 1 February, the severity of the space-shuttle disaster began to sink in. The *Columbia* had broken up during re-entry into the Earth's atmosphere and scattered over Texas. An investigation found the cause of the accident to be a rogue piece of heat-insulating foam – a tiny flaw that proved fatal, as superheated gases penetrated the shuttle's wing, ripping it apart from the inside. The seven-person crew had been conducting a 16-day science expedition. *Columbia* had been the first shuttle to travel the Earth's orbit in 1981 and its demise was sobering for all who worked on space flight or who dreamed of extra-planetary adventure.

152

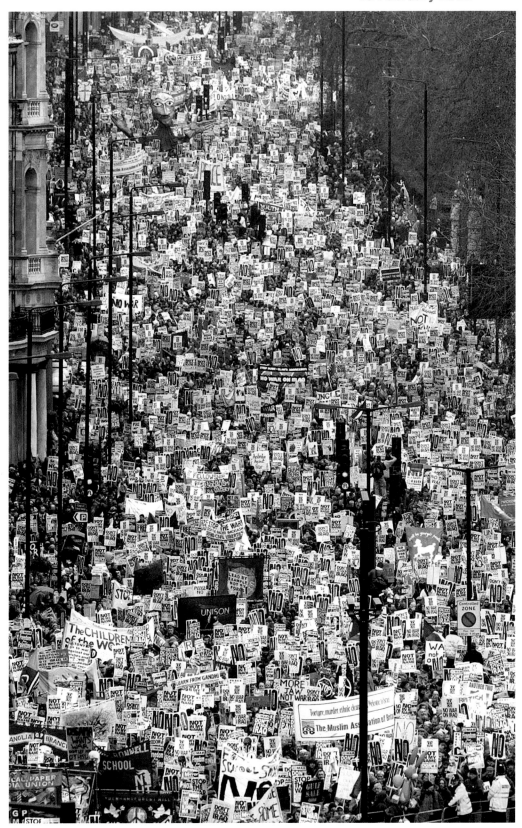

Londoners march through the capital in protest as Western governments contemplate the invasion of Iraq.

As the imminent war in Iraq shuddered closer, millions of people took to the streets in a weekend of coordinated global protest. The worldwide outpouring seemed to personify the body democratic, as marches, rallies and demonstrations drew attention to legal, pacifist and moral objections to the proposed invasion. In London, all police leave was cancelled in anticipation of public disorder; in fact, there was little disturbance from the high-spirited crowd, estimated to be 750,000-strong by the authorities, but almost three times that by organizers Stop the War Coalition. Convened predominantly by a network of social movement organizations communicating via email, the march was the largest ever political demonstration in the UK and hinted at a new generation of globalized activism.

153

In early 2003 the 20-year civil war between north and south Sudan seemed to be ending. However, in the western region of Darfur, desertification and overpopulation had led to tensions between Arab camel-herders and black arable farmers; increasing marginalization of the area's Fur tribe compounded the problem. In February, tribesmen from rebel groups such as the Sudan Liberation Army and the Justice and Equality Movement took up arms against the Sudanese government. The ruling National Congress Party in Khartoum responded with a violent campaign executed by the Arab Janjaweed proxy militia, in a move described by many as ethnic cleansing. Darfur had become the scene of one of the worst humanitarian crises to date as several hundred thousand Darfurians died amid claims of genocide, in a three-year conflict that split the international community.

154

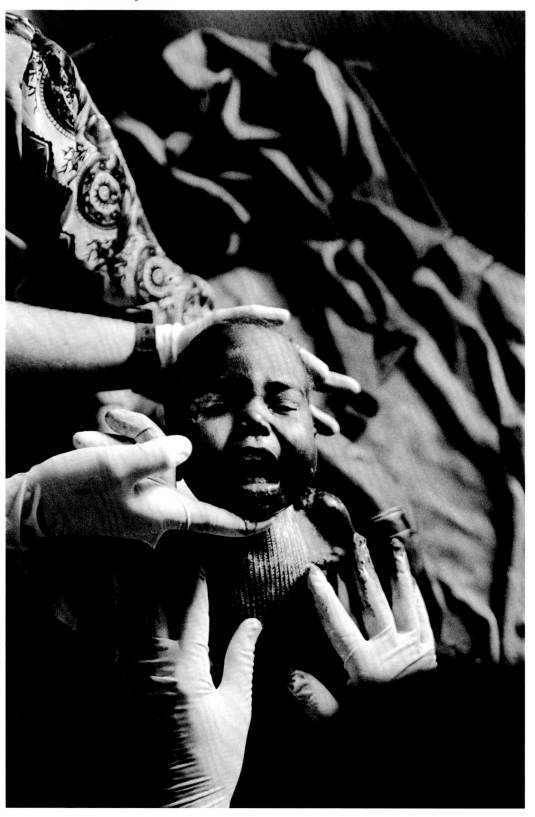

A wounded child, one of the many victims of Darfur's humanitarian catastrophe, is treated in Golo Hospital, West Darfur.

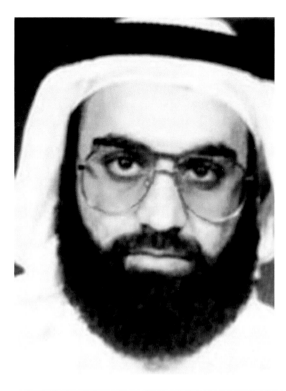

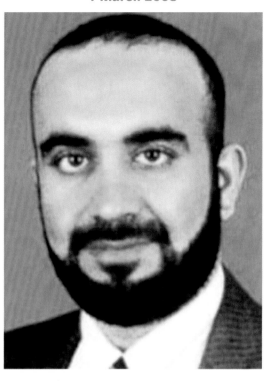

Captured by Pakistani intelligence agents on 1 March 2003 in Rawalpindi, Khalid Sheikh Mohammed was suspected of being the principal organizer of Al Qaeda's international terrorism network and chief planner of the 9/11 attacks. The US administration had offered a reward of up to $25 million for his capture. Investigations into his murky past revealed that Kuwaiti-born Mohammed had once studied in the US and his nephew, Ramzi Yousef, was one of the terrorists behind the 1993 bombing of the World Trade Center. By the late 1980s he had joined forces with Osama bin Laden in northwest Pakistan and subsequently travelled the world cultivating new Al Qaeda recruits.

155

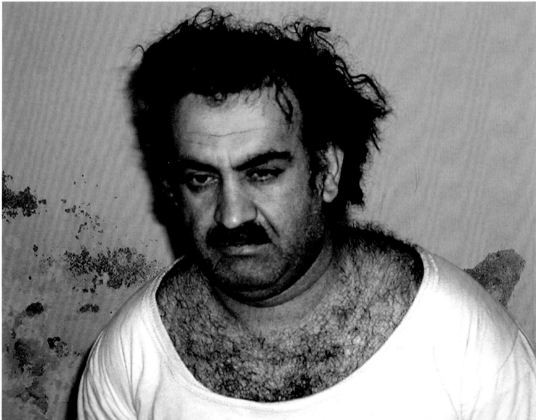

One of the FBI's most wanted terrorists, Khalid Sheikh Mohammed, in better days and after his capture.

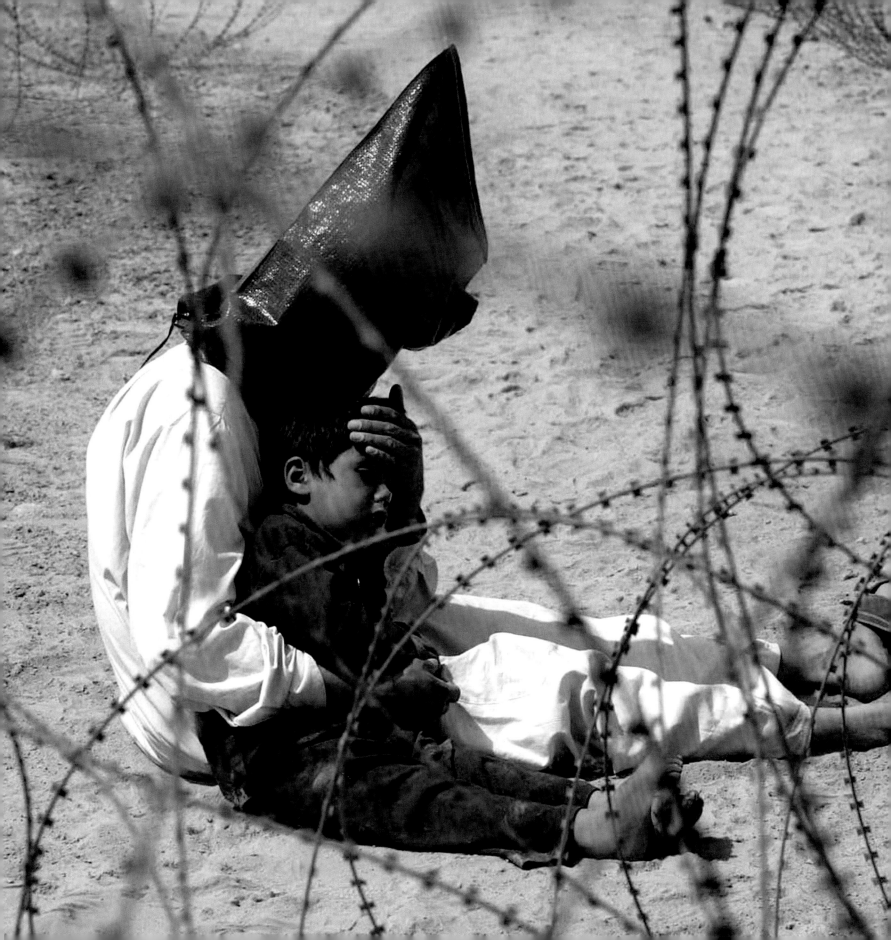

Deprived of his dignity, an Iraqi prisoner of war comforts his son at the base camp of the US Army 101st Airborne Division, near An Najat in southern Iraq.

157

In the early morning of 20 March 2003 – two days after US President George W. Bush's demand that Saddam Hussein surrender and leave Iraq went unheeded – a coalition led by US forces began bombing Baghdad. The subsequent invasion was a triumph of coalition firepower and strategy and, within three weeks, the Iraqi regime was ousted and its capital city had fallen. Coalition casualties were low but several thousand Iraqi soldiers, foreign combatants and civilians were killed in the fighting, and thousands more taken prisoner. The US and its allies justified the invasion on the grounds of Iraq's alleged possession of weapons of mass destruction and the threat Saddam Hussein posed to international security. On 1 May, Bush declared that 'major combat operations in Iraq have ended'. After an initial period of relative calm, however, lawlessness quickly spread.

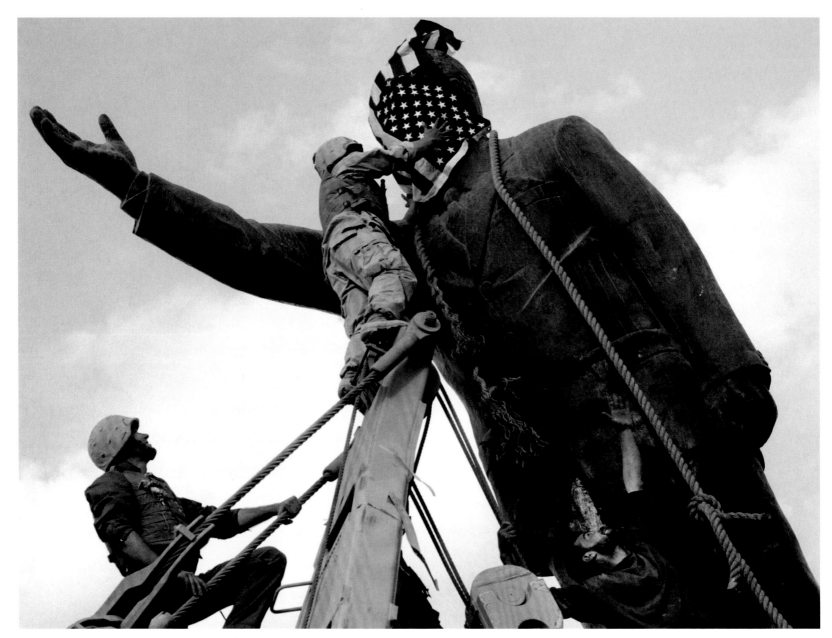

In a diplomatic *faux pas*, a US marine shows off his national colours in Baghdad.

The toppling of Saddam Hussein's statue in Firdos Square on 9 April 2003 was initially portrayed as a spontaneous display of contempt for the dictator by a newly freed people. Television images of Iraqis dancing and waving the country's pre-1991 flag were beamed around the world (though not before cameras captured US marines initially covering the statue's head with the US flag). Investigations later suggested that the event was stage-managed for the world's media by US forces. Over the next six months, as Iraqis grew resentful of the occupation and foreign fighters infiltrated the country, more US soldiers were to die in insurgent attacks and suicide bombings than during the whole war.

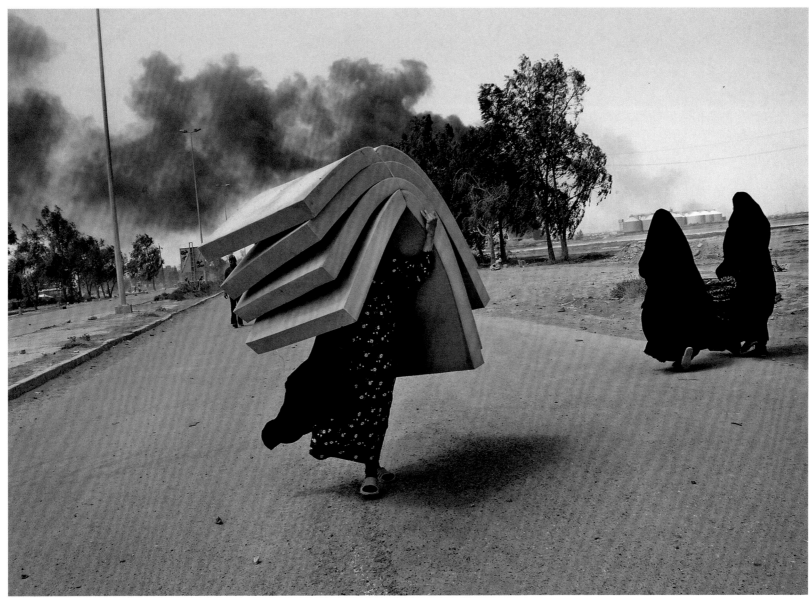

Iraqi women cart away their modest plunder as looting spreads across the capital.

159

The unchecked chaos that followed the collapse of Saddam Hussein's Baathist regime on 9 April 2003 hardened international criticism of the US-led invasion of Iraq. In the immediate aftermath of Saddam's fall, US troops protected Iraqi oil facilities but did nothing to halt massive looting elsewhere. Most alarming was the plunder of Iraq's world-renowned national museum and the theft of thousands of priceless artefacts. In words that would later come back to haunt him, the US Defence Secretary Donald Rumsfeld dismissed the significance of the looting, quipping that 'stuff happens'.

US basketball legend Michael Jordan plays his last NBA game. Again.

At the time of his retirement, Michael Jordan was almost universally considered the greatest basketball player of all time. His gravity-defying jumps, unrivalled shooting prowess and sportsmanship earned him innumerable accolades, including two Olympic gold medals and five NBA (National Basketball Association) Most Valuable Player awards, an NBA record. His final NBA game concluded with a standing ovation from over 21,500 fans and players. Jordan retired twice before 2003 – once to take up baseball, the next time to unsuccessfully try his hand at management. With no comeback this time round, Jordan left an insuperable legacy, having popularized basketball (and Nike shoes) for a new generation around the world.

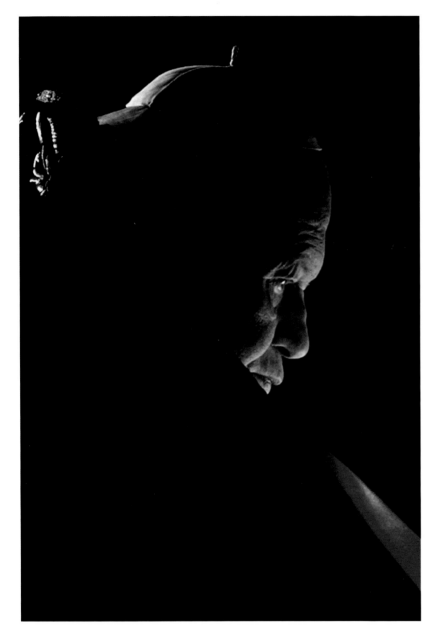

162

Pope John Paul II presides over the Good Friday service at Rome's Colosseum.

Soul legend Nina Simone gives a characteristically uplifting performance at London's Royal Festival Hall in 1999.

Twenty-five years on from his election as pontiff, Pope John Paul II could barely speak or walk, debilitated by Parkinson's disease, numerous hip and knee ailments, and the legacy of four bullet wounds from the failed attempt on his life in 1981. The frail pope's determination to continue to reach out to his followers inspired the world's billion Catholics. During his pontificate he had visited 129 countries and canonized more saints than all his predecessors combined. His pivotal role in ending the communist regime in his native Poland was widely acknowledged by world leaders and people of all faiths.

One of the most influential singers of the late twentieth century, Nina Simone died on 21 April in Carry-le-Rouet, France, aged 70. Born Eunice Waymon in North Carolina, Simone started out as a classical pianist but soon took a job in an Atlantic City nightclub, where she captivated audiences with her performances, which blended genres, from soul, jazz and pop to gospel, classical and opera. She recorded over 40 albums, her hits including 'I Put a Spell on You' and 'My Baby Just Cares for Me'. Her disillusionment with show business and racism in US society led her to nearly three decades of self-imposed exile in Europe, the Caribbean and Africa.

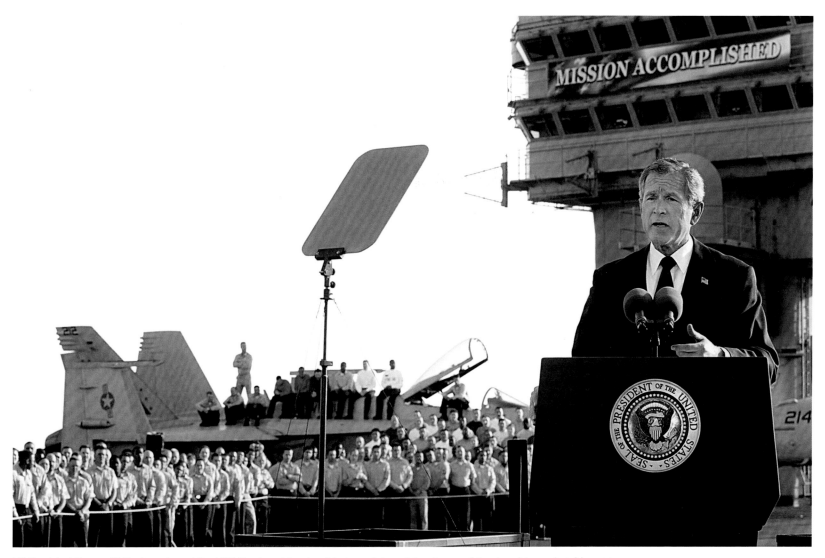

163

US President George W. Bush, on board the USS *Abraham Lincoln*, all but proclaims victory in one of the decade's unwinnable wars.

On 1 May, US President George W. Bush dramatically arrived on the deck of the USS *Abraham Lincoln* – in a Lockheed S-3 Viking jet aircraft. The aircraft carrier had returned from service in the Gulf and was 48 kilometres (30 miles) from San Diego, California.

In a televised address, Bush proudly announced the end of major combat operations in the Iraq War, with a banner stating 'Mission Accomplished' clearly visible in the background. By the end of the year, with the insurgency gathering strength and US casualties

mounting, the picture-perfect moment had become prime fodder for critics of the Bush administration, who portrayed it as wholly premature.

164

Two HIV-positive girls seek medical help in Zambia, a country afflicted by widespread poverty in addition to the African AIDS epidemic.

One of the world's poorest nations, Zambia continued to suffer from a devastating HIV/AIDS epidemic. Nicknamed 'the viral genocide', 2003 government figures showed it claimed the lives of 300 Zambians a day, reducing life expectancy to 33 years, the lowest in the world. Despite massive cobalt and copper resources, poverty is rife and Zambia's social conditions have deteriorated over the decade, contrary to international trends. In 2002, although 2 million people were threatened by the spectre of famine, President Levy Mwanawasa rejected food aid that included genetically modified products, calling it 'poison'. Though Germany cancelled $207 million of debt in May 2003, Zambia's debt servicing fees still exceeded its combined annual spending on health, education, water and sanitation, condemning the southern African country to an uncertain future.

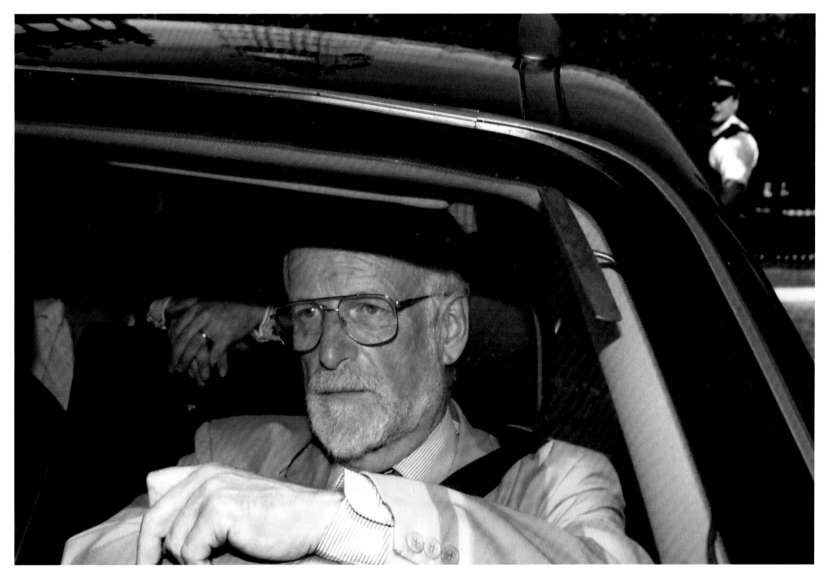

165

In the eye of the storm: Dr David Kelly leaves the House of Commons, London, after a Select Committee hearing.

Caught in the middle of a media frenzy, Dr David Kelly had been distraught two days before his death. He was exposed as British journalist Andrew Gilligan's key source for an inflammatory BBC report that decried the notion that Iraq could deploy weapons of mass destruction in 45 minutes – a claim that had been at the heart of the government's case for intervention. Following a mauling at a hearing of the Foreign Affairs Select Committee, Kelly was found in woods near his home on 18 July 2003, after apparently taking his own life. The government and the BBC were sharply criticized in the wake of his death, but cleared of any wrongdoing by the Hutton Inquiry in 2004. Nevertheless, the air of conspiracy continued to excite considerable attention.

Africa's oldest republic, Liberia was relatively calm until 1980 when food riots led to more than two decades of vicious conflict, which claimed 250,000 lives and turned the country into a haven for gun-runners and diamond smugglers. Both government and rebel forces committed gross human rights abuses. The so-called Second Liberian Civil War began in 1999 and ended in October 2003, when 200 US troops intervened in support of a UN-backed West African force to end the rebel siege on Monrovia that had left the capital city in ruins. Liberia's warlord president, Charles Taylor, was forced into exile in Nigeria.

The head of a Liberian rebel, a gruesome token of the brutal civil war, is paraded in Monrovia.

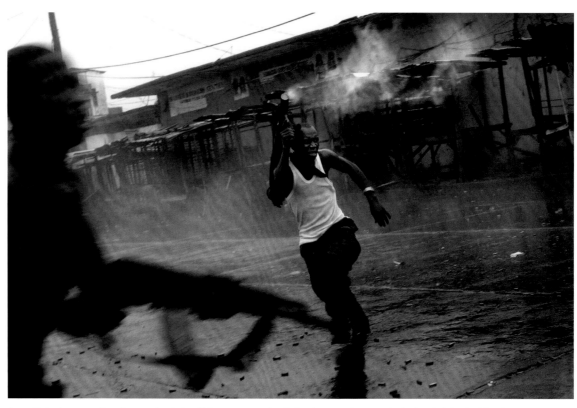

A gunfight between loyalists and rebel militia ensues as both factions seek control of a key bridge in Liberia.

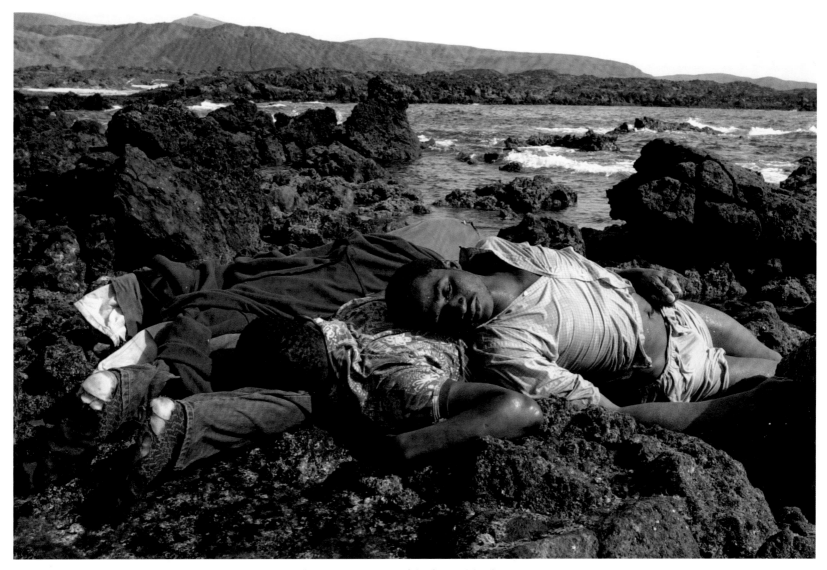

Victims of the immigrant dream are washed up on the rocks of Fuerteventura, one of the Canary Islands.

167

Another day, another tale of human tragedy in the Strait of Gibraltar. Every year, thousands of people made the perilous journey from Africa in tiny, flimsy boats in search of a better future; in the five years preceding 2003, 4,000 were estimated to have died or disappeared at sea. Many people setting out from Morocco attempted to make it to the Canary Islands – but often ended up on a Fuerteventuran beach, having been washed ashore or abandoned by traffickers, if their boats had not first been turned back by the Spanish coastguard. Nearly 80,000 immigrants were repatriated in 2002; the others found a life of hardship and alienation on the streets. It was to be another year until the Spanish government relaxed its rules, offering legal recognition to those already in the country and an amnesty to those on their way.

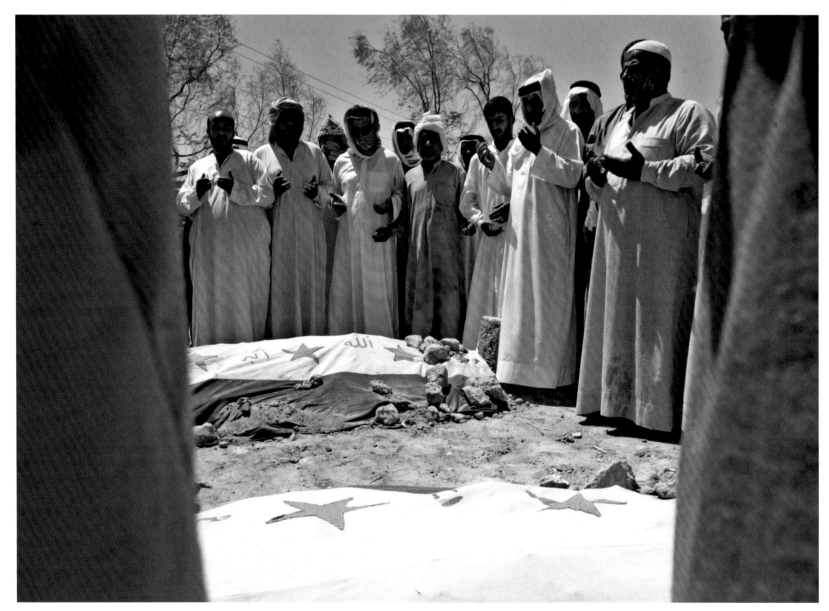

Relatives mourn the deaths of Saddam Hussein's progeny in a cemetery in the northern Iraq town of Ouja.

168

In the months following the US-led invasion of Iraq, the second and third most-wanted men on America's list of Iraqis involved in Saddam Hussein's administration were Uday and Qusay Hussein. Their father, Saddam, was number one. Qusay controlled large parts of Saddam's security apparatus and was being groomed as his heir, while the infamously brutal Uday ran the country's media. On 22 July 2003, US soldiers, backed by rocket-fire from helicopter gunships, stormed a villa in the northern city of Mosul after a tip-off from an Iraqi informant. Saddam's sons were killed in the attack, along with Qusay's 14-year-old son, Mustafa.

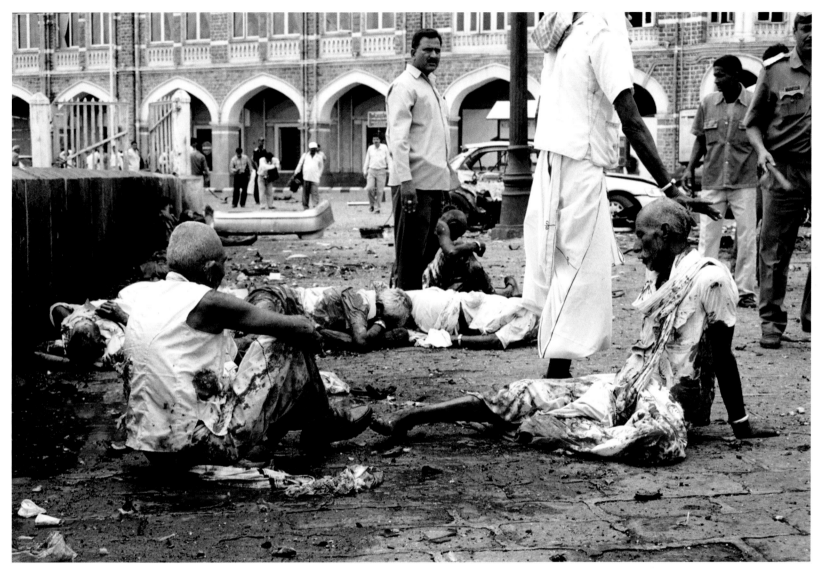

Bystanders lie bruised and bloodied in the aftermath of an indiscriminate bombing in Mumbai, India.

169

On 25 August two taxis carrying explosives blew up within minutes of each other in Mumbai, India's financial capital. One explosion occurred at the Gateway of India, the city's top tourist attraction. The blasts killed 52 people and left nearly 150 injured. Suspicion immediately fell on Pakistan-based militant groups fighting for Indian withdrawal from the disputed territory of Kashmir. The following day India demanded that Pakistan hand over several suspects connected to previous terrorist attacks in the country. The bombings in Mumbai threatened to derail the growing rapprochement between the nuclear-armed neighbours.

170

Wholesome pop-idol Britney Spears indulges in a brief moment of passion with the arch-temptress, Madonna.

Youthful American pop star Britney Spears, adored for her girl-next-door persona as much as her chart-topping hits, returned to the music scene in 2003 after a year out of the limelight. She seemed bent on sabotaging her squeaky-clean image. First she declared that she had lost her virginity and then she kissed her hero, Madonna, on the live broadcast of MTV's Video Music Awards show. It may have been a publicity stunt to promote her new album, but it also marked the beginning of a downward spiral for the Louisiana-raised singer. Within a year her second marriage in nine months had ended and her increasingly chaotic personal life completely overshadowed her music.

Sheikh Ahmed Yassin, revered and reviled in equal measure, arrives at a Hamas rally in Gaza City, earlier in the year.

On 6 September 2003 the Israeli army wounded the founder and spiritual leader of Hamas, Sheikh Ahmed Yassin, in a failed assassination attempt at a house in Gaza. A quadriplegic and nearly blind, Yassin was a hate figure for Israelis: according to government ministers, 'his hands were tainted with the blood of hundreds of Israelis, children, women and babies'. Large numbers of Palestinians saw him as a hero, responsible not only for anti-Israeli activities but also the establishment of libraries, hospitals and other essential services in the impoverished Gaza Strip. He was a fierce advocate of resistance rather than negotiations to end the Israeli occupation. On 22 March 2004, Israel again set out to kill Yassin, launching a missile attack as he was leaving early morning prayers. This time they were successful.

The most famous American country music singer-songwriter of the post-war era, Johnny Cash, died on 12 September. 'The Man in Black' was born into an Arkansas sharecropper family and garnered early success with his mournful songs about the downtrodden and forgotten, but his life was plagued by drug and alcohol abuse. However, with June Carter, his musical collaborator, whom he married in 1968, his career experienced a renaissance, including landmark live recordings made at Folsom and San Quentin prisons and the popular 'Johnny Cash Show' television series. Cash died four months after Carter unexpectedly passed away in May. Their relationship was the subject of an Oscar-winning film, *Walk the Line* (2005).

A portrait by Mark Seliger captures singer Johnny Cash shortly before his death.

Swedes mourn the passing of Anna Lindh outside the department store where she was stabbed.

173

Anna Lindh, the bright, forthright Swedish Foreign Minister, was stabbed on 10 September 2003, and died the next day, after surgeons were unable to stem internal bleeding. Her murderer had attacked her in an upmarket department store, only days before a referendum on the euro, of which Lindh had been one of the fiercest proponents. In the days following her death, she smiled down on mourners from campaign posters around the city. Fear and speculation surrounding the initial suspect – a neo-Nazi – and then the second – a Swedish Serb – highlighted just how divided Sweden had become, struggling to come to terms with its multi-ethnic society. Although Swedes were united in grief by Lindh's death, they didn't change their minds about adopting the euro. Perhaps desiring to retain Sweden's traditions, voters rejected the new single currency.

174

Arnie greets his campaign supporters in Santa Maria, preparing for his transformation from action hero to governor of the world's eighth largest economy.

Arnold Schwarzenegger, the body-builder turned actor turned politician, announced his candidacy for California state governor on 'The Jay Leno Show', a stalwart of US television entertainment. Running against the incumbent, Gray Davis, in a recall election, Schwarzenegger capitalized on his celebrity status and won despite his lack of political experience. The 'Austrian Oak' had won Mr Olympia seven times and become famous for his action-hero roles. His governorship victory came in the same year that he reprised his Terminator role for the third instalment of the popular science-fiction movie franchise. This new position, however, would see Schwarzenegger battling quite different foes, including wildfires, budget deficits and trenchant political constituencies.

At Tate Modern in London, visitors are rapt by the ochre incandescence of *The Weather Project*.

Olafur Eliasson's ambitious work, *The Weather Project*, filled the Turbine Hall's colossal volume. The Danish/Icelandic artist's mesmerizing installation at London's Tate Modern used 200 street lamps to create an artificial sun that filled the void with an eerie glow. Awed visitors were drawn towards the gigantic spectacle like primitive man to the celestial body, an ethereal fog enveloping those who prostrated themselves under the mirrored 'sky'. Eliasson was the youngest artist to have undertaken the highly successful Unilever commission, describing the simulacrum of the natural world in Tate Modern's central gallery as an opportunity to 'see oneself sensing'.

175

Members of the Asia-Pacific Economic Forum in Bangkok, including George W. Bush, enter into the spirit of cooperation by donning matching Thai costumes.

176

In October, leaders from 20 nations gathered at the Asia-Pacific Economic Cooperation (APEC) meeting in Bangkok, Thailand. APEC was established in 1989 to promote collaboration between the Asia-Pacific region's economies, and its members generated about half of the world's trade by 2003. Along with trade, security dominated the talks. President George W. Bush clamoured for tougher action against North Korea – one of his three 'axis of evil' countries – over its nuclear ambitions. Other APEC powers, namely Russia and China, disagreed, advising the US leader that offering security guarantees to the Pyongyang regime was the best way to dissuade North Korea from developing weapons of mass destruction.

The Walt Disney Concert Hall opens, delighting its visitors with superlative acoustics and bold aesthetics.

Among the skyscrapers and office blocks of downtown Los Angeles, the steel wings of the Walt Disney Concert Hall sweep and billow in the distinctive Frank Gehry style. Designed to house the Los Angeles Philharmonic, the structure was originally conceived in stone but, after 16 years of revisions, the fluid metallic shapes were finally crafted to soar like the music played within. State-of-the-art acoustics ensured that the classical repertoire could be equally enjoyed from any seat of the vast interior. This architectural landmark contributed to the revival of Los Angeles' central business district, which had been much neglected during the post-war era.

A Surui elder, from the Brazilian rainforest, glances through a *cocar* (a traditional head-dress) of blue macaw feathers.

Brazil's indigenous population has shrunk almost beyond recognition in the 500 years since the country's colonization by white settlers. The decimation of the rainforest and loss of territory to cash crops has threatened the native way of life, while exposure to the 'modern world' has brought with it crippling alcohol and drug dependencies, poverty and infectious diseases. In the midst of the crisis, the 2003 Indigenous Nations' Games, an annual gathering of tribespeople from the lush basin of Mato Grosso, provided an opportunity to demonstrate ancient rituals as well as bow-and-arrow skills. The athletes, bedecked in feathers and paint, stamped their feet to traditional rhythmic songs, commemorating the vibrancy and vitality of their culture.

178

St Peter's Basilica in Rome hosts the state funeral of 17 Carabinieri killed in Iraq.

On 12 November a suicide terrorist attack on the Italian military police headquarters in Nasiriyah, Iraq, killed 27 people including 17 Italian Carabinieri and two Italian civilians. It was the highest loss of Italian lives in conflict since World War II. A shocked Italian public was plunged into three days of national mourning and the soldiers were given a state funeral. The decision by Italian Prime Minister Silvio Berlusconi to support the US-led invasion of Iraq was highly controversial within Italy. The soldiers' deaths increased pressure on his government to withdraw all Italian troops from Iraq.

A man is helped from the remains of the British Consulate in Istanbul, Turkey, after a wave of terror attacks in the city.

180

The British Consulate in Istanbul was situated in a magnificent building, Pera House, which had been purpose-built to serve as an embassy to the Ottoman Sultans. On 20 November a truck bomb detonated outside the consulate, devastating it. Ten staff were killed, including Consul-General Robert Short. In all, 25 people died and hundreds more were injured. It was part of a wave of attacks by Islamic extremists in the city: on the same day, the local HSBC headquarters, in a busy shopping area, was also blown up by terrorists. Five days before, two synagogues had been bombed, killing 27 civilians, most of whom were Turkish Muslims.

A tired Jonny Wilkinson soaks up adulation from jubilant fans at the very apex of his career.

181

Already acknowledged as one of the world's best rugby players prior to the 2003 Rugby World Cup, Jonny Wilkinson was to emerge from the tournament a national hero in England. The fly-half scored the winning drop goal in the last minute of extra time against defending champions Australia in the final. The devastatingly accurate kicker was the tournament's leading scorer with 113 points overall. The defeat riled sports-mad Australians, with one newspaper headline exclaiming 'Good to see the back of you, Jonny'.

Flying for the last time, the stiletto airframe of Concorde soars off the runway at Heathrow Airport, London.

On 26 November, Concorde 216 took a ceremonial lap of honour from London to Bristol, ending 34 years of British supersonic history. It was the last flight of Concorde. The final commercial flights between London and New York had taken place in late October, including one on 24 October that was laden with celebrities and dignitaries. An icon of the aviation industry, the Franco-British aeroplane – with its delta-shaped wings and Rolls Royce turbojet engines – had captured the imagination of a generation. Following the crash at Charles de Gaulle airport in 2000, in which 113 people died, and the decline of air travel post-9/11, Concorde was retired without a successor. After a final lavish celebration, the glamorous era of luxury travel at 60,000 feet (18,300 metres) was over.

The Turner Prize, the notoriously controversial British award for contemporary art, was won in 2003 by Grayson Perry, a transvestite potter whose alter ego, Claire, featured prominently in his work. The £20,000 prize, accused of rewarding 'cold, mechanical, conceptual bullshit' by the British Culture Minister the previous year, celebrated its 20th anniversary with a shortlist of four artists whose superficially attractive work belied complex messages and subversive ideologies. Perry's beautiful ceramics, etched with images of social distress – what the artist called his 'guerrilla tactic' – won over the jury and the public, putting both pottery and dressing-up centre stage.

184

Artist Grayson Perry attends the Turner Prize ceremony at Tate Britain, London, in his own inimitable style.

A Nicaraguan student in Managua makes clear his feelings about threatened cuts to the education budget.

185

Globalization was both a maker and breaker of fortunes in Nicaragua. Devastated by Hurricane Michelle in 2001, the country also faced a severe economic crisis as the global recession and low coffee prices began to pinch. 2003 was a year of protest as Nicaraguans took to the streets. In August, thousands of the country's coffee-workers marched to the capital for a third consecutive year. On 18 September, some 10,000 members of unions, civic groups and environmental organizations protested against the US-Central America Free Trade Agreement talks in Managua. Later that year, students demonstrated against government economic changes that jeopardized the constitutionally given budgetary support for education. With Molotov cocktails and homemade grenades, some protesters turned violent.

After an eight-month manhunt, Saddam Hussein was unearthed from an underground hideout near his home town of Tikrit. Following a tip-off, Operation Red Dawn swung into action on 13 December: US special forces infiltrated part of the town of al-Dawr under the cover of darkness, searching two sites before discovering the coffin-like chamber in the ground. The former Iraqi dictator was said to be bewildered and disorientated; despite being armed with a pistol, he made no attempt at resistance. Saddam was escorted to a secret location and examined by a US doctor. Meanwhile, his capture elicited mixed feelings: celebratory gunfire echoed around Baghdad and relief flooded the West; however, many urged caution, emphasizing that the detention of the former leader would not necessarily bring a US military victory.

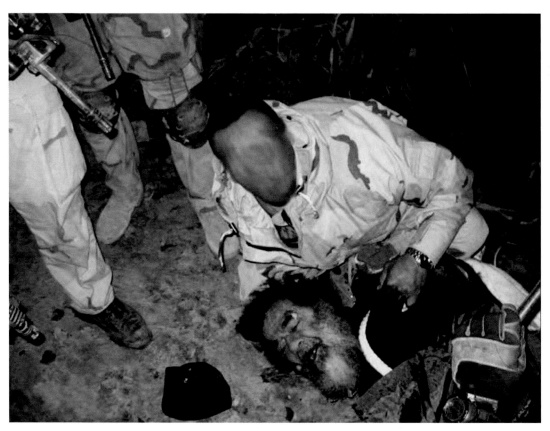

Saddam Hussein, the dictator who once promised the world the 'mother of all battles', is ignominiously hauled from his hideout by US special forces.

The ever-optimistic Professor Colin Pillinger reports on the *Beagle 2* space probe as it prepares to land on Mars.

Named after Charles Darwin's expedition ship, the HMS *Beagle*, which allowed him to gather evidence from inhospitable, distant lands, *Beagle 2* was the European Space Agency's attempt to discover past or present life on Mars. Conceived by scientists from the UK's Open University, the probe was designed to be released from the European Space Agency's *Mars Express* before landing on the red planet's surface. The lander was successfully launched into Mars's orbit, but failed to make its scheduled contact on Christmas Day 2003. There was still no sign of the £40 million probe months later, with the subsequent investigation concluding that a number of unforeseen circumstances were to blame.

187

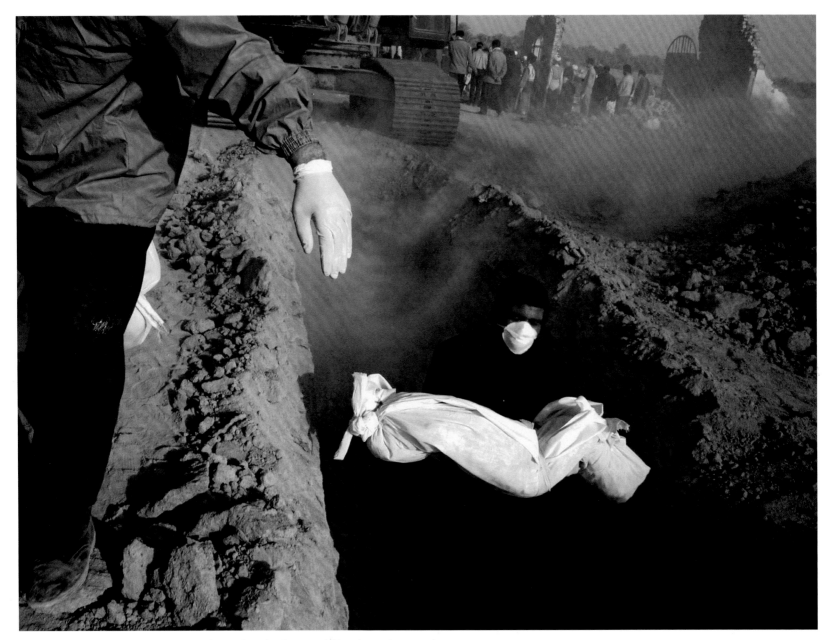

A father buries his son, who has died in the earthquake that struck Bam in southeastern Iran.

In a matter of moments the Arg-é Bam, an ancient adobe citadel on the edge of the Lut desert in Iran, crumbled to dust. Having stood for 2,000 years at the heart of a bustling city, the UNESCO World Heritage Site was just one of the victims of an earthquake in the early hours of 26 December. Many homes in Bam were also built of mud, designed to keep cool in the summer but not to withstand the reverberations of terra firma. Reports of the earthquake's impact were difficult to confirm, but official estimates put the number of deaths at 45,000; the Iranian Red Crescent meanwhile distributed 92,000 tents for those left homeless in the middle of the bitterly cold winter.

Hong Kong 'Cantopop' diva Anita Mui is mourned following her early death by cancer.

The Chinese pop music scene was devastated by the death of 40-year-old Anita Mui. Widely dubbed the 'Madonna of Asia' for her energetic dancing and outrageous costumes, Mui was the undisputed queen of 'Cantopop'. During her prime, the Hong Kong native also acted in more than 40 films and won numerous awards. Although she was diagnosed with cervical cancer in mid-2003, she continued to perform regularly until she was admitted to the Hong Kong Sanatorium Hospital. Close friends, including action-film legend Jackie Chan, kept vigil at the hospital until she died on 30 December.

2004
Tempest

It was the year that the cultural world said goodbye to some of its most famous icons, both living and inanimate. In New York, Luciano Pavarotti gave his final encore at his last performance in an opera. A warehouse fire in London, in May, destroyed the collection of Charles Saatchi, wiping out valuable contemporary artworks for ever. Although some were remade, most were lost. Sadly, photographer Richard Avedon and actor Christopher Reeve passed away – both giants who, in their respective fields, had contributed so much to Western culture. Although in some instances the United States was able to celebrate the contribution of its citizens, in others it was shamed by their behaviour. The abuses at Abu Ghraib prison marked the nadir of the US's engagement in Iraq, vilifying a foreign policy that had been justified in the highest moralistic tones. Many felt that the campaign could not recover, and indeed it was an ugly year in Iraq. In March, terrorist bombings tore through Karbala and Baghdad on the holy Day of Ashura. When four

American contractors were murdered in cold blood a few weeks later, the spiral of retaliatory violence deepened: US soldiers resorted to base tactics to take the insurgent stronghold of Fallujah, while Nick Berg was gruesomely beheaded in revenge for the abuses carried out at Abu Ghraib prison. Within days millions across the world had accessed the execution video online. While US soldiers perpetrated indecent crimes, their nation also paradoxically displayed a new level of enlightenment: Massachusetts became the first American state to permit same-sex marriages. Spain experienced a similar polarization of emotions. Although Madrid was ripped apart by a coordinated terrorist attack on the commuter train system, Spaniards found something to be hopeful about with its first royal wedding in nearly a hundred years. Russia, however, had no ameliorating anniversary to expunge the memory of the Beslan school hostage tragedy in September. Worldwide, the effects of climate change and global warming began to demonstrably take

their toll. In north Africa, billions of locusts emerged to obliterate the harvest, compounding the hardship of people in the region. Nature continued to deliver surprises when a humpback whale swam off-course, landing on a beach in Rio de Janeiro; after much local effort, it could not be saved. In the Middle East, tensions escalated between Israel and Palestine, as the former pursued an offensive strategy of targeted assassination. Later in the year Israel began the construction of a security barrier, a tangible reminder of the gulf between the two nations. In Ukraine, the Orange Revolution brought Viktor Yushchenko into office, heralding a new direction for the former Soviet republic. France also created a connection with the future, its Millau Viaduct becoming the tallest vehicular bridge in the world. The engineering feat suggested humankind's ability to conquer the natural world, a conceit that was resoundingly and wretchedly overturned by the Indian Ocean tsunami on Boxing Day, which left 10 million people devastated and homeless.

An extraordinary shot captures the agony of self-immolation.

When photographer Malcolm W. Browne documented the self-immolation of a Buddhist monk in Saigon in 1963, it resulted in a change of US policy towards South Vietnam. Forty years later, the extreme act had not lost its poignancy, although its ability to initiate change had diminished. Gulam Hassan Anwari died on 27 January 2004, having set himself ablaze outside the offices of the United Nations refugee agency in Kuala Lumpur, Malaysia. Unable to obtain refugee status, he claimed to have been cheated by a local money-laundering company. He was not the first asylum seeker to turn to this most desperate of protests, and he was not the last, as stories of similar cases emerged throughout the decade.

The Super Bowl is the most watched sporting event in the United States, attracting an average of around 100 million viewers. Its half-time shows are spectacles in themselves. When pop stars Justin Timberlake and Janet Jackson performed together, however, viewers got more than they bargained for. In what was described as a 'wardrobe malfunction', a part of Jackson's outfit was ripped off, revealing her right breast on live television. Many viewers were incensed; the US media regulator was inundated with half a million complaints. The broadcaster CBS was slapped with an unprecedented $550,000 fine for the split-second shot.

193

Singers Janet Jackson and Justin Timberlake offer a brief show of flesh at the Reliant Stadium, Houston.

Capitalizing on early social networking websites such as Friendster, Mark Zuckerberg created Thefacebook on 4 February. Inspired by his high-school yearbook used to introduce new classmates to one another, it enabled users to share interests and connect with colleagues and friends. Zuckerberg's online community of Harvard University students rapidly expanded; in the early weeks, thousands from the Boston area signed up. By the summer, Facebook.com was incorporated and making waves in the online world. Rejecting acquisition bids from some of the industry's biggest players – including $1 billion from Yahoo – Facebook continued to grow until, by September 2006, anyone over 13 years old could join. By the end of the decade, Facebook had become the world's largest social network, with over 400 million users.

Now attracting users of all ages, in 2004 the social network Facebook came out of left-field to transform the way people interact online.

194

Young girls in Tehran wait while their mothers cast votes for the Iranian parliament.

Iranian President Mohammad Khatami's seven-year campaign for social and political reform ended abruptly with the 2004 parliamentary election. Since 2000, change in Iran had been thwarted by an increasingly powerful bloc of conservative elements.

In January the ruling Guardian Council disqualified around 2,500 candidates from running in the election, including reformist leaders of parliament. This divided Khatami's movement: some called for a boycott, others encouraged high voter turnout to confront their

opponents. But almost two-thirds of the first-round seats were won by the conservatives at the 20 February election, demonstrating the enormous disillusionment and disengagement among Iranian voters, many of whom stayed at home on voting day.

Every year, just before Lent, Rio de Janeiro is transformed by a rhythmic mass of glittering, heaving bodies as Carnival takes over the city. For four nights, thousands of sequined dancers from each of the city's principal samba schools dance along the Sambadrome, an 85,000-seat parade ground in downtown Rio, in a fierce competition that has become a centrepiece of Brazil's cultural identity. In this photograph, the Salgueiro School showcases some of its carefully choreographed work for the 2004 pageant, which was ultimately won by the artistically extravagant Beija-Flor School from Nilópolis. The following year, the Samba de Roda of the Recôncavo of Bahia was added to the UNESCO list of Intangible Cultural Heritage of Humanity.

A long exposure transforms samba dancers into whirling dervishes.

After years of unregulated industrial emissions that included the 1986 Chernobyl nuclear power plant disaster, Ukraine was saddled with a number of environmental problems, in particular high industrial pollution. On 4 February 2004, the Ukrainian parliament agreed to ratify the Kyoto Protocol, the international treaty amendment aimed at combating global warming by stabilizing the level of global greenhouse gas emissions. Just a few weeks later, in what seemed a reward for Ukraine's progress on climate change mitigation, Kiev enjoyed a brief spell of unseasonal warmth, bringing the best out of local residents, who stripped off in the sunshine.

Residents of Kiev enjoy a positively balmy winter's day as temperatures soar to -3 °C (27 °F).

196

A frightened young boy grabs what he can as chaos descends on Port-au-Prince in Haiti.

In February 2004 the long-suffering Caribbean nation of Haiti – the poorest in the Western hemisphere – became engulfed, once again, in chaos and violence. Against a backdrop of acute economic hardship and social discord, efforts to broker a settlement between the governing party, led by President Jean-Bertrand Aristide, and a coalition of opposition groups failed to yield results. Rebels seized the northern half of Haiti and the president, allegedly under US pressure, was forced to resign and flee the country. Within weeks UN peacekeepers were on the ground. The year marked the 200th anniversary of Haiti's independence.

At the 76th Academy Awards, *The Return of the King* won 11 Oscars, including Best Picture and Best Director, bringing the total for the *Lord of the Rings* saga to an astonishing 17 awards. Years in development, it seemed fitting that the trilogy, once considered a metaphor for World War II, should emerge during the War on Terror, a conflict often framed as a battle between the forces of good and evil. Director Peter Jackson was able to recreate J.R.R. Tolkien's world of hobbits, orcs and wraiths using advanced computer simulation technology, and the help of the New Zealand Defence Force, who fought in the epic battle scenes.

At the Academy Awards in Hollywood, director Peter Jackson proudly shows off one of his many Oscars received for *The Return of the King*.

The morning after the night before: the remains of the Junko Shimada party at the Hôtel de Crillon, held during Paris Fashion Week.

199

Lars Tunbjörk is known for capturing life's absurdities in his vivid reportage work. In this award-winning photograph he juxtaposes the glamour of Paris Fashion Week with its hidden tedium, exposing the seamier side of the sartorial circuit. As always, Paris Fashion Week was a whirl of parties and celebrity engagements. The remnants of this party at the Hôtel de Crillon barely give a hint as to the identity of the host – in this case, it was the eccentric Japanese designer Junko Shimada, whose avant-garde pieces draw on both a colourful opulence and an experimental futurism.

During the annual Ashura holy rites festival, devout Shi'as strike themselves with swords and chains to atone for the martyrdom of Husayn ibn Ali (Imam Hussein), grandson of the Prophet Mohammed, in AD 680. It was the murder of Husayn's father that gave rise to the schism within Islam between Sunni and Shi'a. In Shi'a-dominated Iran the Ashura religious festival was commemorated annually, but in neighbouring Iraq, which also has a majority Shi'a population, it had been banned for decades by Saddam Hussein.

200

In the deadliest attacks in Iraq since the end of major combat operations was declared by US President George W. Bush in May 2003, more than a hundred people were killed in coordinated bombings in Baghdad and the holy city of Karbala on Ashura, the holiest day in the Shi'a Muslim calendar. A series of blasts tore through throngs of Shi'as as they gathered at holy shrines to perform Ashura rituals. The government blamed extremists loyal to Abu Musab al-Zarqawi, who had orchestrated previous sectarian attacks on Shi'as in a campaign to destabilize Iraq and the US-led occupation.

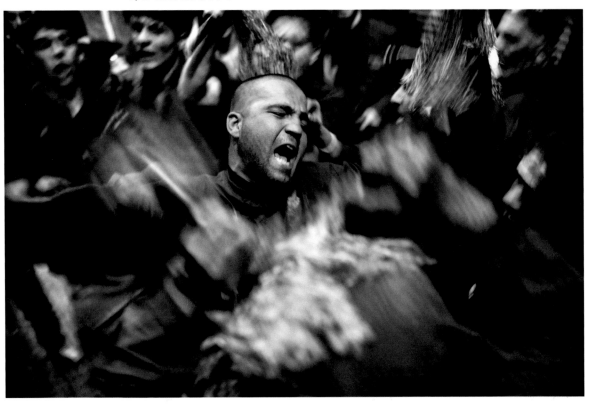

Devout Shi'as whip themselves into a religious fervour during a holy festival in Tehran.

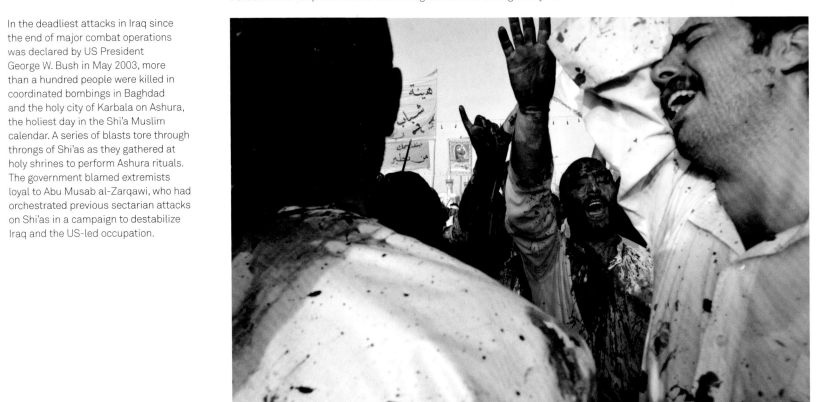

Terrorist atrocities kill scores of faithful in Karbala, a city holy to Shi'a Islam.

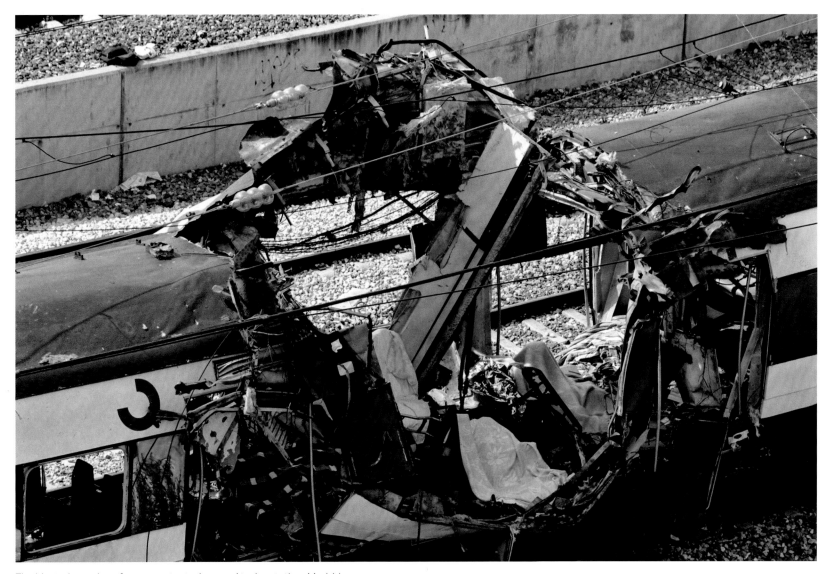

The blasted remains of a commuter train near Atocha station, Madrid.

A series of coordinated bomb attacks on Madrid's commuter trains unleashed torrents of grief and fury as Spain struggled to come to terms with the extent of the devastation. Nearly 2,000 civilians were injured and 191 killed by 10 improvised explosive devices, detonated during the morning rush hour. Uncertain of the identity of the perpetrators, the ruling conservatives blamed the Basque terrorist organization ETA for the attack. However, it later became clear that Islamic extremists had masterminded the plot. Although there was no evidence to suggest the direct involvement of Al Qaeda, the incident was considered 'Spain's 9/11'.

202

Luciano Pavarotti takes his curtain call after his final performance of Puccini's *Tosca* at The Metropolitan Opera, New York.

Luciano Pavarotti was one of the world's greatest tenors. His 40-year career won him numerous accolades, for his oft-emulated rendition of Puccini's 'Nessun Dorma' and, in particular, for his ability to hit the high Cs in Donizetti's *La Fille du Régiment*. His last opera performance was at New York's Metropolitan Opera on 13 March 2004, though his final public show was to be a performance of his trademark aria at the 2006 Winter Olympics in Turin, before he succumbed to cancer the following year. In 2008, the conductor Leone Magiera disclosed that the 'live' performance had been faked, with both the star and the orchestra having pre-recorded their parts. This revelation, however, did little to taint the great singer's legacy.

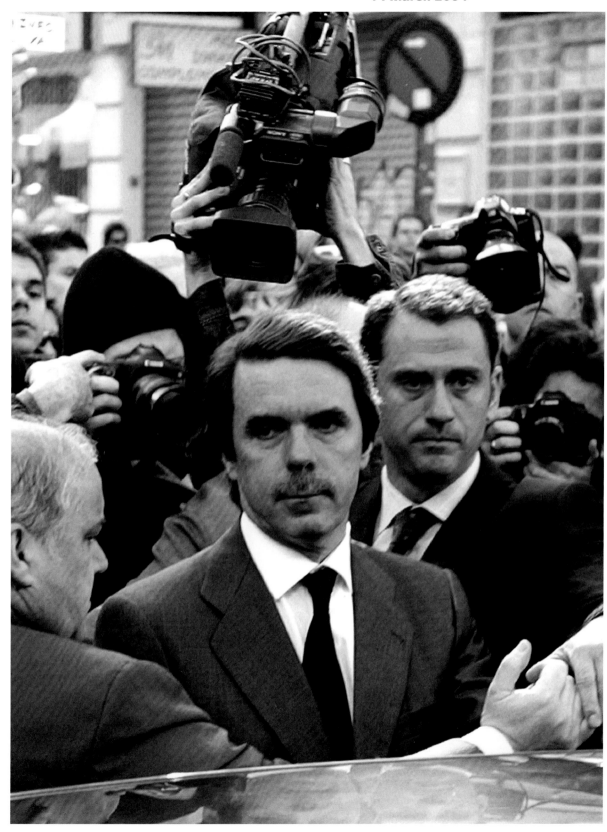

The centre-right Partido Popular (PP) had been the expected winner of Spain's general election until the atrocities in Madrid on 11 March 2004 altered the political landscape. Two million people demonstrated in the city, angry at the mishandling of the crisis, in which José María Aznar's PP government hastily – and mistakenly – blamed ETA for the bombings. Aznar's support for the Iraq War and the Bush coalition was raked over in the press, in unfavourable comparison with the opposition candidate's anti-war ticket. In a spectacular change of fortune, José Luis Rodríguez Zapatero's socialist party was elected with a relative majority. Within a few weeks, the new premier ordered the return of Spanish troops from Iraq.

203

Spanish Prime Minister José María Aznar casts a vote for his doomed administration.

In a landmark move, the Republic of Ireland became the first country in the world to ban smoking in enclosed spaces. Intended to mitigate the deleterious effects of passive smoking, the ban also applied to pubs and restaurants – both at the heart of Irish social culture. Despite fears of widespread opposition, there was little resistance and a year later a *British Medical Journal* study found that pub workers' exposure to harmful chemicals had fallen by 80 per cent. Having braved the displeasure of ardent smokers and libertarians, the Irish ban was hailed a success, and other countries soon followed suit.

An Irishman observes the new smoking ban by enjoying his tobacco outside the pub.

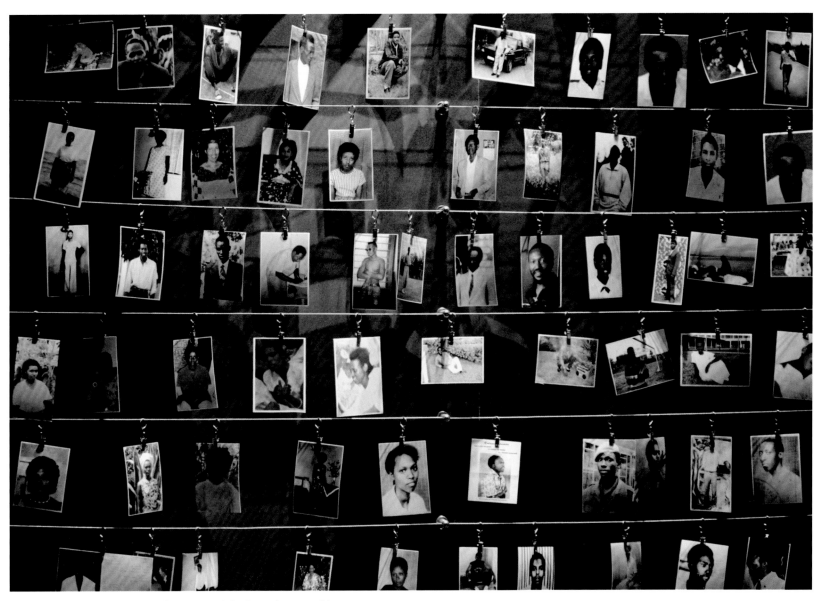

A simple but poignant memorial for victims of the Rwandan genocide.

In April the Kigali Memorial Centre opened in Rwanda. The opening marked the 10th anniversary of the genocide that engulfed the tiny central African country in the spring of 1994. Some 250,000 of the roughly 800,000 Tutsis and moderate Hutus who perished at the hands of Hutu extremists were buried in mass graves in what became the grounds of the memorial centre. Rwanda's president, Paul Kagame, who led the army that liberated the country and ended the genocide in 1994, used the 10th anniversary to publicly condemn the international community for failing to prevent the slaughter.

206

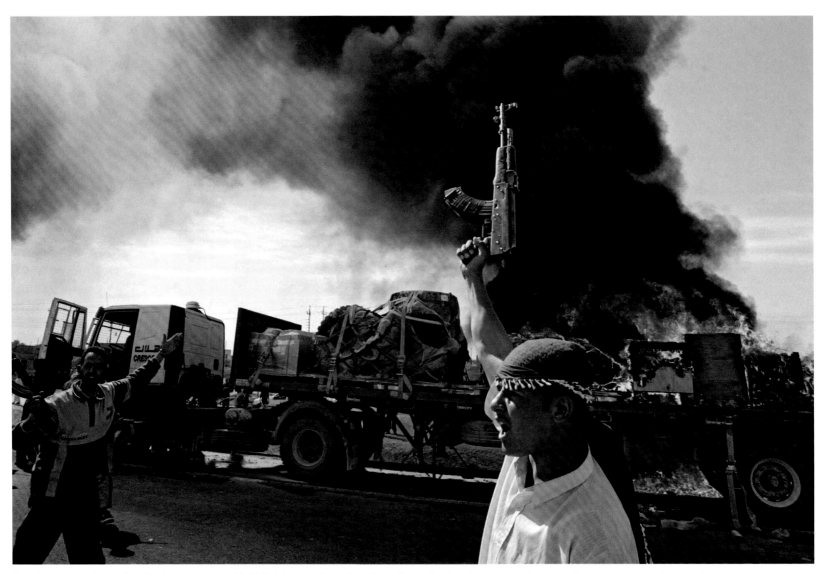

Sunni militants cheer a burning US convoy outside Fallujah, one of a series of attacks as the American occupation turns into a war among the people.

On 31 March 2004 a convoy of US contractors was ambushed by insurgents in the city of Fallujah, 64 kilometres (40 miles) west of Baghdad. The rebels killed four of the contractors and dragged their mutilated corpses through the streets. The grisly incident prompted a US operation to retake control of the city, which had become a hotbed of Sunni resistance to the occupation of Iraq. Codenamed Operation Vigilant Resolve, the engagement was a disaster for US forces. Their allies, the Fallujah Brigade, led by a former Baathist general, were given chief responsibility for the attack, but they soon collapsed, leaving the city in the hands of the Sunni fighters.

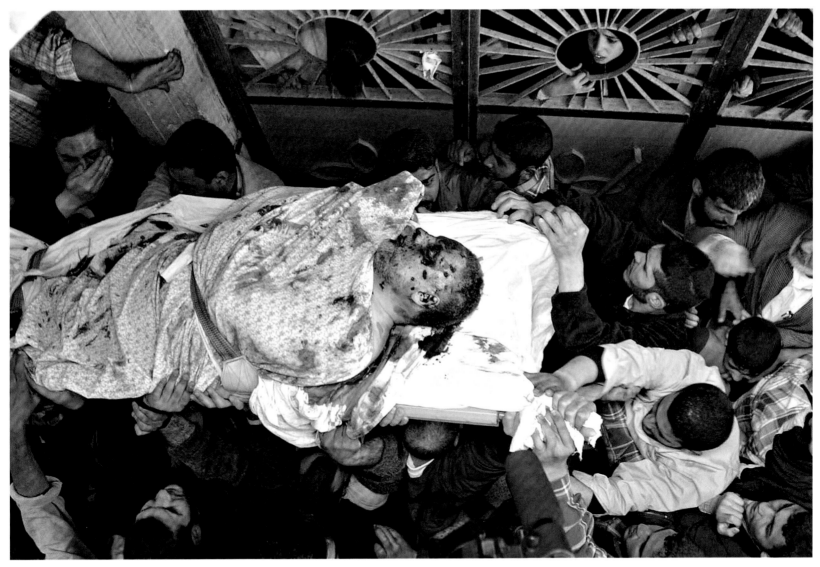

The shattered corpse of Hamas leader Abdel Aziz al-Rantissi is carried by Palestinian mourners in Gaza, the day after his assassination.

207

An outspoken Palestinian activist, Abdel Aziz al-Rantissi was briefly leader of Hamas until his assassination by Israeli security forces on 17 April 2004. Born near Jaffa, he became a refugee in Gaza with his family in 1948. He was an outspoken opponent of Israel, arguing that Palestinians had the right to resist by all means – including the suicide bombing of civilians – and declaring that such acts were not terrorism. His killing was part of a wider Israeli policy of 'targeted assassination' of militant leaders in the West Bank and Gaza. Israel insisted that it would continue to strike not only those who had carried out attacks, but also those who were planning such attacks.

208

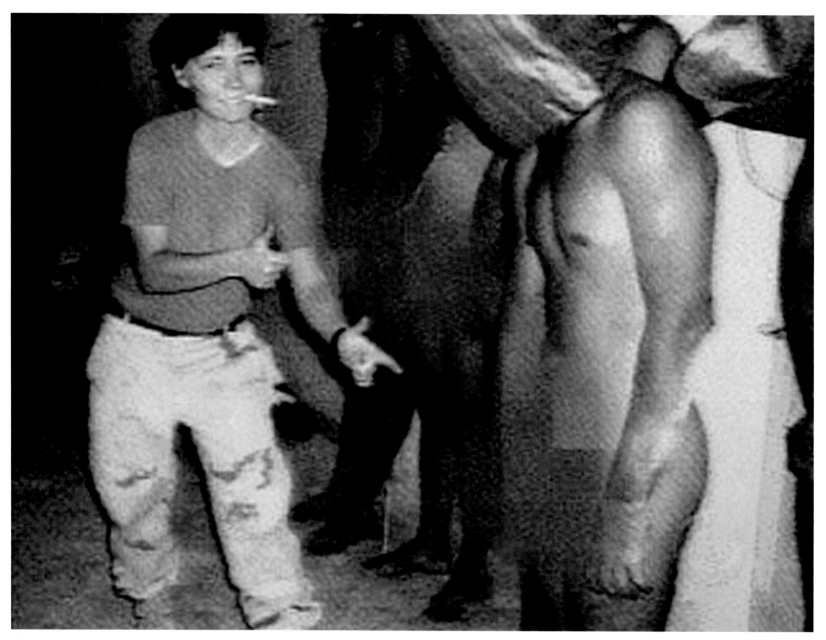

US Army Private Lynndie England (left) and her colleagues document their abuse of Iraqi prisoners at the notorious Abu Ghraib prison.

In late April 2004 the scandal of Baghdad's Abu Ghraib prison was publicly exposed after photographs of US soldiers torturing Iraqi prisoners were broadcast on the CBS news programme '60 Minutes'. The depictions of physical, psychological and sexual abuse severely damaged the international reputation of the United States, especially in the Muslim world. Several soldiers were convicted in courts-martial, sentenced to military prison and discharged from service, although many claimed they were only following guidelines set by their superiors. Later investigations into so-called 'extreme interrogation techniques' used on detainees revealed that controversial practices were in use not only at Abu Ghraib but also at US military bases in Iraq, Afghanistan and Guantánamo.

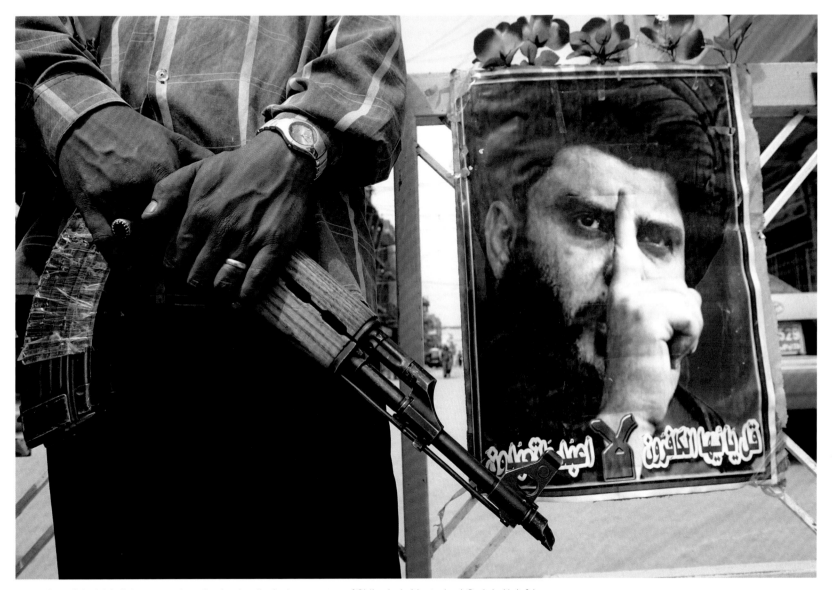

A member of the Mahdi Army guards a checkpoint displaying a poster of Shi'a cleric Moqtada al-Sadr in Najaf, Iraq.

The radical cleric Moqtada al-Sadr rose to prominence after the fall of Saddam Hussein in 2003. Young and charismatic, he embodied a potent mix of Iraqi nationalism and Shi'a radicalism which drew a vast number of Shi'a followers, especially among the poor.

He called for nation-wide armed resistance against occupying forces, led by his fiercely loyal militia, the Mahdi Army. The militia was ostensibly created to protect the Shi'a religious authorities in Najaf, which saw weeks of heavy fighting in 2004 after al-Sadr led

uprisings against US forces based in the holy city. At the same time, he was also increasingly drawn into the political process and appeared to seek a role for himself within the new, US-supported government.

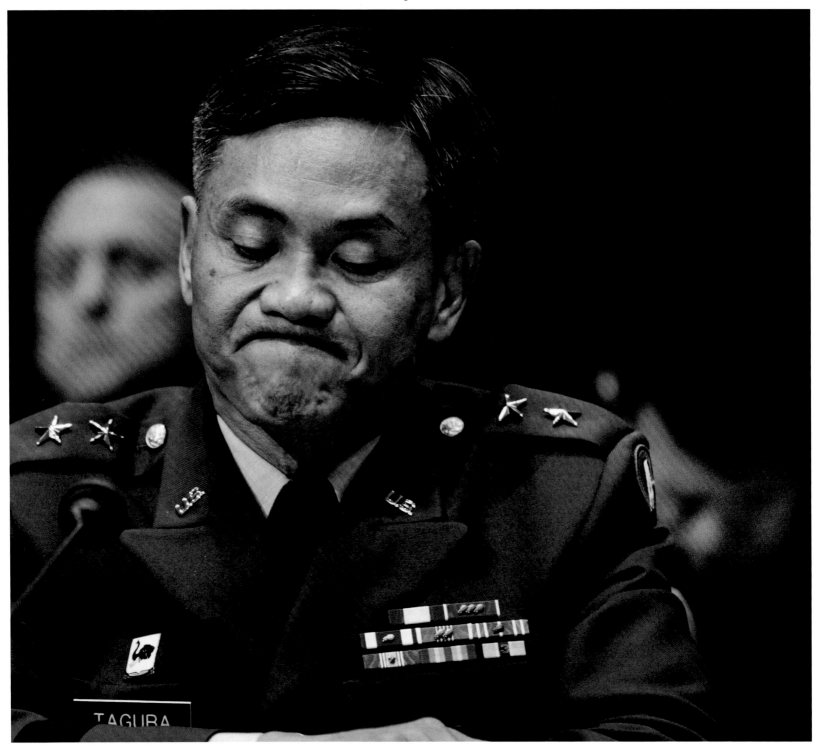

210

General Taguba seems lost for words at the US Senate hearing into the Abu Ghraib scandal.

In January 2004, Major General Antonio Taguba was appointed to inquire into the alleged abuse by US military personnel of detainees held at Baghdad's Abu Ghraib prison. His highly critical internal report for the US Army – later known as the Taguba Report – was issued, then leaked, in March. Taguba appeared before the US Senate in May to give further evidence. In his report he accused US soldiers of 'egregious acts and grave breaches of international law' and he documented a litany of 'sadistic, blatant and wanton criminal abuses'.

After just six months in Iraq, contractor Nick Berg is abducted by Al Qaeda, who record on video his last moments before his execution.

Nick Berg travelled to Iraq in December 2003 to secure contract work for his company, which inspected and rebuilt communication antennas. Drawn by lucrative work opportunities, the 24-year-old from Pennsylvania joined legions of foreign technicians, businessmen and security personnel who flooded into the country following the collapse of Saddam Hussein's regime. In May 2004 Berg was abducted by an Al Qaeda-affiliated group and, in apparent retaliation for the abuse and torture of Iraqi captives at Baghdad's US-run Abu Ghraib prison, he was beheaded. According to CIA sources, Abu Musab al-Zarqawi, leader of Al Qaeda in Iraq, personally committed the execution. Millions viewed a videotape of the gruesome killing on the internet.

212

In Provincetown, Massachusetts, a gay couple celebrates their wedding.

On 17 May, Massachusetts became the first US state to issue same-sex marriage licences, following a landmark ruling by the state's Supreme Judicial Court the previous November. A thousand applications were made on the first day, and a number of weddings even took place, including that of Julie and Hillary Goodridge, who led the fight for gay marriage in the state. The development sparked a wave of opposition across the United States: two months earlier, President George W. Bush had endorsed a constitutional amendment to restrict marriage to heterosexual couples. By the end of the year, amendments had been passed in 11 states, galvanizing conservative voters and proving a trenchant issue in the Bush re-election campaign.

Though he is marrying a commoner, none of the pomp is spared for Spanish Crown Prince Felipe's royal wedding.

213

It had been nearly a hundred years since the last royal wedding in the Spanish capital but, on 22 May, Madrid was awash with well-wishers and supporters as the heir apparent Prince Felipe wed Letizia Ortiz, former news broadcaster and now Princess of Asturias.

Married in the Almudena Cathedral, the couple paid homage to the victims of the recent train bombings, dedicating their wedding mass to those who lost their lives. International royalty and foreign leaders joined prominent Spanish guests at the ceremony, as Letizia

became the first Spanish-born future queen in over a century, and the first commoner ever to be in line to the throne.

Taking his oath of office in New Dehli, Manmohan Singh prepares to steer the world's largest democracy.

214

The National Congress party won a surprise victory over the Bharatiya Janata Party, the party of the serving prime minister, in India's May 2004 election. Many expected Sonia Gandhi, president of the Indian National Congress party, to form a government. However, a closed-door meeting of the Congress parliamentary party led to the nomination of Dr Manmohan Singh, an economist and former finance minister, which was accepted by the president shortly afterwards, despite protests by Congress followers aimed at securing Gandhi's premiership. On 22 May, Singh was formally inaugurated as the 14th Indian prime minister and the first Sikh leader of the Hindu-dominated country.

It was described as a tragedy for contemporary art. The blaze at the Momart warehouse in east London burned for hours, spreading over an area the size of a football pitch. Many valuable and controversial works were lost, including significant works by the late Patrick Heron and 'Britart' pieces such as Tracey Emin's Turner Prize-nominated *Everyone I Have Ever Slept With 1963–1995* from Charles Saatchi's multimillion-pound collection. In all, 50 years' worth of British art was destroyed. Not all the art was irreplaceable, however: the Chapman brothers set about recreating their lost artwork, a diorama of torture and murder entitled *Hell*, just a few months later.

An east London warehouse containing a priceless store of British contemporary art is left gutted after a fire.

215

Ronald Reagan died on 5 June 2004, at the age of 93. As the 40th President of the United States (1981–9), he emphasized liberal free-market economics and a bold stance against the Soviet Union during the last decade of the Cold War. An optimistic and charismatic man, he had been nicknamed 'the great communicator'. In 1994 he publicly announced that he was suffering from Alzheimer's disease. Following his death 10 years later, he lay in state in Washington DC's Capitol Rotunda, where 100,000 members of the public paid their respects. At his funeral, world leaders filled the National Cathedral, among them Mikhail Gorbachev, the Soviet Union's last leader.

Former first lady Nancy Reagan pays her last respects to her husband Ronald, lying in state in the Capitol Rotunda in Washington, DC.

The wounded are rescued after an insurgent bomb goes off in Baghdad.

The powerful car bomb that ripped through a convoy of 4×4 vehicles in Baghdad on 14 June typified the insecurity in Iraq just two weeks before the formal handover of sovereignty from the occupation authority to a new Iraqi government. A suicide bomber detonated the device as a group of international contractors, working on the failing electricity grid, drove past. Twelve people were killed in the attack, with the injured picked up off the street by passers-by and driven to hospital. Illustrating the widespread resentment at the occupation, angry crowds soon formed around the bombsite, chanting anti-American slogans.

To its opponents, it was an 'apartheid wall' – a shocking example of Israel's arrogance and flouting of international conventions. To its supporters, it was the 'security fence' – a series of obstacles designed to stem the tide of suicide bombers and terrorists hitting Israel. This gulf in interpretation of the barrier's objectives mirrored the impasse in peace negotiations. Palestinians clashed with Israeli security forces, incensed at the barrier's annexation of areas of Arab land, especially near Jewish settlements. Many Palestinians found themselves on the wrong side of the barrier – in Israeli territory. On 30 June the Israeli Supreme Court ruled that a portion of the barrier was illegal and that it be rerouted, but that otherwise the measure separating Israel from Palestine was legal.

217

An Israeli border policeman fires tear gas at Palestinians protesting against Israel's wall, near Az-Zawiya in the West Bank.

218

In a preliminary hearing, Saddam Hussein angrily contests the charges laid against him in an Iraqi courtroom.

The former Iraqi dictator was defiant throughout his year-long trial, boycotting proceedings that he claimed made a mockery of international and Iraqi law. The dramatic hearing included moving testimonies from witnesses about the scale of torture and extra-legal activities under his regime, as well as the assassination of a number of Saddam's defence lawyers. Found guilty on 5 November 2006 for the massacre of 148 Shi'as in Dujail in 1982, Saddam was sentenced to death by hanging, despite requesting a soldier's death by firing squad.

Once 'the baddest man on the planet', a dazed Mike Tyson hits the canvas.

England's Danny Williams stunned the boxing world in July when he knocked out former world champion Mike Tyson with a flurry of punches in the fourth round of their heavyweight fight in Louisville, Kentucky. Tyson started brightly, displaying some of the fearsome power that helped him become the youngest man ever to win the WBC, WBA and IBF world heavyweight titles. But the 38-year-old American ran out of steam as the fitter Williams went on the attack. Although he was to fight one last time, Tyson's fifth defeat signalled the end of the career of one of boxing's most intimidating and controversial figures.

Disciplined workers at morning assembly in an air-conditioning factory, Changsha, China.

China's Communist Party based its legitimacy on the promise of economic prosperity and rising standards of living. Emerging as the world's fourth-largest economy, China had experienced year-on-year growth of 10 per cent throughout the decade. Fuelled by investment and exports, it pulled millions of people out of poverty and secured its place among the leaders of the global economy, although reliance on foreign consumers and narrow sectors of the economy led to concerns of 'overheating' at the start of 2004. Nevertheless, end-of-year figures showed that the success story was far from over, as the National Bureau of Statistics reported economic expansion of a staggering 9.5 per cent.

Despite their valiant efforts, these volunteers fail to rescue this beached humpback whale.

With its long pectoral fins and knobbly head, the humpback whale is a prince of the ocean. Once nearly hunted to extinction, humpbacks are no longer endangered; nevertheless, the death of a young male, over 9 metres (30 feet) long and weighing about 10 tonnes, resonated with many around the world. When he washed up on Jurujuba beach by Rio de Janeiro, scores of rescue workers tried for three days to tow the whale back to sea, but their effort was no match for the giant's dead-weight. Scientists believe the whale had grown tired during its annual swim from the Antarctic to warmer breeding waters.

222

A household name in kitchens across North America, Julia Child (shown here in one of her cookery shows) dies at the age of 91.

Nicknamed 'Our Lady of the Ladle', Julia Child was the first and best-loved American TV chef, encouraging a whole generation to attempt French cooking. Her translation of classic French recipes – sole meunière, boeuf bourguignon, French onion soup – into foolproof formulas for home-cooking transformed the way Americans approached and prepared food. Forty years later, *Mastering the Art of French Cooking* – her epic introduction to cordon bleu cookery with Simone Beck and Louisette Bertholle – was still a bestseller. Child died at the age of 91 on 13 August 2004, still beloved by a legion of fans. A Julia Child biopic, starring Meryl Streep, was released in September 2009, charting the efforts of Julie Powell, who made all 524 recipes from *French Cooking* over the course of one year.

223

Public health officials dressed in protective gear prepare to tackle bird flu at a poultry farm in Ayutthaya, Thailand.

The world's fourth-largest chicken exporter, Thailand finally admitted to the presence of avian flu in January 2004, two months after chickens had started dying in the north of the country. Thailand had claimed that the milder disease of chicken cholera had infected its birds, but with 6 million slaughtered and two human cases, it joined Cambodia, Indonesia, Korea, Japan and Vietnam in seeking a coordinated solution to what had quickly become a serious outbreak. Widespread destruction of infected chickens began in an attempt to root out the epidemic. However, in September, the first death from human-to-human transmission was reported in Thailand, raising fears of a lethal mutation.

Kelly Holmes did not follow the usual path to Olympic glory. She initially settled on a career in the army, but in 1992 she saw a former opponent of hers from her junior running days, racing in the Barcelona Games – and decided to once again run competitively. Holmes's career had been blighted by injury and she had also suffered bouts of depression. Many thought her a great underachiever. At the Athens Games she defied her critics, winning gold in the 800 metres, not her main event, and repeating the win in the 1,500 metres. She was the first British female runner to win two gold medals at the same Games. At her homecoming parade in Tonbridge, Kent, 40,000 fans turned out to celebrate her victory.

British runner Kelly Holmes winning the first of two gold medals at the Olympics in Athens.

224

One of the original endurance events returned to its spiritual home with the 2004 Athens Olympics: organizers set the start of the marathon in the town and site of the ancient battle that lent its name to the race. The men's event, however, was marred by an unfortunate incident. The leader of the field, Vanderlei de Lima of Brazil, was tackled by a spectator – Cornelius Horan, an Irishman who had disrupted other sports events with his Messianic protests. Shaken, De Lima lost his lead soon after restarting and finished third. But the International Olympic Committee rewarded his perseverance, awarding him the Pierre de Coubertin medal for sportsmanship at the conclusion of the Games.

A protestor tackles Brazilian Vanderlei de Lima as he leads the Olympic marathon.

During the summer of 2004, swarms of desert locusts from North Africa invaded the Sahel zone and West Africa, causing widespread damage to crops. The plague was the largest in 15 years and threatened to destroy a sizeable portion of Africa's food supply. One swarm in Morocco measured 230 kilometres (143 miles) in length and contained an estimated 69 billion locusts. Lack of rain and cold temperatures in the winter breeding area, together with strict pest control methods, enabled locust control agencies to halt the cycle in early 2005, but not before an estimated $2.5 billion worth of food harvests had been lost.

In Dakar, Senegal, a swarm of locusts provide amusement – and perhaps a meal – for two local boys.

Chaos at a school in Beslan, northern Ossetia, as Russian commandos try to rescue hostages.

226

On 1 September 2004, Chechen terrorists demanding the withdrawal of Russian troops from their homeland seized School Number One in Beslan, a town in northern Ossetia. More than 1,000 hostages were packed into the school's gym in appalling conditions: without food and water, hostages were forced to drink their own urine. Russian special forces stormed the building on the morning of 3 September. In the ensuing gun battle and a fire in which the gym burnt down, 331 people were killed, nearly 200 of whom were children.

The Russian President Vladimir Putin condemned the siege as an act of 'international terror', seeking to distance the incident from the Chechen conflict.

American photographer Richard Avedon's subjects ranged from drifters to Marilyn Monroe, from coal miners to Truman Capote and Dwight D. Eisenhower to Andy Warhol, but they were all unmistakably taken by the same hand – typically a frontal view, unflinching portraits, mostly in black and white, with a neutral background and the black frame of the film visible. These stark and revealing portraits made Avedon one of the most important American portrait photographers of the twentieth century. Thanks to his iconic work for *Harpers Bazaar*, where he worked closely with graphic designer Alexey Brodovitch, and *Vogue* over a period of over 40 years, he also revolutionized fashion photography. His most important books were *Observations* (1959), a collaboration with Truman Capote, and *Nothing Personal* (1964), with text by James Baldwin. The 1957 film *Funny Face* with Fred Astaire and Audrey Hepburn was based on his career.

227

Renowned photographer Richard Avedon, seen here in 1979, dies in San Antonio, Texas, while on assignment for *The New Yorker*.

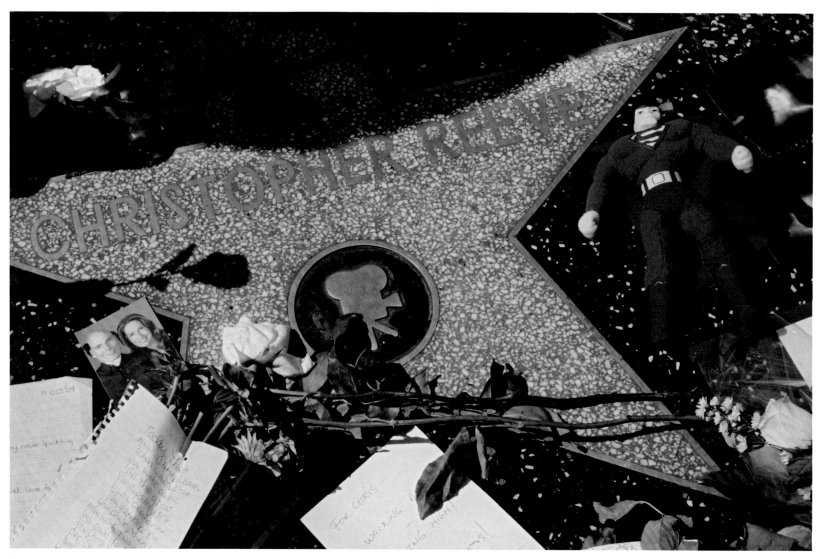

Saddened fans pay tribute to Christopher Reeve, who had defied paralysis in his later years.

228

Christopher Reeve, the actor and director best known for his portrayal of Superman in the Hollywood film series, died on 10 October. Reeve had been a quadriplegic since a horse-riding accident in May 1995 shattered his first and second vertebrae.

He died of a heart attack following systemic infection from a pressure wound. Famed for his turn as the 'Man of Steel', Reeve had gone on to win acclaim for his activism, in particular his advocacy for spinal cord injury research. During his later years he lobbied

the US Congress many times over the issue of stem-cell research funding and, with his wife, founded the Christopher and Dana Reeve Paralysis Foundation.

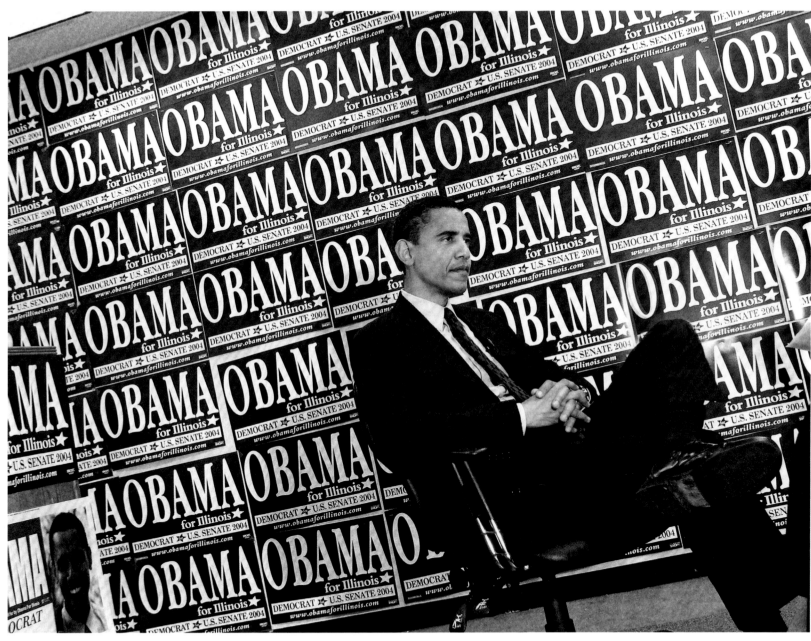

A star on the rise: Democratic candidate for the Senate Barack Obama meets with trade unionists in Bloomington, Illinois.

229

Little known outside Illinois, Barack Obama was catapulted into the limelight on winning a landslide victory in the US Senate election on 2 November. Having previously served in the state senate for three consecutive terms, Obama had made a name for himself as a charismatic politician, committed to dissolving partisanship and improving race relations, as well as delivering healthcare reform. A big win at the primary stage earlier in the year had raised Obama's profile as a bright young star in the Democrat Party; his popular speech at the July national convention assured his career trajectory. Obama became the only serving black US Senator, the fifth African-American holder of the post in the country's history.

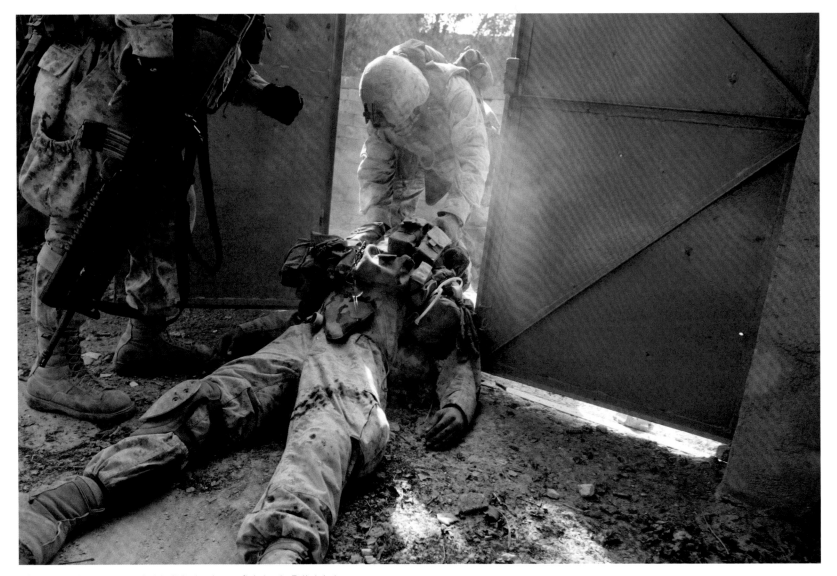

US Marines 'leave no man behind' during heavy fighting in Fallujah, Iraq.

230

Following their abortive attempt to recapture the insurgent stronghold of Fallujah in April 2004, US forces launched a new operation to retake the city in November. Operation Phantom Fury involved heavy bombardment of the city by artillery and attack jets.

Nearly a hundred US troops and more than 1,350 insurgent fighters were killed in the operation. US forces used highly controversial weaponry in the battle, including white phosphorus, and some soldiers were alleged to have committed indiscriminate violence

against civilians and children. Once the Second Battle of Fallujah ended, insurgents' bomb-making factories and beheading chambers were discovered in the shattered city.

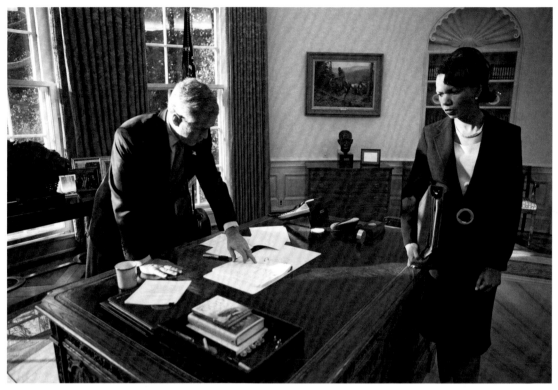

On 16 November, US President George W. Bush named Condoleezza Rice his secretary of state. By his own admission, Rice had taught Bush everything he knew about foreign affairs. Born and raised in segregated Alabama, Rice was a precociously talented youngster. She entered university early, earmarked for a career as a concert pianist, but eventually took a doctorate in political science and became an academic at Stanford University. Her time as an advisor in Bush Sr's administration (1989–93) paved the way for her return to Washington in 2001 as Bush's national security advisor. Her nomination as secretary of state was confirmed by the US Senate on 26 January 2005 despite opposition from some Democratic senators who accused her of telling lies to justify the invasion of Iraq.

Condoleezza Rice is nominated as the first African-American female US Secretary of State, seen here with President George W. Bush in the Oval Office.

231

Formerly a Soviet Republic, Ukraine had struggled to assert its autonomy from Russia after the USSR's collapse. In 2004, Viktor Yushchenko, the former prime minister and leader of the opposition, ran in the presidential election against the incumbent prime minister. On 6 September, Yushchenko was admitted to hospital with a number of medical complaints but doctors were unable to identify the cause and he returned to the campaign a week later, his face pockmarked. Yushchenko had, allegedly, been poisoned; later tests confirmed traces of dioxin in his system, although claims of falsified blood tests dogged Yushchenko for years. Nevertheless, following two runoff elections and Ukraine's Orange Revolution, Yushchenko won the presidency on 26 December.

Viktor Yushchenko the day after a disputed presidential runoff ballot. His ravaged features are testament to the attempt on his life.

The graceful Millau Viaduct hangs in the air across southern France, up to 343 metres (1,125 feet) at its highest point.

The Millau Viaduct, the tallest vehicular bridge in the world, was formally inaugurated on 14 December, and opened to traffic two days later. Like an elegant sculpture, the bridge spans the valley of the Tarn River, affording motorists a sensational view of southern France. Supported by cables, the bridge has seven masts, one of which is higher than the Eiffel Tower. Designed by structural engineer Michel Virlogeux and architect Norman Foster, the bridge took three years to build – a massive feat of construction that used a hydraulic wedge system to slide the bridge 'deck', piece by piece, from each plateau until it met in the middle, creating an airborne thoroughfare.

'The art of invisibility': artist Agnes Martin is photographed in 1991, with one of her minimal line paintings.

Agnes Martin was an American painter of Canadian birth, whose abstractions, often in pencil and pale washes, have been credited with influencing the US minimalist movement, though she regarded herself as an abstract expressionist. Fine straight lines are executed by hand so that each grid composition contains subtle irregularities. The marks give Martin's work a sublimely balanced air, described by poet and art critic Nicolas Calas as the 'art of invisibility'. Inspired by Eastern philosophical ideas about humility and the suppression of ego, and the spare landscape of New Mexico where she later settled, her paintings encourage serene meditation. Martin chose a quiet life, distancing herself from fame and company. She died on 16 December at the age of 92.

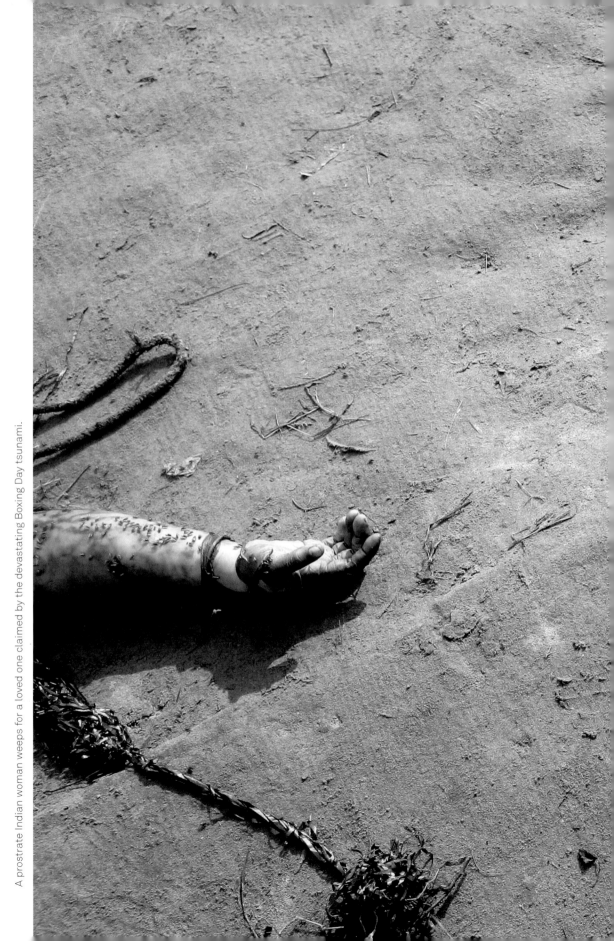

234

On the morning of 26 December 2004 an earthquake measuring 9.3 on the Richter scale struck off the coast of northern Sumatra. The upward thrust of the sea floor unleashed a devastating tsunami, which travelled across the Indian Ocean and shattered coastal communities in countries as far apart as Indonesia, Thailand, the Maldives, India and Somalia. It was one of the deadliest natural disasters in recorded history. More than 225,000 people were killed in 11 countries, with many bodies either being lost to the sea or remaining unidentified. Some low-lying coastal landscapes in the region were altered unrecognizably as the destruction obliterated roads, bridges and farmland several kilometres from the shore.

A prostrate Indian woman weeps for a loved one claimed by the devastating Boxing Day tsunami.

2005
Solace

The phenomenal devastation wreaked by the Boxing Day tsunami set a sombre tone for the new year. As candles commemorated those lost to the tempest, daily tragedies continued elsewhere. Although the worldwide public had rallied to staunch the humanitarian crisis in the Indian Ocean, support for Africa's millions of AIDS sufferers was not enough to stem the pandemic. The death of Nelson Mandela's son opened up debate on the taboo subject in South Africa, challenging misconceptions about the disease. Meanwhile, Iraq sought to embrace a new future by overturning 50 years of history with its first democratic parliamentary elections. The fragile sense of progress in Iraq contrasted sharply with events in Lebanon, where a massive bomb killed the former prime minister and plunged the country back into disarray in February. The ensuing Cedar Revolution brought thousands of civilians onto the streets to protest Syria's meddling. In the Vatican in Rome, crowds gathered for a very different purpose: to mourn the passing of Pope John Paul II at the largest funeral service in history. In July, London was also flooded with crowds, celebrating its successful bid to host the 2012 Olympic Games. The jubilation came to a swift end the next day when a series of terrorist bombings targeted commuters on the capital's public transport system, intended to punish the UK for its involvement in the Iraq War. As London tried to come to terms with the incident, British police introduced tougher measures to counter the terrorist threat, measures that cost a young Brazilian his life. On the other side of the world, religion-based conflicts in Israel, Palestine and Thailand claimed countless lives. However, these man-made horrors were put into perspective by yet another natural disaster, Hurricane Katrina, which engulfed New Orleans in a matter of hours. While the United States mourned the tragedy in public, the repatriation of soldiers' bodies from Iraq and Afghanistan was done silently. Although Washington may not have wished to confront the true cost of the two US-prosecuted wars, the death of 1,000 Iraqis in a Baghdad stampede following a rumoured suicide attack was a sad indictment of the persistent fear and insecurity there. The impact of the War on Terror was also felt in Indonesia, as another wave of bombings ripped through Bali in October. In the same month, India and Pakistan put aside their enmity to care for the victims of the Kashmir earthquake; the spirit of neighbourly cooperation was not, however, evident on the Chad–Sudan border in Africa, where increasingly deadly skirmishes threatened regional stability. As the year came to a close, new leaders elected in Liberia, Germany and Bolivia all broke the mould, promising a new approach to the enduring problems of the decade.

238

Nelson Mandela and wife Graça at the funeral of another victim of AIDS in Africa – Mandela's own son.

Nelson Mandela, the former South African president, broke one of Africa's most obdurate taboos when he revealed that his son, Makgatho, had died of AIDS. While in office Mandela was largely silent on the disease that affects millions of Africans, but in retirement he was one of the few statesmen on the continent willing to speak openly about the pandemic. In contrast, his successor Thabo Mbeki was roundly criticized for failing to openly acknowledge the link between HIV and AIDS earlier in the decade. Mandela announced his son's death at his Johannesburg home, continuing his campaign for greater awareness by calling upon South Africans to acknowledge AIDS as a 'normal illness'.

Fingers inked to prevent voter fraud, these women in Najaf have just cast ballots in Iraq's historic election.

239

On 30 January more than 8.5 million people turned out to vote in Iraq's first democratic election in more than half a century. Fears that election day would be marred by widespread attacks on polling stations proved largely unfounded: voter turnout was roughly 60 per cent and only sporadic incidents were reported across the country. The aim of the election was to elect members of a new 275-seat transitional National Assembly that would be in place until a new constitution was drafted. Most Sunni Arabs, however, who comprise about 20 per cent of the population, boycotted the election.

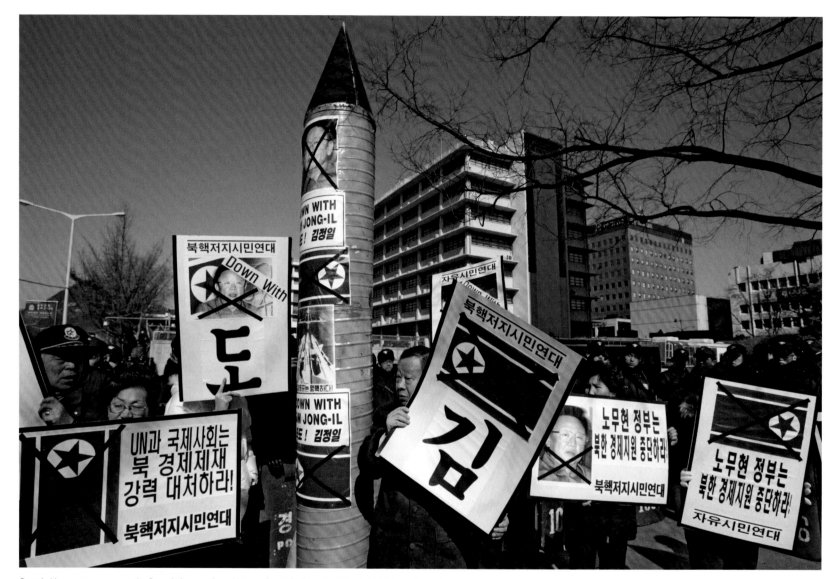

South Korean protestors in Seoul demand action against their communist neighbour's nuclear programme.

On 10 February efforts to forestall North Korea's development of nuclear weapons took a turn for the worse. The regime in Pyongyang announced to the world that it was now a nuclear power (though no actual warhead was tested). More importantly, it immediately withdrew from the international six-party talks on its weapons programme. North Korea blamed US belligerence for its decision – in particular, statements made by President George W. Bush and Secretary of State Condoleezza Rice. Observers familiar with the regime's past record on nuclear talks, however, saw it as another attempt by Pyongyang to extract economic concessions from China, South Korea and the United States.

A veritable slalom of fabric gates brightens up a wintry Central Park in New York.

241

The artists who had wrapped Paris's Pont Neuf in gold fabric and dotted Japanese rice fields with blue umbrellas returned to New York with their latest installation. Unfurled on 12 February, the public artwork by Christo and Jeanne-Claude consisted of 7,503 saffron banners arranged along a 37 kilometre (23 mile) serpentine trail in and among Central Park's woodlands and lakes. Flapping in the breeze, the gates took on different hues in the winter sunshine; thousands flocked to admire or ridicule the spectacle. In place for just 16 days, the project had been financed by the artists through the sale of preparatory sketches and artwork.

242

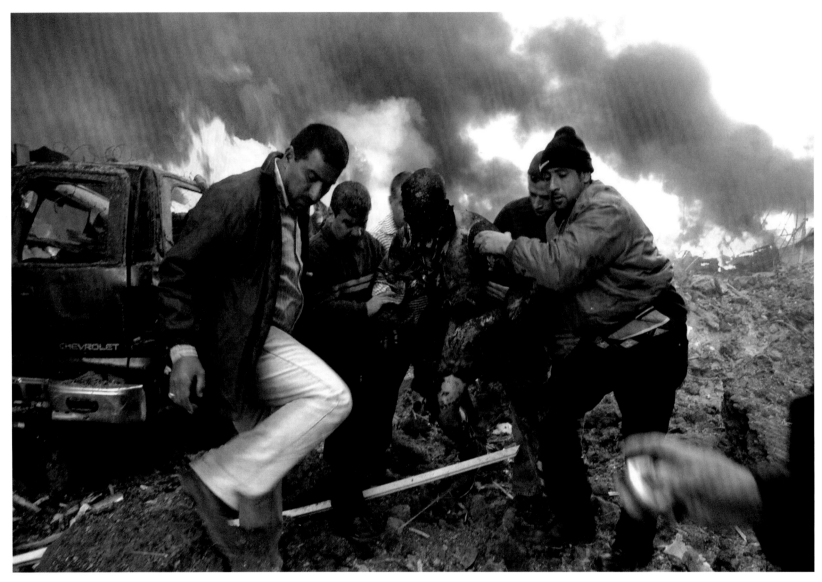

Horrific burns on this Lebanese man attest to the sheer power of the bomb that killed the country's former prime minister.

On 14 February, a massive bomb was detonated in an upmarket district of Beirut. Caught in the blast was Lebanon's former prime minister and the apparent target, billionaire Rafik Hariri. He and 21 others were killed. Many Lebanese instantly suspected Syria, which had great influence over the Lebanese government and 14,000 troops stationed in the country. The so-called 'Cedar Revolution' saw tens of thousands take part in protests against Syria's role in Lebanese politics. But this dredged up the old social divisions: pro-Syrian Lebanese, including Hezbollah supporters, launched counter-demonstrations. Although international pressure eventually forced Syria out of Lebanon, a further wave of political assassinations in Beirut demonstrated that Lebanese politics was still volatile.

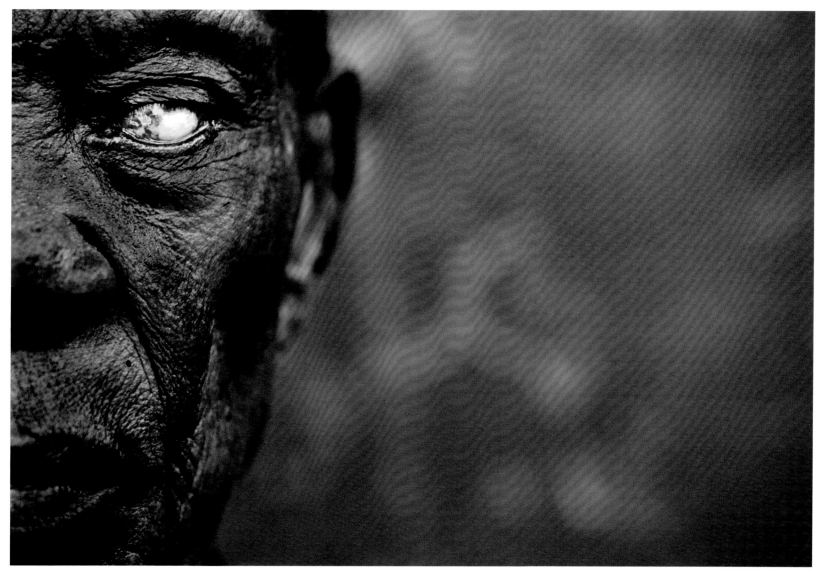

The disconcerting stare of a leper colony chief in eastern Liberia.

One of the oldest known human diseases, leprosy is still a major problem among the poorest communities of sub-Saharan Africa and Asia. If left untreated leprosy can leave sufferers deformed and crippled. One of the biggest hurdles to complete eradication worldwide has been the stigma associated with this chronic infectious disease which primarily affects the skin and nervous system, especially of the hands, feet and face. Liberia is one of several countries where pernicious myths about leprosy – namely, that sufferers are cursed or possessed – have endured. More recently, however, there has been a sharp rise in leprosy victims seeking treatment at health posts around Liberia, suggesting that attitudes towards the disease are finally starting to change.

A sombre memorial is held for four Canadian Mounties in Edmonton, Alberta, shot in the line of duty.

Michael Jackson and his father Joe leave a courthouse in Santa Maria, California.

In the worst single killing of Canadian police for more than a century, four officers of the Royal Canadian Mounted Police – Mounties, perhaps the best-known symbol of Canada – were shot dead on a remote farm in northwestern Alberta. They were investigating allegations of stolen property and a marijuana growing operation. The extremely rare deaths of Mounties in the line of duty thrust the country's comparatively liberal attitudes towards soft drugs use into the spotlight. US authorities expressed particular concern that 'the Amsterdam of the North' was now the biggest source of cannabis for US citizens.

The trial of Michael Jackson on multiple counts of child molestation began in Santa Maria, California, on 28 February 2005. Predictably, the world's media descended on the small Californian town and stayed throughout the sensational five-month trial, recording Jackson's every move. Hordes of (mostly) well-wishers also gathered each day to support and catch a glimpse of their flamboyant hero. His frequently bizarre showmanship, strange outfits and waning physical health ensured that Jackson was rarely off the front page. On 13 June the pop star was acquitted on all counts. The two years between the charges and his acquittal had taken a heavy financial, psychological and physical toll on Jackson. After the trial he relocated to Bahrain in the Gulf, as a guest of Sheikh Abdullah.

Four million Catholics descended on the Vatican to pay their last respects to Pope John Paul II, who died at the age of 85 on 2 April 2005. Kings, queens, presidents and prime ministers – as well as humble pilgrims – attended the largest funeral service in history. Born in Poland as Karol Jozef Wojtyla, John Paul II was the second-longest serving pontiff, having been elected in 1978. For many of the faithful, he was the only pope they had known. In his home country, the memorials were doubly poignant: not only had Poland lost a native son, it had lost a figure who had played a pivotal role in its struggle against communism.

245

Cardinals surround the coffin of Pope John Paul II at his funeral in St Peter's Square, Rome.

246

Sporting a John Bull outfit, an ardent patriot on Windsor's High Street celebrates Prince Charles's wedding.

The wedding of the Prince of Wales, heir to the British throne, and Camilla Parker Bowles was a distinctly modern fairytale. Almost 30 years after first meeting, they married in Windsor on 9 April, in England's first royal civil wedding. The relationship had divided the British public but many supported the couple on the day, turning out to celebrate their union. Charles and Camilla, now Duchess of Cornwall, were blessed by the Archbishop of Canterbury in St George's Chapel, Windsor Castle. The following reception was hosted by the Queen and attended by international royalty, Commonwealth governors and a number of British celebrities.

A silty pool offers cooling relief for an Indian boy in a Mumbai heat wave.

247

According to the World Meteorological Organization, 2005 was the second-warmest year on record, with a global mean temperature of nearly half a degree Celsius above the average for 1961–90. Countries around the world experienced the effects of this change: in southern Asia an extreme heat wave in April, May and June saw temperatures reach peaks of 50 °C (122 °F), and 400 people perished across northern India, Pakistan and Bangladesh. A continent of climate contradictions, the story was painfully different elsewhere: 994 millimetres (39 inches) of rain in Mumbai on 26 July exceeded all previous city records and rainstorms in southwest India led to massive flooding, affecting millions of people and claiming hundreds of lives.

After the mourning of Pope John Paul II, the business of electing a new leader of the Catholic Church began. Cardinals from around the world arrived in the Vatican for the Papal Conclave, the ancient process of secret deliberation and election. The first day, 18 April, proved inconclusive. On the afternoon of the next day, white smoke billowed from the chimney, signifying that a new pope had been chosen. Cardinal Joseph Ratzinger was elected the 265th Bishop of Rome and the new pontiff. Born in Germany, he had become a distinguished theologian and had been a close friend and adviser on issues of religious doctrine to John Paul II. On election, Ratzinger took the name Benedict XVI.

Bavarian Cardinal Ratzinger, now Pope Benedict XVI, hails the faithful from St Peter's Basilica, Rome.

Roman Abramovich (centre) defies critics that said money couldn't buy the Premiership: Chelsea's win over Bolton delivers the title.

The purchase of Chelsea Football Club by a Russian oligarch with an immense fortune was the epitome of London's 'super rich' era. Roman Abramovich bought the west London club for £140 million in 2003. Chelsea was now flush with cash and money was literally no object in assembling a new team to win glory, but Italian manager Claudio Ranieri failed to deliver. He was sacked and the Portuguese José Mourinho brought in for a record salary of £4.2 million. The results were immediate. In the 2004–5 season, Chelsea won their first league title for half a century, conceding just 15 goals in the process and losing only one match.

250

Despite some questioning a 'memorial to national ignominy', the Memorial to the Murdered Jews of Europe opens in Berlin.

Sixty years after the end of World War II, a German memorial to the Jewish victims of the Holocaust was dedicated at a site in Berlin between the Brandenburg Gate and the former location of Adolf Hitler's bunker.

The labyrinthine monument comprises 2,711 concrete pillars, or stelae, of different heights, among which visitors can walk. Addressing more than 1,500 guests at the dedication, including Holocaust survivors, the

German chancellor and the memorial's American architect Peter Eisenman, Bundestag president Wolfgang Thierse called the monument 'a constructed symbol for the incomprehensibility of the crime'.

Richard Serra's *Torqued Spiral (Open Left Closed Right)* is installed permanently at the Guggenheim Bilbao, one of seven sculptures that form his work *The Matter of Time*.

251

The minimalist works of Richard Serra, a former steel-mill worker and industrial sculptor, encompass both art and engineering. His massive torqued shapes have an overwhelming physicality that is balanced by the intimate spaces formed between the steel sheets.

So it was fitting that a permanent exhibition of his work should be housed in the Guggenheim Bilbao, a Frank Gehry building that marries metallic fluidity with great architectural presence. The seven site-specific pieces were commissioned in 2003, and in

2005 joined *Snake*, an earlier work already installed at the museum. Taken together, *The Matter of Time* was an epic meditation on form that confirmed Serra's place among pre-eminent contemporary sculptors.

252

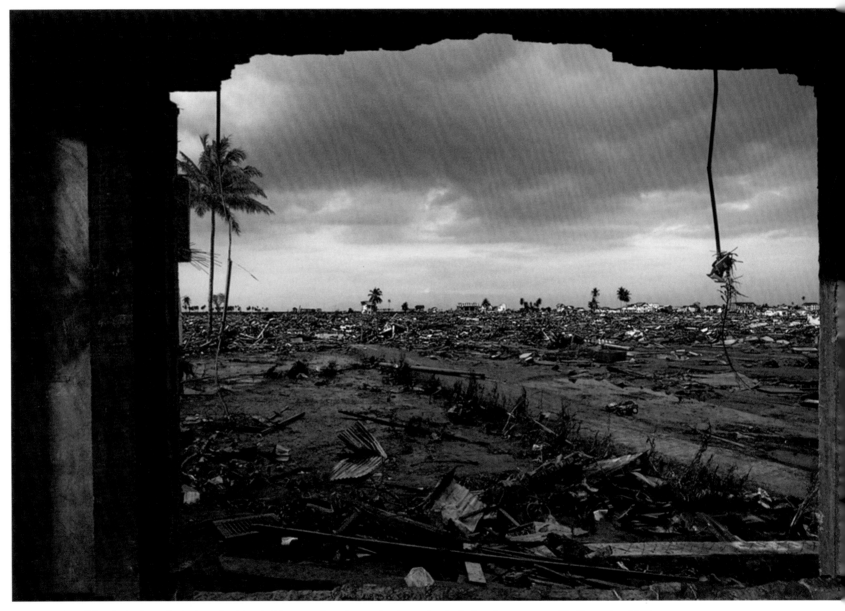

Whole swaths of Banda Aceh on the Indonesian island of Sumatra have been wiped away by the Indian Ocean tsunami in December 2004.

The desperate plight of the millions affected by the Indian Ocean tsunami prompted a massive humanitarian response on the part of relief agencies and the militaries of the United States, Europe and the Far East. More than $7 billion in aid was spent in the countries worst hit, where as many as 10 million people were left homeless or displaced. Some national governments were overwhelmed by the scale of the disaster. The catastrophe resulted in a widespread reappraisal of the tsunami threat by governments around the world and the introduction of a tsunami warning system in the Indian Ocean region.

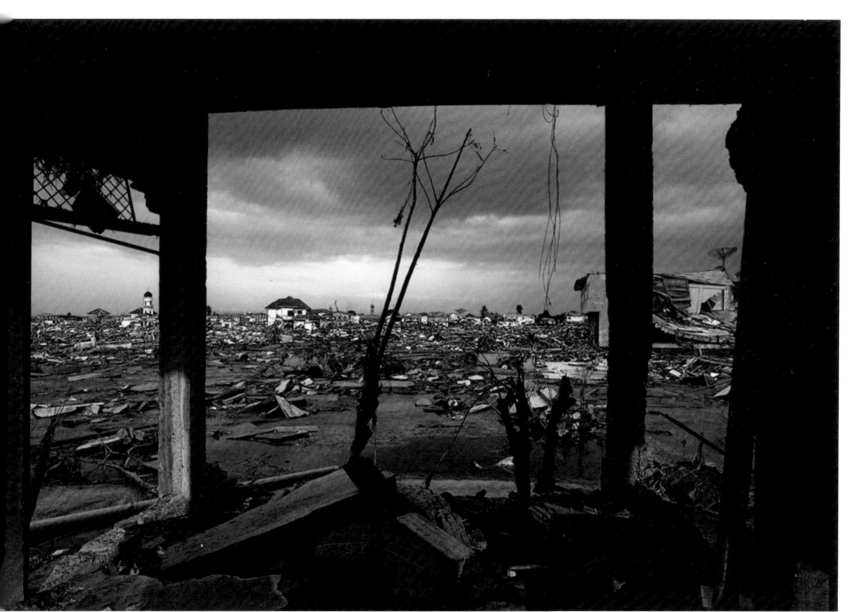

254

The crush proves almost too much for this young horse wrestler in Spain.

In the quiet Galician village of Sabucedo a tradition dating back hundreds of years took place in July. The annual Rapa das Bestas festival sees wild horses from the nearby mountains rounded up and shorn. Thousands of visitors descend on the tiny hamlet – mostly young men, eager to prove their strength and indulge in several days of partying. The main event is the corralling of horses into the main arena, the *curro*. Untamed horses are wrestled to the ground by bare-handed *aloitadors* (combatants), who then trim their tails and manes, as they have done for centuries. But, in a more modern spirit, the horses are now also tagged with electronic tracking chips.

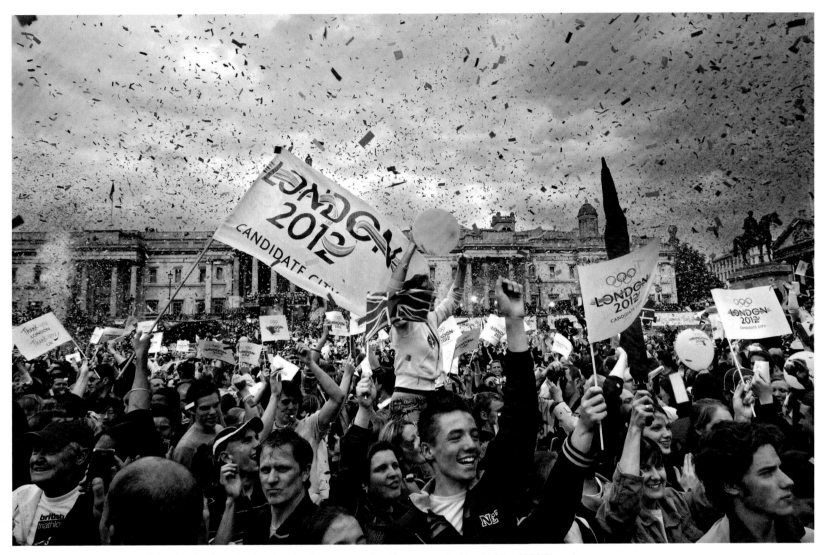

Trafalgar Square erupts in celebration (and confetti) as London is announced as the unexpected host of the 2012 Olympics.

255

At the time London's bid for the 2012 Olympics was submitted, the city had not hosted the Games since 1948, in the aftermath of World War II and during an era of austerity. Other British cities – Birmingham and Manchester – had made unsuccessful bids for the 1992, 1996 and 2000 Games, but the work of Lord Coe – a gold medallist himself – heading the bid committee propelled London into the final round of voting in Singapore. The British capital was to become the first city to host the Olympics three times. Victory was made even sweeter for Londoners by beating Paris, their traditional rival and favourites in the contest.

During London's morning rush hour on 7 July, four British Muslim men carried out a series of coordinated attacks on the city's transport system. Their apparent motivation was Britain's involvement in the Iraq War. Three bombs exploded within 50 seconds of each other on three Underground trains, a fourth exploding an hour later on a double-decker bus. Fifty-six people were killed, including the bombers, and about 700 were injured. It was later revealed that one of the suicide bombers, Mohammad Sidique Khan, had been under surveillance by the UK's security service but had not been deemed a serious threat. He and his accomplices carried out the deadliest bombing in London since World War II. Nearly a third of the victims were foreign nationals.

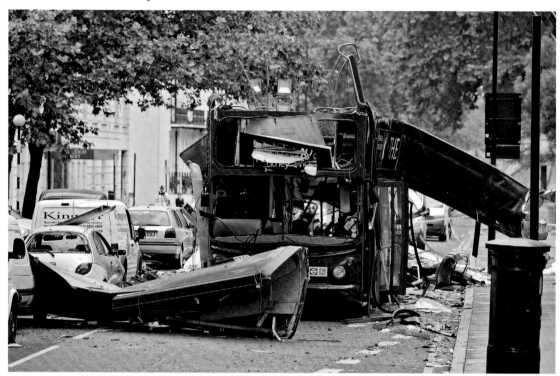

Ripped apart by a suicide bomb, the wreckage of a London bus is strewn across Tavistock Square.

256 The 7 July bomb attacks in London were remarkable for a reason quite apart from their savagery. Over the years, mobile phone technology had matured to the extent that almost every device had some kind of image-capture functionality. As a result, in millions of pockets of people going about their everyday business were devices that, despite their grainy low fidelity, could capture the essence of the moment before the professional photojournalists arrived on the scene. The BBC received thousands of such pictures on the day of the attack. Some of the most iconic images and videos of the bombings were snapped on these camera phones, and 'citizen journalism' entered the common lexicon.

A hastily taken cameraphone image captures the evacuation of commuters as the London Underground is hit by terror attacks.

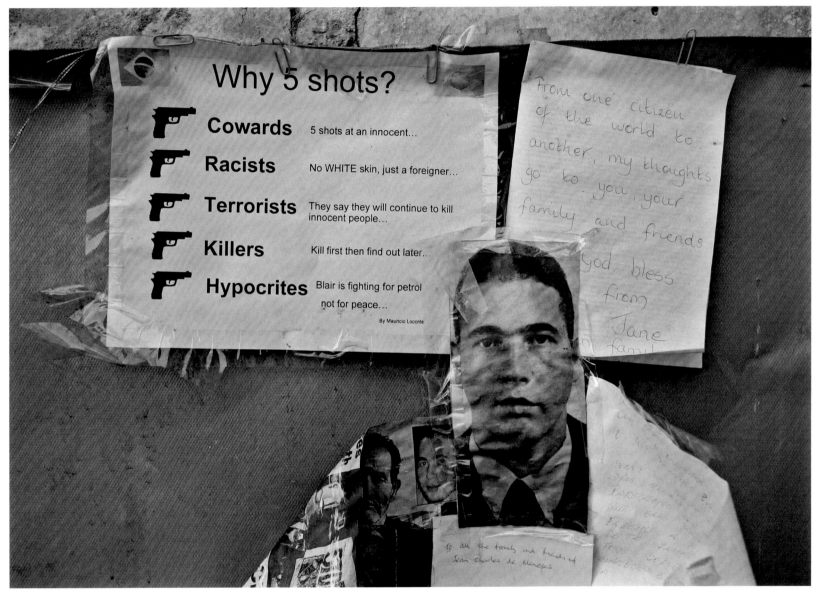

A makeshift memorial outside Stockwell tube station in London for Jean Charles de Menezes, killed in a terrible police error.

257

Jean Charles de Menezes was shot seven times in the head by officers of London's Metropolitan Police as he sat on a tube train on 22 July. De Menezes, an electrician from Brazil who had arrived in the UK in 2002, was wrongly identified as one of the four would-be suicide bombers who had attempted to carry out explosions on the city's Underground network the previous day, replicating the 7 July attacks. In the following days, different accounts of the circumstances surrounding the killing emerged in the press, fuelling calls by De Menezes's family and their supporters for a full inquiry and the resignation of the country's top police officer, Sir Ian Blair. The tragedy also focused public attention on Operation Kratos, the shoot-to-kill policy introduced to deal with terrorist threats.

American cyclist Lance Armstrong had already endured the ordeal of testicular cancer at the age of 25 by the time he made his mark on the sport. Throughout his career he had been the subject of intense speculation over the use of performance enhancing drugs. But although many allegations were levelled publicly, none was proved. On 24 July 2005 he won the Tour de France, cycling a gruelling 3,607 kilometres (2,241 miles) and beating the runner-up Ivan Basso of Italy by over 4 minutes. It was his seventh consecutive title, extending his already record-breaking streak of victories, leaving the Tour's former greats such as Merckx, Indurain and Hinault – each with five wins – further behind.

The powerful, record-breaking legs of American cyclist Lance Armstrong, after a training ride through the Hollywood Hills, Los Angeles.

The developing West African nation of Niger was ravaged by hunger in 2005. The food crisis was blamed largely on the previous year's drought and locust infestation, although the country's over-reliance on subsistence farming had always left it vulnerable to even slight changes in the environment. The UN reported that 3.6 million citizens were suffering from malnutrition. Then UN Secretary-General Kofi Annan visited the country in August to raise awareness of the crisis, even though Niger's president claimed it was propaganda invented by his political opponents. Significant international assistance did not materialize until images of the hungry appeared in Western media, but the predicted famine was averted.

With his tiny right hand, one-year-old Alassa Galisou reaches for his mother in an emergency feeding clinic in Niger.

259

The brainchild of celebrated Israeli-Argentine pianist and conductor Daniel Barenboim and the late Palestinian author and academic Edward Said, the West-Eastern Divan Orchestra was established in 1999. They believed that an orchestra composed of young Arabs and Jews could encourage greater understanding between them and ultimately serve as inspiration for a just resolution of the Arab–Israeli conflict. The orchestra's success led to the establishment of a permanent home in Seville, Spain, in 2002. On 21 August 2005, as Israel was completing its tense withdrawal from the Gaza Strip, the orchestra gave a concert in the West Bank city of Ramallah.

While Daniel Barenboim conducts Jewish and Arab musicians in Ramallah, peace overtures in the Israel–Palestine conflict will end in discord.

The coffin of US Marine Second Lieutenant James Cathey, killed in Iraq, is unloaded from a passenger plane in Reno, Nevada.

260

By the end of 2005 more than 2,100 US soldiers had died in Iraq since March 2003 and about 16,000 had been wounded. Americans' support for the war had plummeted. Photographing the coffins of the US war dead as their bodies were returned home was officially banned. Supporters of the ban, introduced by President George H.W. Bush in 1991, claimed that it protected the privacy and dignity of families of the dead. Its opponents, who included some of the victims' families, said it sanitized the conflicts in Iraq and Afghanistan and was intended to conceal the human cost of the wars. The ban was lifted in 2009.

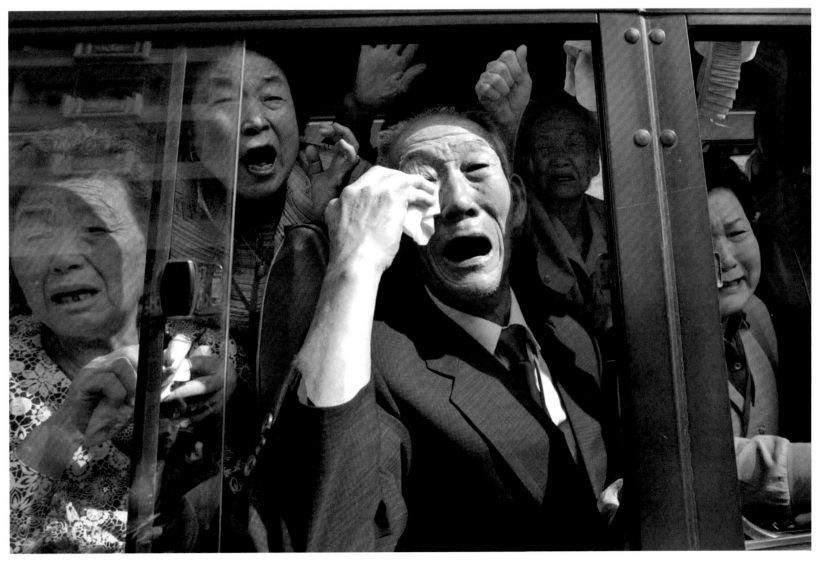

Overcome by emotion, families divided by the Korean armistice line bid sad farewell: their brief reunion is over.

261

With the Korean War frozen in 1953 into a permanent armistice, millions along the new, closed border between North and South Korea found their families torn asunder, able neither to write to nor visit each other. As part of a minor thaw in relations between North and South, some organized family reunions were scheduled from 2000 onwards. In August 2005 work began on a reunion centre at Mount Kumgang in North Korea, although its progress was to be delayed by disputes between Seoul and Pyongyang over nuclear weapons and aid. Reunions were emotional affairs: elderly relations knew that the three-day gatherings were likely to be the last they would enjoy together.

Hurricane Katrina smashed into the Gulf Coast of the United States on 29 August. One of the strongest Atlantic hurricanes ever recorded, it caused flooding that destroyed coastal cities in Alabama, Mississippi and Louisiana. New Orleans was particularly affected by the storm tide, which overwhelmed the city's levee system. Eventually over 80 per cent of New Orleans was engulfed and the floodwater lingered for weeks. More than 1,000 residents of the famed city lost their lives and the cost in terms of damage ran into tens of billions of dollars. The US government's muddled response to Hurricane Katrina raised serious questions about the nation's disaster recovery plans and President George W. Bush's leadership.

In the aftermath of Hurricane Katrina, the confused and ineffective response was roundly criticized. Thousands of people were left stranded at the New Orleans Convention Centre with neither food nor water; supplies and equipment were slow to arrive despite advanced warning of the storm; and local, state and federal agencies publicly bickered over the failures. There was also wrangling between federal Republicans – including the head of the Federal Emergency Management Agency (FEMA), Michael Brown – and the Democrat governor of Louisiana. Despite increasing criticism of the lack of leadership over relief efforts, President Bush publicly praised the head of FEMA for 'doing a heck of a job'.

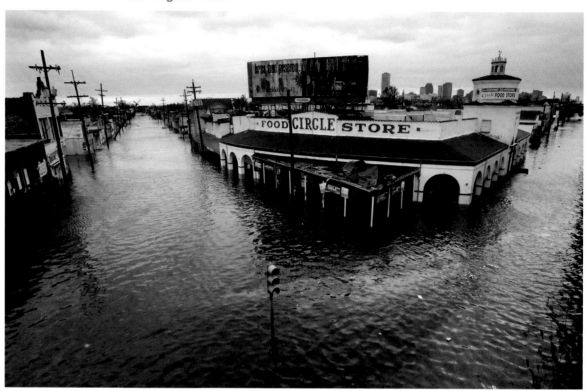

The famous New Orleans Circle Food Store, open since 1938, is practically submerged by the Hurricane Katrina flooding.

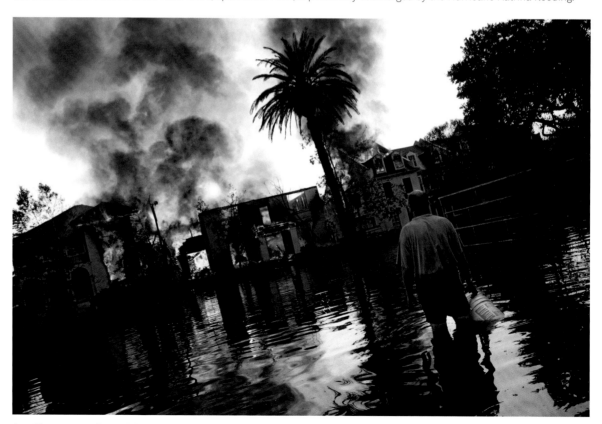

An affluent area of New Orleans burns as fires erupt in the wake of Hurricane Katrina.

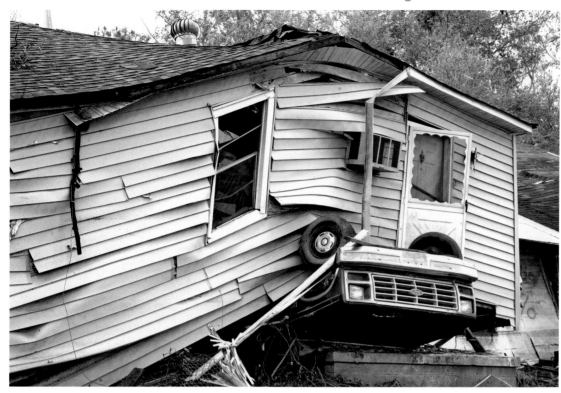

The damage wrought by Hurricane Katrina was immense. Insurance claims topped $40 billion – almost twice that of 1992's Hurricane Andrew, the previous record. Over 200,000 homes were destroyed, most of them in New Orleans and its metropolitan area (Hurricane Andrew had annihilated 25,000). New Orleans's port and nearby oil facilities were also knocked out of action, hitting the shipping industry and pushing up the global price of oil. Twelve per cent of Louisiana's jobs were lost; in New Orleans, this figure reached almost a third. Many refugees were slow to return, if at all, to the devastated city.

An incredible scene showing a car flattened by a house after Katrina.

263

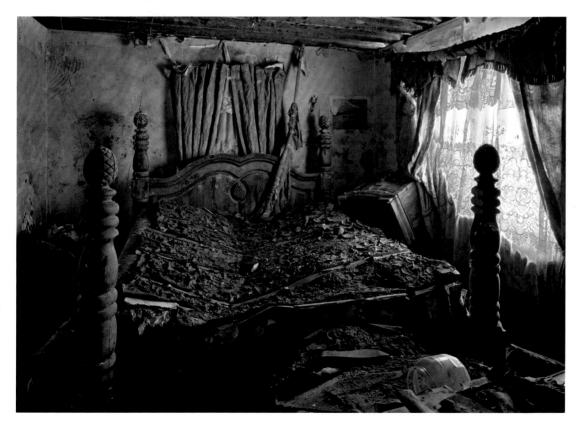

The power of water damage is evident in this destroyed New Orleans bedroom.

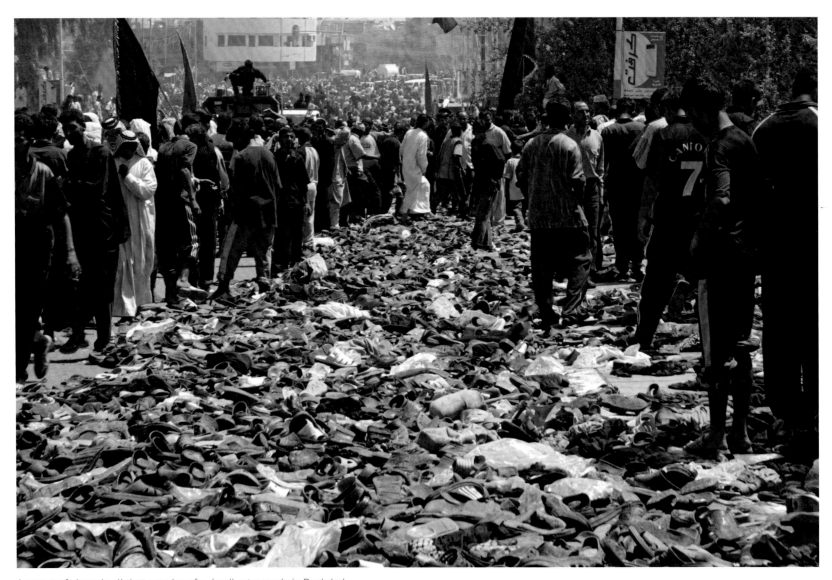

A carpet of shoes is all that remains of a deadly stampede in Baghdad.

In the largest loss of life in a single day since the US-led invasion in 2003, around 1,000 people were killed in a stampede during a religious festival in Baghdad. Up to a million pilgrims had gathered to march to the shrine of Imam Musa al-Kadhim when panic erupted on the overcrowded Al-Aaimmah bridge over the Tigris, caused by rumours of suicide bombers among the vast throng. A mortar attack earlier in the day had killed several pilgrims. Part of the bridge's iron railings collapsed, sending hundreds of people into the river below. Among the victims who drowned or suffocated in the crush were many elderly people, women and children. Iraqi Prime Minister Ibrahim al-Jaafari declared three days of national mourning.

The charred remains of a Buddhist professor killed by Muslim rebels near Yala in southern Thailand.

Conflict in Thailand's deep south had been raging on and off since the region's incorporation in the early 1900s. In a predominantly Buddhist nation, the southeastern region of Pattani is more than two-thirds Malay and Muslim, a reality that chafes against the dominant notion of 'Thai-ness'. Early 2004 saw the resurgence of separatist violence as years of top-down government policies – alternating between suppression and assimilation – fuelled the rise of violent Islamic factions. The violence targeted both local Buddhists, including several monks, as well as so-called 'traitors' – Muslims who refused to join the militants. In this photograph from September 2005, a Buddhist professor joins the thousands murdered in this forgotten insurgency.

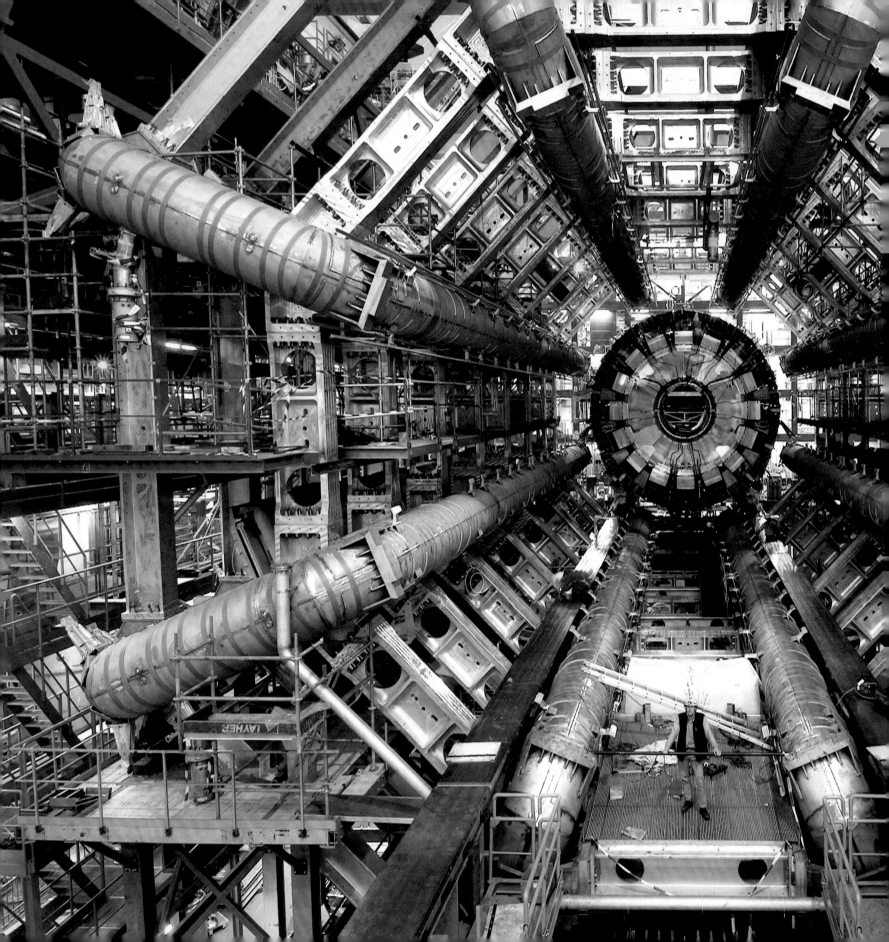

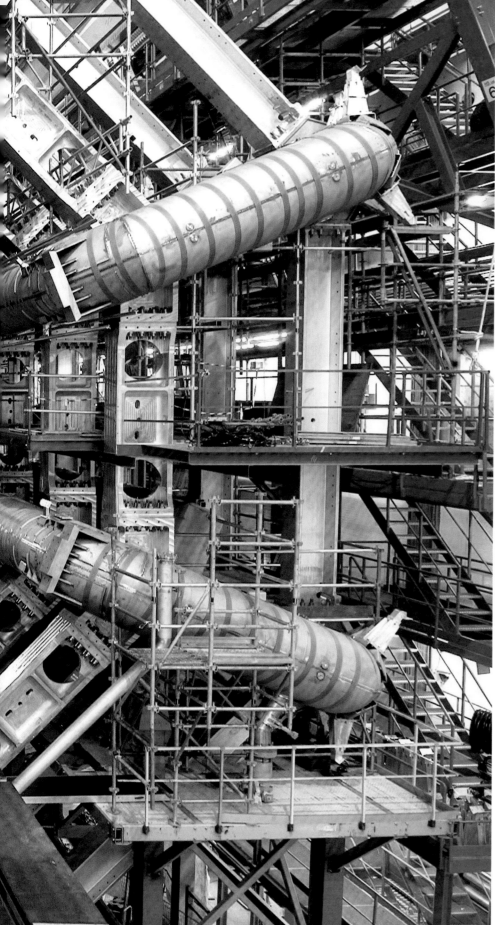

Construction continues on a vast machine designed to discover infinitesimal particles that will answer the biggest questions in science.

267

1 September 2005

The world's largest particle accelerator is a gigantic scientific instrument that spans the Franco-Swiss border. By colliding two beams of sub-atomic particles at very high energy – the equivalent of firing two needles 10 kilometres (6 miles) apart to meet at an equidistant point – physicists hope the Large Hadron Collider (LHC) will unlock the secrets of the universe. Construction took over 15 years, involving thousands of international scientists; the original completion date of 2005 was pushed back by two years following cost overruns. The unveiling ceremony on 20 September 2008 was overshadowed by minor public hysteria about the apocalyptic potential of the device. Such fears proved unfounded; instead, the LHC was shut for over a year when some of its super-cooled magnets failed.

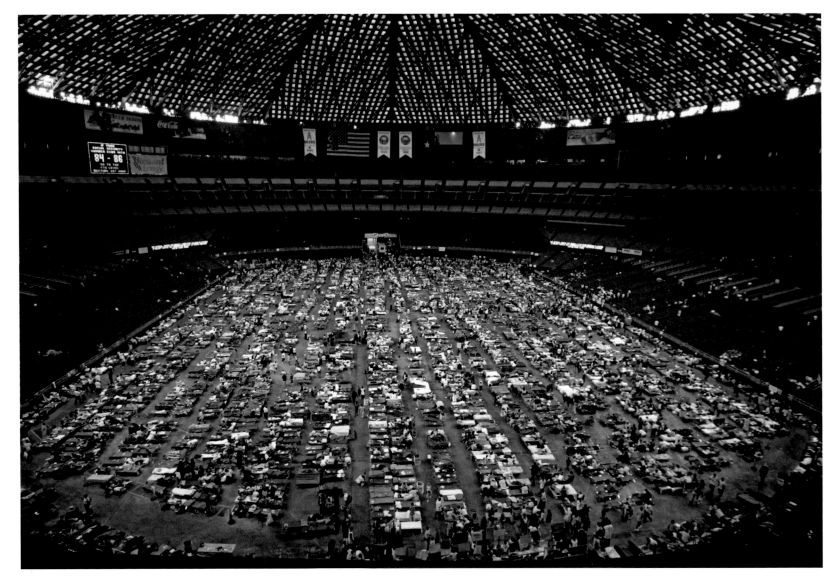

As many as 16,000 refugees from New Orleans find warmth and safety at the Houston Astrodome in Texas.

As large portions of New Orleans lay inundated beneath the waters of the Hurricane Katrina storm surge, many evacuees found a safe refuge in the Houston Astrodome in the neighbouring state of Texas. It offered clean water, showers, air conditioning and hot food. By contrast, the Louisiana Superdome – where as many as 25,000 people were sheltering – was in a state of chaos and without food and water. Troops trying to establish order were rebuffed by angry mobs; helicopters delivering aid had to make air drops to avoid the desperate crowds. The refugees were eventually bused to the Houston Astrodome.

Egyptian leader Hosni Mubarak (in painted wood form) towers over passers-by in Cairo.

Hosni Mubarak had been in power for 24 years, but never faced an opponent in his four previous referendum-style elections. Following domestic and international pressure, however, the Egyptian president amended constitutional rules earlier in the year to permit multi-candidate elections. Ten contenders emerged, although Mubarak enjoyed significant incumbent benefits, including coverage in the government-run newspaper and a vast support network derived from years of patronage. Mubarak won over two-thirds of the vote. Despite only a 25 per cent turnout and widespread electoral irregularities, the election was considered a breakthrough in a country with such a chequered democratic history.

269

Less than two weeks before the third anniversary of the 2002 Bali bombings, a series of suicide bombs ripped apart Indonesia's sense of security for the third time in as many years. On 1 October three terrorists blew themselves up in the resorts of Jimbaran and Kuta, killing over 20 people and injuring at least 100 Indonesian residents and foreign tourists. Earlier in the year, Abu Bakar Bashir, the alleged leader of Islamist group Jemaah Islamiyah, was convicted of conspiracy for the 2002 attacks. Jemaah Islamiyah was also held responsible for this latest round of attacks, which used shrapnel bombs to engender panic and fear on the island.

270

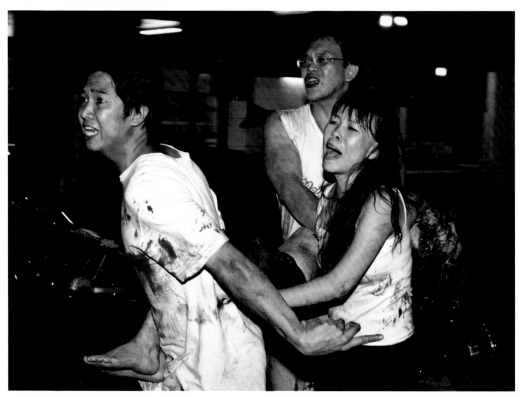

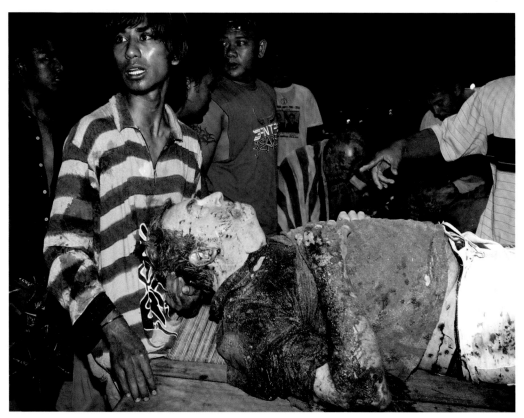

Holiday-makers and inhabitants alike are victims of the indiscriminate slaughter of another terrorist bomb in Bali, Indonesia.

Kashmiri earthquake refugees find basic shelter in a tent city in the Pakistani capital, Islamabad.

At 8.52 a.m. on 8 October 2005 a massive earthquake tore across South Asia. Over 80,000 people died and 3.5 million were left homeless by the seismic upsurge, the tragedy compounded by the multiple after-shocks that destabilized rubble and shredded survivors' nerves. Much of the destruction occurred in Kashmir, leading India and Pakistan to put aside their differences to focus on the catastrophe. Many people were trapped in remote mountainous regions, unable to access aid. Others tried to rebuild their lives in the tent cities that sprang up to provide basic shelter and sanitation. However, a shortfall in international aid pledges meant hundreds of thousands still needed help months later.

272

Wearing 'chocolate-chip' fatigues, soldiers of the Sudan Liberation Army practise drill in South Darfur, Sudan.

For centuries, herders in East Africa traversed their grazing territory without borders. In modern times the porous boundaries were a mixed blessing, permitting not only trade and transit along traditional routes, but also the spillover of conflict. The implosion of Darfur in 2005 drew in neighbouring Chad: thousands of refugees fled to camps there, while Sudanese rebels sought sanctuary. Meanwhile, anti-government forces in Chad conducted raids from Sudan, and frequent skirmishes in the border region heightened tensions. On 24 December the slaughter of a hundred Chadians in Adré by Sudan-based militias led Chad to declare a 'state of belligerence' with Sudan.

What began as a tragedy in a Paris suburb on 27 October 2005, when two French youths were electrocuted in a power substation while hiding from police, rapidly turned into the worst country-wide rioting since 1968. Tensions had been simmering in the deprived areas of French cities for some time. Many young men in immigrant communities resented the dearth of economic opportunity and what they saw as their second-class status in society. The minister of the interior, Nicolas Sarkozy, controversially referred to the rioters as 'scum', taking a hard line on the disturbances. Thousands of cars and buses were set alight over a period of three weeks and two deaths were attributed to the unrest.

273

French rioters set alight the Parisian suburb of Clichy-sous-Bois on a sixth straight night of civil unrest.

274

The charismatic Ellen Johnson-Sirleaf greets supporters after a visit to church in Monrovia, Liberia.

Ellen Johnson-Sirleaf became Africa's first elected female head of state after a runoff in Liberia's presidential election in November 2005. The ex-banker and UN official defeated her opponent, former World Footballer of the Year, George Weah, by a margin of 20 per cent. Nicknamed 'Africa's Iron Lady' by her supporters, Johnson-Sirleaf had nearly 30 years of high-level political experience. She had been a minister under President Tolbert in the 1970s and was imprisoned for a time in the 1980s for criticizing the dictatorship of Samuel Doe. On becoming president, Johnson-Sirleaf pledged to end corruption and restore peace, law and order to a country shattered by decades of conflict and misrule.

The heart of the insurgency in Iraq in 2005 appeared to lie in Anbar province, a vast, arid area to the north and west of Baghdad. Insurgents from Iraq's minority Sunni Muslim group operated more or less freely in the area, and Anbar's long border with Syria became the principal entry point for foreign fighters seeking to join the battle against US forces. Sunni fundamentalists sought to assert authority over key cities such as Ramadi and Fallujah, the scene the previous year of vicious urban combat between insurgents and US Marines that destroyed the city.

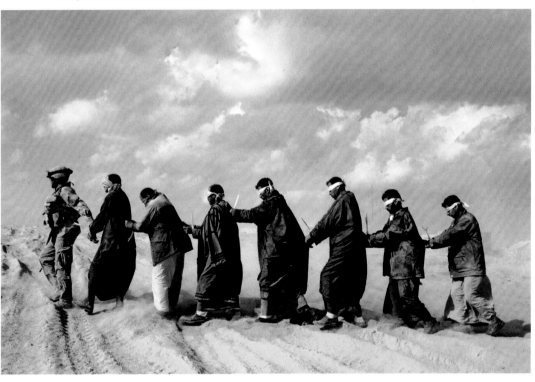

Searching for Iraqi insurgents, a US Marine leads villagers away for questioning.

275

The 2005 German federal elections were called in response to a vote of no confidence in Chancellor Gerhard Schröder. The centre-right union of the CDU/CSU, led by Angela Merkel, initially enjoyed a 21 per cent lead in the polls over the centre-left SPD, but by election day this had collapsed to 1 per cent. Nevertheless, Merkel emerged as chancellor in the 'grand coalition' between the CDU/CSU and SPD. She was Germany's first female chancellor and the first from the former East Germany. Her platform of reform and her scientific background drew initial comparisons with Margaret Thatcher, the former British prime minister – but Merkel proved far less radical in her policy agenda.

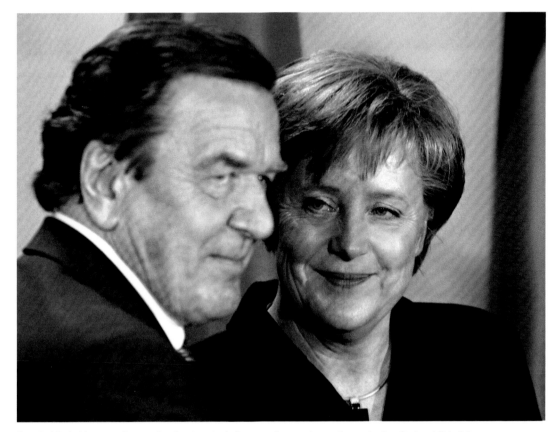

Angela Merkel has much to smile about – she is Germany's new chancellor replacing Gerhard Schröder.

Isabelle Dinoire, 38, was attacked by her own dog, who bit off her lips, cheeks, chin and most of her nose. On 27 November, the French woman received the world's first face transplant; a triangle of facial tissue, muscle and nerves from a 46-year-old donor. The 15-hour operation – conducted by Bernard Devauchelle and Jean-Michel Dubernard – was roundly applauded, as Dinoire recovered her ability to speak and feed herself. Nevertheless, serious tissue-rejection necessitated the use of extremely potent immune-suppressing drugs, putting Dinoire's kidneys at risk. The medical community was divided on bioethical grounds, many criticizing the lack of psychological support provided for the woman who now wore another's face.

276

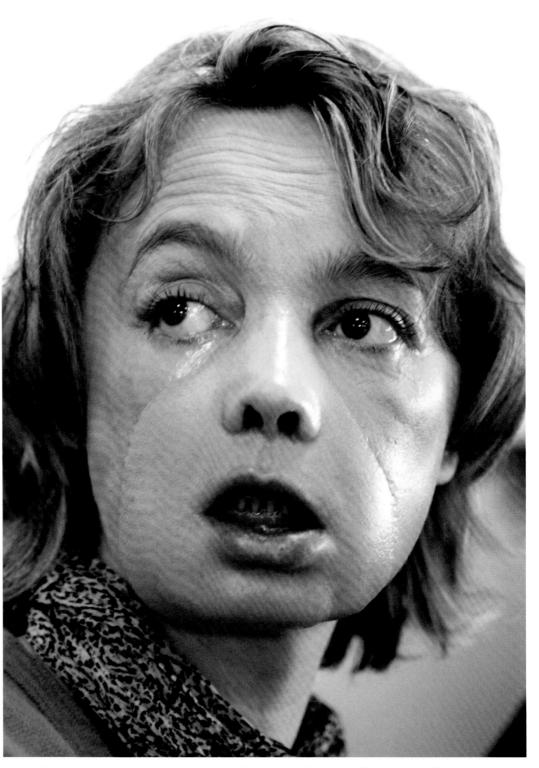

For medical professionals, a remarkable new kind of transplant. For Isabelle Dinoire, a new life.

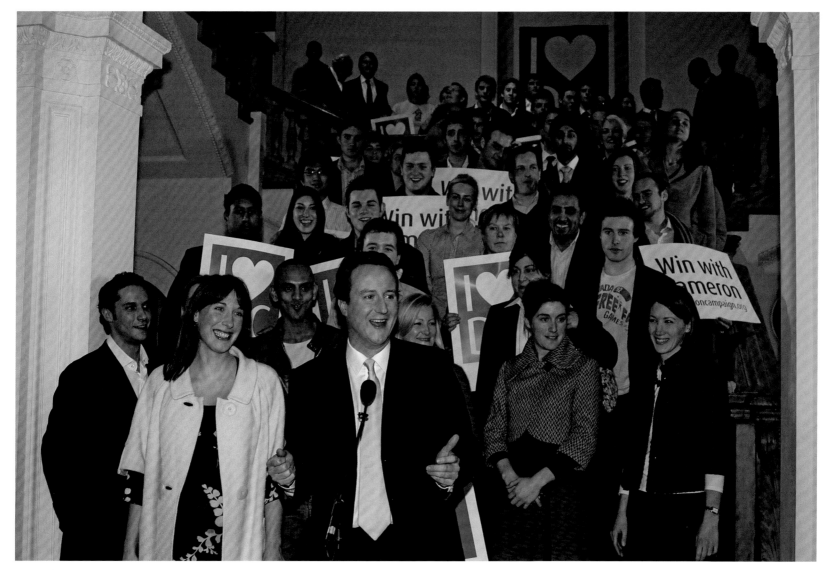

A cheerily photogenic crowd of young supporters indicates the direction new Conservative leader David Cameron intends for his party.

277

The fourth leader of the UK Conservative Party since 1997, David Cameron inherited a party that had lost its way. A member of parliament for only four years, Cameron had already served in the shadow cabinet prior to the leadership contest precipitated by Michael Howard's resignation. Promising 'compassionate Conservatism', Cameron was likened to an early Tony Blair: young, moderate and media-savvy. The MP for Witney did well in the first two electoral rounds, going on to win twice as many votes in the ballot of party members as his rival, David Davis.

Drunken louts attack a 'foreign-looking' man during race riots in Cronulla, Australia.

Racial tensions in Cronulla, a Sydney suburb, erupted into rioting in December. After a number of violent assaults that the locals blamed on Lebanese immigrant communities, a large protest took place on 11 December. Around 5,000 people demonstrated against the attacks. However, the drunken mob became increasingly rowdy. Large numbers began chanting anti-immigrant and nationalist slogans, and 'foreign-looking' men were attacked and beaten. The racist rioting even spread to some neighbouring areas as police were brought in to quell the disturbances. In a television address, Prime Minister John Howard denounced the rioters and defended Australian society – but the damage to the country's international reputation was done.

Wearing his usual casual style, Evo Morales gives a press conference in La Paz after his election victory.

An eight-man race, the Bolivian presidential election was won on 18 December by Evo Morales, a former labour-union leader and Bolivia's first fully indigenous head of state. Having missed out on the post by less than 50,000 votes three years earlier, the leftist contender successfully mobilized broad swaths of the country, defying commentators who believed he would miss out on the requisite 50 per cent of the popular vote. Calling himself 'the candidate of the most disdained', Morales vowed to support indigenous people, principally through the legalization of coca production – a popular though controversial position, and not the only election promise to raise alarm bells in Washington, DC.

2006
Eclipse

Asia grappled with major social and political upheaval in 2006. North Koreans revelled – doubtless not of their own free will – in eightieth anniversary celebrations of the Down-With-Imperialism Union. The country's shadowy leaders used the opportunity to berate the United States and the West for their call for tougher sanctions against the North Korean regime due to its nuclear activities. By far its most important ally, China celebrated the Year of the Dog and scientific breakthroughs in stem-cell research in Taiwan. But it was a difficult year for the millions of Chinese forced to move home because of the Three Gorges Dam. The world's largest hydro-electric project was an engineering marvel, but Beijing would later admit that the environmental and human costs to areas along the Yangtze River were much greater than they had calculated during the early phases of the dam's construction. All of Asia could take pride, however,

in one of its own becoming Secretary-General of the United Nations for the first time since 1971. South Korea's Ban Ki-moon was to need all his much-heralded skills as a mediator to forge cooperation in an acutely divided world. In 2006 no one could quite agree whether Iraq was in a state of insurgency or a civil war between Sunnis and Shi'as. The debate mattered little to ordinary Iraqis who suffered appalling violence on a daily basis. Their brutal former dictator Saddam Hussein was hanged for crimes against humanity. The tawdry spectacle of his execution did not spark the mass celebrations it might have done, had most Iraqis believed that his death would stem the tide of suicide bombings and sectarian fighting. Although a kind of international justice was delivered for the victims of Saddam Hussein, the same could not be said for those who suffered at the hands of former Serbian dictator Slobodan

Milosevic. He died in custody in The Hague while standing trial for crimes committed during the wars in the former Yugoslavia in the 1990s. His death prompted sharp criticism of international justice, which Milosevic had successfully impeded and manipulated for his own propagandist ends over several years. Latin Americans marched in their hundreds of thousands across the United States to protest against tougher immigration laws and border security. Billed as 'The Great American Boycott', the event was designed to be a potent reminder of immigrants' contribution to the US economy. No reminders about the contribution to American – and global – culture of larger-than-life conductor and cellist Mstislav Rostropovich were needed. The former musical director of Washington's National Symphony Orchestra and outspoken Soviet dissident conducted his last major concerts in November, with the Orchestre de Paris in France.

282

A rather fluorescent pig in Taipei, Taiwan, is testament to the inexorable march of progress.

At the tail end of the Chinese zodiac's Year of the Rooster, scientists in Taiwan announced the birth of the world's first wholly transgenic pigs. The team from the National Taiwan University's Department of Animal Science added DNA from fluorescent jellyfish to swine embryos. Implanted sows then gave birth to three piglets that appeared green in daylight and glowed in the dark. The breakthrough was designed to boost understanding of stem cell research: the glowing genetic material can easily be traced when transferred into other organisms, giving scientists insight into the development of the so-called 'magic' cells.

'The Gandhi of the Balkans', Ibrahim Rugova, is honoured by a newspaper in Pristina, Kosovo.

Ibrahim Rugova, a softly spoken professor educated at the Sorbonne in Paris, had long been a key figure in Kosovar Albanian aspirations for independence. As Yugoslavia was falling apart in bloody conflict in 1992, he was voted president of Kosovo in an unofficial election held by the Albanian community in the province, then still part of Serbia. His non-violent stance on the issue of independence frustrated many Kosovar Albanians who saw armed struggle as the only means to independence. Rugova did not live to see the Kosovar declaration of independence: he died on 21 January 2006. Five days later, his funeral attracted a reported half a million people.

284

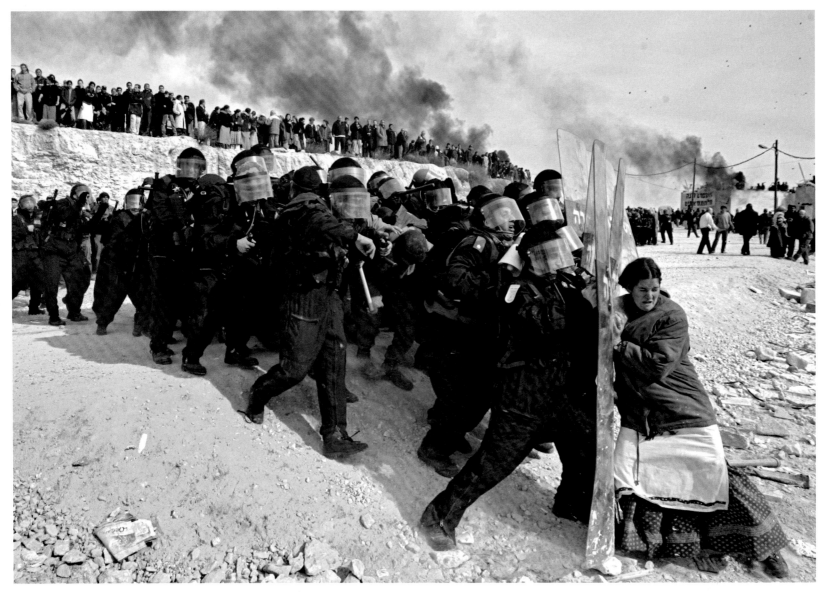

A squad of riot police are resisted by a lone settler in the village of Amona, in the West Bank.

The issue of Jewish settlements in the Palestinian territories of the West Bank and Gaza Strip had been a major impediment to any peace overtures in the region. Prime Minister Ariel Sharon in 2005 had pulled out Israeli forces from and dismantled settlements in Gaza before falling into a coma. In February 2006 his successor Ehud Olmert followed a Supreme Court order to dismantle an illegal settlement in Amona, in the West Bank. Descending upon the hilltop settlement from all over Israel, 3,000 protestors sought to defend the outpost of houses as 5,000 police and military moved in with water cannon, horses and batons. Over 300 people suffered injury.

John Howard, prime minister of Australia, speaks at a memorial service for businessman Kerry Packer at the Sydney Opera House.

The billionaire Kerry Packer died on 26 December 2005 from kidney failure, aged 68. The media tycoon was Australia's richest man, with an estimated $5 billion fortune. Packer was renowned for his abrasive character, extravagant gambling and sharp commercial instincts, famously starting a sporting revolution in 1977 by setting up World Series Cricket and taking advantage of the emerging television market. In later life he gave generously to public health causes. However, a state memorial service held on 17 February 2006 at the Sydney Opera House was beset by protesters, upset at the use of taxpayers' money to commemorate a man who abided by a personal principle of tax minimization.

286

The Chicago River turns a stunning shade of green during St Patrick's Day celebrations.

Roughly 35 million residents of the United States claim Irish ancestry – nearly 10 times the current population of Ireland itself. St Patrick's Day, the feast day of the patron saint of Ireland, is celebrated across the nation, by Irish and non-Irish alike. Since 1961 the Midwestern city of Chicago has dyed its eponymous river green to mark St Patrick's Day on 17 March (or on the preceding or following Saturday). The city's pollution-control workers got the idea from their own use of dyes to trace illegal sewage discharges. Today tens of thousands of Chicagoans line the river every year as 18 kilograms of dye turn the waterway green for several hours.

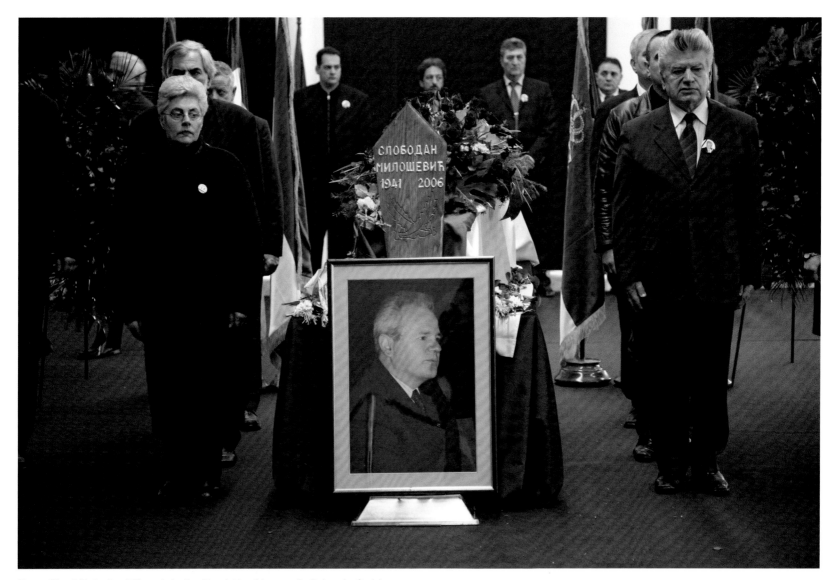

The coffin of Slobodan Milosevic in the Revolution Museum in Belgrade, Serbia.

287

Slobodan Milosevic died in a prison cell in The Hague on 11 March 2006. Some suggested a conspiracy, claiming his medication had been withheld or that he had been poisoned – for which there was no evidence. His trial for Serbian war crimes in Croatia, Bosnia and Kosovo during the 1990s had dragged on for four years. The International Criminal Tribunal for the former Yugoslavia was criticized for ignoring its own legal procedures and giving Milosevic a public platform rather than executing justice. Reaction to his death in the former Yugoslavia was mixed. Serb nationalists mourned his passing; other Serbs shrugged off the death of the old dictator. However, many Bosnians, Kosovars and Croats felt cheated of justice.

Throughout March 2006 the inaugural World Baseball Classic competition took place in stadiums in Japan, Puerto Rico and the United States. In a 16-team tournament, each team played the others in its group, before the top-scoring teams moved on to the next round. In the final at San Diego's Petco Park, Japan and Cuba met for their 38th encounter in an international competition, with Japan beating the favourites Cuba 10-6. The tournament proved more popular than expected, as stadiums sold out and millions watched televised games around the world, proving the international appeal of a game considered a typically North American pastime.

288

The Japanese baseball team swarm round the World Baseball Classic trophy after winning it in San Diego, California.

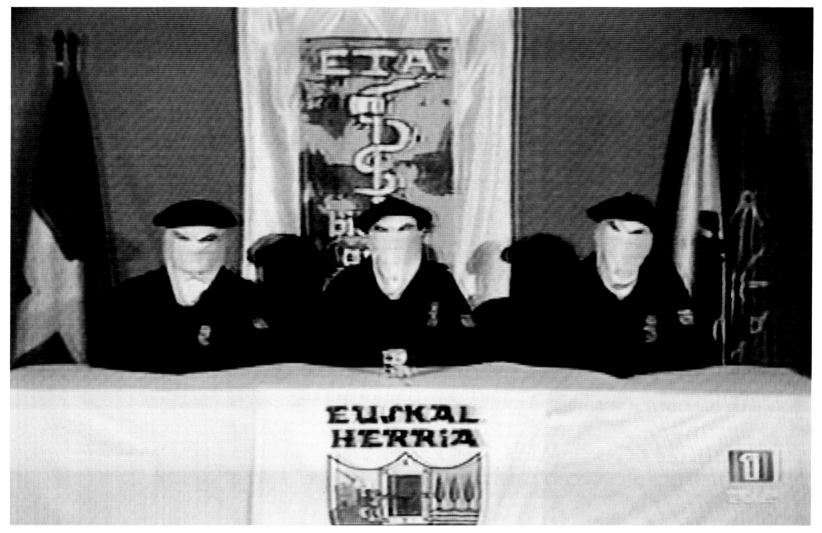

Despite their menacing appearance, Basque separatists of ETA declare a permanent ceasefire.

ETA, the separatist movement seeking independence for northern Spain's Basque region, declared a permanent ceasefire to begin on 24 March 2006, a first for the group blamed for 800 deaths and thousands of casualties. Via a DVD message, three masked figures wearing black Basque berets announced the organization's desire to end the conflict and establish a democratic process in the contested region. The ceasefire marked the end of 40 years of violence, but was treated with caution by the Spanish government. Many believed ETA's violent programme had become untenable after the 2004 Madrid bombings, which elicited a public backlash against terror tactics for political ends.

290

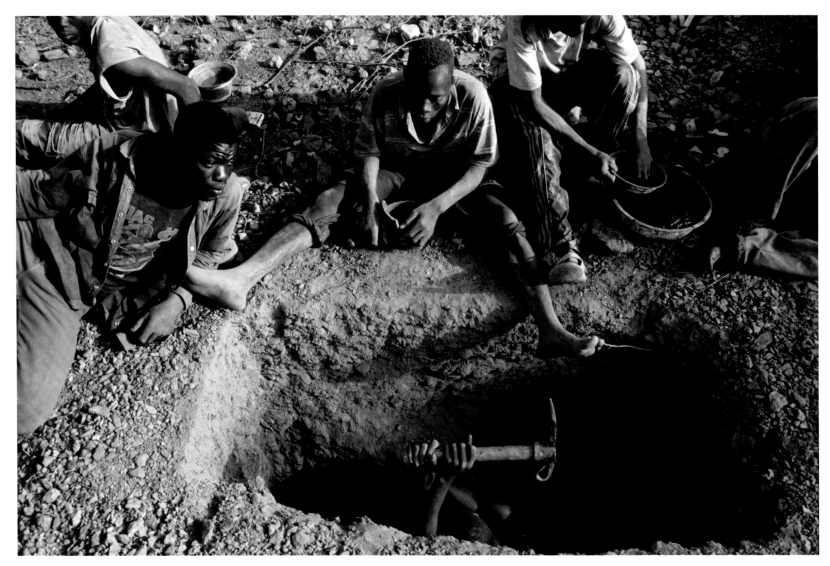

With cotton crops failing, Burkinabe miners scratch out a tough existence from a makeshift gold mine.

One of the poorest countries in the world, landlocked Burkina Faso is beset by political instability and recurring droughts. A decline in cotton crops – the country's main export, dubbed 'white gold' when Burkina Faso was Africa's top producer – fuelled the growth of artisanal mining at over 200 sites thought to contain significant mineral deposits, especially gold. In 2006 the country's government granted hundreds of prospecting licences to foreign mining firms in a widespread effort to privatize the gold sector. Industrialization threatened the livelihoods of tens of thousands of traditional small-scale miners. They eke out a living digging for gold in isolated mining communities, where cholera and AIDS are rife and accidents are commonplace.

The great cellist, conductor and political activist Mstislav Rostropovich, rehearsing here with the National Orchestra of Spain; a year later he dies of cancer in Moscow.

Mstislav Rostropovich spent much of his illustrious career abroad, in self-imposed exile from the Soviet Union over his backing of dissident writer Alexander Solzhenitsyn. For 17 years he conducted the US National Symphony Orchestra in Washington, DC, and once graced the cover of *Time* magazine in recognition of his incalculable contribution to classical music. At his 80th birthday celebration a month before his death on 27 April 2007, Rostropovich was hailed by Russian President Vladimir Putin as not only 'a brilliant cellist and gifted conductor', but also 'a firm defender of human rights'. Perhaps his most famous gesture was his exultant performance of a Bach Suite at the Berlin Wall as it came down in 1989.

292

Thousands of Latin American immigrants march through downtown Los Angeles, proudly bearing the symbols of their adoptive country.

On 1 May (International Workers' Day) more than a million immigrants in the United States staged a day of nationwide action to protest against measures to crack down on illegal immigration. In 50 cities protesters waved US and Latin American flags and encouraged supporters to boycott work and refrain from selling or buying products – in order to demonstrate the vital role of illegal immigrants. In Los Angeles alone, an estimated 400,000 people – many wearing white as a sign of solidarity – took part in two marches.

The California senate described 'The Great American Boycott' as an effort to enlighten citizens about 'the tremendous contribution immigrants make on a daily basis to our society and economy'.

Australian miners Brant Webb and Todd Russell emerge from their two-week subterranean ordeal.

293

In May, two miners were rescued after being trapped underground for 321 hours. An earthquake had caused the Beaconsfield Gold Mine in Tasmania to collapse, killing Larry Knight and burying two others 1 kilometre (0.6 miles) beneath the surface. Brant Webb and Todd Russell survived the first five days on one cereal bar and a trickle of groundwater, until emergency workers could pass them supplies via a small tunnel. Rescuers worked tirelessly to blast through the extremely hard rock. After discovering that the pair had kept their spirits up by listening to the band on an iPod, the Foo Fighters wrote the 'Ballad of the Beaconsfield Miners' to commemorate Webb and Russell's courage and resilience.

In 1999, Chicago's Millennium Park initiated a design competition for an iconic public sculpture. British artist Anish Kapoor's proposal for a seamless structure inspired by liquid mercury won over the judges. Years of technical and financial problems delayed construction of 'The Bean', as the piece is affectionately known by locals, but the 168 stainless-steel plates were welded together in time for the park's 2004 grand opening. It took a further year to polish the panels to achieve the reflective surface for which the sculpture has become famous and it was officially unveiled to the public in May 2006. *Cloud Gate* mirrors the city's skyline, creating a bridge between the urban world and the cloudscape above, and embodies Kapoor's dominant theme of the duality between the solid and immaterial.

The highly reflective surface of Anish Kapoor's *Cloud Gate* distorts the Chicago skyline.

296

In Athens, Finnish heavy metal band Lordi prove a surprise winner of the Eurovision Song Contest, Europe's premier festival of kitsch.

Proclaiming the forthcoming 'arockalypse', Finnish rock band Lordi beat the competition favourites to win the 51st Eurovision Song Contest in Athens on 20 May. The band sang 'Hard Rock Hallelujah', accompanied by pyrotechnics and wearing gruesome masks and Viking-style armour. The group were initially criticized by host nation Greece for glorifying Satanism, but the voting public disagreed, with many countries awarding Lordi maximum points. It was the first-ever win in the competition for Finland. The band broke another record on their return to Helsinki, when 80,000 people sang along to the winning anthem at Lordi's first public concert, setting a Guinness World Record for the largest karaoke sing-along to date.

Reminiscent of the clippers of old, the elegant lines of *The Maltese Falcon* cut through the Sea of Marmara.

Aside from being one of the largest luxury yachts in the world, displacing 1,125 tonnes (1,240 tons), *The Maltese Falcon* also represents one of the most significant advances in sailing design for over a century with its 'DynaRig' concept. Originally commissioned by US venture capitalist Tom Perkins, the ship incorporates a revolutionary computer-controlled system of sails without traditional rigging. The advanced carbon-fibre masts reach 58 metres (190 feet) in height, and contain over 2,415 square metres (26,000 square feet) of sail. Without the use of its engines, the boat can reach 20 knots with just the sails. *The Maltese Falcon* is also renowned for its superlative standards of luxury, with 12 private cabins, a gourmet kitchen and even a submarine on board.

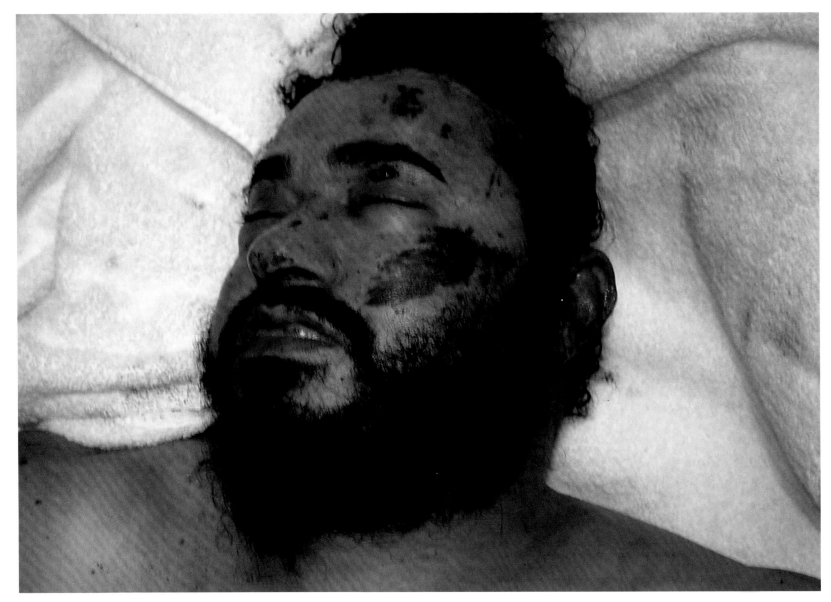

A key figure in the insurgency, Abu Musab al-Zarqawi, is killed near Baqubah in Diyala province, Iraq.

On 7 June the man behind hundreds of kidnappings, bombings and beheadings in Iraq was killed in a US air strike north of Baghdad. For several months Abu Musab al-Zarqawi had been the US-led coalition's number one target. The United States put a $25 million price on his head – the same bounty offered for Osama bin Laden. The Jordanian-born extremist catalysed violence between his fellow Sunni Muslims and Iraq's Shi'a majority. The 39-year-old was also believed to be personally responsible for US contractor Nick Berg's gruesome killing. US and Iraqi officials hailed al-Zaqarwi's death as a 'great success' but warned that it may not stem the tide of the insurgency.

298

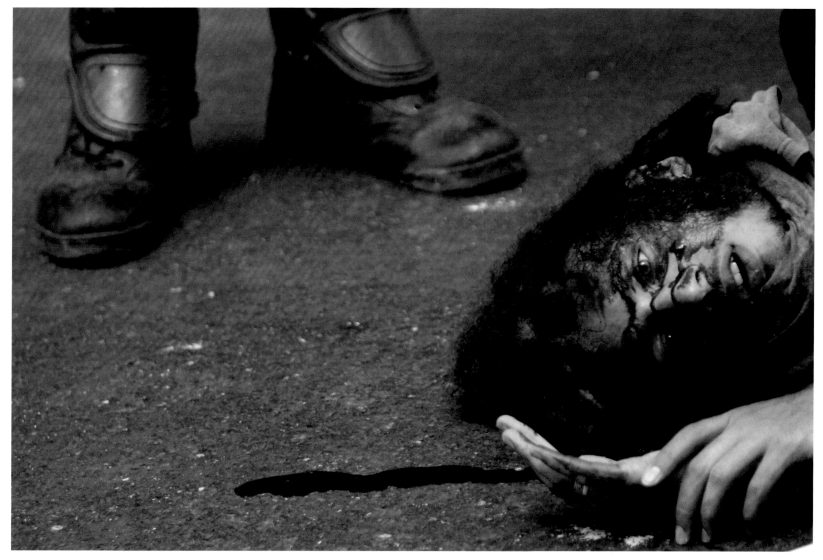

299

A Greek student lies bleeding, following a clash with Athens riot police over education reforms.

Thousands of students and university staff protested when the Greek minister of education announced a change to the constitutional right to public and free tertiary education. Sit-ins occurred in over 400 faculties around the country and 20,000 students participated in the largest student march in 20 years in the centre of Athens on 8 June. The proposal to create private institutions, introduce fixed time periods for degrees and abolish free textbooks was an attempt to increase foreign direct investment and improve national competitiveness in a drive to meet the reforms required by the Organization for Economic Cooperation and Development.

300

The Three Gorges Dam on China's Yangtze River during construction.

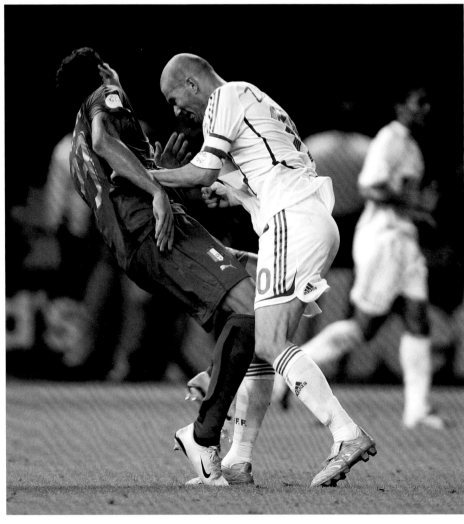

With 715 million people watching, French captain Zinedine Zidane takes issue with something Italy's Marco Materazzi has said.

As China continued its industrial ascendancy, it found itself torn between unbridled economic growth and the attendant environmental costs. The Three Gorges Dam on the Yangtze River was the flagship project in China's renewable energy commitment and the world's largest hydropower installation. Yet construction of the engineering masterpiece entailed the displacement of over a million people, the flooding of settlements and archaeological relics, and reservoir-induced seismic activity. It also had a profound impact on biodiversity in the region. Having silenced critics during the early phases of construction, Beijing later admitted to hidden dangers in the project, and the need to relocate more people, this time to the cities.

French with Algerian roots, Zinedine Zidane was an unequalled midfielder: perhaps the greatest footballer of his time. Come the 2006 World Cup, however, the three-times FIFA World Player of the Year was entering the twilight of his career. Nevertheless, he was crucial to France's progression through the tournament and was awarded, before the final, the Golden Ball for best player. However, during extra time in the 9 July final against Italy, played in Berlin, Zidane revealed a flash of the temper that had always lurked behind his accomplishments. Provoked by a remark about his family, he fiercely headbutted Italy's Marco Materazzi and was sent off. It was an ignominious end to an otherwise glorious career.

A spectacular lava flow on Mount Etna reminds Sicilians of the volcano's fearsome power.

Sicily's Mount Etna is one of the most active volcanoes in the world, bubbling and frothing almost constantly. For six months it had been largely silent, an innocuous lava flow slipping from its upper southeastern flank. Then, just before midnight on 14 July, a fissure opened in its southeast crater, spewing lava towards the Valle del Bove. The intense eruption continued for 10 days, reaching a peak on 20 July, when the flow reached 10 cubic metres (13 cubic yards) a second. Locals have learned to live with Etna's unpredictable outbursts and no one was hurt, a contrast to the enormous death toll of its most terrifying eruption in 1669.

The Host (*Gwoemul*) was released on 27 July in South Korea and quickly became the country's highest-grossing film. It was the third feature film for director Bong Joon-ho and was widely interpreted as a criticism of the United States' military presence in Korea. The illegal dumping of formaldehyde in the Han River by a US-base employee unintentionally creates a mutant amphibious creature that terrorizes civilians and kidnaps Park Gang-du's daughter. As the US military prepares to use the chemical weapon Agent Yellow against the alleged 'virus' carried by the creature, Gang-du and his family struggle to rescue the girl in time.

South Korean actor Song Kang-ho (left) stars in *Gwoemul*, the greatest box-office success in his country's history.

303

Days before Ron Mueck's exhibition opens to the public, a security guard ducks behind Mueck's self-portrait *Mask II*, providing the perfect photo opportunity.

Were it not for the size, Ron Mueck's self-portrait would be almost indistinguishable from his own visage. The artist's hyper-realistic sculptures are disconcertingly accurate, though rendered reassuringly artificial by the manipulation of scale. The meticulous replication of his own face displayed in his work *Mask II* (2001/2002) is just one of the former model-maker and puppeteer's popular explorations of life, death and sex. A major exhibition of Mueck's work was held at the National Galleries of Scotland in 2006 (opening on 5 August) outselling a recent Claude Monet retrospective.

The coffin of Janin Yusef Shawadan, a Hezbollah fighter, is carried at his funeral in Zefta, Lebanon.

On 12 July paramilitary forces of the Lebanese group Hezbollah fired on an Israel Defense Forces (IDF) patrol on Israel's side of the border, killing several soldiers and capturing two. Israel responded with a massive aerial bombardment of south and eastern Lebanon, causing serious damage to the country's infrastructure. Israel mounted an air and naval blockade, followed by a ground invasion of southern Lebanon. Hezbollah retaliated with missile attacks on towns in northern Israel and guerrilla operations against invading troops. The 34-day war cost the lives of about 1,000 people, mostly Lebanese civilians. Nearly 1 million Lebanese and 400,000 Israelis were temporarily displaced. Hezbollah, which remained largely intact, claimed victory; in Israel, the conflict was generally portrayed as an embarrassing debacle for the more heavily-armed IDF and the government.

305

Princess Kiko of Japan and her newborn son Prince Hisahito leave a Toyko hospital. His birth settles a major constitutional question.

On 6 September, Princess Kiko of Japan gave birth to the first imperial male heir in 40 years and, in doing so, averted a crisis that could have heralded the extinction of the world's oldest hereditary monarchy. A 1947 succession law had ruled that only male descendants of the emperor could take the crown. Over time, the mood in Japan shifted towards permitting an empress to ascend the Chrysanthemum Throne. The proposed back-up plan had provoked heated debate between conservatives and liberals, but the arrival of young Prince Hisahito led to widespread jubilation across the country.

The bucolic village of Paradise was the scene of one of the United States' most ghastly school shootings. On the morning of 2 October 2006, milk truck driver Charles Carl Roberts IV stormed an Amish schoolhouse in Pennsylvania, prepared for a siege with guns and knives. He released the male pupils and adults, tying up the remaining 10 girls aged 6 to 13 and shooting them execution-style in the back of the head. Five of the children survived, but the others perished – two at the scene and three more later in hospital. Roberts took his own life, his motives for the horrible attack unclear. As the United States recoiled in horror at the third shooting that week, the Amish community quietly forgave Roberts, leaving judgement to God while they buried the girls in little white dresses.

The funeral procession of four murdered Amish schoolgirls travels through Bart Township in Pennsylvania.

On 15 February 2005 three computer designers launched YouTube, a video-sharing website that was to change the way media was disseminated on the internet. Founded by Chad Hurley, Steve Chen and Jawed Karim, the site enables users to share homemade content easily, for free. Within a year, more than 65,000 video clips were being uploaded every day, making it one of the most popular sites on the web. YouTube went on to capitalize on the growth of mobile phone video functionality and the explosion of online social networking via websites such as Facebook, MySpace and Bebo. In October 2006 it was bought by internet giant Google for $1.65 billion, although the brand – and unique viral community – remained independent.

307

Internet entrepreneurs Chad Hurley and Steve Chen cash in from the Google buyout of their company.

The new Secretary-General of the United Nations, Ban Ki-moon (bottom) addresses the General Assembly.

After 10 years of popular – though not infallible – leadership, Kofi Annan was always going to be a tough act to follow. On 13 October 2006 the United Nations formally elected its next secretary-general by acclamation, demonstrating that international cooperation was still possible, even in a time of uncertainty. The former foreign minister of South Korea, Ban Ki-moon, was widely regarded as a consummate bureaucrat and mediator, with skills acquired from years of diplomatic endeavour concerning wrangling over North Korea's errant ways. Campaigning on a platform of institutional reform, environmental protection and counterterrorism, Ban was a clear front-runner, and was the first Asian to head the UN since 1971.

The legendary Country, Blue Grass and Blues (CBGB) club in New York, at its closure.

Hosting bands from the Ramones to the Misfits to Talking Heads, New York's much-loved CBGB club made its name at the height of punk and new wave music. A dispute with the local residents' committee over rising rent in 2005 led to a refusal to renew the club's lease, though a 14-month reprieve was granted. When it closed, on 16 October 2006, veteran fans mourned the passing of the legendary music venue which had been open since 1973. Many grumbled that the closing of the club was indicative of the gentrification of a once-gritty downtown Manhattan music scene. Patti Smith, the so-called 'Godmother of Punk', played during the last gig at CBGB.

310

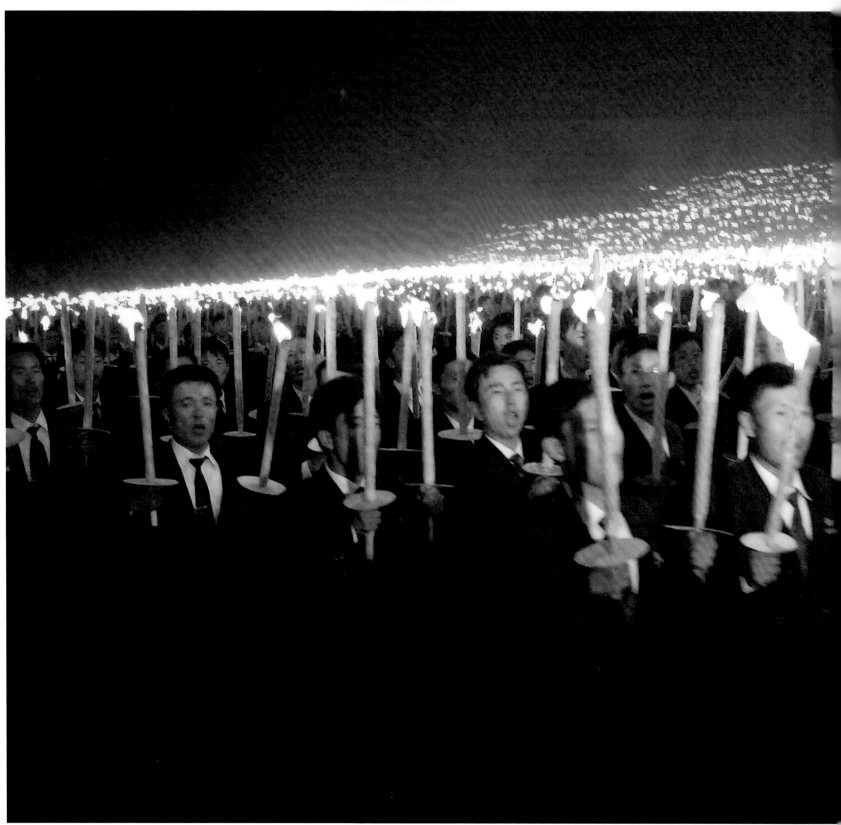

North Korea's 80th anniversary celebrations of the Down-With-Imperialism Union include this mass parade in Pyongyang.

Considered by North Korea to be the foundation of its ruling party, the Workers' Party of Korea, the Down-With-Imperialism Union (DIU) was founded on 17 October 1926. The original aim of the DIU was to fight Japanese imperialism and promote Marxism-Leninism. North Korean legend has it that Kim Il-sung, the country's late leader, established the organization at the tender age of 14. As the nation marked the DIU's 80th anniversary with parades and torchlight processions, North Korean leaders used the occasion to rail against the United Nations for threatening tough new sanctions on the regime over its recent nuclear test.

312

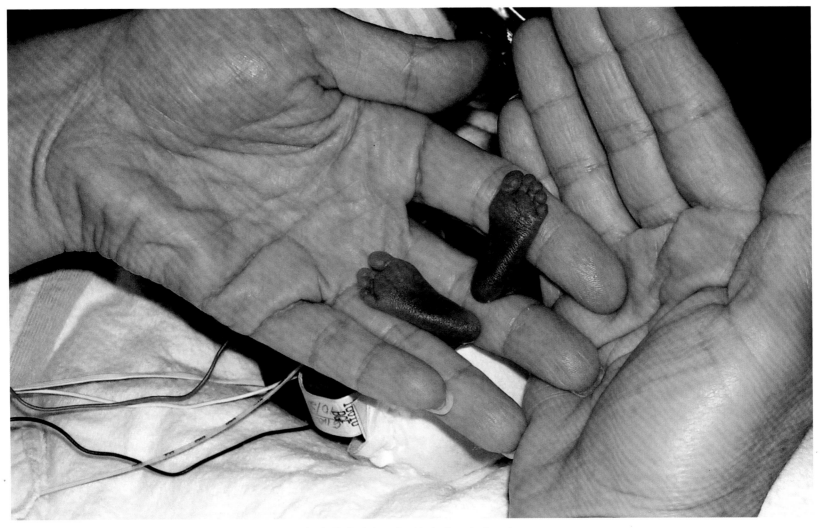

The most premature baby ever known to have survived, Amillia Sonja Taylor is here barely the length of a ruler.

Weighing just 283 grams (10 ounces) and only 24 centimetres (9½ inches) long, Amillia Sonja Taylor was born in Florida on 24 October after less than 22 weeks in the womb – the shortest gestation period of a surviving baby ever recorded. Despite suffering a mild brain haemorrhage, digestive and respiratory problems and a damaged ear from the Caesarean birth, Amillia's resilience was called miraculous. After four months in an incubator, she was allowed home with parents Sonja and Eddie, 11 days before her actual due date. Amillia's survival ignited the debate on abortion laws, as her survival gave succour to those campaigning for a decrease of the 24-week limit.

Newspapers in Kinshasa, the capital of the Democratic Republic of Congo, declare that Joseph Kabila is elected president.

313

The first democratic elections held in the Democratic Republic of Congo in four decades saw the incumbent President Joseph Kabila defeat his rival Jean-Pierre Bemba. Kabila won 58 per cent of the votes compared to Bemba's 42 per cent in a tense runoff, which was closely observed by hundreds of international election monitors. This vast country in central Africa had recently emerged from five years of devastating conflict. The Second Congo War, dubbed 'Africa's World War' owing to the large number of foreign armies involved, reportedly claimed 5.5 million lives, mostly from disease and starvation, making it the deadliest conflict since World War II. Despite hosting the world's largest UN peacekeeping mission, parts of the country remained under the grip of militias and warlords.

314

Actor François Cluzet is on the run in a scene from the French thriller *Tell No One* (*Ne le dis à personne*).

Tell No One (*Ne le dis à personne*) is a French film adaptation of Harlan Coben's electrifying novel of the same name. The protagonist, Alex Beck, finds himself embroiled in a labyrinthine conspiracy eight years after the murder of his wife Margot. Having been sent CCTV footage of his wife, apparently alive, Alex attempts to discover what really happened the night of her disappearance, exposing him to a seedy underworld of hired thugs and corrupt police. Fast-paced and packed with intricate plot twists, the film departed at points from the novel, but Coben acknowledged the cinematic ending as better than his own. Released in France on 1 November 2006, the film won four Césars in 2007.

A US soldier keeps guard during a search in Rawah, Iraq. Meanwhile, in Washington, momentum builds for a large 'surge' of US troops.

Rising sectarian violence across Iraq throughout 2006 seemed to call the Bush administration's policies into question. At home in the United States, President Bush faced a backlash as the autumn mid-term elections – widely considered a referendum on the war – gave the Democrats a majority. It was clear that a new direction was needed: a group of Washington insiders sensationally recommended a significant increase in the number of US military personnel – the so-called 'surge'. By January 2007, Bush had agreed, promising to send more than 20,000 additional troops to Baghdad and Al Anbar province, in order to support political reconciliation. Meanwhile, the US public increasingly questioned whether the war could be won at all.

316

Wearing heavy clothing as protection, Afghan horsemen compete fiercely in the traditional sport of *buzkashi* in Kabul.

Buzkashi has been Afghanistan's national game since antiquity. The name means 'goat dragging' in Persian, and scoring a goal involves lobbing a mutilated animal carcass into a white chalk circle at the end of an unmarked pitch. The sport requires unrivalled horsemanship and strength, and is regarded as an imitation of ancient battles. Only the most accomplished riders participate and they often continue playing with broken limbs or cracked ribs. Banned by the Taliban, *buzkashi* enjoyed a resurgence after 2001, particularly in Kabul, where warlord-owned teams competed as NATO helicopters flew overhead. A particularly exhilarating match is captured here on camera, its gladiatorial spirit appearing to mirror the country's turbulent politics.

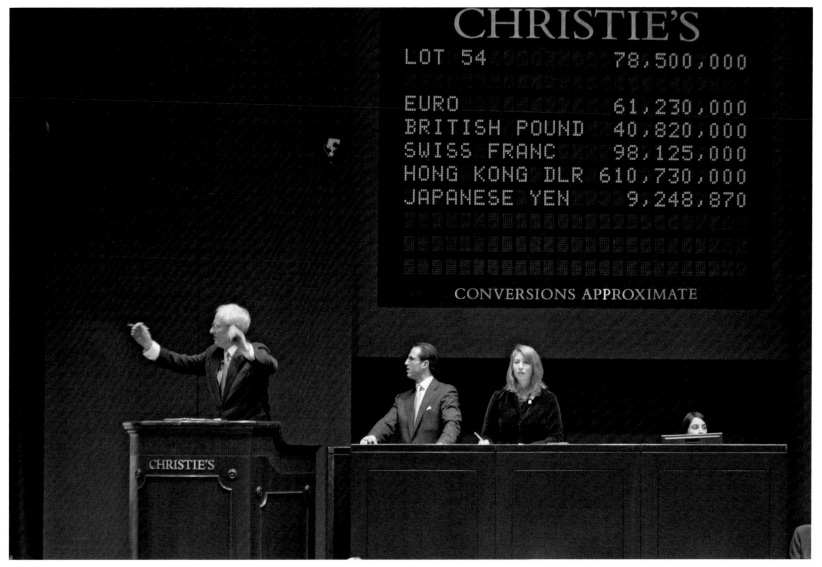

CHRISTIE'S

LOT 54 78,500,000

EURO 61,230,000
BRITISH POUND 40,820,000
SWISS FRANC 98,125,000
HONG KONG DLR 610,730,000
JAPANESE YEN 9,248,870

CONVERSIONS APPROXIMATE

As if conducting an orchestra, Christie's auctioneer takes multi-million dollar bids for Gustav Klimt's Adele Bloch-Bauer II of 1912.

Four works by Austrian Art Nouveau painter Gustav Klimt dominated a record-breaking sale at Christie's in New York, which reported a final tally of $491.4 million, smashing the previous record for a single sale set by the same auction house 16 years earlier. Klimt's paintings, which only a few months previously had finally been restituted by Austria to Jewish heirs after a lengthy legal battle, fetched a total of $192 million. His 1912 portrait, Adele Bloch-Bauer II, went for almost $88 million, the third highest price for a work of art purchased at auction at the time. 'I've never seen anything like it,' marvelled Christopher Burge, chief auctioneer at Christie's.

In May 2005, during her 'Showgirl' tour, popstar Kylie Minogue was diagnosed with breast cancer. She postponed the remaining tour dates to receive treatment in Paris, getting the all-clear six months later. Resuming the tour on 11 November 2006 in Sydney, the 37-year-old pop star appeared in good health, decked out in feathers and sequins for the renamed 'Homecoming' series of concerts. Minogue's much-publicized illness was credited with raising awareness of breast cancer, and in 2008 Minogue – who had had 42 hit singles in the UK – was awarded an OBE.

318

With her usual glamour, Australian pop icon Kylie Minogue launches her 'Showgirl Homecoming' tour in Sydney after having beaten cancer.

Hollywood's pre-eminent couple met on the set of the 2005 film *Mr. & Mrs. Smith*. At the time, Brad Pitt was married to actress Jennifer Aniston. She filed for divorce following a tabloid frenzy over allegations that he and co-star Angelina Jolie were having an affair. So enthralled by the sensational pairing of the unconventional, darkly beautiful Jolie, herself twice divorced, and leading Hollywood hunk Pitt, the entertainment media coined a new word, 'Brangelina'. The couple's films faded into near obscurity as attention turned to their ever-growing family and global activism. In late spring 2006 celebrity journalists descended on little-known Namibia in southwest Africa, which the couple chose as the birthplace for their daughter, Shiloh, born on 27 May. Many blamed Pitt and Jolie, a United Nations Goodwill Ambassador, for orchestrating the tawdry media circus that seemed to follow them wherever they went.

Brad Pitt and Angelina Jolie, with children Zahara and Maddox, in Mumbai, India, during a break in shooting *A Mighty Heart*, in which Jolie plays the wife of kidnapped US journalist Daniel Pearl.

319

Ségolène Royal, president of the Poitou-Charentes region of France, comfortably won the Socialist Party primary, securing her the nomination for the 2007 presidential election. Addressing the world press from her home town of Melle, she evoked the spirit of John F. Kennedy by declaring 'ask what you can do for your country'. Royal's victory increased her stature among colleagues who had publicly questioned the wisdom of having a 'Madame la Présidente'. Her outsider status gave her credibility, trumping her male rivals' more conventional resumés. Ultimately, however, her incoherent campaign was unable to overcome divisions on the left, and she lost out to UMP candidate Nicolas Sarkozy.

With over 60 per cent of the vote, Ségolène Royal wins the Socialist Party leadership race in France.

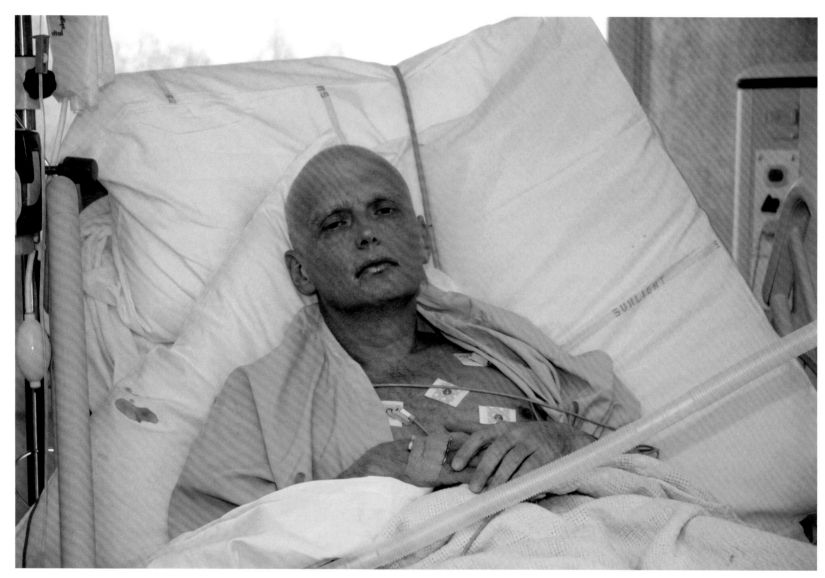

Former KGB operative Alexander Litvinenko languishes in University College Hospital, London, three days before his death.

In the late 1990s Russian security officer Alexander Litvinenko broke ranks and publicly accused his superiors of plotting to murder the tycoon and oligarch Boris Berezovsky. After being arrested he fled to the UK, where he was granted political asylum. While living in London he became an outspoken critic of Russian President Vladimir Putin and the country's security services, accusing them of political assassinations and terrorist acts. On 1 November 2006, Litvinenko suddenly fell ill and was hospitalized. Doctors discovered the presence of polonium-210, a poisonous radioactive isotope, in the 43-year-old's body. He died three weeks later. Suspicions quickly fell on Andrei Lugovoi, an ex-KGB agent Litvinenko met at a London sushi bar on the day he was poisoned.

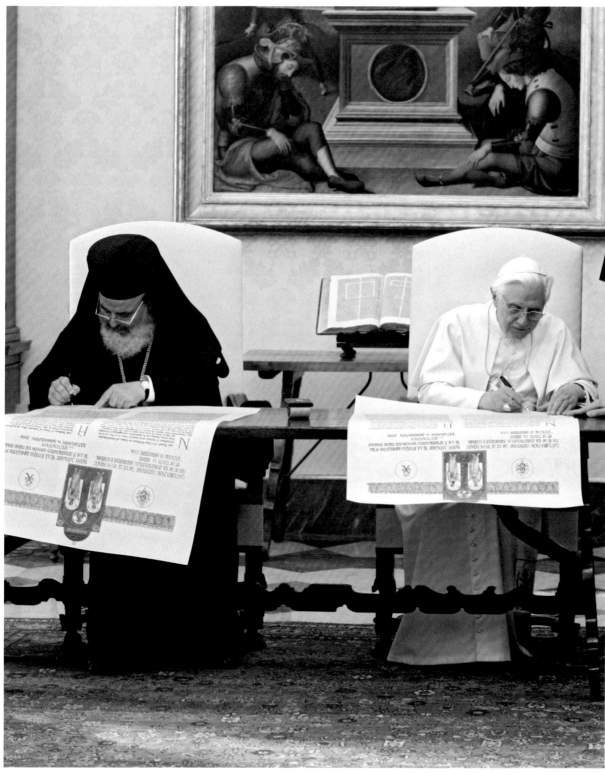

In the Pope's private apartment at the Vatican, Rome, Benedict XVI and Greek Orthodox Archbishop Christodoulos sign an agreement to promote Christian unity.

Pope Benedict XVI made a concerted effort in December 2006 to promote ecumenical unity within the Christian faith. Early in the month he travelled to Turkey to meet Patriarch Bartholomew I, spiritual leader of 250 million Orthodox Christians, where they issued a joint declaration reaffirming their desire to restore full communion between the Eastern and Western branches of the Church. On 14 December, Pope Benedict and the head of the Orthodox Church of Greece, Archbishop Christodoulos, also signed a joint declaration, this time at the Vatican. The two leaders called for constructive theological dialogue on healing the thousand-year-old rift, and agreed to join forces in defending Christian values against the 'new risks' of secularism, relativism and nihilism.

321

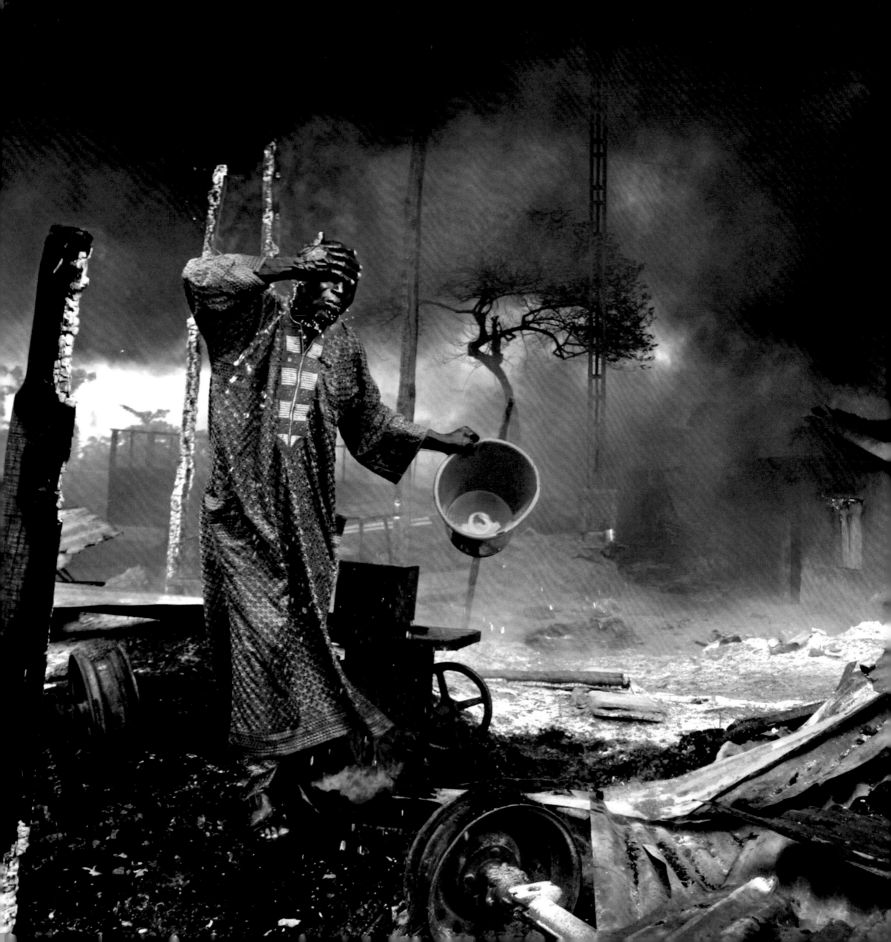

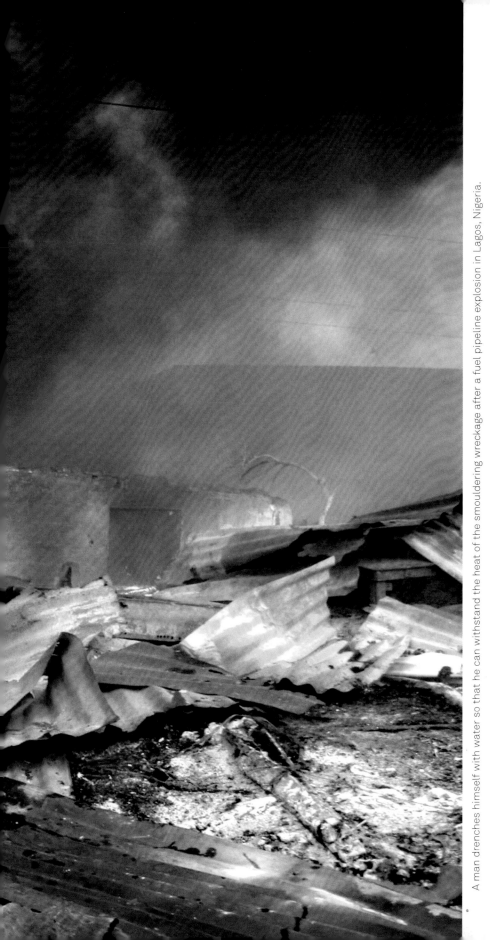

A man drenches himself with water so that he can withstand the heat of the smouldering wreckage after a fuel pipeline explosion in Lagos, Nigeria.

323

Nigeria is one of the world's largest oil producers. Pipelines criss-cross the country, many cutting through residential areas, including Lagos. On 26 December a punctured pipeline exploded in the heavily populated neighbourhood of Abule Egba, killing over 200 people. It had been ruptured by thieves looking to siphon off oil – despite the abundance of the crude resource, most Nigerians struggle to get enough for cooking and transport, as corruption and poor management leads to fuel shortages. The source of the ignition was unclear. Bodies strewn over the area may have included those of the vandals but they were burned beyond recognition.

Saddam Hussein's final moments before his execution in Baghdad. With his last breaths he cursed the United States, traitors and Persians.

324

Saddam Hussein, the Iraqi dictator deposed during the US-led invasion of 2003, was executed on 30 December 2006 for crimes against humanity. An official videotape played on Iraqi state television showed images of Saddam, carrying a copy of the Koran, being led by hooded security personnel to the gallows in a building his intelligence agents once used for executions. The footage ended with the noose being placed around Saddam's neck. Within hours an unauthorized mobile phone recording of the full execution, which captured exchanges between Saddam and his executioners in the moments before he fell through the trap door, was broadcast around the world. The tawdry spectacle drew international criticism and divided opinion among Iraq's Shi'as, who took to the streets in celebration, and Sunnis, many of whom viewed the former dictator as a martyr.

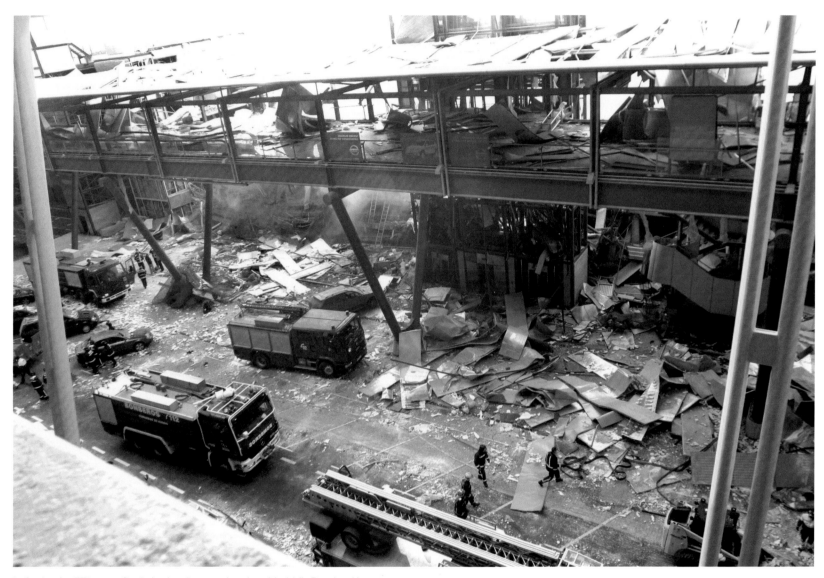

In Spain, the ETA ceasefire is broken by a car bomb at Madrid's Barajas Airport.

Plumes of black smoke signalled the end of the cease-fire between the Spanish government and the Basque separatist movement ETA when a car bomb exploded at Madrid's Barajas Airport on 30 December. Destroying the car park of the new terminal, the bomb claimed two lives. ETA apologized for the collateral damage, claiming that it had warned the government, which was therefore to blame for failing to fully evacuate the blast zone. These were the first deaths attributed to the organization in three years, representing their frustration at the slow progress of the peace talks promised in June following March's historic ceasefire.

2007
Surge

No American general since World War II garnered as much international attention as David Petraeus did in 2007. After President Bush rejected a bleak report that the White House had commissioned on the future of the military campaign in Iraq, he turned to a dwindling band of experts who believed the war could still be won, provided there was a major increase in US troop numbers. Bush accepted their findings and appointed General Petraeus as overall commander of the so-called 'surge'. Petraeus was an unlikely army general, as much for his slight stature as for having a PhD from Princeton. He rightly predicted that the start of the surge would result in some of the highest monthly troop and civilian death tolls recorded since the war began. By the end of the year, violence in Iraq had begun to abate under his deft command, but he constantly reminded Americans, Iraqis and the world that such gains were fragile and could easily be reversed. The other, 'forgotten war' fought by a US-led coalition in Afghanistan was heating up. The Taliban, ousted from power in 2001, were resurgent in the lawless southern provinces of the country, where the proliferating opium trade was supplying 90 per cent of the world's heroin. Their main strongholds and source of funds and manpower lay across the border, in neighbouring Pakistan; its turbulent politics were rocked by the assassination of Benazir Bhutto. The charismatic former prime minister had sensationally returned to Pakistan in late 2007 to campaign for a third term as the country's leader when she was killed while leaving a political rally in Rawalpindi. Blame fell quickly on the Taliban and Al Qaeda. At the end of the year violence also marred elections in other parts of the world, notably Kenya. The once stable East African nation, famed for its wildlife and national parks, erupted into chaos after elections for its president were rigged to ensure that Mwai Kibaki remained in power. The tribal character of the violence raised the spectre of another African genocide, although dire poverty and years of government corruption also contributed to Kenyans' anger. There was no violence but plenty of drama in France's presidential election, which saw the mercurial Nicolas Sarkozy emerge victorious over his glamorous opponent, Ségolène Royal. The new French president made clear his intention to repair his country's relationship with Washington by taking his annual summer holiday in New Hampshire in the United States. And, nearly 20 years after a doping scandal rocked the world of athletics, the sport suffered another massive blow with a belated admission by former Olympian, Marion Jones. The American sprinter and long jumper was stripped of all her medals, including three golds and two bronzes, which she had won at the 2000 Sydney Olympics in Australia, when she was forced to concede that she had taken performance-enhancing drugs. Meanwhile, in children's literature, Britain's J.K. Rowling retained her position as the world's best-selling author with the hugely anticipated release of the seventh and final instalment of the Harry Potter series *Harry Potter and the Deathly Hallows*. Few believed there would ever be a publishing phenomenon like hers again.

328

Raging intermittently since 1963, the nationalist Touareg insurgency flared up again in Niger in 2007. Claiming that greater political representation and economic opportunity promised by the 1995 peace treaty had not been realized, the Touareg focused their fury on government security forces, which in turn used considerable force to suppress the rebellion. The nomadic tribe makes up less than 10 per cent of Niger's population, with a majority based in the uranium-rich north. Niger is one of the world's top producers of the nuclear fuel, and in June 2007, the world price hit $135 per pound. The Touareg, however, are victims of Niger's dire poverty, exacerbated by the lack of government investment and the ecological impact of increased mining and did not benefit from the dividend.

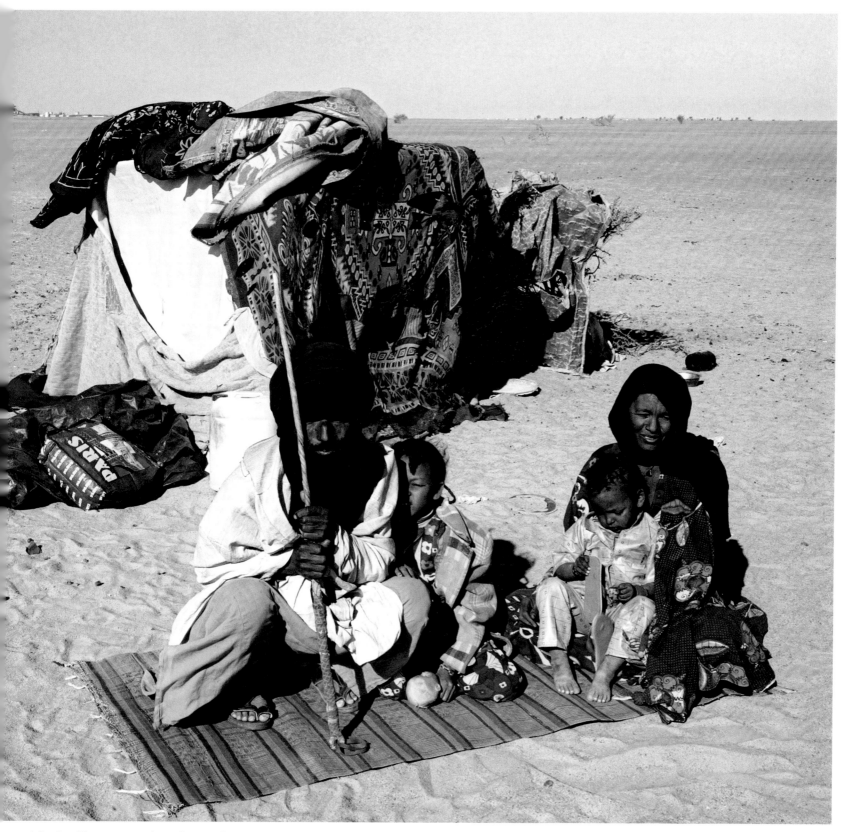

A family of Touareg nomads settles as refugees near the mining town of Arlit, Niger.

330

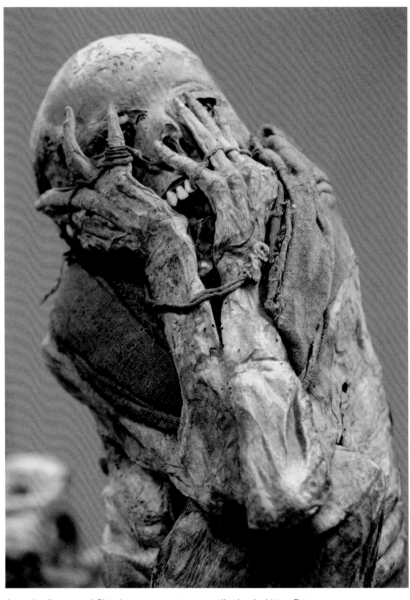

Steve Jobs launches the much-anticipated Apple iPhone in San Francisco.

A newly discovered Chachapoyas mummy on display in Lima, Peru.

Apple's entry into the mobile phone market ended years of internet and press speculation. The iPod had already become a bestseller, turning round the company's fortunes; technology enthusiasts saw the phone as a natural next step. Apple CEO Steve Jobs announced the product at the Macworld convention in San Francisco on 9 January 2007 to great fanfare; the company's share price rose 7 per cent that day alone. The iPhone's most anticipated feature was its revolutionary touch screen, with only one button for operating the device. Dedicated fans queued for hours outside Apple stores when the product was launched in June.

Entombed for 600 years in an underground grave, mummified members of the Chachapoyas tribe were discovered by chance deep in the Amazonian rainforest. Put on display at Lima's Museo de la Nación in January 2007, the 12 desiccated figures were members of a pre-Incan race that ruled an Andean kingdom from AD 800 to 1500, which was annexed by the conquering Incas. Few records exist of the so-called 'Warriors of the Clouds' except for the dramatic citadel Kuelap, built high in the forest. The 2007 discovery of this tomb, including its painted murals, gave archaeologists more clues about the lost civilization.

331

British supermodel Naomi Campbell is led from a Manhattan courtroom after pleading guilty to assaulting her housekeeper with a mobile phone.

One of the first supermodels, Naomi Campbell had defined glamour throughout her 20-year fashion career. Leaving Manhattan Criminal Court on 16 January charged with second-degree assault, she flashed a brilliant smile at the gathered photographers, giving no hint of remorse for the behaviour that cost her five days of community service and an anger management course. Although she said she had accepted responsibility for throwing her mobile phone at her housekeeper, it was neither the first nor the last brush with the law for the tempestuous model. A violent tantrum on board a British Airways flight in London two years later landed Campbell in court, although the model again escaped jail.

Giant Mexican newborn Antonio Cruz (top) lies alongside a baby of a more modest birth-weight.

332

Residents of the Mexican resort of Cancun flocked to the town's hospital after the birth of Antonio Cruz on 28 January. Delivered by Caesarean section, he weighed in at a whopping 6.4 kilograms (14 pounds), double the average weight for newborn babies, earning him the nickname 'Super Tonio'. Antonio's parents Luis and Teresa were relieved to hear that despite his abnormal size, he was a normal healthy child. Remarkably, 'Super Tonio' was nowhere near the heaviest weight for a newborn confirmed by the Guinness Book of World Records. That honour was still held by an Italian born in 1955 who weighed a colossal 10.2 kilograms (22 pounds, 8 ounces).

A masterful depiction of the East German police state in *The Lives of Others*.

Described as the best film of the decade, *Das Leben der Anderen* (*The Lives of Others*) wowed critics in Germany and beyond, going on to win Best Foreign Language Film at the 2007 Academy Awards on 25 February. Directed by Florian Henckel von Donnersmarck, the film is both a political commentary and a human drama, a counterweight to nostalgic accounts of the era. Gerd Wiesler, a Stasi officer, is committed to East Germany's regime – until his involvement in a wiretapping operation exposes his masters' corruption and the dissidents' humanity. Wiesler's transformation from disciple to saboteur is masterfully depicted by Ulrich Mühe, who sadly died of cancer only a few months after the film's Oscar success.

333

Penélope Cruz pauses backstage at the Academy Awards held at Hollywood's Kodak Theatre on 25 February.

Nominated for Best Actress at the 79th Annual Academy Awards on for her role in Pedro Almodóvar's *Volver*, Penélope Cruz lost out to British actress Helen Mirren. Cruz first gained renown in the 1992 film *Belle Epoque* and became a darling of the international film circuit, before breaking into Hollywood in the 2000s. Widely acclaimed for her versatility, the seductive and playful actress finally garnered an Oscar in 2009. Madrid-born Cruz became Spain's first female Oscar-winner when she was named Best Supporting Actress for her comic turn as a hot-tempered lover in Woody Allen's *Vicky Cristina Barcelona*.

A veteran of Northern Irish politics, the DUP leader Ian Paisley (middle) has just cast his ballot in East Belfast for the Northern Ireland Assembly.

334

The third elections to the Northern Ireland Assembly were held on 7 March. The British and Irish governments hoped the outcome would lead to the end of 'direct rule' and the restoration of devolved government, suspended since October 2002 amid allegations of an IRA spy ring at Stormont. The greatest number of votes went to Reverend Ian Paisley's Democratic Unionist Party and Sinn Féin, a result that suggested strong support for power-sharing between unionist and nationalist politicians. The hard-line views of 80-year-old Paisley had clearly softened. Within two months he and Sinn Féin's Martin McGuinness, once the fiercest of enemies, were appointed Northern Ireland's first minister and deputy first minister respectively.

335

As Zimbabwe's political turmoil continues, opposition leader Morgan Tsvangirai recovers from injuries sustained in police custody.

Since his election as leader of Zimbabwe's Movement for Democratic Change in 2000 Morgan Tsvangirai had been the international symbol of resistance to President Robert Mugabe's increasingly repressive rule. Charismatic and extraordinarily brave, the former trade unionist risked imprisonment, beatings and assassination while attempting to restore democratic politics to the devastated southern African country. On 11 March 2007, a day after his 55th birthday, Tsvangirai was arrested on his way to a prayer rally in Harare. During his torture by government security forces he suffered multiple head and facial injuries. President Mugabe claimed that the opposition leader, who was later released, deserved his treatment and had been 'disobeying' police orders.

Early on 16 April two students were shot dead in a hall of residence at Virginia Tech, a university in Blacksburg, Virginia. Believing it to be a domestic incident, campus police refrained from locking down the area. Two hours later, in a carefully crafted attack, Cho Seung-hui barricaded the doors of Norris Hall and opened fire on faculty members and students, killing 32 people. Ten minutes into the second massacre, Cho turned the gun on himself. Reportedly likening himself to Jesus Christ, Cho had sent a manifesto denouncing snobbery and wealth to news channel NBC. Details of his mental ill health emerged later, though they gave little relief to the victims' families and friends.

Cho Seung-hui's mental instability is apparent in the video he made before carrying out the Virginia Tech massacre.

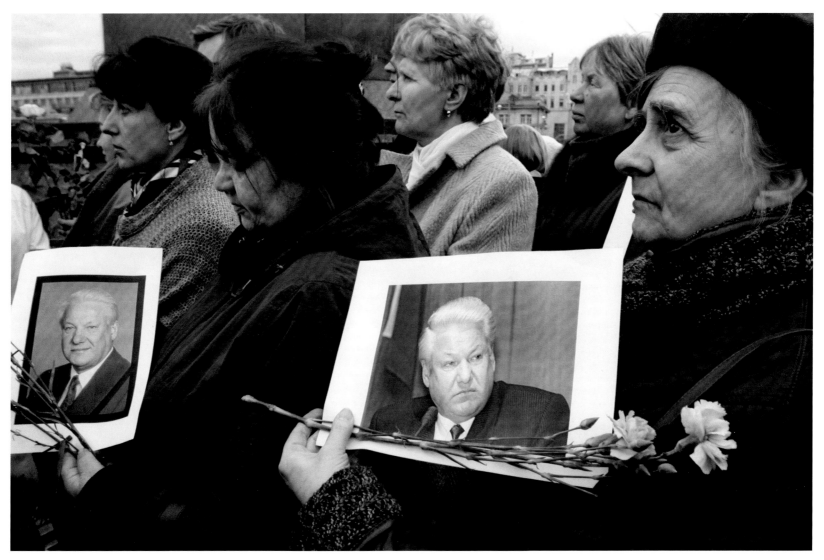

Mourners outside Christ the Saviour Cathedral, Moscow, bid farewell to former Russian president Boris Yeltsin.

337

The first democratically elected leader in Russia's history, Boris Yeltsin died of heart failure at the age of 76 on 23 April 2007. His record as president was mixed. He had stood firm against any return to Communism or descent into nationalist dictatorship. But he was also indelibly associated with and blamed for the severe economic hardships suffered by Russians in the post-Soviet era. However, he was genuinely mourned by many who saw him as the father of a new Russia. His funeral service was held in Moscow's Cathedral of Christ the Saviour – destroyed by Communists in 1931 and rebuilt with Yeltsin's approval. Former US presidents Bill Clinton and George H.W. Bush attended.

The new French president, Nicolas Sarkozy, cheerily walks up the steps of the Élysée Palace a few weeks after his victory of 6 May.

338

On 6 May, Nicolas Sarkozy won the French presidency following a second round of voting. The leader of the ruling centre-right party, Sarkozy ran against socialist candidate Ségolène Royal on a platform of tough law and order, tighter immigration control and national unity. Both candidates were considered political mavericks and promised energized leadership and a modern approach after Jacques Chirac's 12-year reign. As Sarkozy announced his intention to be president of 'all the French', anti-Sarkozy protests were reported around the country. Nevertheless, the near-record 84 per cent turnout and clear margin of victory gave him a strong mandate to carry out his far-reaching policies.

339

Tony Blair leaves Trimdon Labour Club in Sedgefield, northeast England: he has just informed his constituents that he will stand down as MP and prime minister.

He had been prime minister for 10 years, steering the UK through the War on Terror, the invasion of Iraq, the rejection of the euro and historic peace in Northern Ireland, but on 27 June 2007, Tony Blair resigned the leadership. Earlier he received a standing ovation in the House of Commons, and tributes from across the party spectrum. The politician, who was loved and loathed in equal measure, announced he was to take on the role of Middle East envoy, mediating in the Israeli-Palestine conflict on behalf of the United States, United Nations, European Union and Russia. On 10 May he had addressed his Sedgefield constituents and apologized for his failings, saying 'I did what I thought was right'.

340

Marie-Josée Croze's character develops a communications system for a paralysed patient in *The Diving Bell and the Butterfly*, which premieres at the Cannes Film Festival.

Based on Jean-Dominique Bauby's bestselling memoir, *The Diving Bell and the Butterfly*, the 2007 film depicted the writer's 18-month struggle with locked-in syndrome. Former editor-in-chief of French *Elle* magazine, Bauby suffered a massive stroke in 1995, which left him cognitively aware but severely paralyzed. Able only to control the blinking of his left eye, repeated recitation of the alphabet by a helper enabled him to choose the letters of his words and, through this tortuous process, Bauby dictated his eloquent and heartfelt book. Directed by acclaimed artist and filmmaker Julian Schnabel, the film was praised for conveying Bauby's frustration and isolation, the impressionistic cinematography depicting his retreat into an internal world of memory and fantasy.

341

David Hockney stands in front of his painting *Bigger Trees Near Warter* at the Royal Academy in London.

The influential British artist David Hockney, famous for his photomontages and vibrant paintings, displayed his largest work to date at the Royal Academy of Arts' annual Summer Exhibition in 2007. Made up of 50 small canvases, *Bigger Trees Near Warter* is a 4.6 by 12.2 metre (15 × 40 feet) masterpiece that depicts a small coppice in Yorkshire. This grid enabled Hockney to work on the individual panels *in situ*, and then consider the whole using computer technology. The resulting scale captures the majesty of the bald winter trees, giving the branches space to stretch and interconnect: a magnificent rendering of the English countryside.

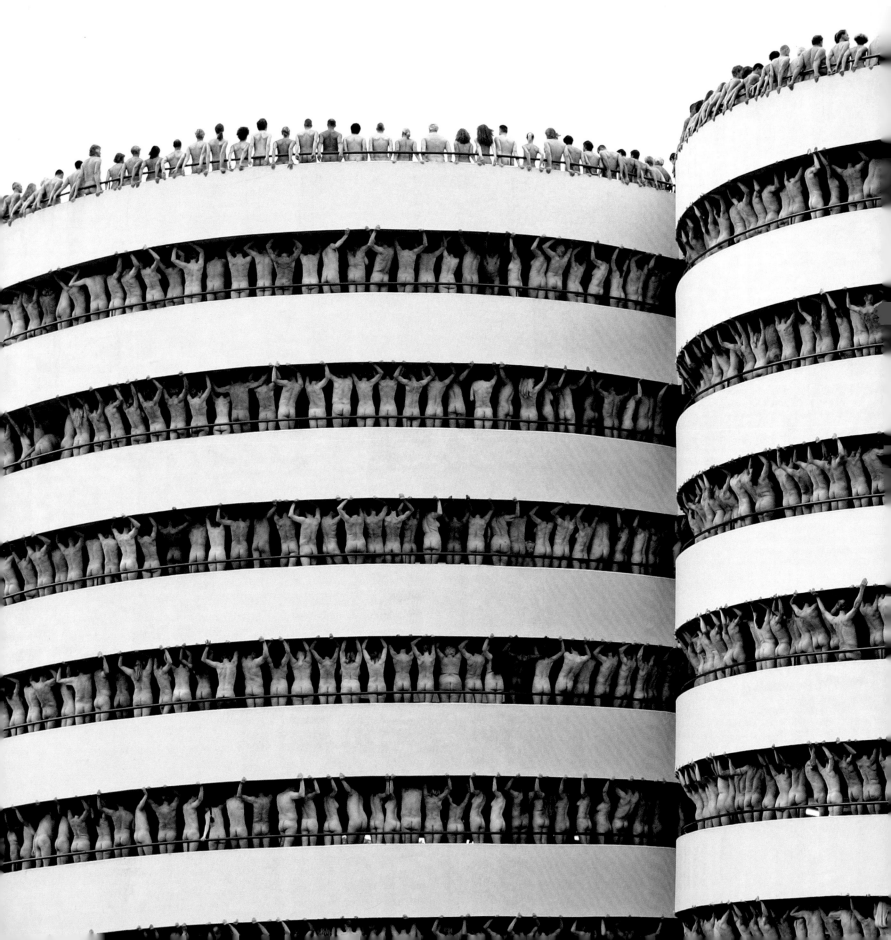

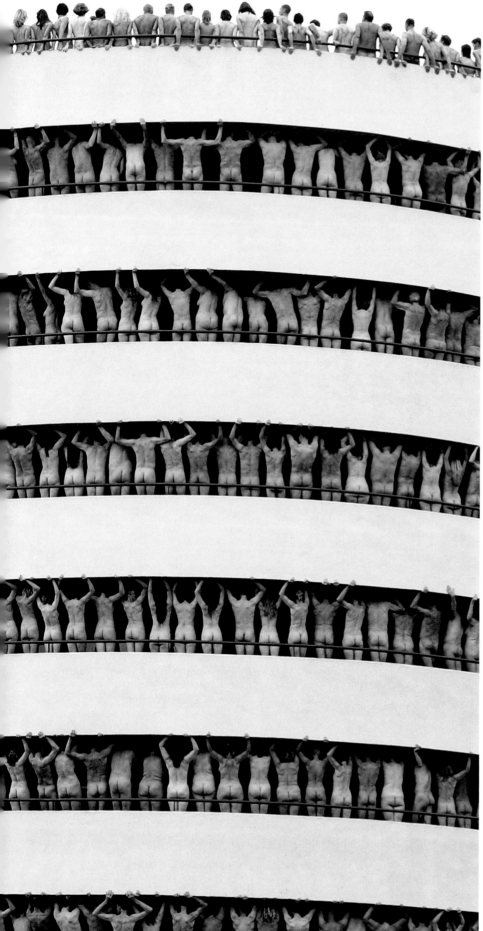

343

Two thousand volunteers bare all for photographer Spencer Tunick in Amsterdam.

US photographer Spencer Tunick has created installations in some of the world's biggest cities. Using public spaces, he makes living sculptures made up of people dressed only in what he calls 'Adam costume'. Volunteers are arranged in symmetrical abstractions that challenge perceptions of nudity and privacy. On 3 June, 2,000 naked people lined the two towers of Marnixstraat's car park in Amsterdam. The installation was the first commission of Dream Amsterdam, an annual display of contemporary artwork in the city. The following month, Tunick set a record when he photographed 18,000 naked people in the Zócalo of Mexico City for his next project.

344

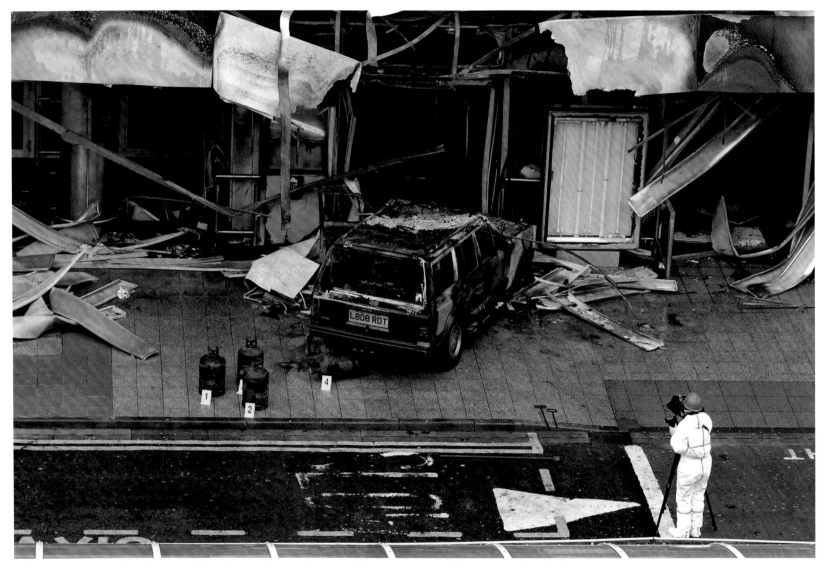

A forensics team examines the scene of the Glasgow Airport attack, in which the only person killed was one of the bombers.

On 30 June two men attempted to drive a burning Jeep Cherokee packed with petrol and gas canisters into Glasgow Airport. It was the day of the state opening of the Scottish Parliament, the day after two failed car bombings in London and just three days after the appointment of the first Scottish prime minister in 50 years. It also became the day that fear of terrorism spread across the British Isles. Blocked by bollards, the driver and his accomplice abandoned the vehicle and attempted to ignite a firebomb. It failed to go off, and the two men, one of whom was in flames, were tackled to the ground by passers-by. The burning man later died in hospital, but eight other conspirators, including NHS medical doctors, were arrested.

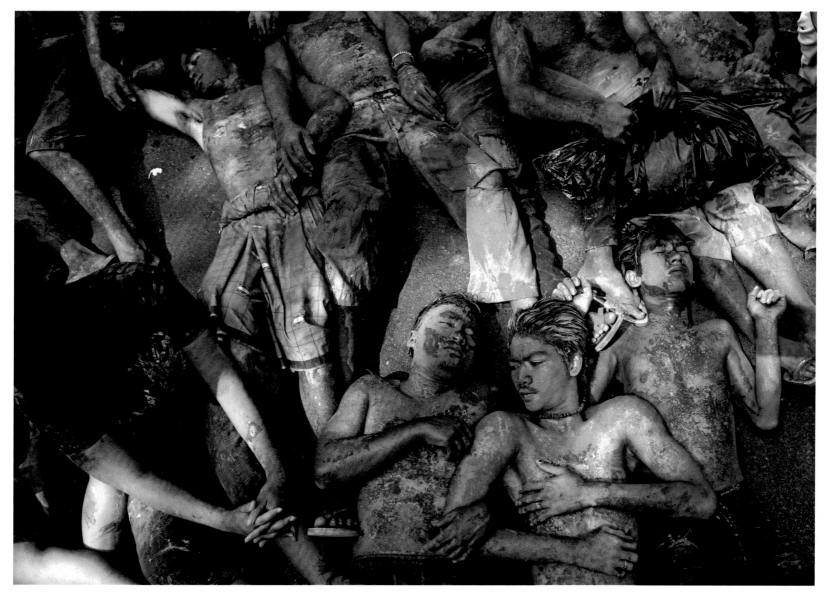

Indonesian environmental activists protest in Jakarta against Lapindo Brantas, an oil company linked to Indonesia's government.

345

Having suffered a tsunami, earthquake and volcanic eruption during the previous two years, Indonesia had already had its share of natural disasters. Then, on 28 May 2007, a build-up of subterranean pressure produced a ferocious geyser of hot, putrid mud in Sidoarjo, East Java. Over the following four months, the daily discharge increased in volume until the so-called 'mud volcano' was spewing out 125,000 cubic metres (4.5 million cubic feet) a day. Although there were no direct deaths, thousands of people lost their homes and livelihoods. The crater was still gushing two years later as experts met to discuss the cause, overwhelmingly agreeing that the irresponsible drilling of the Lapindo Brantas oil company was to blame.

After 45 years in the business, Valentino was truly a master of couture. His clothes defined feminine elegance: his clean lines, often in a signature lipstick red and accessorized with grown-up bows, had been worn by some of the world's most famous women. A three-day gala celebration in Rome conjured up *la dolce vita* as the designer presented his 2007 haute couture collection in the eighth-century Santo Spirito complex, followed by a dinner for a thousand guests at the Temple of Venus where he was fêted by his peers. Meanwhile, a retrospective exhibition at the Ara Pacis Museum showcased 300 gowns, expressing the fashion house's timeless glamour.

346

Mannequins pose in Valentino's signature red at the designer's retrospective at the Ara Pacis Museum in Rome.

347

Charged with murder in the second degree, Phil Spector sits in a Los Angeles courtroom.

An undisputed musical genius and originator of the 'Wall of Sound' production technique, Phil Spector worked with some of the most famous names in popular music over a 40-year career. He was also a bully and misogynist, who over the years allegedly threatened several female acquaintances at gunpoint. In 2007 Spector pleaded not guilty to the murder of actress Lana Clarkson, who was shot in the mouth at his Los Angeles home. His defence team claimed that Clarkson killed herself over financial concerns and her failing career. The trial was abandoned when the jury failed to reach a unanimous verdict. Two years later Spector was convicted after a five-month retrial and sentenced to between 19 years' and life imprisonment.

In the 1980s, Afghanistan produced roughly 30 per cent of the world's opium. The 2007 World Drug Report, the United Nations' annual assessment of illegal drugs, announced that that figure had tripled. One Afghanistan province alone, Helmand in the south of the country, cultivated almost half the world's illegal opium. The report's alarming findings forced a dramatic rethink of the internationally funded poppy eradication programme and the role of the drugs trade – said to involve over 3 million Afghans – in fuelling the Taliban insurgency and other criminal activities in Afghanistan.

Afghan drug addicts smoke heroin in a ruined building in Kabul.

Harry Potter and the Deathly Hallows was the seventh and final book of the Harry Potter series by J. K. Rowling. Simultaneously launched in 93 countries on 21 July, 15 million copies were sold in the first 24 hours, after fans queued up overnight to be the first to read the children's tale. Midnight parties took place around the world, with wands, witches' hats and wizards' cloaks galore. The book chronicles the efforts of the three young wizards to destroy the physical incarnations of the wraith-like villain Lord Voldemort, in a terrifying adventure whose success could spell the demise of Harry Potter's lifelong nemesis and the triumph of good over evil. In real life, the enduring popularity of the Harry Potter series, together with a commitment to adapt each book into a feature-length film, signified a publishing triumph.

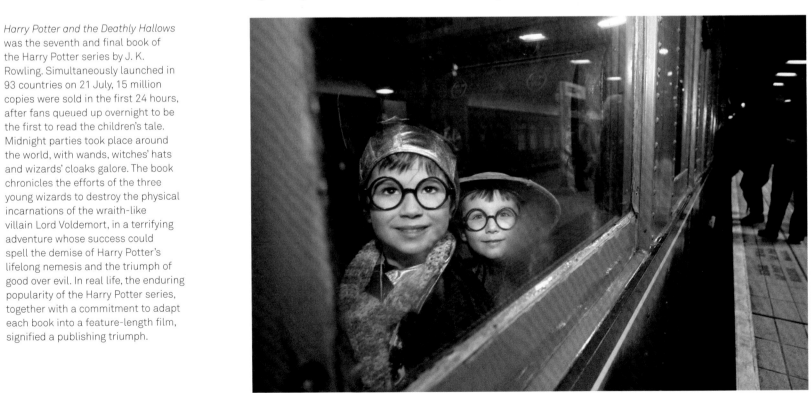

Costumed Harry Potter fans travel (by train, naturally) to a secret location in Sydney for the launch of the last book in the hugely successful Harry Potter series.

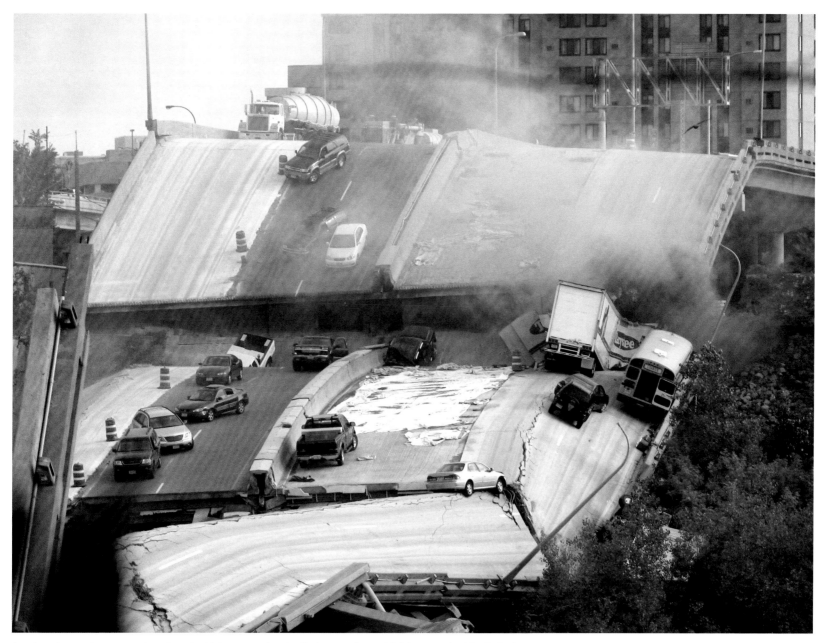

An almost unreal scene as abandoned vehicles precariously sit atop a collapsed bridge over the Mississippi.

349

It was an ordinary Wednesday evening in Minneapolis, Minnesota. Without warning, the I-35W Bridge crumpled and buckled, collapsing into the Mississippi River and taking its load with it. As if in a scene from a movie, a school bus full of children balanced precariously on the edge, while dozens of cars were submerged. Thirteen people died, with many more injured and traumatized. Although it had passed its annual inspection, serious structural deficiencies and stress fractures had finally taken their toll on the 40-year-old bridge. Thousands of people assisted in the relief effort, including a number of 'citizen heroes' who helped trapped compatriots.

350

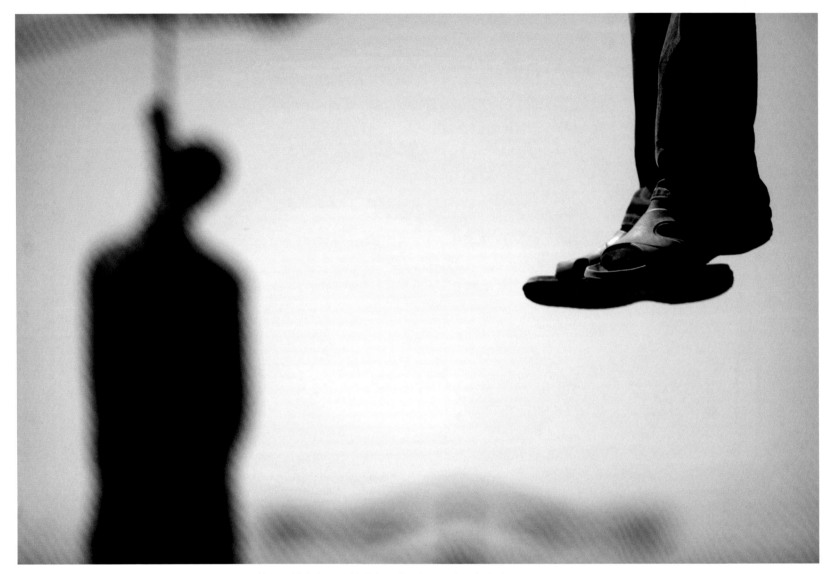

The bodies of Majid Kavousifar and Hossein Kavousifar, publicly hanged in Tehran for the murder of a judge.

The first public execution in Iran's capital since 2002 saw two relatives hanged for the murder of a prominent judge. Hossein Kavousifar and his uncle, Majid Kavousifar, were executed on the same day and in the location of the murder two years earlier. Tehran's chief prosecutor told reporters that the uncle had expressed no remorse for murdering a 'corrupt' judge who had jailed many reformist dissidents. A crowd of several hundred people, some recording the event on their mobile phones, witnessed the hangings. According to international human rights groups, only China executes more criminals than Iran.

351

President Nicolas Sarkozy scowls at photographers while on holiday in New Hampshire.

President Vladimir Putin basks in (carefully choreographed) media attention in Siberia.

Newly elected French President Nicolas Sarkozy made a political point by taking his August summer holiday in the United States. It was a bold move. In France he had already received criticism for taking a pro-US stance. Nevertheless, he was eager to mend ties at the start of his presidential term. Accompanied by his then wife, Cécilia Ciganer-Albéniz, and their son, he stayed in a mansion on Lake Winnipesaukee, near Wolfeboro, New Hampshire. His visit attracted much press attention in the US. It also led to a minor altercation:

Sarkozy, out on a boat fishing and wearing only his swimming trunks, jumped on board a vessel carrying photographers and angrily demanded that they leave.

A former KGB officer, Russian President Vladimir Putin was an avid fitness fanatic, his physical prowess standing in marked contrast to that of his predecessor, Boris Yeltsin, who had struggled with alcoholism. In August 2007, Putin's holiday with Prince Albert of Monaco was documented through a series of images

showing off the president's physique. Some saw this as evidence of a personality cult being built around Putin: his office distributed the photos of the half-naked leader to the press, ahead of another leadership election the following year. The campaign was also part of a reinvigoration of Russia's image – a country now awash with petrodollars due to the high price of oil that once again was beginning to assert itself on the world stage.

A family try to keep warm in what is left of their house in the Peruvian town of Cañete after a massive earthquake strikes the country.

The South American and Nazca tectonic plates run along most of the continent's Pacific coast. On 15 August, at six in the evening, a large earthquake struck the fault line near Peru. With an epicentre 145 kilometres (90 miles) southeast of the capital, Lima, it measured a massive 7.9 on the Richter scale. Poor, rural areas were the most affected. In the city of Pisco, a church packed with more than 300 people collapsed during a memorial service: 90 people died, most of them from one extended family. In all, the earthquake took the lives of 540 people and thousands were made homeless.

Greek firefighters struggle to contain a major forest fire near the village of Andrítsaina in the Peloponnese.

During a sweltering summer that saw temperatures reach over 40 °C (104 °F) in temperate Europe, Greece struggled to battle more than 3,000 forest fires. Many people died after becoming trapped by the ferocious flames; others failed to flee in time, unwilling to abandon their homes. Firefighters in the worst-hit region of the Peloponnese described it as a crematorium, as the fire razed whole villages. The Greek government declared a national state of emergency and, believing arson to be behind some of the breakouts, later announced a reward for any information leading to the identification of those responsible.

353

Key figures in the 'surge', General David Petraeus (left) and Ambassador Ryan Crocker report to their superiors on Capitol Hill.

On 10 September, General David Petraeus, commander of the multinational force in Iraq, and Ryan Crocker, US ambassador to Iraq, presented their report on progress in the country. Reporting on the military situation, Petraeus commended the surge policy, noting a decline in security incidents and civilian deaths, and calling for a measured drawdown of troops by July 2008. Democrat representatives, however, called the report a publicity stunt and questioned the validity of the cited statistics; others accused Petraeus of 'cooking the books' for the Bush administration. Crocker meanwhile admitted that political progress had been uneven, candidly declaring that there would be 'no single moment at which we can declare victory'.

Photographer Jonathan Torgovnik captures Tony Amato preparing for rehearsal at the Amato Opera Theater, New York, before its closure.

The Amato Opera Theater was a leading light of Manhattan's cultural fringe. From a 107-seat theatre at 319 Bowery Street, New York, Tony and Sally Amato had staged thousands of operas since the company's founding in 1948. A modest operation – Tony directing the nominal orchestra, Sally as costumier and lighting designer – the repertoire included over 60 operas, sung by amateurs and students, some of whom went on to have successful professional careers. Jonathan Torgovnik's photographs caught the Amato's irrepressible spirit and charm, and won third prize at the 2009 World Press Awards, the same year that the Amato finally closed after 61 years in the business.

The disgraced former US football star O. J. Simpson found himself at the centre of another sensational trial when he was arrested in connection with an attack on a sports memorabilia collector in a Las Vegas hotel. In 1995, Simpson had been controversially acquitted of the brutal murders of his ex-wife and her friend, but was later found liable for the deaths in a civil case that left him bankrupt. An increasingly isolated and pitiful figure, Simpson on this occasion alleged that he was only reclaiming items that belonged to him. The court disagreed. The following year Simpson was convicted on charges of armed robbery, conspiracy to kidnap and assault with a deadly weapon. He was sentenced to at least nine years in prison.

O. J. Simpson is brought to a Las Vegas courtroom to hear charges of armed robbery and kidnapping.

357

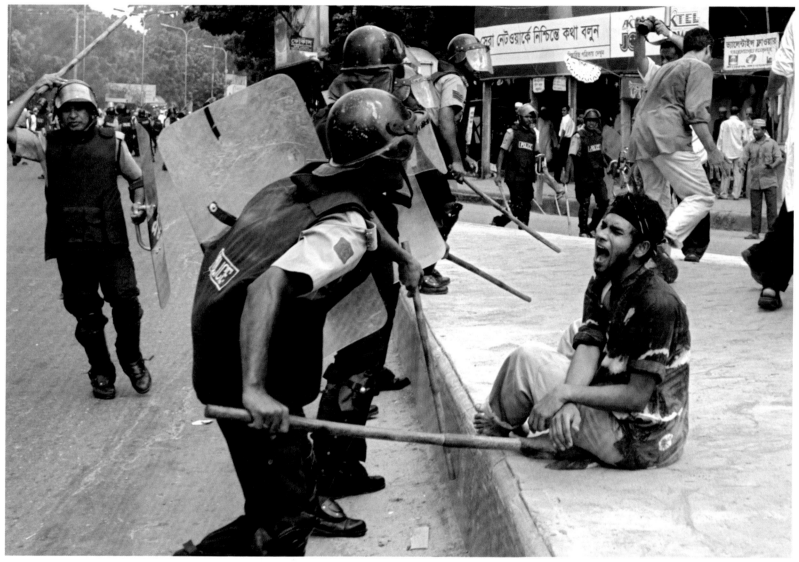

Muslim protestors in Dhaka, Bangladesh, are set upon by police wielding bamboo lathis.

Violent clashes broke out in the Bangladeshi capital, Dhaka, between police and Islamic activists following the publication of a 'blasphemous cartoon' that ended with a joke about the prophet Mohammed's name. The cartoon appeared in a weekly satirical magazine supplement in the country's leading Bangla-language newspaper, *Prothom Alo*, on 17 September 2007. Extremist religious leaders called for mass protests even though demonstrations were officially banned under Bangladesh's state of emergency and despite a prompt apology from the newspaper's owners and the arrest of the cartoonist. The clashes in Dhaka took place nearly two years on from the controversial publication of 12 drawings featuring the prophet Mohammed in a Danish newspaper, *Jyllands-Posten*, which sparked riots across the world and led to dozens of deaths.

358

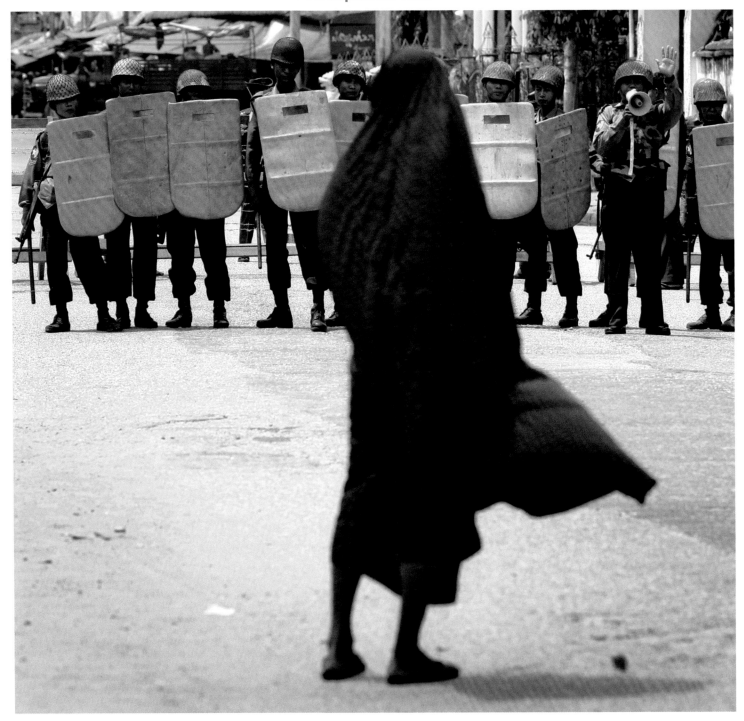

A lone monk faces off riot police as anti-government protests are snuffed out across Burma, one of the poorest countries in the world.

On 15 August 2007 the ruling military junta in Burma dramatically increased the price of fuel, leading to protests in the capital and beyond as the new policy's impact was quickly felt among Burma's poor. The discontent escalated as civilians and monks took to the streets to demonstrate against political repression and economic hardship. On 24 September, as many as 100,000 people participated in an anti-government march in Rangoon, the biggest rally of its kind in 20 years. The flush of democracy was short-lived, however, as a violent crackdown began two days later. Riot police fired shots and tear gas in attempts to disperse the protesters, and hundreds of monks were injured and arrested. Despite strict censorship, bloggers were able to smuggle images of the violence out of the country, exposing the Burmese regime to fresh censure from the international community.

Marion Jones was the undisputed female star of the Sydney Olympic Games in 2000, where she won three gold and two bronze medals. In 2004 the Los Angeles-born athlete filed a multimillion-dollar defamation suit against a former colleague who accused her of using performance-enhancing drugs. Three years later, however, she was forced to concede that she had taken steroids before the Sydney Olympics and lied to federal agents investigating the use of drugs in US sports. Jones was also found to be complicit in a cheque fraud. In a spectacular fall from grace, the mother of two was stripped of all her medals. On 11 January 2008 she was sentenced to six months in prison.

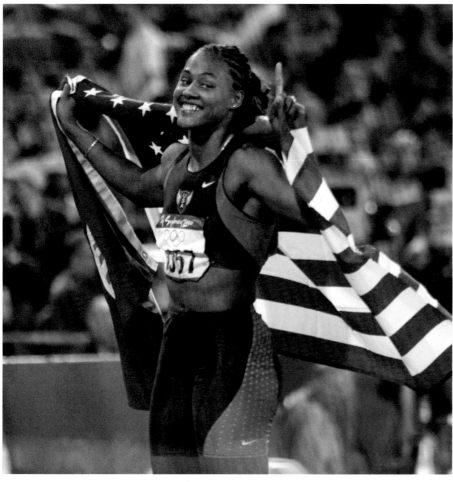

Marion Jones celebrates winning gold in the 100 metres at the Sydney Olympics in 2000.

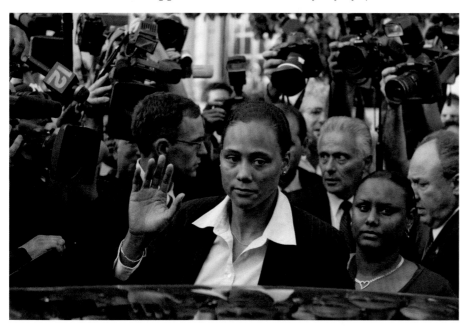

The shamed US sprinter leaves the Federal Court in New York after pleading guilty to drug use.

360

On her London doorstep, prodigious author Doris Lessing accepts congratulations for her Nobel Prize.

Best known for her works *The Golden Notebook*, *The Memoirs of a Survivor* and *The Summer Before the Dark*, British author Doris Lessing was awarded the Nobel Prize for Literature on 11 October, just days before her 88th birthday. Lessing became the second British writer to win in three years – Harold Pinter was honoured in 2005 – and only the 11th woman ever to win the prize. Lessing is considered a pioneering figure among feminists even though she has distanced herself from the feminist movement. In the Nobel citation, the Swedish Academy described her as 'that epicist of the female experience, who with scepticism, fire and visionary power has subjected a divided civilization to scrutiny'.

The incredible puppetry of the National Theatre's production of *War Horse* steals the show on its opening night in London.

361

Adapted from Michael Morpurgo's novel of the same name, *War Horse* was first staged at the National Theatre in London in October. The play's central character is Joey, a cavalry mount caught in the crossfire of World War I, represented by a lifesize puppet from the Handspring Puppet Company. The story is a tale of loyalty and friendship, but this production also emphasized the brutal and dehumanizing nature of war, brought into sharp relief by the equine lead's seeming obliviousness to the horrors wrought by his human compatriots. Winner of Olivier, Evening Standard and Critics' Circle awards, the extraordinarily engaging puppetry elevated *War Horse* from a children's story to a critically acclaimed production.

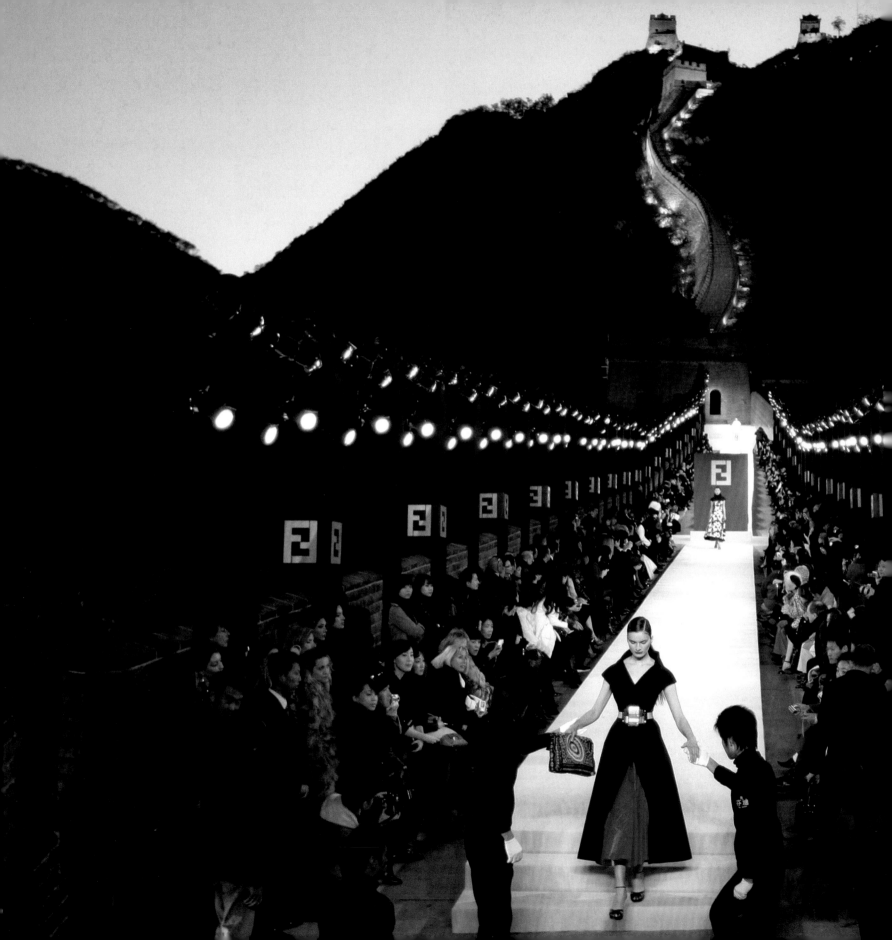

An unashamed display of luxury capitalism takes place on the Great Wall of China, while the country's Communist Party hosts its annual conference elsewhere.

The latest global brand to penetrate the Chinese luxury market, Italian fashion house Fendi held a spectacular fashion show on top of the Great Wall of China. The ancient fortification, constructed to keep enemies from the north at bay and stretching for thousands of miles, became the longest catwalk in the world, showcasing exclusive outfits from the Karl Lagerfeld-designed spring/summer collection. Eighty-eight models walked the platform as VIP guests sat under the twilight sky. Fendi received permission for the project, 12 months in the planning, a mere six weeks earlier, though the concurrent Communist Party's annual congress meant that no representative of the government was able to witness this glamorous confirmation of China's rising star.

US paratroopers carry the dead body of Staff Sergeant Larry Rougle from a Taliban ambush in the Korengal valley, Kunar province, Afghanistan.

In the autumn of 2007 the prime target of American military might was Iraq, where a surge in troop numbers was resulting in a sharp rise in US casualties but also the first clear signs that US forces might be gaining the upper hand against the insurgents. In the 'forgotten' war in Afghanistan, however, the situation was deteriorating. American military deaths, suicide bombings and Afghan civilian deaths hit record highs in 2007. Six years after the US-led invasion, large swaths of the country, especially in the south, were still effectively ungoverned and thus steadily falling under Taliban control.

The field commander of the Sudan Liberation Movement, Adam Bakheit (middle, rear), arrives in Libya for peace talks.

365

In one of the world's worst humanitarian crises, hundreds of thousands of civilians were killed in the fighting in Darfur, the war-torn western region of Sudan. The fighting involved a complex mosaic of largely Arab militias, their Sudanese army allies and a number of disparate armed factions. Millions were displaced throughout the region. Libya hosted full-scale talks between the Sudanese government and rebel leaders from Darfur in October. Hopes of a breakthrough were pinned on Libyan leader Colonel Gaddafi's eagerness to broker a compromise deal. He proved unable to allay the acute mistrust between the parties and prevent several groups from boycotting the talks. They ended without a new deal to stem the bloodshed.

Alicia Alonso is a cultural icon in Cuba. The legendary prima ballerina commands a mass following for almost single-handedly marshalling the development of world-class ballet in the communist country. Sixty years ago she founded the National Ballet of Cuba, which went on to become one of the most prestigious dance companies in the world. In November the auspicious anniversary was celebrated at the 21st International Ballet Festival. Aged 87 and almost blind, Alonso was escorted on stage to intense applause, before taking her place beside President Fidel Castro, a long-time supporter of her work. The programme included four world premières, with dancers from 19 countries also performing classical works such as *Giselle*.

Alicia Alonso, prima ballerina and founder of the Cuban National Ballet, announces the 60th anniversary celebrations of the company in Havana.

At the geographical mid-point between the economic dynamos of Asia and the established economies of Europe, the Arab Gulf states have sought to develop as regional hubs at the crossroads of East and West. Dubai, part of the United Arab Emirates, in particular sought to turn itself into a rich city state comparable to Singapore and Hong Kong. It began a vast construction programme in the sea and desert, transforming the landscape. In 2007, residents had already started to occupy villas on the Palm Jumeirah, the largest artificial island in the world, costing almost $13 billion. Many criticized the government's use of low-wage, foreign labour. Shaped like a palm tree, on its fronds stood villas with owners ranging from English footballers to Russian billionaires.

367

Dubai's ambition illustrated by the Palm Jumeirah, part of which is shown here under construction. Nouveau riche and old money alike snap up these luxury homes.

Venezuela's Simón Bolívar Youth Orchestra treats a Carnegie Hall audience to their ever-vivacious performance of *Mambo*.

Unlike its North American and European counterparts, the Simón Bolívar Youth Orchestra of Venezuela is not only a career boost for talented young musicians but a way out of poverty. Founded by José Abreu (an economist-turned-musician) in Caracas in 1975, the orchestra has survived Venezuela's political changes, continuing its work of plucking children from the slums and harnessing their raw musical talent. It is as much an extraordinary social programme as it is an institution of musical excellence, with the government significantly investing in the scheme. The orchestra toured Europe in summer 2007, impressing audiences with its lively performances. One favourite was Bernstein's *Mambo*, in which the players would leap from their seats and twirl their instruments in the air.

Paris commuters, enduring the third strike in a week, seem resigned to their misery.

369

Nicolas Sarkozy had campaigned for the French presidency on a platform of pension reform, and staked his political reputation on seeing it through only a few months into his new role. The proposed changes to so-called 'special pension regimes' would increase the number of contribution years for public sector workers. The last leader to attempt such reform – Alain Juppé in 1995 – was forced to make an embarrassing climb-down after three weeks of strikes. Sarkozy also faced resistance: strikes on 18 October 2007 were followed by nine days of strikes by transport and energy workers in November, who were later joined by teachers, postmen and printers, costing an estimated €400 million a day.

As survivors of Cyclone Sidr await relief a week later, a man helps a woman who has fallen sick.

The Category-5 cyclone that hit Bangladesh on 15 November 2007 was estimated to be as severe as the 1991 tempest that claimed 143,000 lives. Cyclone Sidr's death toll was mitigated by widespread advance evacuation and effective protective measures, although the devastated infrastructure complicated the task of assessing the situation: aid agencies estimated as many as 10,000 fatalities in the early hours. The livelihoods of countless people were destroyed as pre-harvest crops were swept away. In the Sunderbans, home to the endangered Bengal tiger, the storm surge battered the World Heritage-classed mangrove forest, which experts said would take 40 years to recover.

Eight years after he swept to power in a bloodless coup, Pervez Musharraf resigned as chief of army staff, handing over the command baton to his successor on 28 November 2007. He remained Pakistan's president, and was sworn in as a civilian head of state the following day. In an emotional address, the general spoke of how he would miss his service uniform after 46 years in the army. Musharraf had come under increasing pressure to resign his military commission after the March suspension of the Supreme Court's chief justice, and his declaration of emergency rule in November.

Pervez Musharraf hands over his command of Pakistan's army to General Ashfaq Pervez Kayani in a ceremony in Rawalpindi in the province of Punjab.

372

With his distinctive flair, Libyan leader Colonel Muammar Gaddafi attends the EU-Africa Summit in Lisbon, Portugal.

The 2007 EU-Africa Summit in Lisbon was overshadowed by the inclusion of Zimbabwe's President Robert Mugabe on the delegate list. British Prime Minister Gordon Brown was particularly scathing about Mugabe's participation, citing his deplorable human rights record and political abuses. Brown boycotted the meeting but 67 African and European leaders attended. On the eve of the summit, Libya's eccentric leader Colonel Muammar Gaddafi – who declined the accommodation offered by his Portuguese hosts in favour of a tent he had erected outside Lisbon – chided European governments for not compensating their former colonies. Gaddafi seemed unimpressed by European calls for a new partnership with Africa on issues including trade, development and security.

Having already been compared to Eva Perón, Argentina's most famous first lady, Cristina Fernández is sworn in at the Casa Rosada palace in Buenos Aires.

Although Cristina Fernández de Kirchner was not Argentina's first female president – on that count, she remained in the shadow of Isabel Martínez de Perón – she was the first woman to be democratically elected as leader of the Latin American country. As the candidate for the Front for Victory (a Perónist party), she won 45.8 per cent of the vote – far ahead of any other rival and enough to take the presidency. Fernández succeeded her husband, Néstor Kirchner, inheriting from him an economy that had impressively rebounded from collapse in 2001, but now faced high rates of inflation.

Disgraced newspaper magnate Conrad Black leaves a Chicago courtroom where he has just been sentenced.

374

Conrad Black, for a time the world's third biggest newspaper baron, owned some of the most respected titles in the industry, including the *Daily Telegraph* in Britain and the *Chicago Sun-Times* in the United States. After settling in Britain in the 1980s, Black became one of the country's most outspoken right-wing figures, eventually securing his much-coveted place within the establishment by gaining a peerage. Brash and extravagant – with multimillion-dollar homes in London, New York, Toronto and Palm Beach – Black finally fell foul of the US Justice Department. On 13 July 2007 he was convicted in Illinois District Court and was later sentenced to serve 78 months for diverting funds, owed to Hollinger International, for his personal benefit.

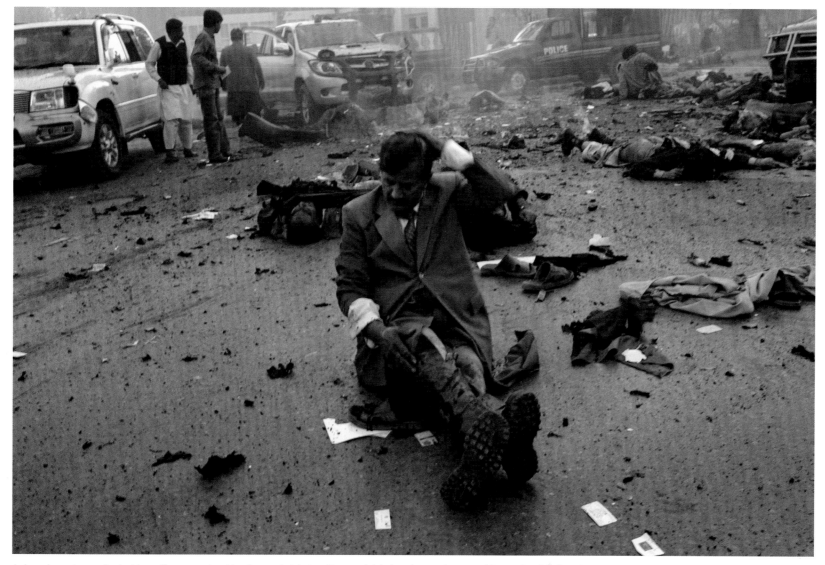

A dazed survivor collects himself, among dead bodies and debris, after a suicide bomb was detonated immediately after the assassination of Benazir Bhutto.

375

Benazir Bhutto was campaigning for a third term as Pakistan's prime minister when she was assassinated during a political rally in Rawalpindi. She had survived an attack two months earlier, when she returned to her native Pakistan after eight years of self-imposed exile. Born into a prominent political family, Bhutto was educated at Harvard and Oxford before becoming the Muslim world's first female prime minister at only 35 years old. Yet throughout her life Bhutto was dogged by political and financial scandals. Many of her close supporters urged her not to return to politics, fearful that she would meet the same fate as her father, a former president of Pakistan, who was executed in 1979.

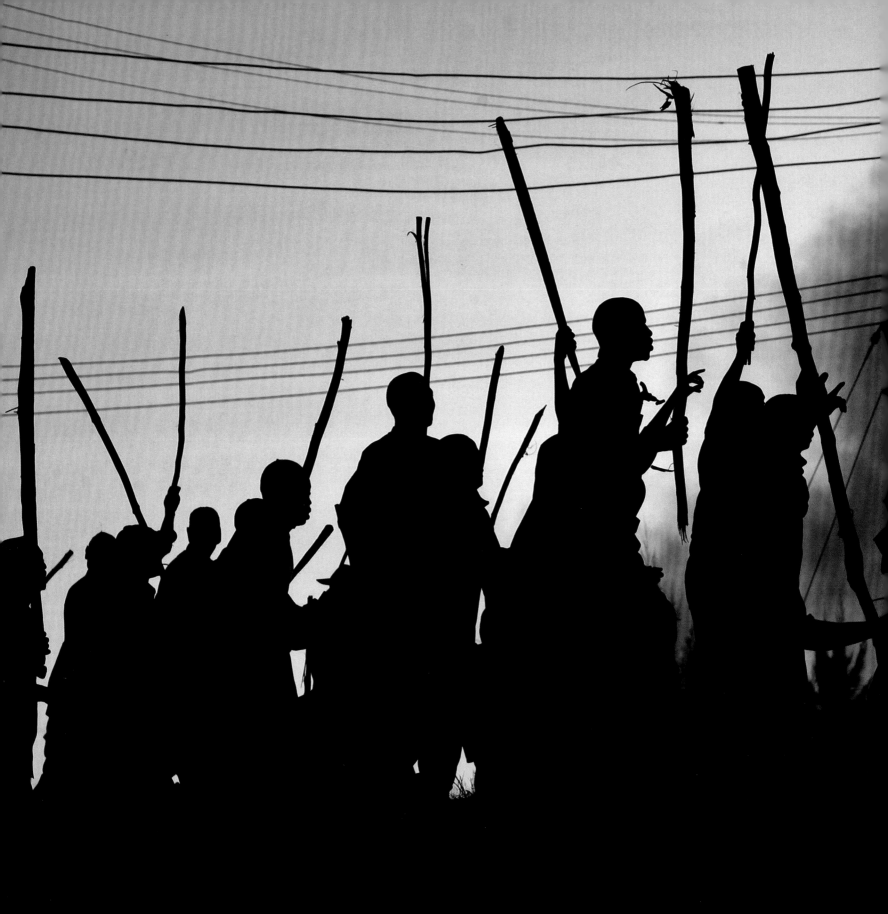

An angry mob forms in one of Nairobi's slums, as opposition supporters vent their fury over a disputed election.

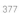

After Kenya's incumbent President Mwai Kibaki was declared winner of an election marred by allegations of fraud, supporters of Raila Odinga of the Orange Democratic Movement accused the government of vote-rigging. Gangs rampaged through the capital's slums and countryside, setting fire to homes and targeting people of the Kikuyu, the president's tribal group. In turn, Kikuyu gangs threatened communities, primarily Luo and Kalenjin, supporting Odinga. Not all violence was ethnically based, however. Outrage at extreme poverty and government corruption boiled over in a country once regarded as an oasis of stability in East Africa.

2008
Reckoning

In 2008 the dominant system of Western capitalism was rocked to its core, and its two greatest proponents – the United States and Britain – were left reeling. At first it seemed that the poorer countries were at most risk. A global food crisis unfolded in the spring that led to riots in 30 countries, with scores dead. Alongside this, the price of oil rocketed to incredible highs, bringing economic uncertainty to millions. However, worse was to come. The unsustainable economics of the previous decade finally toppled. Financial giants in New York and London saw balance sheets irretrievably deteriorate. Banks collapsed; governments poured billions of dollars into saving the markets. An entire institution – the investment bank – disappeared into history. Like a plague, these failures threatened to bring down the global financial system, and even sober academics feared the utter ruin of the international economy. And in the throes of the worst crisis since the Great Depression, few would risk endorsing the discredited Anglo-American capitalism. Many asked whether this year truly embodied the shifting of the international balance. Turmoil, however, was not only financial. The war-weary Congo saw another round of bitter fighting and misery in its Kivu region. A new Cold War beckoned when Russia invaded Western-backed Georgia, an example of just one of many unresolved conflicts in the former Soviet Union. Frightening terrorist attacks in Mumbai claimed the lives of 200 innocent bystanders when gunmen opened fire across the city. India pointed the finger at Pakistan – and the two nuclear powers went to alert status. But all this man-made violence paled in comparison with the awesome power of nature, as an earthquake in Sichuan province, China, killed 70,000 and displaced millions in the cold of winter. However, 2008 was not totally shrouded in misery. Beijing, announcing with marvellous exuberance its new place on the world stage, hosted an Olympic Games in which the very limits of human endeavour were tested. The Jamaican sprinter Usain Bolt and American swimmer Michael Phelps became the greatest athletes of all time in their disciplines – and in some small way stole the show from the Chinese set piece. Many feared the battering the arts would take as patrons' funding dried up in the wake of the economic crisis. Nevertheless, the New York Philharmonic played in North Korea, the first significant cultural contact between the two nations in over 50 years. Closing the year was the United States' demonstration of both its unique spectacle of democracy and its boundless capacity for reinvention. After a political marathon, Barack Obama, the African-American senator from Chicago, won the presidential election and revived America's image in the eyes of the world. His message was simple: Hope.

380

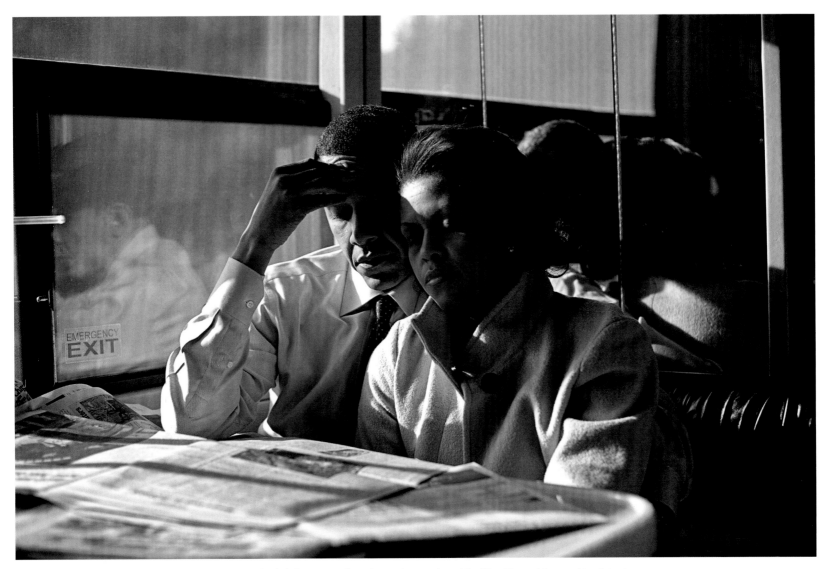

US Senator Barack Obama and his wife Michelle snatch a brief moment of respite on the morning of the New Hampshire presidential primary.

Barack Obama's presidential campaign broke the mould in more ways than one. His ability to reach out to small donors changed expectations for future elections. The use of text messaging and social networking mobilized individual supporters into a nationwide community of Obamaphiles. His wife Michelle, whom he had met 20 years earlier in a corporate law firm, proved a valuable asset on the campaign trail, able to talk boldly about gender and race issues. Together, the Obamas appealed to the aspirational values at the heart of the idea of the American nation, urging voters to dare to dream of change.

381

Seven-year-old Monday Lawiland screams in alarm as police conduct a raid in Kibera, an opposition stronghold and Nairobi slum, during Kenya's political turmoil.

By the time political rivals Raila Odinga and incumbent President Mwai Kibaki signed a power-sharing agreement on 28 February 2008, some 1,300 Kenyans had died and hundreds of thousands had been forced from their homes in violence sparked by the country's disputed election in late December 2007. Human Rights Watch later produced a report suggesting that the initial spontaneous outburst of violence gave way to attacks by criminal gangs working under the direction of politicians, community leaders and businessmen. Their report also stated that police actions often exacerbated the violence. By the year's end there was evidence that gangs were already rearming themselves in preparation for the next presidential election, scheduled for 2012.

A promising young actor, Heath Ledger rose to fame through his much-talked-about role as Ennis Del Mar in Ang Lee's film, *Brokeback Mountain*. Adapted from a short story by Pulitzer Prize-winning writer Annie Proulx, the film told the story of two young men embarking on a complex, passionate and ultimately tragic affair under the breathtaking Wyoming sky. Ledger died at the age of 28 from an accidental prescription drug overdose in January 2008. He later won an Academy Award for his role as the Joker in *The Dark Knight*, the second such posthumous Oscar ever awarded to an actor.

The Aboriginal peoples migrated onto the Australian landmass some 40,000 to 50,000 years ago. From the eighteenth century onwards, with the arrival of European settlers, they were quickly displaced and fell under white British rule. One example of the abuses Aboriginals suffered was the so-called Stolen Generation: until the 1960s, children were forcibly taken from their families by the authorities in order to 'integrate' them into white society. In February, the Australian parliament passed a motion apologizing for this policy, acknowledging past wrongs. While Aboriginals generally welcomed the move, they also criticized the lack of any monetary compensation, arguing that words were not enough to address their community's social and economic problems.

Australian actor Heath Ledger on the set of *Brokeback Mountain*, three years before his untimely death.

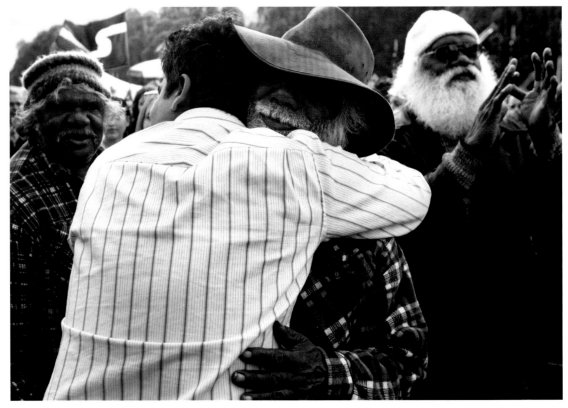

Aboriginal men embrace after the Australian government apologizes for centuries of injustice.

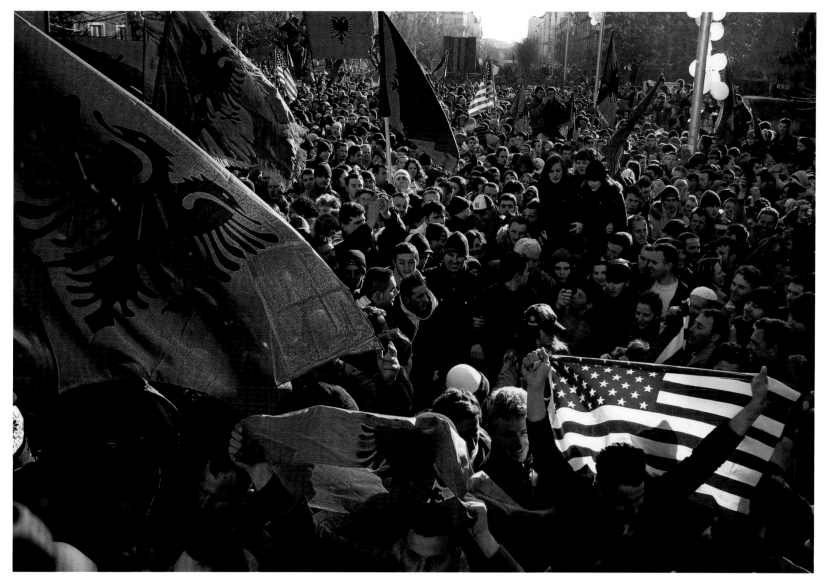

383

Kosovar Albanians celebrate their declaration of independence on the streets of Pristina – and acknowledge the contribution of the United States.

Kosovo had languished in diplomatic limbo since 1999, after NATO forces had occupied the province to halt the conflict there. While it nominally remained under Serbian sovereignty, it was in fact governed by an international UN administration. A final agreement on the status of Kosovo could not be agreed: the majority ethnic Albanians agitated for full independence, while the Serb minority demanded otherwise. Major international initiatives to resolve this question failed throughout the decade. In the end, with backing from the United States, the Kosovar Albanian parliament declared independence. But, along with Serbia, many countries – including Russia and China – refused to formally recognize the new state.

With his green fatigues, bushy beard and cigar, Fidel Castro had been an icon of the twentieth century, leading Cuba's communist administration for nearly 50 years. Castro had handed over power temporarily to his younger brother Raúl in July 2006 while undergoing surgery for an undisclosed intestinal problem. After months of speculation, Castro announced his resignation in an open letter on 19 February 2008, stating that he would not seek another presidential term, but would continue 'fighting like a soldier of ideas'. The United States called for free and fair elections, but declared that the 1962 embargo would remain. Five days later, Raúl was elected president of the Caribbean island nation.

384

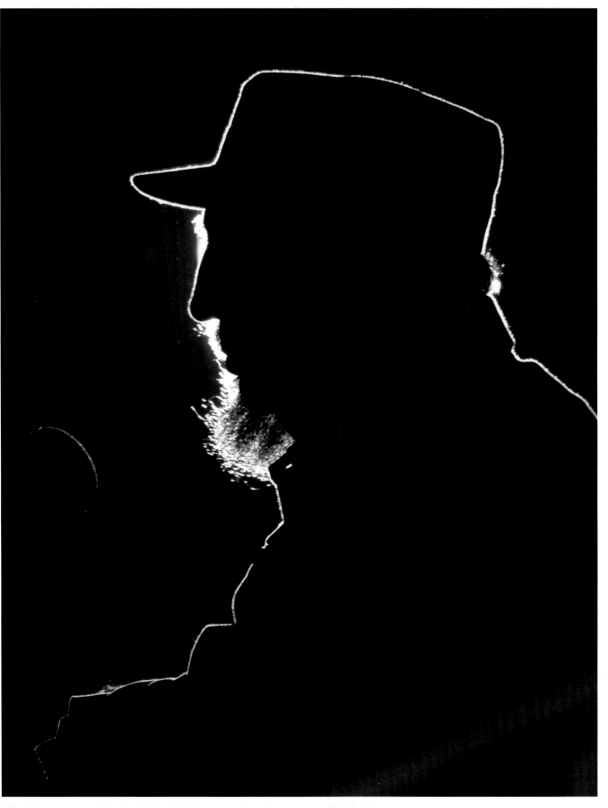

After 49 years as president of Cuba, Fidel Castro resigns for reasons of ill health.

The New York Philharmonic, the first US cultural organization to perform in North Korea, plays 'The Star Spangled Banner' at the East Pyongyang Grand Theatre.

When the New York Philharmonic flew into Pyongyang in February 2008, the 400-strong ensemble was the largest delegation of US citizens to visit North Korea since 1958. Although much of the country was suffering food shortages, the guests were treated to a splendid dinner of pheasant soup and roast mutton at the Palace of Culture. The orchestra later played a mixed repertoire that included Gershwin, Wagner and a rendition of the Korean folk song 'Arirang', which won over the audience. The performance was also broadcast on state television, giving North Koreans a rare insight into Western culture, in a development that brought inevitable comparisons with the United States' use of ping-pong to thaw diplomatic relations with China in the 1970s.

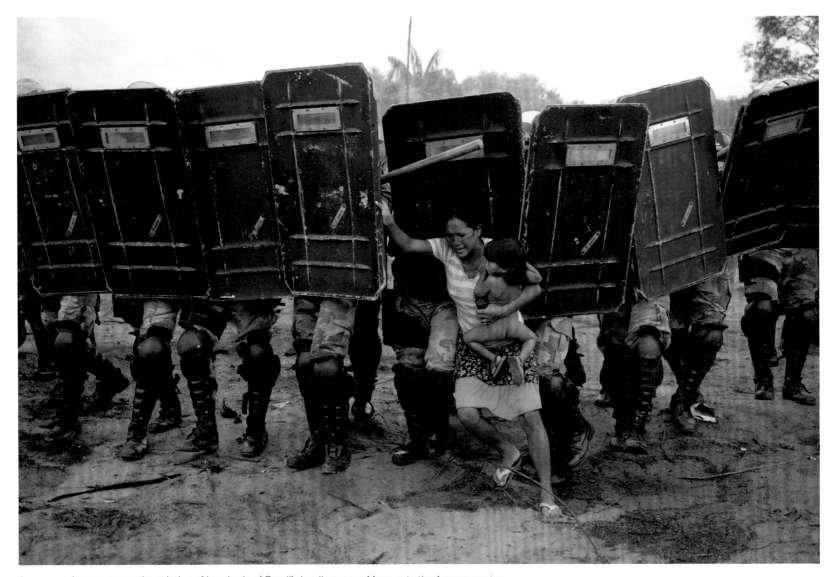

A woman tries to prevent the eviction of hundreds of Brazil's landless near Manaus in the Amazon region.

In Brazil, 40 per cent of the population own just 1 per cent of the land, making the distribution of land there among the most uneven in the world. Despite government promises to rehouse 400,000 Brazilians by 2006, the number of homeless citizens continued to grow during the decade. In rural areas, commercial purchase of indigenous territories increased pressure on small farmers, leading to violent protests by groups such as the controversial landless activism organization, Movimento dos Trabalhadores Sem Terra. Meanwhile, in the cities, tens of thousands of people lived on the streets because of the lack of affordable housing. But squatters who reclaimed abandoned buildings were dealt with forcefully by the police, meaning the destitute had no choice but to make their home in the ever-expanding shanty towns.

Bhutanese citizens form an orderly queue at a polling station in Zulekha, near the capital Thimphu, as the country votes for the very first time.

387

On 24 March 2008, Bhutan held its first elections for a lower assembly. Two parties ran on an identical ticket of promoting Gross National Happiness, though the Bhutan Peace and Prosperity Party won 45 of the 47 seats, leaving the new legislature without an effective opposition. The election was the final stage in the country's transition from absolute monarchy to constitutional democracy, as decreed by the former king to coincide with the centenary year of the ruling Wangchuck dynasty. Many in the tiny Buddhist kingdom feared the change would bring with it the corruption and mismanagement evident in neighbouring states.

388

A rescue team attend to a high-speed train that derailed in a tunnel near Fulda, Germany, after colliding with a flock of sheep.

At almost 11 kilometres (7 miles) in length, the Landrückentunnel, near Fulda in central Germany, is the longest tunnel in the country. On 26 April, a high-speed Intercity Express train travelling between Hamburg and Munich at over 200 kph (120 mph) derailed when it ploughed into a flock of sheep that had strayed onto the tracks. Ten of the 12 carriages came off the rails. The accident could have been worse: because it derailed inside the tunnel, the train was kept from completely decoupling and the carriages crashing into each other. Four people were seriously injured with broken bones. Twenty sheep died.

A myriad of lights as South Koreans flood the streets in Seoul in protest after the US beef ban is lifted.

The announcement by Lee Myung-bak's government that the five-year ban on US beef imports would be lifted provoked weeks of protests and candlelit vigils in South Korea. The country had been the third largest market for US beef before a BSE outbreak in 2003 led to the ban. In 2008 the new president sought parliamentary ratification of a $20 billion free-trade deal with the US, as part of his election promise to revive the national economy. Lee's popularity plummeted, however, as South Koreans feared this concession would be followed by further compromise over how to confront North Korea's nuclear capabilities.

As the polls close in the Indiana Democratic primary, former US president Bill Clinton leads the applause for his wife, presidential candidate Hillary Clinton.

Hillary Rodham Clinton, the New York senator and former First Lady, had been confident in her candidacy for the Democratic presidential nomination. An experienced stateswoman, she regularly topped the polls on questions of leadership and policy knowledge.

Though Clinton's bid to be the first female president appealed to women, in the year where 'change' was the dominant political currency, her strategy emphasized incumbency and inevitably alienated voters. On Super Tuesday, Clinton narrowly won the Indiana primary

while being trounced in North Carolina, a sign of things to come. Upon acceding to the presidency, Barack Obama paid tribute to his former rival, appointing her secretary of state.

Vladimir Putin alongside the new Russian president, Dmitry Medvedev, at the Kremlin Palace, Moscow.

On 7 May, Dmitry Medvedev became the third Russian president of the post-Soviet era, and at 42 the youngest head of state in a century. At the inauguration ceremony in the Kremlin's Andreyevsky Hall, Medvedev was flanked by Vladimir Putin. The former president, and mentor to the politically inexperienced Medvedev, Putin was nominated as prime minister only a few hours later, reflecting his enduring influence over the Russian state. A former law professor, Medvedev promised to overcome the prevailing legal nihilism and prioritize human rights. Only hours earlier, however, crowds protesting the electoral *fait accompli* had been silenced, suggesting the new president would have much to do to repair civil liberties in Russia.

392

Proving that life goes on, a couple prepares food in the shell of a house destroyed by a massive earthquake in Leigu, near Beichuan.

The Sichuan earthquake hit China on the afternoon of 12 May, devastating villages and fracturing the landscape. Almost 70,000 people died across the province, including many from the tiny Qiang ethnic group based in Beichuan. Almost half the town's population was lost, leaving hundreds of orphans and many childless parents. The Chinese government granted a temporary reprieve of the one-child policy, but the move was criticized as an attempt to silence victims of the tragedy ahead of the Olympic Games. As plans unfolded to rebuild Beichuan away from the Dragon Gate fault line, survivors lobbied for the preservation of the town as a memorial to those they had lost.

393

394

A girl runs through the remnants of a library, waterlogged and ruined by Cyclone Nargis.

Described as a 'once-in-every-500-years' event, Cyclone Nargis was Burma's worst natural disaster. The tropical storm, which struck on 2 May 2008, swept across the low-lying Irrawaddy Delta, the most vulnerable and densely populated part of the country. The loss of mangrove forest to agricultural land had removed the riverine region's natural defences, so that the 3.6 metre (12 feet) storm surge laid waste to villages and farmland in moments. The so-called 'climate change victims' – over 140,000 fatalities and millions left homeless – were also casualties of the Burmese junta's political hubris: underplaying the crisis, the military denied aid workers access in the first critical days and later confiscated emergency supplies in what was denounced as a crime against humanity.

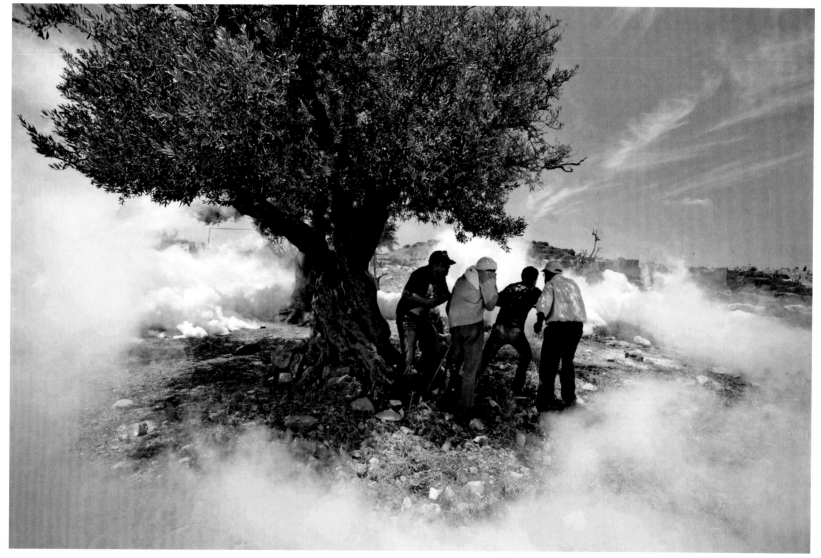

A cloud of tear-gas encircles four Palestinian activists on the West Bank as Israeli troops disperse another protest against the extension of Israel's security barrier.

Ni'lin is a Palestinian town in the West Bank, near the border with Israel. In May, local protestors and international activists began weekly demonstrations against the Israeli decision to extend the security barrier further into their land, arguing that this amounted to a straightforward land grab – two nearby Israeli settlements would profit from the border move. The issue of settlement growth began to dominate the peace process: while the Palestinians claimed these were illegal annexations of land, the Israeli government argued that most of the growth was due to a natural increase in population. The international quartet of negotiating states – the United States, European Union, Russia and United Nations – criticized Israeli settlement building.

David Beckham began his football career as just one of many talented young players. Despite his impressive goal-scoring (Beckham's right foot came to be considered a national treasure), few would have predicted that 15 years later he would be a global brand, known as much for his celebrity lifestyle as his soccer skills. On 18 June 2008 a five-storey tall poster of Beckham was unveiled as part of a three-year deal as the face of Armani Underwear. Giorgio Armani reportedly considered the multimillion-dollar star to represent a modern notion of masculinity – a sportsman, husband and father. Consumers apparently agreed, as Armani reported a 150 per cent growth in underwear sales following Beckham's endorsement.

396

David Beckham adorns the front of Macy's department store in San Francisco, California.

Former presidential candidate Ingrid Betancourt is held hostage in the Colombian jungle.

On 23 February 2002, Colombian presidential candidate Ingrid Betancourt was captured by FARC (Revolutionary Armed Forces of Columbia) rebels deep in the jungle. Betancourt, an outspoken politician who campaigned on an anti-corruption ticket, had travelled to San Vicente del Caguán, defying advice from both the government and the military not to enter the recently remilitarized zone. A high-profile individual, she had been a severe critic of the FARC; she and her aide, Clara Rojas, spent six and a half years in captivity, together with a number of other political hostages. Her family initially opposed a rescue operation, following the failure of such an undertaking in 2003; the Colombian government meanwhile refused a prisoner exchange. Following intervention by both France and Venezuela, Betancourt was finally rescued on 2 July 2008, along with 14 other prisoners.

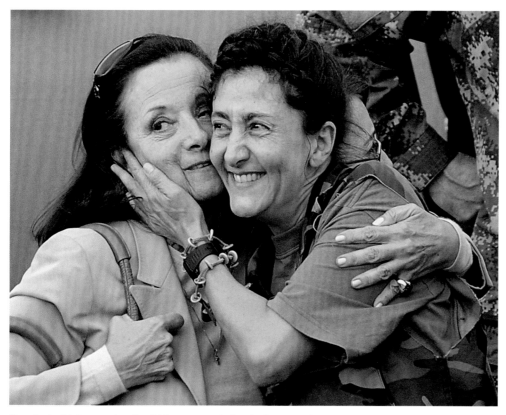

Reunited with her mother, Ingrid Betancourt is freed after over six years in captivity.

398

Roger Federer concedes the men's singles title to Rafael Nadal at the Wimbledon tennis championship.

In a final hailed by many as the best of all time, the two outstanding tennis competitors of modern times matched stamina and wits in a gruelling five-hour match. Rafael Nadal finally defeated Roger Federer, denying him a sixth consecutive title at Wimbledon.

But the decade would still remain the 'Federer era': his elegant style, steely determination and skilful dominance of the court was to return in summer 2009, winning him both the French Open and Wimbledon men's singles titles. With a further victory at the All England Club that year, he surpassed Pete Sampras's record of 14 Grand Slam men's titles and became the most successful player of the Open era.

Pro-Putin youths mock political opponents including oligarch Boris Berezovsky (centre) at a summer youth camp on Lake Seliger.

399

Nashi (Ours) was formed in 2005 as a pro-government youth movement in Russia. The organization's work included volunteering, civic works and even patrolling the streets. It was not a novel idea: in the Soviet era, many joined the Komsomol youth movement and the *druzhniki* volunteer corps helped the police keep order. The Nashi manifesto called for Russia to be restored to its former greatness and for oligarchic capitalism to be brought down. Members took part in organized activities, including summer camps, grooming them for future leadership positions. Critics feared that the movement was being used to disrupt opposition meetings and indoctrinate young people to support the Russian Prime Minister Vladimir Putin.

400

Sensational fraudster Jérôme Kerviel is hounded by the press following revelations of his deceit.

On 24 January Jérôme Kerviel, a junior trader with France's second largest bank, Société Générale, was identified by his employer as responsible for committing what was then the largest fraud in banking history. Société Générale claimed not to know the whereabouts of the unassuming 31-year-old Frenchman, suspected of causing a $7 billion loss due to rogue transactions. This announcement triggered mayhem on world financial markets and prompted a massive internet search for images of the little-known Kerviel. When he emerged, Kerviel told investigators that he had been made a scapegoat, top Société Générale executives having turned a blind eye to such practices. In July, court judges in Paris ordered Kerviel to stand trial for forgery, unauthorized computer use and breach of trust.

401

Having outwitted the authorities for a decade, Radovan Karadzic is stripped of his disguise on the first day of legal proceedings at The Hague (right).

Radovan Karadzic, the former leader of the Bosnian Serb breakaway state of Republika Srpska, had spent over 10 years on the run when he was arrested in 2008. Indicted in 1995 by the International Criminal Tribunal for the former Yugoslavia for crimes committed during the siege of Sarajevo and the massacre at Srebrenica, he quickly disappeared, much to the frustration of international peacekeepers and Bosnian Muslims and Croats. On 21 July 2008, Serbian security forces arrested him in Belgrade after a tip-off. He had grown a thick beard, was using the alias Dragan Dabic and posing as an alternative medicine practitioner. In Sarajevo, residents took to the streets to celebrate his capture. Within a few days, Karadzic was on trial at The Hague.

402

Chinese police patrol the national stadium in Beijing, Herzog & de Meuron's structure of interlocking steel twigs reminiscent of a bird's nest.

The dramatic opening and closing ceremonies of the Summer Olympics were held at the 'Bird's Nest', the centrepiece of the Beijing Games. The result of an international competition, the National Stadium by Swiss architects Herzog & de Meuron later won the prestigious RIBA Lubetkin Prize for its innovative design. Leading Chinese artist Ai Weiwei was the artistic consultant on the project. China's first Games were controversial due to the choking air pollution and unresolved human rights issues in the country, but were nevertheless the scene of numerous record-breaking achievements. The digital enhancement of 29 sky-bound firework 'footprints' during the opening ceremony symbolized the importance of the international event to China's external image.

403

404

Superlative athlete Michael Phelps powers through the water in the 200-metre butterfly semi-finals on 12 August, putting his daily 12,000 calories to good use.

The record for the highest number of golds won at an Olympics by a single athlete had stood since 1972, when American swimmer Mark Spitz won seven. But at Beijing this achievement was exceeded by fellow countryman Michael Phelps. His victory in eight finals – the freestyle, medley, butterfly and relay events – was made even more remarkable by the fact that he set seven world record times and one Olympic record in the process. Not all commentators were equally awed, however. Some pointed out that only in swimming could an athlete compete in so many events. Nevertheless, Phelps's impressive haul ensured he would be regarded as one of the most talented Olympians ever to compete.

Although Cuban triple jumper Alexis Copello had been expected to reach the final of his event at the Beijing Summer Olympics, his distance of 17.09 metres (56 feet) on 18 August failed to qualify by a couple of centimetres. The triple jump was instead won by Portugal's Nelson Évora. Cuba's medals came in other events: gold in Graeco-Roman wrestling and 110-metre hurdles; and silver in men's baseball, in which Cuba has excelled in previous Games. Although Cuba came only 28th in the official table, when considering medals per head of population it was much more successful: 10th, behind such nations as Bahrain, Norway and Slovenia.

Momentarily entwined by a sand trail, Cuba's Alexis Copello completes a triple jump in the Beijing Olympics qualification rounds.

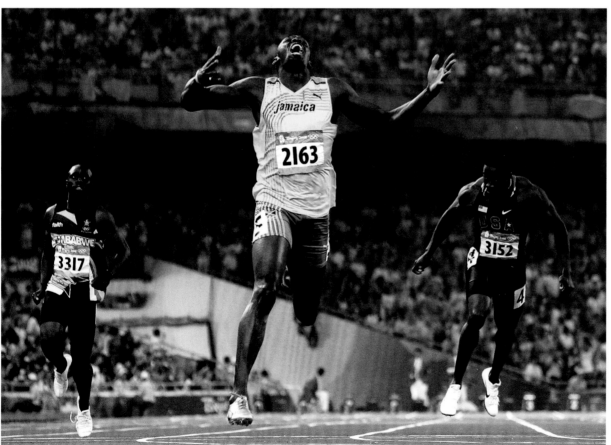

The aptly-named Jamaican Usain Bolt thrilled spectators around the world on becoming the fastest man in history at the 2008 Beijing Olympics. Despite the ease with which he defeated the rest of the field, he was perhaps an unlikely victor. As a teenager, he had been extremely tall and skinny – not normally a sprinter's physique. Yet his incredible, raw talent at a young age prompted his coaches to divert him from cricket into athletics. Bolt won two other gold medals at the Olympics, including this win at the 200 metres on 20 August but, most importantly, he reinvigorated the 100-metre sprint, an event wracked by a decade of doping scandals.

405

Usain Bolt is triumphant as he crosses the finish line in the men's 200-metre final, winning gold and breaking the world record.

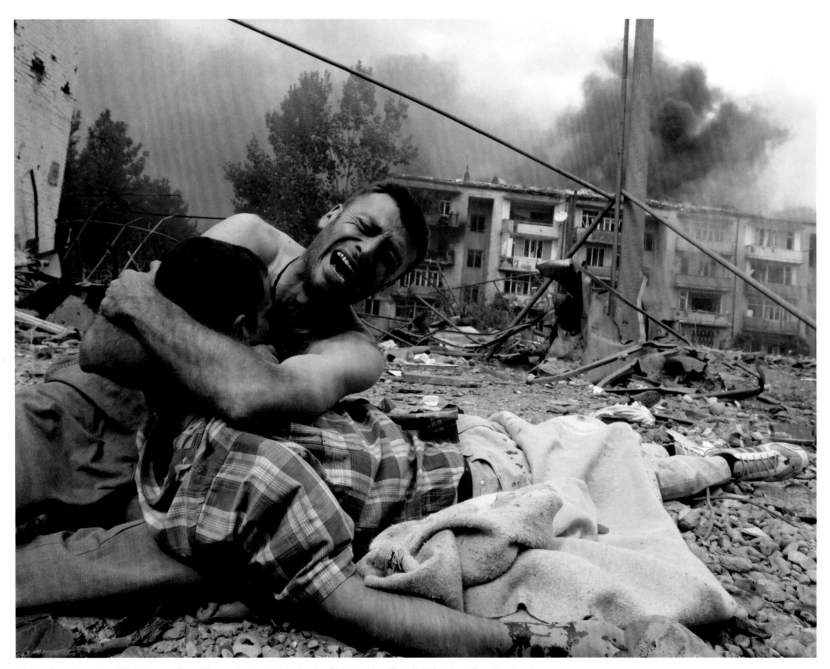

As the Georgian city of Gori burns, Zaza Rasmadze holds the body of his brother Zviadi, killed by a Russian bomb.

South Ossetia, Georgia, was one of several 'frozen conflicts' within the former Soviet Union that had not been resolved since the collapse of communism. Russian peacekeepers had been stationed in South Ossetia since 1992, and there had been a history of sporadic confrontation between them and Georgian troops. On 7 August 2008, the Georgians shelled the disputed town of Tskhinvali; the Russian military responded with a full-scale invasion that reached the major Georgian city of Gori. Each side accused the other of provocation. Several hundred civilians were killed, and over 150,000 were displaced. Georgia lost control of South Ossetia, which began to move towards declaring independence.

Pervez Musharraf's resignation fails to extinguish protest on the streets of Multan, Pakistan.

407

Nine years after he swept to power in a bloodless coup, Pervez Musharraf resigned as president of Pakistan on 18 August. In his address, the general spoke of how he had always put Pakistan first. The move was brought about by the civilian government's filing of impeachment papers against the former army chief, who stood accused of gross misconduct, economic mismanagement and violating the country's constitution. Many Pakistanis also voiced their objection to Musharraf's complicity in the US military's drone attacks along the Afghanistan–Pakistan border.

408

NEVER GIVE UP WITHOUT A FIGH

Mickey Rourke makes an acclaimed comeback in *The Wrestler*, seen here at the UK premiere in 2009.

The Wrestler was a gritty, unromantic look at the world of professional wrestling that received overwhelmingly positive reviews. Actor Mickey Rourke, in a major comeback role, played Randy 'The Ram' Robinson – a down-and-out wrestler whose glory days were long past. The film's main character appeared to many commentators to parallel Rourke himself. Both men had seen their careers self-destruct: in Rourke's case, a return to boxing in the 1990s stifled a promising film career. Director Darren Aronofsky himself celebrated a return to form after the lukewarm reception granted his film *The Fountain*. *The Wrestler* won the Golden Lion at the Venice Film Festival on 5 September 2008 and grossed $44 million at the box office.

Amid the devastation of Hurricane Ike, a woman despairs for those lost in the Turks and Caicos Islands.

409

In early September, Hurricane Ike slammed into the Caribbean islands. It was the fourth storm in three weeks, and the region was still recovering. Ike hit the Turks and Caicos Islands at 215 kph (135 mph), destroying more than two-thirds of homes. Millions were evacuated in Cuba, though nothing could be done to protect the nation's sugar cane crop. As the hurricane approached the US coast, it spread to 1,400 kilometres (870 miles) in diameter, the largest Atlantic tropical storm ever recorded. As it raged through Galveston, Texas, Ike caused widespread flooding. In all, the storm left billions of dollars of damage in its wake, and claimed almost 200 lives.

410

Balloon Dog stands proudly in Versailles' Hercules Salon as tradition and modernity collide in Jeff Koons's latest exhibition.

The Palace of Versailles, once the opulent seat of the *ancien régime*, hosted a controversial exhibition by American artist Jeff Koons in 2008. Those critical of Koons's output decried his pieces as banal and kitsch, and inappropriate for such a venue. Regardless, he was popular with wealthy buyers, who paid top prices for his work; his *Hanging Heart* sold for $23.6 million the previous year. The show's organizers hoped that an exhibition of Pop art would revitalize the French art scene and bring a contemporary energy to Versailles. Koons himself emphasized that 'the baroque is the ideal context for me to highlight the philosophical nature of my work'.

At the Lehman Brothers investment bank in London, staff gather to be told that the firm's future hangs in the balance.

411

In September 2008 the international financial system came within days of total meltdown. This was the culmination of many economic trends across the globe. Banks (mainly British and US) had taken on too much debt and financial products of dizzying complexity, as surplus capital from Asia sloshed around Western markets. Prophetic critics had warned that banks were dangerously ignoring risk: they were right. The collapse of the US housing market in 2007 triggered an ongoing financial free fall as once-stalwart banking institutions desperately tried to shed bad debt. However, the way the debts had been 'sliced up' and traded meant that no one could know where the money actually was.

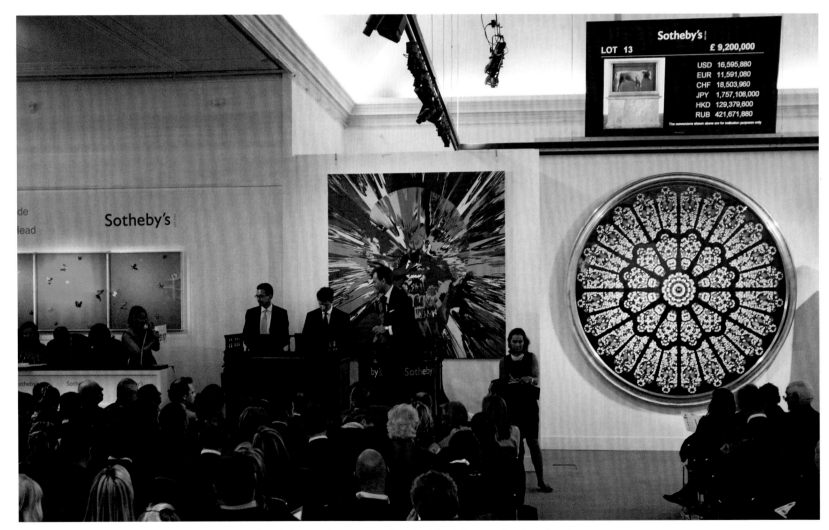

The hammer falls on yet another successful bid at Sotheby's two-day auction of Damien Hirst's latest collection of work.

One of the original Young British Artists, Damien Hirst is a sculptor and a painter renowned for his provocative works, especially those in which dead animals are preserved in formaldehyde. The theme of mortality is a recurring motif in his work. In 2008, in an unprecedented move for a living artist, Hirst sold a collection of his new work by auction, bypassing dealers and galleries, and selling directly to the public. Called 'Beautiful Inside My Head Forever', his auction was held on 15 and 16 September and exceeded all predictions; it raised £111 million and broke the record for a single-artist auction, thus cementing his celebrity reputation. The sale continued the trend of inflating the value of artworks, thereby pricing them out of the reach of most museums and public galleries.

413

A Lehman Brothers employee calls his family (or perhaps a recruitment agent) in New York, following the announcement of the bank's collapse.

On the very same day that the art market soared, the so-called 'credit crunch' became the global financial crisis with the final collapse of Lehman Brothers on Monday 15 September. Despite frantic work over the weekend to save the venerable Wall Street investment bank, no deal was forthcoming. Lehman Brothers filed for bankruptcy protection – the largest in US history, involving more than $613 billion in assets. In New York, the Dow Jones had its sixth worst day in history, down 504 points – the biggest drop since 9/11. Across the Atlantic, Lehman's offices in London also closed: the FTSE 100 Index fell by 3.9 per cent, wiping £50 billion off the value of British companies.

414

Republican vice-presidential candidate Sarah Palin addresses a rally in Golden, Colorado, offering to 'shake things up' in Washington, DC.

The selection of Alaskan Governor Sarah Palin as John McCain's running mate in the 2008 US presidential election shocked pundits across the political spectrum. The straight-talking 'Hockey Mom' built her campaign around the parochial interests of 'Joe Six-Pack'. The former beauty queen and mother-of-five's religious conservatism appealed to core Republican voters; but Democrats ridiculed her inexperience and 'small-town' views. Parodied by comic Tina Fey on television, Palin also fell foul of a prank call three days before the election, in which a radio host pretended to be French leader Nicolas Sarkozy.

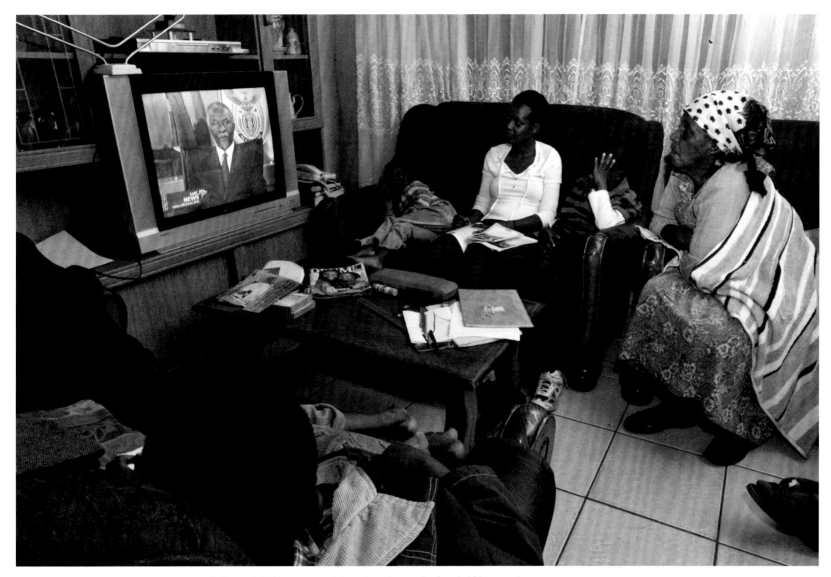

415

In a Soweto home, three generations watch Thabo Mbeki announce his resignation to the South African nation.

On 21 September, Thabo Mbeki was 'recalled' from the presidency of South Africa by the National Executive Committee of the governing African National Congress (ANC) and forced to resign. The move followed a series of political blunders, notably his attempt to influence a corruption case against his ANC rival, Jacob Zuma. As deputy to Nelson Mandela and then as president, Mbeki had led South Africa since the end of apartheid. He presided over a period of economic growth, political stability and black economic empowerment but failed to tackle crime and AIDS. Many regarded his crackpot views on the disease as contributing to the needless deaths of thousands of South Africans who were unable to gain access to effective treatment.

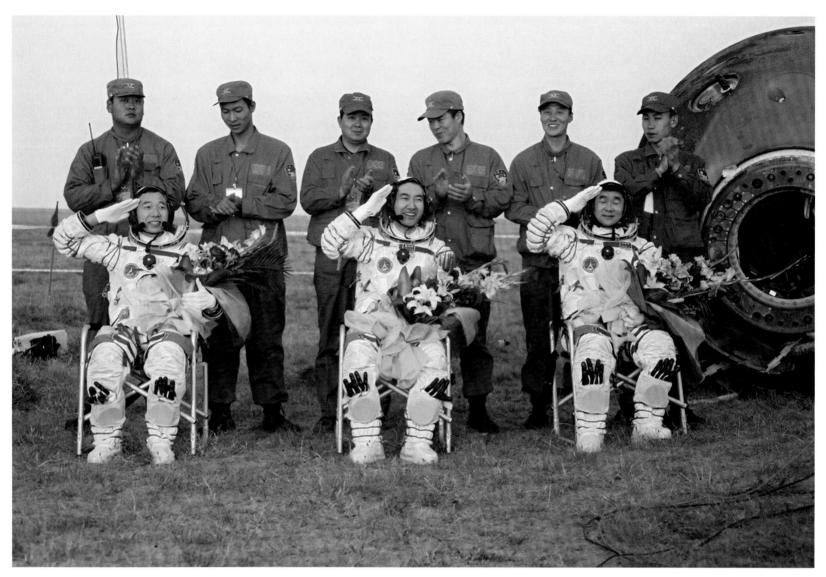

Astronauts Jing Haipeng, Zhai Zhigang and Liu Boming salute waiting media and supporters after making Chinese history.

On 27 September, China became the third country after the United States and Russia to independently complete a space walk. Thousands gathered around televisions and computers on Earth as astronaut Zhai Zhigang conducted a 15-minute walk along the outside of the *Shenzhou VII* spacecraft to retrieve an external experiment. The achievement was a technological breakthrough for China's burgeoning human spaceflight programme, which aimed to build a space station ahead of other Asian powers.

Meanwhile, the United States began winding down its shuttle programme, leading commentators to wonder whether the next generation of space exploration might be conducted from Beijing instead.

Madonna's record-breaking 'Sticky and Sweet' tour was the highest grossing concert series by a solo artist to date, confirming her place in the pop culture hall of fame. Her ability to reference new music and reinvent her image ensured she retained success in the ever-changing world of commercial pop. The following year, the decision to hold the Warsaw leg of her eighth world tour on the feast day of Assumption riled the Catholic Church, who had opposed the artist since her inflammatory 'Like A Prayer' video in the 1980s. Days later the controversial star stirred ethnic tensions in Romania by calling for the end of discrimination against gypsies.

417

Fifty and fabulous: Madonna performs at Madison Square Gardens, New York, on her highly successful 'Sticky and Sweet' tour.

418

The dead body of a woman lies near her children's school in the town of Ilopango; she was shot in El Salvador's escalating gang warfare.

The small Central American country of El Salvador is one of the world's most violent places. Its murder rate is five times the global average, reflecting the dominant culture of fear and impunity. El Salvador was only beginning to recover from its bitter civil war when thousands of young men were repatriated from the US in 1992. They faced marginalization, unemployment and poor prospects; gang culture, imported from Los Angeles, flourished. There are now an estimated 30,000 gang members, who participate in extortion and drug trafficking. The police response has been vicious – reports of extrajudicial murder by the Iron Fist task forces abound – but ineffective, failing to address the poverty that underlies the violence.

419

Congolese rebel leader Laurent Nkunda holds a press conference in Kitchanga, following advances by his armed militia.

In October 2008 fighting erupted again in war-torn North Kivu, an eastern province of the Democratic Republic of Congo (DRC) bordering Rwanda and Uganda. The rebel Tutsi leader Laurent Nkunda sparked the factional violence when his several-thousand strong National Congress for the Defence of the People attacked the DRC army and the ethnic Hutu militia (Democratic Liberation Forces of Rwanda). A former schoolteacher and one-time commander in the government's army, Nkunda declared himself a protector of the Tutsi community. The DRC government and human rights groups accused him of war crimes and alleged that he was supported by Rwanda's Tutsi-dominated government. However, less than three months later, Nkunda was arrested by Rwandan troops, following a surprise pact between the presidents of DRC and Rwanda.

The US president-elect delivered his victory speech in Grant Park, Chicago, where 40 years ago, anti-war demonstrations ahead of the Democratic National Convention had illustrated the schism at the heart of the Democratic Party. On 4 November 2008, however, those rifts appeared healed as Barack Obama presided over a landslide win in Republican stronghold states. Calling for unity, he addressed over 65,000 spectators, many of whom wept at the historic moment. His address echoed the messages of change and enduring hope that had been the watchwords of his campaign. He thanked those who had voted for him, as well as his wife and two daughters who stood by his side.

420

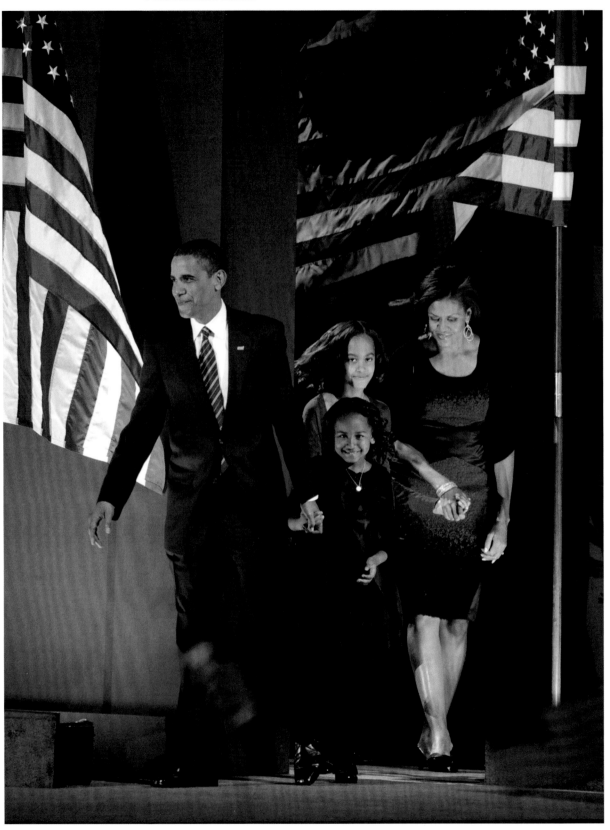

The future first family – Barack, Michelle, Sasha and Malia Obama – on stage at the election-night rally in Grant Park, Chicago.

421

Emotions get the better of the Reverend Jesse Jackson as Senator Barack Obama is elected the first African-American president of the United States.

The Reverend Jesse Jackson, a former presidential candidate and an inspirational figure for many in the black community, had publicly endorsed Barack Obama's campaign to be the first African-American president. On 6 July 2008, however, that support imploded. Jackson accused Obama of 'talking down to black people', his whispered comments at a Fox News interview picked up by a nearby microphone. The damning aside referred to Obama's Father's Day speech in which he chastized young black men for abdicating their familial responsibilities. The civil rights activist had previously berated the Democratic candidate for 'talking white'. Jackson later apologized and was seen in tears during Obama's acceptance speech.

422

Anti-government campaigners camp out at Suvarnabhumi Airport, preventing all outbound flights from leaving Bangkok.

Since a military coup in 2006, Thailand had been in turmoil. In February 2008 a new prime minister, Samak Sundaravej, was installed, but was instantly vilified by the opposition movement – a coalition of middle-class activists, royalists and businessmen called the People's Alliance for Democracy (PAD). Daily protests took place throughout the summer, aimed at ousting the government. In September, Samak was replaced by a relative of PAD's number one enemy, former prime minister Thaksin Shinawatra, further enflaming the crisis. On 26 November anti-government protesters invaded Bangkok's main airport leaving thousands of foreign tourists stranded until the constitutional court dissolved the government on electoral fraud charges on 2 December.

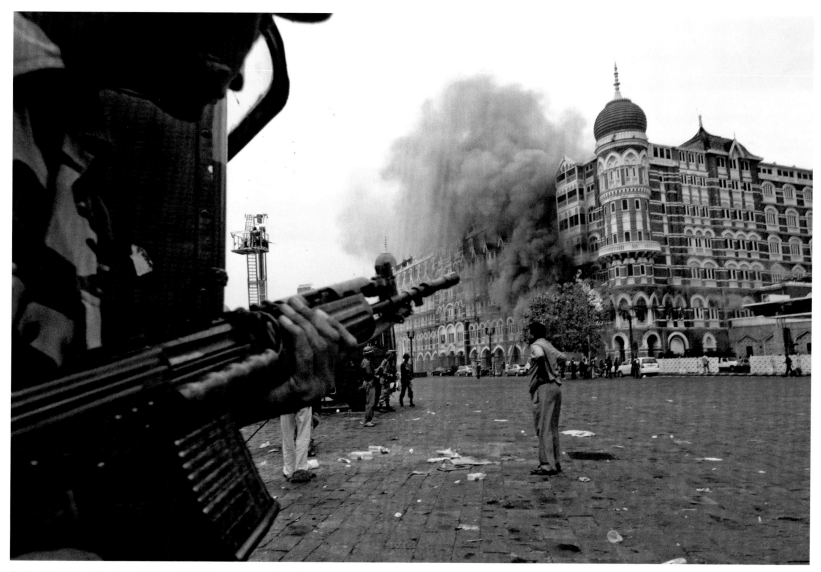

On the third day of the terrorist siege, firefighters try to extinguish a blaze at the Taj Mahal Palace Hotel in Mumbai.

A series of terrorist attacks across India's financial capital on 26–29 November shocked the world. Timed car bombs caused destruction and panic while gunmen with grenades and guns killed bystanders in some of Mumbai's most high-profile locations. Hostage-taking meant the siege at the Taj Mahal Palace Hotel endured for three days. The only surviving operative admitted that the attackers were members of Lashkar-e-Taiba, a Pakistan-based militant group opposed to Indian control in Kashmir. The incident in Mumbai was the latest in a series of bombings that killed hundreds of Indians throughout the decade.

424

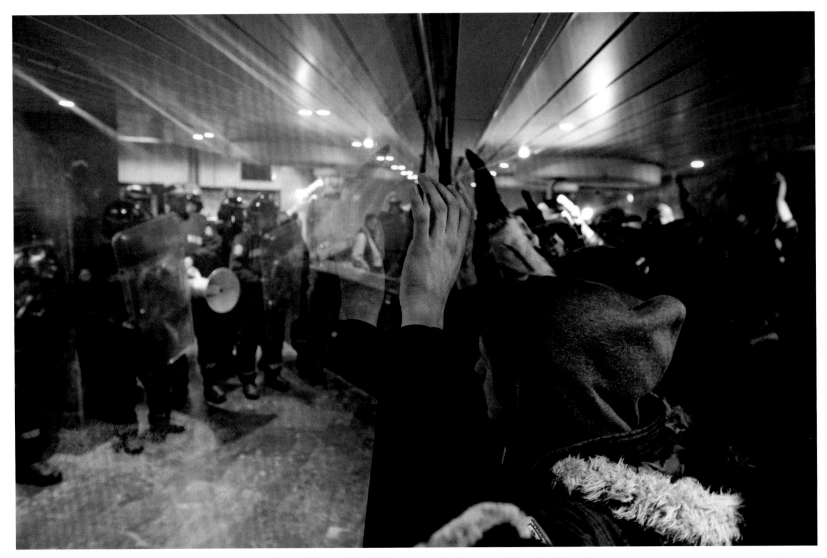

Police guard the Central Bank of Iceland as protesters demand the sacking of the governor; the krona continues to plummet.

In October 2008, the global financial crisis claimed one of its most startling victims: the Icelandic economy. Relative to the size of the national economy, its banking collapse was the biggest in history. The country's three main banks had accumulated debts almost six times the value of Iceland's economy. Icesave, a subsidiary of one of these, had many customers in the United Kingdom. The British chancellor, Alistair Darling, used anti-terrorism legislation to freeze Icesave assets in the UK and protect account holders. The Icelandic government was furious and this decision resulted in a major diplomatic incident. Meanwhile, the value of Iceland's currency collapsed, inflation rocketed and unemploy-ment increased massively.

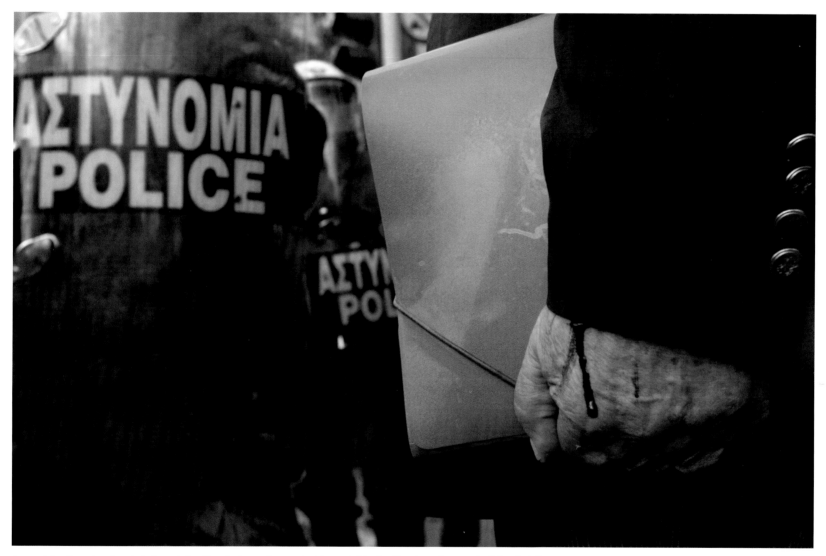

A man bleeds as he stands before riot police during a demonstration outside the Greek parliament building in Athens.

425

The killing of 15-year-old schoolboy Alexandros Grigoropoulos by a police bullet on 6 December 2008 sparked weeks of violent rioting in Athens. Some protestors were enraged by the incident; others took the government to task over corruption, unpopular privatization and high unemployment. National student sit-ins and peaceful marches by thousands of teachers and union members were accompanied by arson attacks perpetrated by hooded anarchists. Many public demonstrations were broken up by tear gas, leading to accusations of police brutality and fuelling retaliatory civil disobedience. They were the worst riots in a generation, and recalled the student uprising that overthrew the Greek military junta in 1973.

2009
Hope

The inauguration of US President Barack Obama was witnessed by over a million people gathered along the length of Washington's National Mall. Ever unflappable, the first African-American president of the United States didn't let his bungled recitation of the oath of office distract him from the main themes of his address: the need to remake America and restore its moral standing in the world. Soon he was to face grave decisions over the country's ailing economy and involvement in two distant wars, but this was a time for celebration. Five days earlier the nation was celebrating for another reason. An unknown airline pilot, Chesley 'Sully' Sullenberger, landed his passenger plane in the Hudson River shortly after take-off from New York's LaGuardia Airport after the aircraft hit a flock of geese, causing both engines to fail. All 155 passengers on board were saved from certain death. In March a hero of a very different kind looked set to revive his status as the King of Pop. Michael Jackson ended years of self-imposed exile to announce a series of live shows in London, likely as a precursor to his first world tour in more than a decade. The seemingly inexhaustible demand for tickets proved that interest in the former child superstar, now 50 years old, had not dimmed. However, Jackson died of a cardiac arrest three weeks before the opening performance. In Austria, the wounds to the national psyche inflicted by Josef Fritzl, the man who imprisoned, raped and neglected his children, were healed to some extent when he was convicted for the monstrous crimes that he had committed over a 24-year period. Fritzl had kept his daughter captive in a sealed basement and fathered seven children by her. Austrians struggled to answer how something so heinous could occur within their midst, although similar cases came to light in other parts of the world during 2009. Despite attempts to contain the H1N1 influenza virus in Mexico, where it first appeared, swine flu spread rapidly. In April the World Health Organization declared it a pandemic. An enormous vaccination programme and greater awareness of safety precautions allayed the most acute fears, but no one would be able to gauge the full impact until the winter was over. In December the UN Climate Change Conference promised solutions but despite months of preparation it ended with many of the same problems still unresolved. Two sports stars made global headlines for all the wrong reasons. Eighteen-year-old middle-distance runner Caster Semenya struck gold in the 800 metres at the World Athletics Championships, but her victory was earned under a cloud of suspicion. The authorities in her native South Africa cried racism when the international athletics governing body called for gender verification tests, only to recant when it was revealed that their own tests indicated that Semenya might have both female and male organs. The US golfer Tiger Woods had his world turned upside down after a car accident in his drive. The incident sparked a cascade of revelations about his private life. By the year's end his personal reputation lay in tatters.

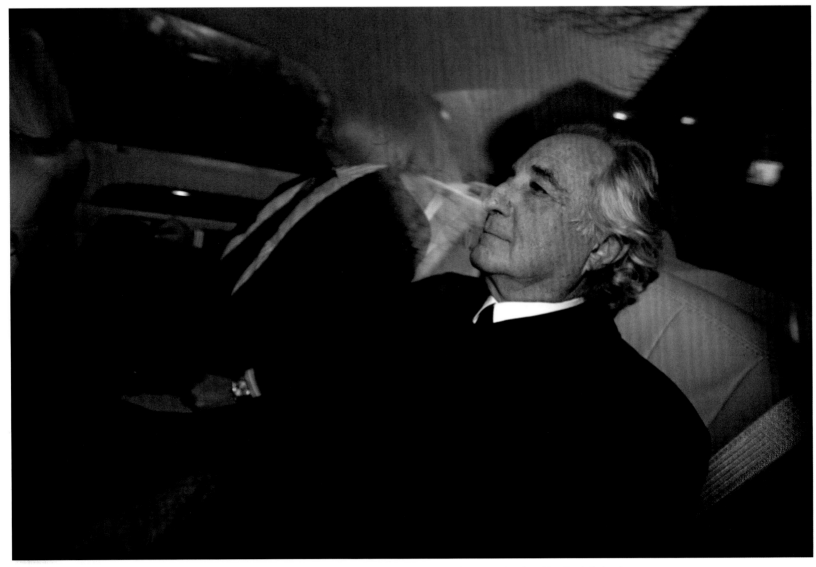

His once fine reputation in tatters, Bernard Madoff returns to his house arrest on Park Avenue after a hearing in a New York federal court.

Bernard Madoff was a fixture on the New York scene. He was considered a mensch – a man of honour and integrity, funding vast philanthropic ventures with his fortune, especially Jewish charities. But in December 2008 he was arrested on suspicion of masterminding a massive Ponzi scheme. Such pyramid operations, whereby established investors are paid returns from the money submitted by newer members, were nothing new. Yet the scale of Madoff's fraud was staggering – up to $65 billion. His impeccable reputation had assisted his crime. People sank money into his investment business based on word of mouth and he created a sense of exclusivity by turning some would-be investors away; those who asked too many questions were booted out. Madoff was sentenced to 150 years in prison.

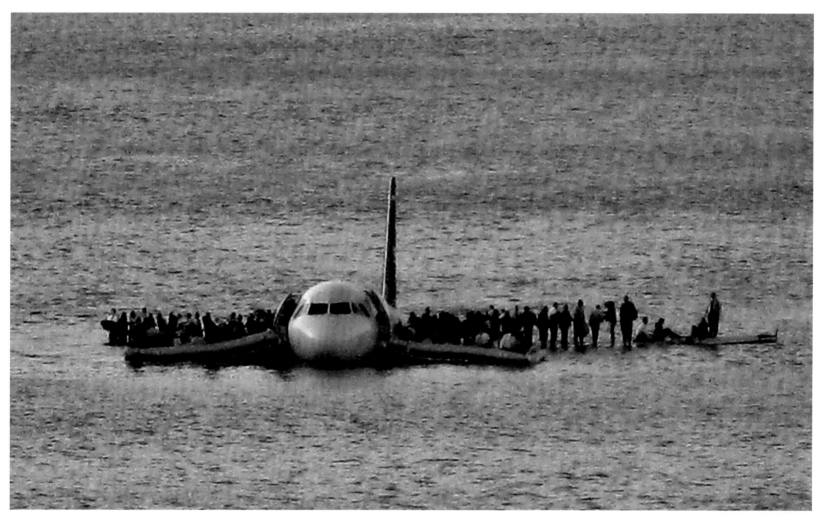

Passengers of US Airways Flight 1549 await rescue on the freezing cold Hudson River.

429

A US Airways flight from New York to Charlotte, North Carolina, ran into trouble shortly after take-off when it hit a flock of geese. Both engines on the Airbus A320 failed at a height of 980 metres (3,200 feet). With only a few minutes to find a suitable landing spot, Captain Chesley 'Sully' Sullenberger – a former fighter pilot – calmly radioed air traffic control, informing them that he would be ditching the plane in the nearby Hudson River. Landing on the water at around 240 kph (149 mph), the plane survived without major damage. As office workers watched from Manhattan's skyscrapers, a flotilla of boats launched to rescue the 155 passengers. All survived and Sullenberger was hailed a hero.

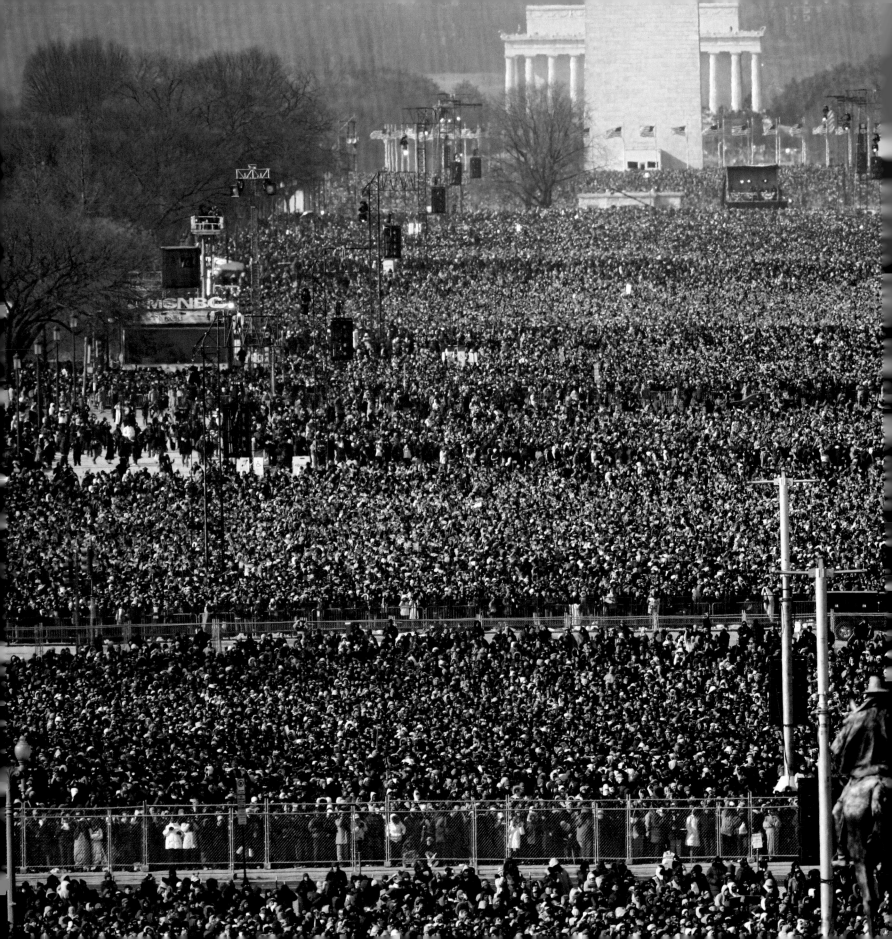

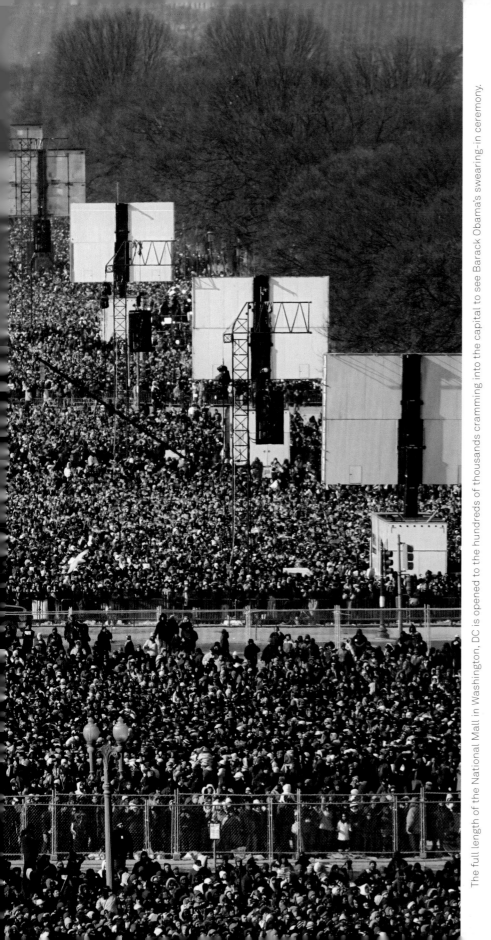

The full length of the National Mall in Washington, DC is opened to the hundreds of thousands cramming into the capital to see Barack Obama's swearing-in ceremony.

Like so much of Barack Obama's journey to the White House, his inauguration as the 44th President of the United States broke with tradition. For the first time, the entire length of the capital's National Mall was opened to ordinary Americans, hundreds of thousands of whom flooded the boulevard to see Obama take his place in history. Around the world, tens of millions more watched the proceedings on television and the internet. Inspired by his campaign slogan, someone in the crowd shouted 'Yes we did', a pithy reminder of the extent to which Obama had captured hearts at home and abroad.

432

Outgoing President George W. Bush bids his successor well.

Taking the presidential oath, Barack Obama swears to faithfully execute his duties and protect the US Constitution.

As he swore on the Lincoln Bible to preserve, protect and defend the constitution, Barack Obama crossed the threshold to become the first African-American president of the United States. A mix-up in the word order led him to later retake the inaugural oath to ensure that there could be no legal challenge to his authority. In his national address, Obama issued a rejoinder to 'begin again the work of remaking America'. He also made reference to the United States' standing in the world, promising that, despite the economic climate and foreign policy challenges, 'We are ready to lead once more'.

On 23 January the Japanese space agency launched the world's first climate satellite. Nicknamed *Ibuki* (Breath), the satellite will observe the distribution of greenhouse gases – in particular carbon dioxide and methane – over a five-year period, in order to see 'how the world breathes'. Using 56,000 points around the globe, the satellite will monitor emission and absorption rates, thus providing a map of nations meeting their Kyoto Protocol commitments to reduce greenhouse gases in the atmosphere. The successful launch showcased Japan's burgeoning satellite programme, as Tokyo sought the advantage in its space race with China.

433

Japan launches the world's first satellite dedicated to monitoring climate change from Tanegashima, an island off the coast of Kyushu.

434

The American author John Updike, who died on this day, is seen here at Harvard University in 2006 after the completion of his novel *Terrorist*.

A true man of letters – his output included novels, short stories, poetry, literary and art criticism – John Updike was one of the great American writers of his time. His writing represented the experience of a generation of 'silent Americans'. *Rabbit, Run* (1960) introduced one of his best-known characters, Harry 'Rabbit' Angstrom, to whom Updike was to return in a series of novels. The juxtaposition of sexual infidelity and personal crisis with the middle-class, god-fearing existence of its characters marked much of Updike's work. 'The writer', he said, must accept 'that aesthetically, the ordinary, the banal, is what you must deal with.'

Responding to a tanker's distress call in the Gulf of Aden, the US warship *Vella Gulf* captures these suspected pirates.

435

The explosion of pirate activity in the Gulf of Aden during the second half of the decade was symptomatic of Somalia's ongoing disorder and chaos in the absence of a functioning state. Opportunistic warlords, as well as impoverished fishermen and local militias, turned to piracy in droves. Many claimed to be simple 'coastguards' protecting their maritime resources from commercial trawlers and illegally dumped toxic waste, but it was clear that this was a boom industry in a country where three-quarters of the population lived on less than $2 a day. By 2009 the pirates had become more sophisticated, commandeering supertankers for millions of dollars in ransom. In response, the international community stepped up naval operations, intercepting and arresting suspected pirates.

London Fashion Week celebrated its 25th anniversary in 2009. Its new venue at Somerset House and its continuing commitment to innovative fashion reinforced London's reputation for 'heritage with a twist'. The British Fashion Council also marked its 25th birthday and, in keeping with its reputation for nurturing new talent, awarded its Fashion Fund prize to three rising stars: Marios Schwab, Christopher Kane and Erdem. Burberry, Pringle and Matthew Williamson also returned, after years of showing in New York. The week included 54 catwalk shows and 200 designers, as well as fringe events, and signalled London's revival as a major fashion capital. The appearance of American *Vogue* editor Anna Wintour after a two-year absence was the final stamp of approval.

436

The work of celebrity hairdresser Charlie Le Mindu is shown off at a London Fashion Week fringe event.

437

Barbie dolls line a wall in the real-life Malibu Dream House in California, commissioned by Mattel for Barbie's 50th birthday.

Barbie celebrated her 50th birthday on 9 March, though she hadn't aged a day since her debut in 1959. The buxom blonde doll brings in over $3 billion a year, with one doll sold every three seconds in 150 countries, making her a global icon. With over a hundred careers, including astronaut, air hostess, paediatrician and first female president, Barbie continues to encapsulate the spirit of a 1950s emancipated woman despite her constant reincarnations. On Valentine's Day, a catwalk show held in her honour at New York Fashion Week showcased designs by Diane von Furstenberg, Anna Sui and Calvin Klein.

438

Josef Fritzl, guilty of holding his own daughter captive for 24 years, appears in court for sentencing in Sankt Pölten, Austria.

The man who had created what he called a 'second family' in the basement of his home was convicted of incest, rape, enslavement, coercion and murder by neglect on 19 March, and sentenced to life in a psychiatric hospital. The 73-year-old Austrian had sequestered his daughter Elisabeth in a specially built cellar, claiming she had run away – in fact, she was subjected to daily rape within the confines of the tiny prison. Josef Fritzl fathered seven children with his daughter, three of whom lived 'upstairs' with him. Three others had never seen daylight and suffered myriad physical and psychological problems, and one died in infancy. In court, the man who had claimed he was 'born to rape' confessed to all the charges.

US soldiers of the 1st Infantry Division enjoy local food at an observation post in Kunar province, Afghanistan.

By the end of March the number of US military personnel in Afghanistan had risen to 33,000, although only a third were assigned to combat operations. This was matched by troops from the other 42 nations in the International Security Assistance Force. Despite their presence, the Afghan mission was beginning to unravel in the face of an intensifying Taliban insurgency. The continuing lack of progress was attributed to a shortage of resources – such as troops, helicopters and intelligence analysts – as well as various national caveats that prevented most troop-contributing nations from engaging in robust counter-insurgency operations.

On 5 April, North Korea launched a rocket in a move Western leaders described as provocative. The communist country claimed it had launched a communications satellite, which would broadcast songs in praise of the supreme leader, Kim Jong-il, and his father, the eternal president, Kim Il-sung. However, without any independent confirmation, the United States, Japan and South Korea all feared that Pyongyang had sought to test a long-range missile capable of reaching their shores. A few hours later, US President Barack Obama addressed 20,000 people in Prague, outlining his vision of a nuclear-free world, and strongly condemning North Korea's actions.

An exhaust trail from a rocket in this satellite image alerts the world to North Korea's developing missile programme.

Firemen in Paganica, a hillside town near to L'Aquila, Italy, recover a marble statue of the Madonna after the earthquake.

In the early hours of 6 April a powerful earthquake struck in the Italian region of Abruzzo. The tremors were felt as far away as Rome, where the third-century Baths of Caracalla were damaged. The medieval city of L'Aquila was at the epicentre of the quake: many of its historic buildings collapsed, including several churches and parts of San Massimo Cathedral. 60,000 people were left homeless in the natural disaster that had been predicted by Italian scientist Giampaolo Giuliani – his claims were dismissed and he was branded an 'imbecile' by the government earthquake agency. Not forewarned, 300 people died in the tragedy. Months later, among ongoing tremors, tens of thousands still remained in tent cities; government authorities estimated it could take 10 years for life in the formerly picturesque town to return to normal.

441

Wrapped up against the cold, South African voters wait outside a polling station in Cape Town.

South Africa's fourth general election since the ending of apartheid was held in April. As predicted, the ruling African National Congress (ANC) won a comfortable majority of parliamentary seats. Two weeks later the National Assembly formally endorsed ANC leader Jacob Zuma as president. The political career of the former guerrilla commander had seemed to lie in tatters only a few years earlier, due to his involvement in an arms scandal. As president he promised to tackle South Africa's rampant crime and provide better social and economic opportunities for the country's poor, who had seen little improvement to their lives during South Africa's transition from white rule to democracy.

442

Amid global panic over swine flu, Mexico City commuters wear surgical masks to protect themselves from the virus.

Easily passed from person to person, the H1N1 influenza virus first appeared in Mexico. Despite attempts to contain the initial outbreak of swine flu, it quickly appeared in multiple countries, often following air travel by infected persons. The World Health Organization declared a 'public health emergency of international concern' in April 2009. Safety precautions included enhanced hygiene vigilance and the rapid manufacture of vaccine Tamiflu. The pandemic, which had claimed several thousand lives by the summer, seemed likely to rapidly accelerate during the winter season, raising fears that health systems in developing nations would be unable to cope.

Stretchered through crowds of government troops, the body of Tamil Tigers' leader Velupillai Prabhakaran provides a grisly signal for the end of civil war.

443

In a televised live address on 19 May, Sri Lanka's President Mahinda Rajapaksa declared an end to the government's 26-year-old war with the Tamil Tiger rebels. His announcement came a day after the Tigers' leader Velupillai Prabhakaran was reported killed in the army's final assault on his last stronghold in the northeast of Sri Lanka, where the rebel group (Liberation Tigers of Tamil Eelam, or LTTE) had fought a bloody struggle for an independent homeland for the island's Tamil minority. In the weeks before the war's end, Rajapaksa had rejected calls by the UN for a truce to protect civilians from the army's artillery barrages; and the Tigers refused to surrender and free up to 100,000 people that they were holding as human shields. Each side accused the other of gross human rights violations although independent verification proved impossible because neither side permitted reporters into the conflict zone.

Burmese compatriots in Japan demand the release of Aung San Suu Kyi, leader of the National League for Democracy, after her incarceration in Insein Prison, Rangoon.

Daughter of the Burmese politician who negotiated independence from Great Britain, Aung San Suu Kyi was an exemplar of non-violent political resistance against a brutal regime. She has been under house arrest intermittently since 1990, after her landslide election as prime minister was annulled by Burma's military junta. From behind the walls of her home she has continued to inspire the struggle for democracy and human rights in the Southeast Asian country, receiving the Nobel Peace Prize in 1991. On 3 May 2009, an American man trespassed on the property – an alleged violation of the terms of confinement – resulting in the arrest of Suu Kyi and her two maids. Despite worldwide condemnation and intervention by the United Nations Secretary-General, Suu Kyi was sentenced to a further 18 months house arrest in August, thus preventing her from contesting the 2010 Burma elections.

445

A refugee boy finding shelter in Peshawar is now safe from the fighting in Pakistan's Swat valley.

Fierce fighting between the Pakistani army and Taliban fighters broke out in Swat in May, driving 1.5 million people from their homes. February's truce between the two forces had soon collapsed, leading to renewed efforts to end the Taliban's stranglehold in the war-torn region. The civilian toll was huge, with heavy shelling destroying villages and killing innocent people caught in the crossfire. The UN likened the enormous displacement crisis to the 1994 Rwandan genocide. Hundreds of thousands retreated to emergency camps, but a million more took advantage of Pashtun hospitality and sought sanctuary with relatives, putting pressure on small communities as the confrontation dragged on.

Former President Roh Moo-hyun had come to power in 2003 promising to cleanse South Korean politics of sleaze and corruption. The self-taught lawyer had a turbulent time in office – his impeachment only a year into the presidency was overturned by the courts – yet he remained popular until the end of his five-year term in 2008. However, following revelations that his family had accepted $6 million from a wealthy shoe manufacturer, Roh was investigated on bribery charges, tarnishing his reputation. On 23 May 2009, Roh leapt to his death from a mountain near his home. A suicide note reportedly contained an apology for 'disappointing' the South Korean people.

446

The funeral motorcade of former South Korean President Roh creeps through a throng of mourners in Seoul.

On the day Iran's supreme ruler opens an investigation into election fraud, angry supporters of opposition candidate Mir Hossein Mousavi fill Tehran's streets.

447

The Iranian presidential election pitted incumbent Mahmoud Ahmadinejad against popular reform candidate Mir Hossein Mousavi. Ahmadinejad appeared to win a significant majority, but concerns about voting irregularities led to civil unrest. Protests against electoral fraud galvanized generations of Iranians, who boycotted state-advertised goods, coordinated power surges during televised news reports and gathered for flash mobs, which quickly dispersed before the arrival of feared pro-Ahmadinejad paramilitaries. Heavy censorship made communication with the outside world difficult, but many Iranians posted updates via social networking websites, such as Twitter. Almost eight weeks later, the new president was formally inaugurated by Iran's supreme leader, Ayatollah Ali Khamenei, though demonstrations continued outside parliament.

Famous for his music, dance moves and highly eccentric personal life, Michael Jackson's death in June 2009 shocked the world. Dubbed the 'King of Pop', he had made a profound impact on popular culture with records such as *Thriller*, *Bad* and *HIStory*. Among many other accolades, Jackson won 13 Grammy Awards and was named the 'Most Successful Entertainer of All Time' in 2006 by Guinness World Records. An investigation into Jackson's death implicated his personal doctor, who was suspected of gross negligence and involuntary manslaughter. Nevertheless, the scandal was unable to dampen the ardour of millions of fans who mourned his passing.

Michael Jackson, whose sudden death hit the headlines on this day, is seen here in March announcing an unprecedented series of concerts at the O2 Arena in London.

450

Uighur women confront Chinese police on the third day of unrest in Urumqi, Xinjiang province.

Violent protests broke out in Urumqi, capital city of China's Xinjiang-Uighur Autonomous Region, after a brawl between Uighurs and Han Chinese at a factory resulted in the death of two Uighur workers. The incident enflamed historic tensions between the two ethnic groups. Overnight, peaceful rallies degenerated into widespread rioting, with both sides claiming the other to be the instigators of the violence. Hundreds were injured and almost 200 died. The Chinese government, who accused foreign elements of fomenting trouble, imposed a curfew and communications blackout, and sanctioned a heavy-handed police response.

At a press conference in Nicaragua, Manuel Zelaya, the deposed president of Honduras, announces that he is willing to return to the country.

451

Manuel Zelaya, the president of Honduras, was ousted after a power struggle over proposed changes to the country's constitution that would have extended his time in office. Soldiers stormed the president's residence in the capital, Tegucigalpa, just after dawn on 28 June 2009 and forcibly removed Zelaya, who was still wearing his pyjamas. Zelaya was flown to exile in Costa Rica but two days later attended the Summit of Central American Presidents in Managua, Nicaragua, where he urged Hondurans to resist their country's new rulers. The coup was roundly condemned internationally, especially by Zelaya's close regional allies, Venezuelan President Hugo Chávez and Bolivian President Evo Morales.

The Dwarf Athletic Association of Northern Ireland (DAANI) hosted the fifth World Dwarf Games in the summer of 2009. The Games are held every four years, the first such event being in Chicago in 1993. The height limit for adult male competitors is 130 centimetres (4 feet 3 inches). DAANI's bid for the 2009 Games was strengthened by their organization of the 2006 European Championships. Traditional track and field, swimming and weight-lifting events took place alongside new age kurling and tennis-ball throwing. Competitors cited friendships forged through common experiences and the opportunity to compete in sports on an equal footing as reasons to take part.

Two Australian competitors in the fifth World Dwarf Games in Belfast, Northern Ireland.

452

The international furore surrounding South African middle-distance runner Caster Semenya was the sporting story of the summer. In August 2009 the 18-year-old won gold in the women's 800 metres at the World Athletics Championships in Berlin. Before the final, doubts about Semenya's gender had been raised by the International Association of Athletics Federations (IAAF), due to her muscular development and spectacular improvements on the track. In the final's immediate aftermath, South African authorities rejected the IAAF's call for further investigations and branded the organization racist, only to recant shamefacedly a few weeks later when it was revealed that tests carried out within South Africa before the event also suggested that Semenya might have a chromosomal irregularity.

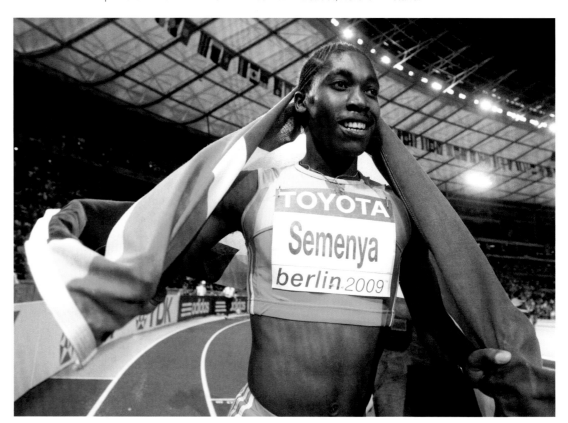

Caster Semenya's victory in the women's 800-metre final at the World Athletics Championships in Berlin sets off a controversy over her gender.

People's Liberation Army soldiers in Beijing rehearse a musical drama ahead of China's National Day, which is celebrated on 1 October.

453

China's National Day in 2009 also marked 60 years since the ruling Communist Party had come to power, sparking massive celebrations. Speaking in front of the Forbidden City, President Hu Jintao commemorated the achievements of Deng Xiaoping's 'socialism with Chinese characteristics', saying China was 'standing tall and firm'. Celebrations in Beijing included a fly-by of 130 helicopters and aeroplanes, and a parade of China's military arsenal – a display apparently directed at Western observers. Soldiers participated in heavily choreographed goose-stepping routines, while schoolchildren spelt out party messages using pompoms. A spectacular firework display over Tiananmen Square was made possible by cloud seeding the previous day, intended to eradicate Beijing's smog.

454

Amid an intense diplomatic furore, Abdelbaset al-Megrahi, one of the so-called 'Lockerbie bombers', is returned home on compassionate grounds.

The parole on medical grounds of Abdelbaset al-Megrahi from Greenock Prison, near Glasgow, caused controversy on both sides of the Atlantic. Convicted of the bombing of Pan Am Flight 103, which broke up over the Scottish town of Lockerbie in 1988 killing 270 people, Megrahi had served only eight years of a life sentence when he was diagnosed with terminal prostate cancer. With apparently just three months to live, Megrahi was released by the Scottish justice secretary on compassionate grounds, purportedly against advice from London and Washington. He arrived in Tripoli a national hero; as of May 2010 Megrahi was still alive.

US Senator Edward Kennedy is buried near his brothers John and Robert in Arlington National Cemetery, Virginia, with family and close friends in attendance.

455

Edward 'Ted' Kennedy lost his battle with cancer on 25 August 2009. Brother of murdered President John F. Kennedy, the Massachusetts senator was a dominant force in American politics for nearly half a century. The so-called 'Lion of the Senate' was re-elected seven times and in 1980 ran for the Democratic presidential nomination. Lingering questions about his role in the death of Mary Jo Kopechne at Chappaquiddick in 1969 doomed his presidential candidacy, but as a senator the liberal-minded Kennedy was hailed as one of the most effective and popular legislators in US history. He was an active supporter of Barack Obama's presidential campaign and worked tirelessly in support of Obama's controversial healthcare reforms.

456

Yukio Hatoyama's first press conference as prime minister marks the start of a new political era in Japan.

On 30 August the Japanese electorate ended the almost 54-year reign of the Liberal Democratic Party (LDP). Gaff-prone Prime Minister Taro Aso's LDP was thrown out of power by the Democratic Party of Japan (DPJ), led by Yukio Hatoyama. From a prominent political family, Hatoyama campaigned against bureaucracy and government cronyism. The DPJ also promised to temper the excesses of free-market capitalism, a pledge that worried many in the business community. Opponents argued that it would not be able to finance its policies, such as a $280 a month child allowance designed to boost Japan's ailing birth rate.

The Sydney Harbour Bridge disappears into a thick dust storm kicked up by gales battering eastern Australia.

On 23 September, Sydneysiders awoke to an eerie scene. The worst dust storm since the 1940s had blown an estimated 3,600 tonnes of desert red soil over the city. The Martian-like atmosphere reduced visibility to 100 metres (330 feet), so that even Sydney Bridge was obscured. Transport ground to a halt as flights were diverted and ferries were suspended. Authorities warned those with breathing problems to stay inside. It was the latest in a series of natural disasters for Australia, which had been hit by earthquakes, hailstorms and bushfires in the previous 24 hours. Scientists later revealed that the meteorological phenomenon had added extra nutrients to the Tasman Sea, enabling microscopic life to absorb more carbon dioxide to counteract man-made emissions.

Polish-born filmmaker Roman Polanski was taken into custody in Switzerland on 26 September 2009 under a US extradition request to face charges of having sex with a 13-year-old girl in 1977. The director of masterpieces such as *Rosemary's Baby* and *Chinatown* was in Switzerland to collect a lifetime achievement award at the Zurich Film Festival. He had travelled to the country several times but this time the US authorities knew of his trip in advance and persuaded their Swiss counterparts to secure his arrest. After fleeing the United States on the eve of his sentencing (he had pleaded guilty to unlawful sex with a minor) in 1978, he settled in France and lived for over three decades as the world's most celebrated fugitive. The French government and most of the worldwide film industry expressed shock and dismay at his arrest, although US officials were adamant that Polanski return to face justice.

458

Roman Polanski entering a Santa Monica court in August 1977 to plead guilty to statutory rape. Thirty-two years later, the saga took a new twist.

459

Master photographer Irving Penn, here in a 1951 portrait by Horst P. Horst, dies this day at his Manhattan home.

Taiwanese girl-group S.H.E., in dazzling costumes, perform at the Hong Kong Coliseum.

Irving Penn died on 7 October 2009 at the age of 92. The influential photographer had worked for Condé Nast for over 50 years, making his first *Vogue* cover in 1943. His photographs were famous for their graphic precision; the minimalist background a constant throughout his career. In addition to fashion, Penn's subjects included still lives, portraiture, voluptuous nudes and studies of street debris. Whatever the subject, Penn's attention to detail endowed each photograph with clarity and definition, while his predilection for the platinum printing process drew out texture and luminosity. His last photo for *Vogue* was of a bunch of overripe bananas – a poignant reminder that, despite his age, Penn's flair had not diminished.

Jen Chia-Hsüan, a young singer from Taiwan, better known by the name Selina, won the Universal Talent and Beauty Girl contest in 2000, and formed successful pop group S.H.E with two of the runners-up. The girls, nicknamed Selina, Hebe and Ella, released 10 albums over the next 8 years, becoming one of the most successful Chinese-language music acts to date. They also appeared in several television dramas and game shows, including the highly rated series 'The Rose'. In 2009 their third concert tour included the world's first 'gravity-defying' stage, with the artists, styled as a sun, star and moon, appearing as if suspended in mid-air.

As an ash cloud billows overhead, pyroclastic flows of hot gas and rock surge down the slopes of the Soufrière Hills volcano in Montserrat.

460

The Soufrière (Sulphur) Hills volcano covers the southern part of the Caribbean island of Montserrat. The volcano famously exploded in 1995, its first eruption since the seventeenth century, burying the capital, Plymouth, under a sea of lava, and creating a modern-day Pompeii. Subsequent activity had left much of the island uninhabitable. After a period of calm, in 2009 the volcano awoke again, sending ash thousands of metres into the air. A lava dome began to grow on top of the summit and pyroclastic flows dribbled slowly from underneath. However, on this occasion, the lava missed Montserrat's homesteads.

461

The last president of the Soviet Union (Mikhail Gorbachev) and the leader of a united Germany (Angela Merkel) on Bornholmer Bridge, where East Berliners first crossed freely into the West twenty years previously.

In November, Europeans celebrated a transformed continent. Just 20 years before, Europe had lain divided between democracy and totalitarian communism: a battleground between two superpowers. Now Germany was once again united and the states of Eastern Europe firmly embedded in the project of European unity. Celebrations took place in Berlin, a city that once physically embodied the divisions of the Cold War. They involved gathering on the Bornholmer Bridge and the toppling of a line of giant, painted dominoes that represented the Berlin Wall, which had once cleft the city in two. Lined up before the Brandenburg Gate, their fall symbolized the chain of events that had ushered in a new era for Europe.

Since April 2007 the coffin of each British soldier repatriated from Afghanistan has passed through Wootton Bassett in Wiltshire on its way from RAF Lyneham. Each soldier has been the recipient of a simple, dignified homecoming, courtesy of the 12,000 residents of this small English town. The first proceedings attracted a few members of the local Royal British Legion, keen to pay their homage to the fallen; by 2009, thousands of townspeople, visitors and journalists would line the High Street. On 10 November, the funeral cortège of another six men passed through the town as the bell of St Bartholomew's tolled in remembrance.

The bodies of three Grenadier Guards, two Royal Military Policemen and one Rifleman, all killed in Afghanistan, are brought home to the UK.

In Brussels, British peer Baroness Ashton – the new 'face of Europe' – is flanked by French President Sarkozy and Lithuanian President Grybauskaite.

463

The Lisbon Treaty was born from the remains of the failed EU Constitution. It streamlined European institutions, reflecting its larger membership, and created a new president of the council and a foreign policy chief. One possibility for the presidency was the former British prime minister, Tony Blair. However, he was considered too controversial a choice, and other European leaders did not want to be overshadowed by such a well-known figure. Belgian Prime Minister Herman van Rompuy, little known outside his country but an effective builder of cross-party compromises, was made president. EU Trade Commissioner Baroness Ashton – a British politician relatively unknown within her own country – was appointed foreign affairs representative.

The much anticipated return of American golfer Tiger Woods, the world's most successful sportsman, to the PGA Tour in 2009 was overshadowed by events in his personal life later in the year. On the night of 28 November 2009 he crashed his car outside his Florida home and was treated for minor injuries. The exact circumstances instantly became the subject of a media frenzy; tabloids began to run stories alleging his infidelity to his wife, Swedish model Elin Nordegren, naming waitress Jaimee Grubbs in particular. In the press, a dozen women claimed to have also had affairs with Woods. Sponsors, including Gillette and Accenture, abandoned Woods, claiming that he was no longer a good representative of their brands.

464

Born in Ukraine in 1920, John Demjanjuk had already faced trial once in Israel for war crimes. In 2009 a German court finally secured his deportation from the United States, where he had settled as an immigrant. He was to stand trial again on 30 November, formally charged with being an accessory to 27,900 murders. Some argued that, given the magnitude of the Holocaust and the savagery of the crimes, such criminals had to be hounded down at all costs: basic justice demanded no less. Others, however, questioned the worth of a second trial for someone who had been only a minor figure, and the validity of eye-witness accounts 70 years after the fact.

Tiger Woods, wife Elin and daughter Sam at a football game a week before his serial infidelity is revealed.

The service records of Ukrainian-born John Demjanjuk, who faces trial again for his role in the Holocaust.

West Point cadets listen intently to President Obama lay out his strategy for the continuing struggle in Afghanistan.

President Barack Obama's highly anticipated address at the West Point military academy put an end to months of debate in Washington, DC, on the future of the beleaguered US-led military operation in Afghanistan. In detailing his new strategy for Afghanistan and the Taliban, and Al Qaeda strongholds in Pakistan, Obama argued that sending an additional 30,000 troops to the region by summer 2010 did not mean a costly, open-ended US military commitment. Instead he pledged to bring troops home within 18 months and reinvigorate the training of the Afghan security forces. His extra troop deployments were widely commended, but opinion was sharply divided on his decision to set a timetable for a withdrawal.

466

A delegate from Guinea-Bissau awaits the start of the climate change summit in Copenhagen.

According to the Global Humanitarian Forum, climate change has affected approximately 325 million people across the globe, costing about $125 billion every year, and negatively impacting economic development, health and livelihoods. The United Nations Climate Change Conference (7–18 December) in Denmark's capital was supposed to be a landmark event in the decade-long international struggle to reach a global agreement. The Copenhagen Accord, thrashed out over sleepless nights and diplomatic *faux pas*, involved the world's largest polluters, China and the US, but was not a legally binding commitment. After months of preparation and high expectations, many commentators considered the summit a failure: without concerted efforts to mitigate the effects of climate change – principally, significant reductions in global emissions – many of the planet's poorest countries will suffer disproportionately over the next century.

The flamboyant media mogul and prime minister of Italy, Silvio Berlusconi, was often in the news for reasons other than his politics. In April 2009, he became mired in controversy after attending the birthday party of an 18-year-old model. His wife filed for divorce in response. On 13 December 2009, Berlusconi was in the crowd at a political rally in Milan when he was hit in the face by a statuette of the city's cathedral, hurled by a man with a history of mental illness. A bloodied Berlusconi was rushed into his car, but soon re-emerged to show his supporters he was fine. He suffered two shattered teeth and a broken nose in the attack.

467

Italian Prime Minister Silvio Berlusconi leaves a Milan hospital several days after being hit in the face with a souvenir.

2010
Witness

The year had barely begun when the small, impoverished Caribbean state of Haiti was virtually flattened by a large earthquake. Poorly built structures simply disappeared into rubble and vital infrastructure was destroyed. Hundreds of thousands died. The Earth trembled again a month later in Chile, but here a larger quake wrought less destruction. The rich Latin American country had stronger buildings and plentiful resources of its own. The tragedy was limited to a few hundred deaths, miraculous for an earthquake so strong it shifted the planet slightly off its axis. The world of sport was also rocked in early 2010. Angola hosted the African Nations Cup, a football spectacle that was intended to erase its image as a conflict-ridden country. But its hopes were shattered when rebels in the north of the country ambushed the Togo football team bus, killing three people. And at the Vancouver Winter Olympic Games, the athletic community mourned the loss of one of their own when a Georgian luger came off the track and was killed. But both shows went on.

The Egyptians won their third African Nations Cup in a row with a laboured victory over Ghana. Canada, meanwhile, grabbed a record tally of gold medals at the Olympics. The sweetest of all was their extra-time victory over the United States in the men's ice hockey – for Canadians, always the showpiece event of any Winter Games. Fashion circles were shocked and saddened by the tragic death of designer Alexander McQueen. The 'bad boy' of British design had become one of the most respected figures in contemporary fashion. Across the Atlantic, one of the most influential writers of the twentieth century – the recluse J.D. Salinger – died in January. His published body of work was so small that some speculated that there must have been a hoard of writings locked away. Salinger's most famous work, *The Catcher in the Rye*, dwelt on the enduring themes of teenage angst and rebellion. Anger and revolt was also to be witnessed in the rising Tea Party movement in the United States. Rejecting the rocketing government expenditure from the bank bailout and President Obama's healthcare reform, this grassroots protest movement adopted the imagery of the American revolutionaries to make their point. At the same time, many consumers in the United States vented their fury towards car manufacturer Toyota, accusing it of covering up critical faults with its cars and sacrificing safety to pursue corporate growth. In April, Poland was shaken to its core by the death in a plane crash of many of its political and military élite; its citizens went into unprecedented mourning. Meanwhile, the Catholic Church struggled to deal with continuing allegations of child abuse cover-ups across the world. And throughout the beginning of the year, it appeared the Iranian nuclear crisis was finally entering its endgame. However, at the time of writing midway through 2010, major nuclear powers spoke of a new era of disarmament, and attention now turned to what a politically reinvigorated Barack Obama would do to halt the Islamic Republic's nuclear ambitions.

470

An Angolan supporter looks on as his national football team takes on Mali in the first round of the African Nations Cup tournament, Luanda.

Angola, a nation once ravaged by civil war, hosted the African continent's premier football tournament in January 2010. Egypt won its third consecutive title, beating Ghana 1-0 in a final where the only goal was scored by substitute Mohamed Gedo five minutes before time. While some matches had tens of thousands of spectators, many fixtures were watched by only a thousand fans. The tournament had been marred before its start by the shocking gun attack on the Togolese football team when their bus was ambushed by rebels. Three people were killed and Togo withdrew from the Cup.

471

Chile's President-elect Sebastián Piñera celebrates victory in Santiago.

Twenty years of centre-left rule in Chile ended with the result of the presidential runoff. The billionaire Sebastián Piñera, who holds an economics doctorate from Harvard as well as having numerous business interests, won just over 51 per cent of the vote against Eduardo Frei, the candidate of the ruling Concertación coalition. Piñera was the first elected right-wing leader in Chile for over half a century; Concertatión had dominated Chilean politics since the fall of the dictator Augusto Pinochet. The new president – who faced an immediate challenge with the aftermath of the devastating earthquake of 27 February 2010 – promised to continue many of the policies of the previous government.

A triumph among the tragedy: Kiki is pulled from the rubble alive and well, seven and a half days after the Haiti earthquake.

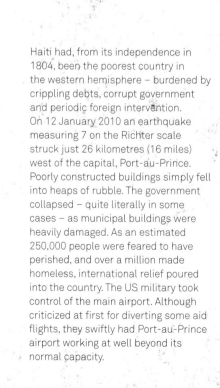

Haiti had, from its independence in 1804, been the poorest country in the western hemisphere – burdened by crippling debts, corrupt government and periodic foreign intervention. On 12 January 2010 an earthquake measuring 7 on the Richter scale struck just 26 kilometres (16 miles) west of the capital, Port-au-Prince. Poorly constructed buildings simply fell into heaps of rubble. The government collapsed – quite literally in some cases – as municipal buildings were heavily damaged. As an estimated 250,000 people were feared to have perished, and over a million made homeless, international relief poured into the country. The US military took control of the main airport. Although criticized at first for diverting some aid flights, they swiftly had Port-au-Prince airport working at well beyond its normal capacity.

474

France sparks controversy as legislators propose a ban on wearing the niqab and the burka in public.

In a landmark decision, French policymakers recommended a ban on the *voile integrale* (full veil) in state institutions and public places. Building on the 2004 legislation that prohibited 'ostentatious' religious symbols in state schools, the move was designed to uphold France's constitutional commitment to secularism. The parliamentary commission found the Islamic face veil to be a debasing 'prison' that ran contrary to civic values. Less than 1 per cent of France's 5 million Muslims wear a full face covering, leading liberal critics to query the real motivations behind a pronouncement that they argued would stigmatize and isolate the Islamic community. As France contemplated the move amid a furore, Belgium's home affairs committee voted unanimously in March 2010 to impose a ban on clothing that disguises a person's identity in a public place. This decision looked set to make Belgium the first European country to ban the burka.

Only a few photographs exist of the notoriously private author J.D. Salinger, who died on this day at his home in Cornish, New Hampshire.

475

J.D. Salinger died on 27 January 2010 at his home in the small New Hampshire town where he had lived in seclusion for more than half a century. Despite publishing only one novel and three collections of stories, his work was hugely influential. In 1951 he published *The Catcher in the Rye*, a captivating tale of adolescent angst and alienation that became an instant classic. The book's popularity, which has never waned, exposed Salinger to unwanted public scrutiny and attention. He turned his back on fame, but in doing so became the United States' most famous literary recluse. Rumours that volumes of unpublished Salinger fiction were stowed away in a vault somewhere became more vociferous after his death.

476

Lead actress Zoë Saldana is transformed into a blue alien by the groundbreaking technology of *Avatar*, the first film to earn $2 billion at the box office.

James Cameron's *Avatar* heralded the next generation of science-fiction movies. In gestation since 1994, Cameron had waited for technology to catch up with his vision for the twenty-second-century planet of Pandora, home to the alien protagonists the Na'vi (pictured). The new cinematography enabled real and virtual actors to interact in a way never before achieved, through new cameras that overlaid the imaginary world onto the real. The success of the computer-generated imagery is apparent in the film's convincing simulation of depth, an evolution of stereoscopic 3D technology, which brings the fantasy to life. *Avatar* topped the international box office, earning over $1 billion in its opening days – a record previously held for more than a decade by *Titanic*, the epic film by the same director.

Galvanized by massive state spending, US activists gather at the National Tea Party Convention in Nashville, Tennessee.

Many had observed the increasing polarization of the US political landscape, starting in the Clinton era during the 1990s. But the global financial crisis and the government's response – bailing out financial institutions with trillions of dollars – as well as President Obama's attempts to push through costly major healthcare reform, were to spur a new, highly visible manifestation of the United States' political fault lines. Adopting the symbolism of the 1773 Boston Tea Party, when colonists had protested against British taxation, a new grassroots movement emerged. Railing against 'big government', they organized rallies, protests, and even heckled politicians at public meetings.

Iran's quest for nuclear power was one of the defining features of the decade. In contradiction to the international commitment to nuclear non-proliferation, Mahmoud Ahmadinejad staked his presidency on securing an independent nuclear capability. Years of inspections, resolutions and sanctions had little impact on Iran's ambition. In a state address on 7 February, Ahmadinejad scuppered diplomatic efforts to persuade Iran to send its uranium abroad for refinement, and instead called on its Atomic Energy Organization to begin enriching uranium to 20 per cent. The United States described the decision as provocative. In turn, Ahmadinejad declared that Iran was a 'nuclear state' that could process weapons-grade uranium if it chose. As the political confrontation heated up, Washington began preparing for 'after Iran gets the bomb'.

President Mahmoud Ahmadinejad sports protective eyewear while visiting an exhibition of the latest Iranian laser technology in Tehran.

Toyota Motor Corporation's managing director makes a deep bow as, witnessed by the press, he submits another car recall document to the Transport Ministry in Tokyo.

479

In an age of increasingly complicated automobiles dominated by electronics rather than mechanics, Toyota had built itself a reputation as the producer of the most reliable cars in the world. The Japanese car giant, however, was brought into massive disrepute in 2010 when a number of faults were revealed, including 'unintended acceleration' and brake problems. Toyota was forced to recall over 8 million vehicles, including almost half a million of its popular Prius hybrid electric car. The firm's CEO, Akio Toyoda, was hauled in front of a US Congressional committee to personally account for the failures as the company was accused of abandoning its own principles of commitment to quality and safety.

480

Gifted British fashion designer Alexander McQueen, shown here in his studio, tragically took his own life weeks before his new collection was unveiled.

The founder and designer of the Alexander McQueen fashion house, Lee Alexander McQueen was found dead in his home, days after the death of his mother. Tributes poured in for the designer once described as a hooligan who had become one of the most admired contemporary artists in British fashion. Beginning as an apprentice on Savile Row, his expert tailoring caught the eye of famous stylist Isabella Blow, who bought his entire collection when he graduated from Central Saint Martins. McQueen spent five years as head designer at Givenchy before establishing his own label, and was a four-time winner of British Designer of the Year.

481

Nodar Kumaritashvili is fatally catapulted from his sled on a training run in advance of the Winter Olympics.

The 21st Winter Olympic Games were hosted in Vancouver, Canada – the warmest location in which they had ever been held. The Canadians became the most successful host nation ever, winning 14 gold medals, including a memorable men's ice hockey final against the United States, won in extra time. However, the death of Georgian luger Nodar Kumaritashvili cast a shadow over the games. The 21-year-old was killed when his sled went off the ice on the fast and challenging track, where speeds exceeded 145 kph (90 mph). Flying through the air, he hit a steel support. Fellow competitors were shocked by the tragedy and many criticized the track's design.

Those dreaming of securing a table at the three Michelin-star elBulli were crushed by the shock announcement that the fêted restaurant on Spain's Catalan coast would close in 2011. Its celebrated chef, Ferran Adrià, is acclaimed for his gastronomic creativity such as deconstructing and reassembling ingredients and dishes in new and unexpected ways. Five times voted number one by *Restaurant* magazine's World's 50 Best Restaurant Awards during the 2000s, elBulli established a reputation for remarkable innovation and near-impossible-to-get tables. Some 8,000 reservations (out of over two million requests) are taken annually by the restaurant for its six month season. Adrià later told *The New York Times* that, after a break of two years, elBulli would reopen as a culinary foundation.

482

Ferran Adrià announces that his gastronomic wonderland, elBulli, will cease to exist in its current form.

With her grey hair, 'thrift-chic' attire and sartorial self-confidence, Tavi Gevinson could have been one of New York Fashion Week's established style mavens – except that this was a 14-year-old girl who missed a week of school to attend. Blogging since March 2008, her online commentary – Style Rookie – became an industry phenomenon. Witty, insightful and inquisitive, Tavi's sophisticated use of digital photography, social networking and creative writing set her apart from similar efforts in the blogosphere, highlighting the internet's ability to empower people of any age to contribute to debate. A self-described 'tiny dork [in] awkward jackets and pretty hats', Tavi was cited as an influence by fashion designers Rodarte, and appeared on the front cover of avant-garde magazine *Pop* in 2009.

483

'Style Rookie' Tavi conducts an interview at the Y-3 show during New York Fashion Week, proving age is no barrier in the world of Web 2.0.

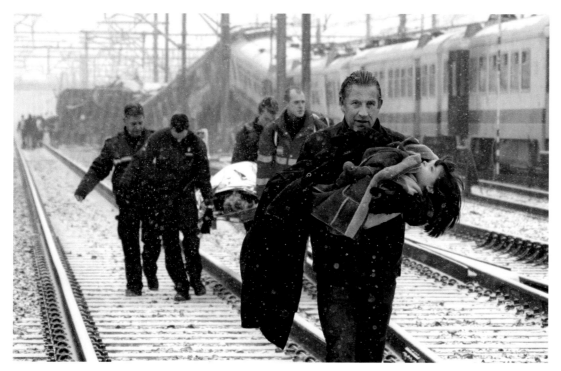

Belgium's worst rail disaster in decades occurred on 15 February when two trains collided 14 kilometres (9 miles) southwest of Brussels. The collision happened in snowy conditions during the morning rush hour – the first two carriages of one of the trains, which were carrying as many as 300 people, were propelled upwards over the first carriage of the second train, creating a pile-up on the tracks. Investigators believed that one of the drivers may have ignored a stop signal. Eighteen people were killed and more than 160 injured in the accident. Belgian Prime Minister Yves Leterme pronounced it a 'black day' for his country.

Belgian rescue workers evacuate victims of a disastrous train collision in Buizingen, outside Brussels.

484

Hindu legend has it that Krishna, jealous of his fair-skinned Radha and known for his pranks, covered her in *gulal* (coloured powder). In response, Radha and her friends chased him away. Today, the lover's tiff is re-enacted in Barsana in Uttar Pradesh, a week before the Holi festival. Men from Krishna's village, Nandgaon, taunt the women of Barsana with provocative songs, and are beaten with lathis (long sticks) in playful punishment. Lathmar Holi is both a colourful battle of the sexes and a celebration of love and equality.

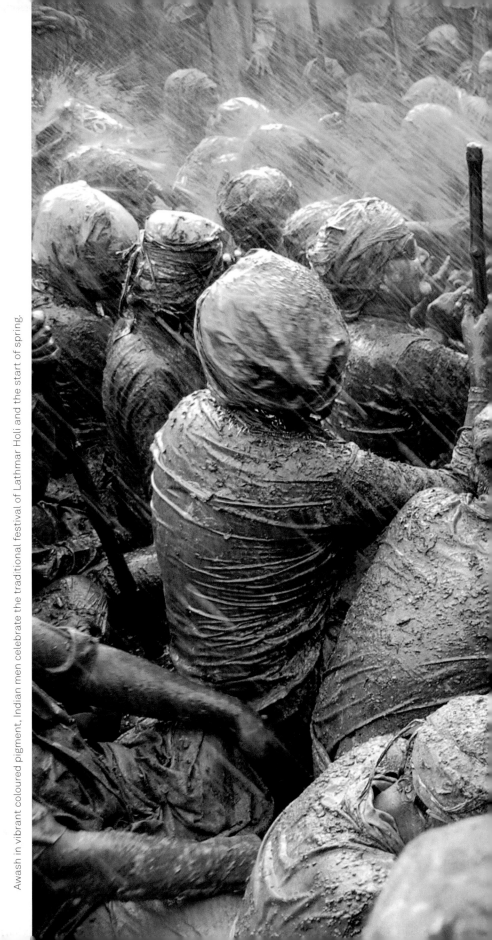

Awash in vibrant coloured pigment, Indian men celebrate the traditional festival of Lathmar Holi and the start of spring.

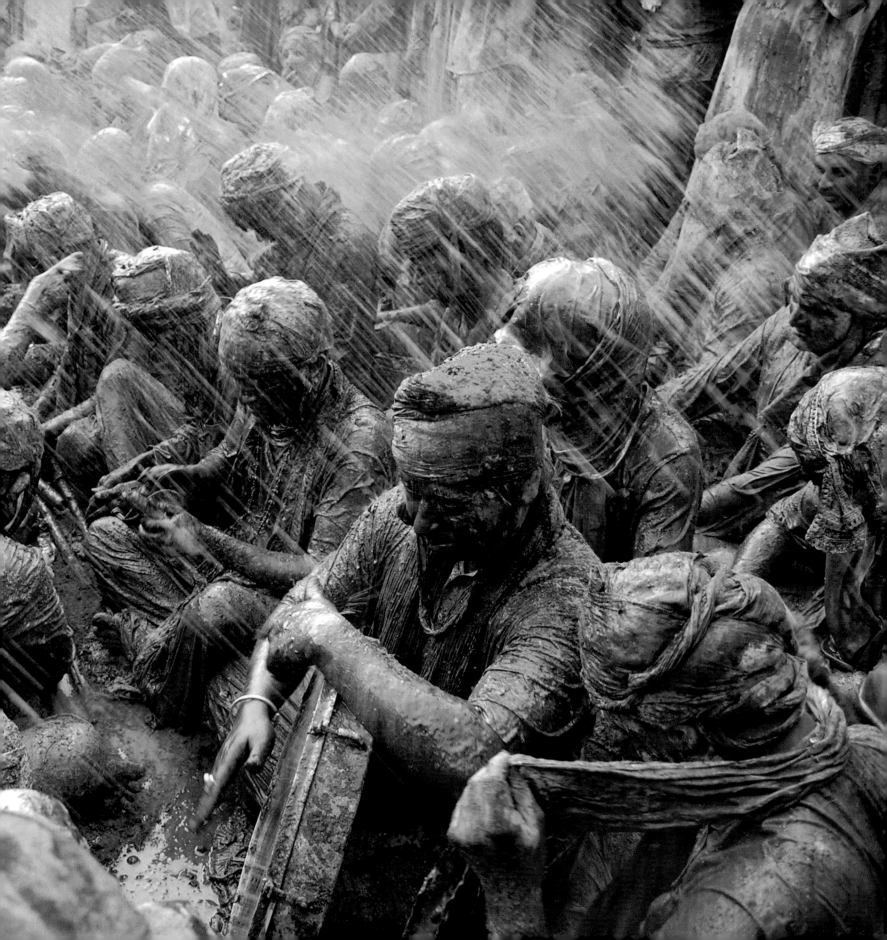

One of the most powerful earthquakes to strike in more than a century hit Chile on 27 February, triggering tsunami warnings in 53 countries. Measuring 8.8 on the richter scale, off the coast of Maule, it killed 342 people, devastated 1.5 million homes and left more than 90 per cent of the population without electricity. Looting broke out in some of the worst affected areas, which led to the imposition of curfews and the mobilization of nearly 15,000 soldiers. Chile's new president, Sebastián Piñera, declared that it would take years and cost at least $30 billion to rebuild his shattered country, which for decades has been a model of economic stability in Latin America.

Near the epicentre in Pelluhue, local Chileans contemplate the damage wrought by an enormous earthquake.

Fellow nominee James Cameron congratulates Kathryn Bigelow as *The Hurt Locker* wins another Oscar at the 82nd Academy Awards.

487

Considered the best film to date on the Iraq War, *The Hurt Locker* follows members of a US Army Explosive Ordnance Disposal team as they defuse improvised bombs and disarm insurgents in a daily war of attrition. Written by Mark Boal, a journalist embedded with such a unit in 2004, filming took place in Jordan using Iraqi refugees as extras, all of which added to a feeling of authenticity. Though criticized by veterans' groups for technical inaccuracies, the film was widely acclaimed for its visceral, relentless pace and immersive camera work; and was a constant in the Top 10 lists of 2009. *The Hurt Locker* won innumerable accolades – not least six Oscars at the 82nd Academy Awards, including Best Director for Kathryn Bigelow, the first female winner to take the prize.

The Catholic Church was hit by successive waves of scandals in 2009 and 2010 as allegations of widespread child abuse began to surface. Furthermore, reports suggested a pattern of cover-ups in the Church hierarchy and a failure to deal with the problems. The accusations related to instances decades past, but the clergy responsible were in many cases still alive. Victims came forward across the world – from Brazil to Germany. In Ireland, official investigations condemned the culture of secrecy and 'endemic' abuse in boys' institutions. The Vatican's response made matters worse. While Pope Benedict XVI publicly apologized to Irish victims in a letter, other statements of his denounced what he saw as persecution of the Church.

A Vatican spokesman fields questions on the day the Pope apologizes to Irish victims of Catholic Church child abuse.

'The bill I'm signing will set in motion reforms that generations of Americans have fought for and marched for and hungered to see.' With those words President Barack Obama signed a landmark healthcare reform bill into law. The highly contentious legislation, which would extend health insurance to 32 million Americans currently without any and prohibit insurance companies from denying coverage to people with pre-existing conditions, represented the most significant expansion of social security measures in more than four decades. Enactment of the $940 billion bill was a momentous victory for Obama, who had made healthcare reform his top domestic objective. His plan was fiercely resisted by Republicans, who pledged to repeal the legislation or even have it declared unconstitutional. Across the country opinion was similarly divided.

489

Barack Obama achieves the unthinkable: healthcare reform in the United States finally begins.

In thick fog on the morning of 10 April 2010, a Polish Air Force Tupelov Tu-154 clipped trees on the approach to Smolensk North Airport. It crashed into a nearby field; there were no survivors. In a grim irony, on board were 89 members of Poland's élite travelling to a remembrance ceremony for the 1940 Katyn massacre of Poland's intelligentsia and officer corps during Soviet occupation. Among others, President Lech Kaczynski, military chiefs of staff and prominent parliamentarians all perished. Poland went into an unprecedented period of mourning and condolences poured in from around the world. The heartfelt response of Russia and its leaders helped thaw frosty Russo-Polish relations, in which the subject of Katyn had been a lingering sore.

Polish President Lech Kaczynski and much of his country's military and state élite are among the 96 killed in a plane crash over Russia.

490

Scientists gather samples as the Eyjafjallajökull volcano continues to spit and spew ash over Iceland.

For the first time since 1821, Iceland's glacier-topped volcano Eyjafjallajökull erupted on 14 April 2010 with almost no warning. Large-scale evacuations began taking place, as torrents of meltwater flooded surrounding farmland, and a choking cloud of ash ballooned over the island, stretching towards northwest Europe. Within 24 hours, a no-fly zone had been declared across the UK and parts of Europe, air traffic controllers fearful of the potential damage to jet engines caused by the airborne ash particles. 100,000 flights were cancelled over the forthcoming days, leaving millions of travellers stranded and businesses around the world struggling. In the weeks following, further havoc occurred as the ash cloud continued to delay flights. The International Air Transport Association claimed the scale of the disruption was greater than the aftermath of 9/11, with an estimated cost to the world's airlines of over $1.5 billion. The initial crisis took more than a week to resolve, with even the British Navy being recruited to help repatriate marooned passengers. Critics slammed the overly cautious response of aviation regulatory bodies; while others questioned the fragility of the highly globalized trade and travel system.

491

The view from Husband Hill in the Gusev Crater, Mars: Barack Obama announces that he expects to see humans set foot here in his lifetime.

At the Kennedy Space Center in Florida – the birthplace of US space exploration – President Barack Obama gave his equivalent of the Kennedy speech. This time, however, the goal was not the Moon but Mars, the distant red planet with little atmosphere and low gravity. In February 2010 the White House administration controversially ended former president George W. Bush's flagship Constellation programme to again put humans on the Moon; instead, $6 billion in additional funding was promised to develop a heavy-lift rocket that could enable astronauts to orbit Mars and land on an asteroid by the mid-2030s. Responding to criticism that the end of the lunar programme would undermine the United States' space leadership, Obama claimed that the new ambition would transform NASA, support space technology breakthroughs and enable deep-space discovery.

For centuries Latinos in the Americas have marked girls turning 15 with a Quinceañera, a coming of age party. Like similar rites of passage elsewhere in the world, the Quinceañera has retained its unique character despite the inestimable changes wrought by globalization and the increasing interconnectedness of different peoples and cultures. What links their disparate traditions is the older generation's hope that the world they bequeath to their offspring will grant them fulfilment and happiness. For that universal wish to become reality, stark challenges have to be addressed. In Mexico nearly half the population is under the age of 25 – in parts of Africa, Asia and the Middle East it is over 60 per cent. As the first decade of the millennium draws to a close, the youth population in developing countries is rising faster than at any time in history. Amid concerns over irreversible climate change, economic uncertainty and intractable war, one of the defining questions of the next decade is whether young people's expectations will be met.

492

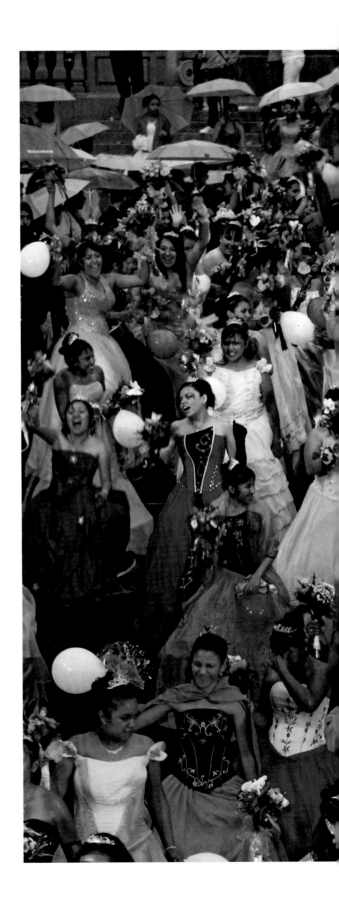

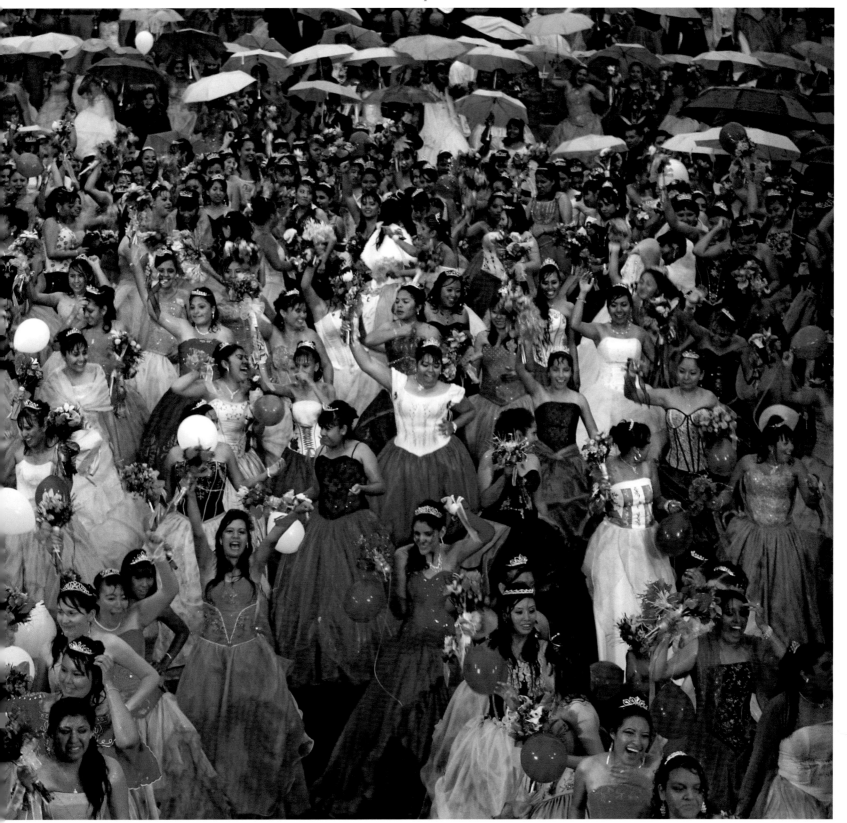

493

Hundreds of young women celebrate their coming of age during a mass Quinceañera celebration in Mexico City.

496

500

A Note for the Reader

Photography, as we knew it in the last century, is dead. We will never see a Walker Evans or an Irving Penn dominate the craft in quite the same way again. This decade we have seen images (the very word 'photograph' is now redundant) of major news events fly around the world in seconds, many shot by amateurs who may never take such a picture again. These 'citizen journalists', as they are now known, are equipped with mobile phones or digital cameras with better quality lenses and more computer memory than many cameras used by the professionals working beside them.

In this first decade of the twenty-first century we have been bombarded with images from some of the biggest news events ever to hit the planet: 9/11 in Manhattan, the tsunami in the Indian Ocean, the London Underground bombings and recently the massive earthquake in Haiti. On a busy day a newspaper will receive over 6,000 pictures. Whether an image comes from a mobile phone, a TV camera or the family video, if it is from the right place at the right time it will be seen within hours on every front page or TV news programme around the world.

The great Bruce Bernard, who edited *Century* (Phaidon's award-winning photographic history of the twentieth century published in 1999), would have looked through hundreds of boxes of prints, wearing his white archival gloves to protect the precious objects inside. While editing *Decade* I looked at thousands of images on screen and never touched a print. The other significant difference from the technology of the last hundred years is that colour now dominates image-making. Why take it in black and white when every computer and newspaper press is geared up for colour? It would take a brave editor to run a huge news picture in black and white on his front page when his bosses have paid millions for colour presses.

For *Decade* I have selected a mixture of the best images from news events and the world of sport, art and culture: 500 pictures that illustrate the first decade of this emerging century. I first started looking at images in New York in June 2009 and finished in London in April 2010. I looked at thousands of images, from the huge international photo agencies that cover the major news events around the globe, to the best freelancers working in various and often highly specialized genres. I also considered the pictures that won the prestigious World Press Awards and many of the runners-up. The result is an incredibly varied collection of images, both in style and content. As well as all the dominant news events of the last decade, we have celebrated the lives of people who have died but left a huge impression: from Luciano Pavarotti and Johnny Cash to Ronald Reagan and the Queen Mother. We have also made space for images of wit and warmth and some of downright madness.

Choice will always be subjective. Why one image from a huge news event is better than another will always cause debate. Look at the various front pages when a big story breaks and only seldom does one image dominate. Taste plays a considerable part. How much do you show of grief and torture? How do you sum up the death of more than 200,000 people as in the Haitian earthquake in January 2010? After much deliberation we settled on a positive image of Kiki, a seven-year-old boy, being pulled from the rubble alive nearly eight days after the quake struck. The picture was seen on most of the newspapers' front pages and every TV screen across the world. It showed hope and that all the hard work of the rescue teams was worth it. Surely photojournalism at its best.

Sport, fashion and the arts gave us some wonderful material to choose from. Who will ever forget the sheer power of Usain Bolt as he burst onto the running track...how does anybody run that fast? You can argue with my edit but it was done with passion, commitment and, I hope, some style. In the end, these 500 images are my choice from this first decade of the twenty-first century which, like Usain Bolt, seems to have gone so fast. Many will argue they are not the best 500 photographs taken, but they are the best of what I saw. I also know that many photographers will feel they have taken better. That is the great joy of image-making...nobody is ever right, all of the time!

Eamonn McCabe

Picture Credits

Biographies

Eamonn McCabe is an award-winning picture editor and a photographer. Formerly the picture editor of the *Guardian* from 1988 to 2001, he won Picture Editor of the Year an unprecedented six times and many credit him with changing the look of British newspapers during this time. McCabe began his career as a sports photographer on the *Observer*, winning the Sports Photographer of the Year four times, and in 1985 he was named News Photographer of the Year. His photographs have been widely exhibited at venues including the National Portrait Gallery and the Photographers' Gallery in London, and the Leica Gallery in New York. His books include *Eamonn McCabe: Photographer* (1987), *The Making of Great Photographs* (2005) and *Artists and Their Studios* with Mike McNay (2008). In 2008 McCabe was made an Honorary Doctor of Letters at the University of East Anglia. He also lectures on photography at various colleges in the UK and appears regularly on radio and television.

Terence McNamee is the Deputy-Director of the Brenthurst Foundation in Johannesburg, South Africa, established by the Oppenheimer family to develop and strengthen Africa's economic performance. Educated at universities in his native Canada and the UK, McNamee received a PhD from the London School of Economics in 2002. He worked in London for several years as an editor and writer for a defence and security think tank. He has published extensively on issues ranging from citizenship and immigration policy to security sector reform and nuclear non-proliferation. McNamee has participated in peace-building initiatives in numerous fragile states, including Afghanistan, Sierra Leone, Lebanon, Rwanda and the Democratic Republic of Congo. His recent publications include *War Without Consequences: Iraq's Insurgency and the Spectre of Strategic Defeat* (2008). McNamee also acted as advisor and wrote the historical background for Phaidon's widely acclaimed *Century* (1999).

Anna Rader is the Editor of the RUSI Journal, a leading defence and security periodical. She has written on contemporary security issues in the Horn of Africa, and is currently conducting research on African identity politics and post-conflict reconciliation in Somalia and Sudan.

Adrian Leon Johnson was born in Sierra Leone and raised in Britain, Israel and Indonesia. He read politics and economic history at the University of Edinburgh and has a Master's degree from the Department of War Studies, King's College, London. He is Director of Publications in a London-based research institute and also writes on contemporary Balkan politics.

Christopher Burge is Honorary Chairman and Chief Auctioneer of Christie's New York. He first joined Christie's in London in 1970 before moving to Christie's New York in 1973 as a specialist of Impressionist and Modern art.

Christopher Coker is Professor of International Relations at the London School of Economics. His areas of expertise include British defence policy, US and British foreign policy and the Atlantic Alliance, war and civil conflict. His many books include *War in an Age of Risk* (2009) and *Warrior Ethos: Military Culture and the War on Terror* (2007).

Frank James is Professor of the History of Science and Head of Collections and Heritage at the Royal Institution in London. Formerly President of the British Society for the History of Science, he is actively engaged in a number of international organizations regarding the history of science and technology.

Simon Kuper was born in Uganda and raised in Britain, the Netherlands, the United States, Sweden and Jamaica. He is now an author and a journalist for the *Financial Times*. His uniquely anthropological take on sport places it within the context of time, country and society.

Jonathon Porritt, CBE, is an environmentalist and writer. A former Green Party co-chair and Director of Friends of the Earth, he is the founding Director of Forum for the Future and is an eminent commentator on sustainable development.

Acknowledgements

Picture Editor's Acknowledgements

First, I must thank Peter Preston, former editor of the *Guardian*, that I became a picture editor at all, way back in 1988. I was a sports specialist working on the *Observer* and he had no idea that I would be any good at editing but he gave me a chance and it seemed to work, as I was there until 2001 when I returned to taking photographs full time.

I have had two great researchers working with me on this book; first, Faye Robson and then the unflappable Tom Wright...to both of you my heartfelt thanks. Their mastery of the new way of finding and storing photographs on the computer never failed to impress me while we looked at thousands of images from all over the world.

Thanks are also due to Phaidon's Editorial Director, Amanda Renshaw, who gave me the chance to picture edit this book and kept me in check with wit and warmth.

I would like thank my old friends at the *Guardian* who helped me enormously, namely Roger Tooth and Fiona Shields, and the picture librarian Jo Blason who saved me from making a fool of myself several times.

Of course, this book would never have happened without the photographers whose dedication never ceases to amaze me, their passion and tenacity have made some of the best photographs ever taken, let alone in the last decade. Thank you.

And finally, all those unsung heroes who work in picture libraries all over the world. Without their skills and filing we would have no book at all.

Author's Acknowledgements

With special thanks to the team at Phaidon Press for thinking of me ten years on from *Century*, especially Amanda Renshaw, Phaidon's Editorial Director, and Victoria Clarke, whose trenchant comments and sure hand improved the book considerably. Thanks also to Lise Connellan and Rosie Pickles, both of whom have provided invaluable editorial assistance, above and beyond the call of duty.

A big thank you to my colleagues and friends in Johannesburg, the city I moved to halfway through this project, above all Greg Mills, Leila Jack and Lyal White, and of course my new employer, E. Oppenheimer & Son. In London, special thanks to Susan Schulman whose remarkable photographs from forgotten (and familiar) corners of the world helped me greatly in my former job and continue to be a source of inspiration. Thanks, as ever, to my friend Richard Taylor, in whose London home I wrote the text for *Century*, and to my family.

It was a privilege to be involved in the *Decade* project and I am grateful to the book's Picture Editor, Eamonn McCabe, for assembling such a compelling collection of images. There can never be a definitive account of any decade, but I hope this comes as close as you can get.

My deepest thanks go to my co-writers, Anna Rader and Adrian Johnson. Both are exceptional writers, researchers and managers. It is rare to find those skills all rolled into one – or in this case, two. And it is rarer still to find them in such wonderful people. Thanks guys.

Publisher's Acknowledgments

The Publisher would like to thank Eamonn McCabe for an extraordinary selection of images, and for his passion and enthusiasm throughout the editing process. In addition, Terence McNamee for his authoritative texts, historical guidance and unwavering commitment to the project. And Adrian Johnson and Anna Rader, who provided essential and expert support both as co-writers and researchers. Thank you also to our contributing writers, Christopher Burge, Christopher Coker, Frank James, Simon Kuper and Jonathon Porritt, who have provided eloquent discussion on the defining themes of the decade.

Phaidon Press Limited
Regent's Wharf
All Saints Street
London N1 9PA

Phaidon Press, Inc.
180 Varick Street
New York, NY 10014

www.phaidon.com

First published 2010
© 2010 Phaidon Press
Limited

ISBN 978 0 7148 5768 8

A CIP catalogue record of this book is available from the British Library.

Printed in Thailand